Yemoja

Yemoja

Gender, Sexuality, and Creativity in the Latina/o and Afro-Atlantic Diasporas

Edited by

SOLIMAR OTERO

and

TOYIN FALOLA

Cover image, *Adenike of Lagos*, Arturo Lindsay, 2003. Digital print, 24" x 21", in the collection of the artist.

Published by State University of New York Press, Albany

© 2013 State University of New York

All rights reserved

Printed in the United States of America

No part of this book may be used or reproduced in any manner whatsoever without written permission. No part of this book may be stored in a retrieval system or transmitted in any form or by any means including electronic, electrostatic, magnetic tape, mechanical, photocopying, recording, or otherwise without the prior permission in writing of the publisher.

For information, contact State University of New York Press, Albany, NY
www.sunypress.edu

Production by Eileen Nizer
Marketing by Anne M. Valentine

Library of Congress Cataloging-in-Publication Data

Yemoja : gender, sexuality, and creativity in the Latina/o and Afro-Atlantic diasporas / edited by Solimar Otero and Toyin Falola.
 p. cm.
Includes bibliographical references and index.
ISBN 978-1-4384-4799-5 (hardcover : alk. paper)
ISBN 978-1-4384-4800-8 (pbk. : alk. paper)
 1. Yemaja (Yoruba deity) 2. Mother goddesses. 3. Afro-Caribbean cults.
4. Cultural fusion and the arts. 5. African diaspora in art. 6. Goddesses in art. 7. Orishas in art. 8. Sex in art. I. Otero, Solimar. II. Falola, Toyin.

BL2480.Y6Y46 2013
299.61211—dc23 2012043678

10 9 8 7 6 5 4 3 2 1

To our mothers, especially Maria Julia Melchor

Yemayá Asesu, Asesu Yemayá
Yemayá Asesu, Asesu Yemayá
Yemayá Olodo, Olodo Yemayá
Yemayá Olodo, Olodo Yemayá

—Traditional Afro-Cuban song for Yemayá

Contents

List of Illustrations and Other Media	ix
Acknowledgments	xiii
Note on Terminology and Orthography	xv
Introduction: Introducing Yemoja *Solimar Otero and Toyin Falola*	xvii

Part 1
Yemoja, Gender, and Sexuality

Invocación / Invocation *En busca de un amante desempleado* / Searching for an unemployed lover *Pedro R. Pérez-Sarduy*	2
Chapter 1 Nobody's Mammy: Yemayá as Fierce Foremother in Afro-Cuban Religions *Elizabeth Pérez*	9
Chapter 2 Yemayá's Duck: Irony, Ambivalence, and the Effeminate Male Subject in Cuban Santería *Aisha M. Beliso-De Jesús*	43
Chapter 3 *Yemayá y Ochún*: Queering the Vernacular Logics of the Waters *Solimar Otero*	85
Chapter 4 A Different Kind of Sweetness: Yemayá in Afro-Cuban Religion *Martin Tsang*	113

Chapter 5
Yemoja: An Introduction to the Divine Mother and
Water Goddess 131
 Allison P. Sellers

PART 2
YEMOJA'S AESTHETICS: CREATIVE EXPRESSION IN DIASPORA

Chapter 6
"Yemaya Blew That Wire Fence Down": Invoking African
Spiritualities in Gloria Anzaldúa's *Borderlands/La Frontera:
The New Mestiza* and the Mural Art of Juana Alicia 153
 Micaela Díaz-Sánchez

Color image gallery follows page 186

Chapter 7
Dancing *Aché* with Yemaya in My Life and in My Art:
An Artist Statement 187
 Arturo Lindsay

Chapter 8
What the Water Brings and Takes Away: The Work of
María Magdalena Campos Pons 197
 Alan West-Durán

Chapter 9
"The Sea Never Dies": Yemọja: The Infinitely Flowing
Mother Force of Africana Literature and Cinema 215
 Teresa N. Washington

Chapter 10
A Sonic Portrait with Photos of Salvador's Iemanjá Festival 267
 Jamie N. Davidson and Nelson Eubanks

Chapter 11
Yemayá Offering a Pearl of Wisdom: An Artist Statement 275
 Erin Dean Colcord

Notes on Contributors 279

Index 285

Illustrations and Other Media

Cover image, *Adenike of Lagos*, Arturo Lindsay, 2003. Digital print, 24" x 21", in the collection of the artist.

Figure 6.1 *Sanarte: Diversity's Pathway*, Juana Alicia ©2005. Suite of four murals and the double helix and cementatious tile walkway at UCSF Medical Center, 400 Parnassus Avenue, San Francisco. 165

Figure 6.2 OLLIN Mural, detail of *Sanarte: Diversity's Pathway*, Juana Alicia ©2005. Suite of four murals and the double helix and cementatious tile walkway at UCSF Medical Center, 400 Parnassus Avenue, San Francisco. 166

Figure 6.3 *MaestraPeace* (1994 and 2000) by Juana Alicia, Edythe Boone, Susan Kelk Cervantes, Meera Desai, Yvonne Littleton, and Irene Perez. Photo Credit: Marvin Collins, Ruben Guzman, et al. All Rights Reserved. 169

Figure 6.4 *MaestraPeace* (Detail) (1994 and 2000) by Juana Alicia, Edythe Boone, Susan Kelk Cervantes, Meera Desai, Yvonne Littleton, and Irene Perez. Photo Credit: Marvin Collins, Ruben Guzman, et al. All Rights Reserved. 170

Figure 7.1 *Sanctuary for the Children of Middle Passage*, Arturo Lindsay, 2000. EXMA Centro Culturale D'Arte e Cultura, Sardinia, Italy. Mixed media installation, dimensions variable. 192

Figure 10.1 Iemanjá Festival, Praia da Paciência, Rio Vermelho, Salvador, Brazil, 2 February 2012, photo by Jamie Davidson. 269

Figure 10.2 Iemanjá Festival, On the Praia da Paciência, the great float of offerings grows. In the background, the Casa de Yemanjá, Salvador, Brazil, 2 February 2012, photo by Jamie Davidson. 270

Figure 10.3 Iemanjá Festival. Flowers and gifts await departure. Praia da Paciência, Rio Vermelho, Salvador, Brazil, 2 February 2012, photo by Jamie Davidson. 270

Figure 10.4 Iemanjá Festival. On a beach strewn with flowers, an ecstatic devotee receives support. Praia da Paciência, Rio Vermelho, Salvador, Brazil, 2 February 2012, photo by Jamie Davidson. 271

Figure 10.5 Iemanjá Festival. Boats carry offerings to the sea. Praia da Paciência, Rio Vermelho, Salvador, Brazil, 2 February 2012, photo by Jamie Davidson. 272

Figure 10.6 Iemanjá Festival. "*A muvuca.*" Revelers make music on the Praia da Paciência, Rio Vermelho, Salvador. 2 February 2012, photo by Jamie Davidson. 272

Figure 10.7 Iemanjá Festival. Song of praise with bead seller. Praia da Paciência, Rio Vermelho, Salvador, Brazil, 2 February 2011, photo by Jamie Davidson. 273

Figure 10.8 Iemanjá Festival. Drummers take the streets. Rua João Gomes, Rio Vermelho, Salvador, Brazil, 2 February 2012, photo by Jamie Davidson. 273

Figure 11.1 *Yemaya Offering a Pearl of Wisdom*, Erin Dean Colcord, 2004. Acrylic on canvas, 20" x 28", courtesy of the artist. 276

Figure 11.2 *Mermaid Playing with Merbaby*, Erin Dean Colcord, 2009. Jar Candle Sticker, color, 3" x 5", courtesy of the artist. 277

Illustrations and Other Media

Color Gallery follows page 186

Plate 1 *La Llorona's Sacred Waters*, Juana Alicia ©2004. Acrylic mural on stucco, 30' x 60'. 24th and York Streets, San Francisco Mission District.

Plate 2 Yemaya Detail from *MaestraPeace* (1994 and 2000) by Juana Alicia, Edythe Boone, Susan Kelk Cervantes, Meera Desai, Yvonne Littleton, and Irene Perez. Photo Credit: Marvin Collins, Ruben Guzman, et al. All Rights Reserved.

Plate 3 *Bay of Portobelo at Sunset*, Arturo Lindsay, 2002. Digital photography, 11" x 14", in the collection of the artist.

Plate 4 *Requiem in Portobelo*, Bay of Portobelo, Panama, Arturo Lindsay, 2005. Bamboo, cayuco (hand-hewn wooden canoe), dried leaves, fire and water, 20' x 10' x 4'.

Plate 5 *The Voyage of the Delfina, a performance art ritual*, Arturo Lindsay with poet Opal Moore, 2002. The Atrium of the Camille Olivia Hanks Cosby Academic Center, Spelman College, Atlanta, Georgia, Multimedia performance/installation, dimensions variable.

Plate 6 *Adenike of Lagos*, Arturo Lindsay, 2003. Digital print, 24" x 21", in the collection of the artist.

Plate 7 *Retorno de las ánimas Africanas / The Return of African Spirits*, Arturo Lindsay, installed by Amy Sherald, photo by Gustavo Araujo, 2000. Museo de Arte Contemporaneo, Panama. Mixed media installation, dimensions variable.

Plate 8 *Boli Catching the Skies #1, 2010* (The Sardine Fishing in Portobelo Series), Arturo Lindsay, 2012. Digital photography, 11" x 14", in the collection of the artist.

Acknowledgments

Many people and organizations helped to make this project a reality. Many thanks for the support and feedback received from the Harvard Divinity School's Women's Studies in Religion program, especially Ann Braude, who sponsored some of the research in Cuba presented in this book. We are grateful as well for the support received from the University of Texas at Austin. We also would like to acknowledge the support received from Dean Gaines Foster, from the College of Humanities and Social Sciences at Louisiana State University. Thank you also to the chair of the Department of English at LSU, Rick Moreland, who enthusiastically believed in this project. We give much thanks to all at the Women's and Gender Studies (WGS) program at LSU. WGS provided necessary support for completing this project, in addition to offering an important intellectual venue for working through the main components of this work. LSU's programs in Louisiana and Caribbean Studies and Atlantic Studies were both extremely helpful and supportive of the collaborative endeavors presented in this book.

There are also many colleagues whose feedback was crucial to developing our vision in the anthology. We are grateful to Aisha Beliso-De Jesús for her thoughtful comments in formulating the early stages of this project. Lucinda Romberg also read early versions of the work and provided much insight. We also thank Norma Cantú and Katey Borland for their useful readings and responses. LSU colleagues Bill Boelhower, Benjamin Kahn, Lara Glenum, Pallavi Rastogi, Carolyn Ware, Rosan Jordan, and Frank De Caro graciously commented on the project in ways that greatly improved our scope and focus. We are grateful to Arturo Lindsay, Juana Alicia, Jamie Davidson, Nelson Eubanks, and Erin Colcord for graciously allowing us to reproduce the powerful artwork and photography found in this book. We especially want to thank the spiritual communities in Africa, Cuba, Brazil, Panama, Puerto Rico, and the United States who generously allowed their wisdom and knowledge

to inform and shape the research presented in this book. Finally, we would like to recognize our families and loved ones—Eric Mayer-García, Rai Otero, Raymond M. Otero, Robert and Blanca Alvarez, and Maria Julia Melchor—for their moral support and belief in the volume. *A dupe, nuestras gracias.*

Note on Terminology and Orthography

Some of the chapters in this book use the diacritical marks that express Yoruba tones and consonances. Yoruba is a tonal language that moved across the Atlantic into contexts where Spanish, Portuguese, and American dialects of English incorporated the language within their own phonetic structures. The differences in orthography reflected in the chapters that follow indicate these shifts in language use. We use the spelling *Yemoja* in the introduction of the volume for clarity. Wherever appropriate, we keep the authors' intended usage of Yoruba terminology. In this manner, the names *Yemayá*, *Iemanjá*, and *Yemoja* relate to the same deity in different cultural and linguistic contexts.

Introduction

Introducing Yemoja

Solimar Otero and Toyin Falola

> Mother I need
> mother I need
> mother I need your blackness now
> as the august earth needs rain.
>
> —Audre Lorde, "From the House of Yemanjá"[1]

"Yemayá es Reina Universal porque es el Agua, la salada y la dulce, la Mar, la Madre de todo lo creado / Yemayá is the Universal Queen because she is Water, salty and sweet, the Sea, the Mother of all creation."

—*Oba Olo Ocha* as quoted in Lydia Cabrera's *Yemayá y Ochún.*[2]

In the above quotes, poet Audre Lorde and folklorist Lydia Cabrera write about Yemoja as an eternal mother whose womb, like water, makes life possible. They also relate in their works the shifting and fluid nature of Yemoja and the divinity in her manifestations and in the lives of her devotees. This book, *Yemoja: Gender, Sexuality, and Creativity in the Latina/o and Afro-Atlantic Diasporas,* takes these words of supplication and praise as an entry point into an in-depth conversation about the international Yoruba water deity Yemoja. Our work brings together the voices of scholars, practitioners, and artists involved with the intersectional religious and cultural practices involving Yemoja from Africa, the Caribbean, North America, and South America. Our exploration of Yemoja is unique because we consciously bridge theory, art, and

practice to discuss *orisa* worship[3] within communities of color living in postcolonial contexts. We also explore the ways that gender and sexuality inform these communities' religiosity.

The contributors in this volume examine Yemoja and her relationship to the construction of gender and sexuality in society and culture through essays and creative works. Some of the creative works in the book include poetry, website production, photo essays, and artists' statements. All of the works are organized into two sections: "Yemoja, Gender, and Sexuality" and "Yemoja's Aesthetics: Creative Expression in Diaspora." These two areas of focus share the evaluative lens of cultural critique that pushes the boundaries of our understanding of how Yemoja traditions situate gender and sexuality in society as transformative and fluid modes of being and doing. Our two unique areas of exploration fit into existing and emerging theoretical, cultural, and historical understandings of Yemoja.

Our foremost goal in this volume is to facilitate scholarly and artistic investigation into the connections among *orisa* religion, art, and practice in interdisciplinary and transnational ways.[4] Our volume uncovers work being done on the discourse and practice of Yemoja traditions and their connections to national identity, gender, sexuality, and race. Indeed, *orisa*-worshipping communities are sites where subjectivities are creatively produced within social and cultural contexts. The chapters and other works in this volume also illustrate the ways that ritual, narrative, and art about Yemoja help to transform these contexts into several important sites of negotiation.

One set of negotiations we emphasize occurs within the African Diaspora, between Afro-Atlantic and Latina/o understandings of Yemoja. Communities that lay claim to Yemoja traditions often inhabit the multiple cultural, social, and racial locations that these descriptors suggest. Therefore, in this volume we are especially interested in addressing and exploring the geopolitical and cultural border crossings that Yemoja religious practices reveal both in daily life and in theoretical terms. To do this, we must examine how the discourses of fluidity found within African and African Diaspora Yoruba religious practices and arts emerge in their many historical and cultural contexts. Here fluidity includes a notion of flexible traditions that are open to hybrid and variable spaces found through Yoruba, and especially *orisa*, itinerant cultural logics and variable aesthetics.[5] From this perspective, many of the contributors presented in this volume seek to uncover the ways that Yemoja is understood and reconstructed to reflect, respond, and challenge colonialism as well as the legacy of slavery in the African Diaspora, Latin America, and the Caribbean.

Finally, the entire volume considers how constructions of gender and sexuality are deeply connected to Yemoja traditions. Our authors explore the complexity of these constructions within a variety of religious and creative contexts. Thus, this volume emphasizes how images of Yemoja in art, literature, and ritual question what kinds of aesthetics and counter-aesthetics determine the contours of gender and sexuality performed through the figure of Yemoja.

Yemoja is a deity known in Yoruba-based Afro-Atlantic religious cultures for her ability to dominate natural phenomena, especially aquatic zones of communication, trade, and transportation such as oceans, rivers, and lagoons. She is also associated with women, motherhood, family, and the arts. One translation of her name in Yoruba is "mother of fish," metaphorically capturing her essence as the mother of all living things. In transnational contexts, she is also known by multiple names: for example, Yemayá in Cuba and Yemanjá, Iemanjá, and Janaína in Brazil. She is also associated with other water deities, such as Olókùn in Nigeria and Mami Wata across West and Central Africa. Scholars have explored her close relationship to the river deity Oshun.[6]

Anthropologists and art historians have also connected Yemoja to the Gelede festival of Ketu, especially in relation to gender and female power in *orisa* art and performances.[7] As the ancestral "mother" of the Gelede masks and the spirit children they embody, Yemoja is also necessarily connected to the powers of the *aje*, "our mothers": powerful and hidden female spiritual forces that are especially propitiated during Gelede.[8] Since Yemoja is noted as a primordial female *orisa*, she is central to how Yoruba religious discourses enact the power of performing gender as a reflexive critique and satire of these roles in society and culture. In this regard, Oyeronke Olajubu's study of women in Yoruba religion, *Women in the Yoruba Religious Sphere*, helps us to consider how religious practices can be gendered through multiple narratives of traditionality that co-exist within the layered tapestry of *orisa* religious practice.[9]

A unifying consideration of this volume is how gender and sexuality are central to Yemoja's fluidity and to the performance of religious agency among her followers. We are interested in showing how postcolonial feminisms and queer theory can provide new and meaningful readings of Yemoja representations and practices. As Jacqui Alexander asserts in *Pedagogies of Crossing*, outspoken and anticolonial expressions of gender and sexuality in vernacular religious traditions are especially vexing to official religious and secular institutions.[10] In this spirit, the queering of Yemoja traditions discussed in this volume further question the naturalization of ideologies of neocolonialism, patriarchy, and homophobia that sometimes mark Afro-Atlantic practices in ways that

lead us away from the religious cultures' transformative powers. Indeed, many of the chapters in this book grapple with the negotiation of what could be considered subaltern communities within these very traditions.

Before discussing the specific contributions to the volume, it is important to examine how scholars have understood gender, sex, and race in how *orisa* religious cultures are represented. Scholars such as Karin Barber and Margaret Drewal have looked at Yoruba religious performances such as *oriki* and ritual dance from the perspective of women's performative agency within an aesthetics of fluidity and play.[11] Although the study of gendered aesthetics remains an accepted way to think about Yoruba performances, debates continue about whether gender indeed exists as an ontological category in Yoruba traditional thought, language, and religious discourse.[12] For example, in *The Invention of Women: Making African Sense of Western Gender Discourses,* Oyeronke Oyewumi argues that Yoruba linguistic registers do not account for gender. The construction of gendered discourses, and the hegemonies that they imply in the West, she argues, were part of the British colonial project but also have manifested in contemporary Western feminist and anthropological work on *orisa* religions. Her main argument is that biology, like gender, is socially constructed in its mutability and that Yoruba concepts and performances of both gender and biology are guided by social relationships.[13]

J. Lorand Matory responds vehemently against this argument in *Black Atlantic Religion: Tradition, Transnationalism, and Matriarchy in Afro-Brazilian Candomblé*. He argues that gender and sexuality do indeed exist in Yoruba culture, especially in Yoruba religious cultures, and that these aspects of social identity are coded within the paradigms of the performance of transnational imagined communities.[14] He goes on further to suggest that traditions of secrecy in *orisa* religious cultures are the matrix by which gender and sexuality are reinterpreted for a variety of transnational political ends. Thus, "Yoruba" transnational allegiances hinge on how gendered ritual histories have been reinvented with an idea of a cosmopolitan authenticity at their base.[15] Clark likewise grapples with the concept of gendering *orisas* and *orisas* gendering practitioners in ritual practices like spirit possession, in the context of Santería.[16] How feminism, postcolonialism, and race are to be negotiated in multiple contexts whereby *orisa* religious culture performs important work in these three areas is at the heart of these debates.

Queer theory also thinks through the shifting manifestations of gender and sexuality within *orisa* performances.[17] It is important to note here that seminal lesbian and queer women writers, theorists, poets, and activists like Audre Lorde, Gloria Anzaldúa, and Lydia Cabrera devoted

important sections of their lives' work specifically to Yemoja (Yemayá).[18] Indeed, though often depicted as the eternal mother, Yemoja can perform different kinds of gender roles, and she has the power to shift, change, and display an ambiguous sexuality in mythology and ritual. Yet Yemoja also reminds us that marking gendered and sexual difference has real consequences within *orisa* religious cultures that grapple with the historical and social legacies of patriarchy and homophobia.[19] Thus, this volume presents provocative essays that connect Yemoja aesthetics and mythology with the legacy of gendered hybridity found in ritual, art, and writing about Yemoja from queer and feminist perspectives that have been understudied thus far.

Poet Pedro R. Pérez-Sarduy opens the discussions in the book as an invocation with his poem "*En busca de un amante desempleado /* Searching for an unemployed lover." The piece brings us into Havana, a city bordered by the sea. It is a lyrical love song to the "Queen of the Sea" revealing the bittersweet material realities of contemporary Cuba and relating the island's history of conquest and colonialization to Yemayá's imagery and mythological messages. Pérez-Sarduy reminds us that the transnational and transcultural contexts of Yemoja arts are marked by the converging histories of conquest and encounter that traversing the ocean suggests.[20]

The book's first section "Yemoja, Gender, and Sexuality" explores how representations of Yemoja are gendered, sexed, and racialized in Afro-Atlantic ritual, literature, and art. Sometimes represented in the form of the voluptuous, dark mother, Yemoja has been recast in a variety of images that reflect a kind of *tropicalization* of her character in the Caribbean and the Americas—here she becomes racially black in both a discursive and historical sense.[21] Similarly, Elizabeth Pérez explores how representations of black women as mothers move throughout the Afro-Atlantic world. Pérez's piece, "Nobody's Mammy: Yemayá as Fierce Foremother in Afro-Cuban Religions," unites queer and postcolonial theory to challenge representations of Yemayá in Afro-Cuban religious cultures that fix her within the colonizing gaze of the "mammy" figure. Her interpretation of the queer term "fierceness" disturbs representations of the "mammy" in ways that recall Jose Muñoz's formulation of disidentifications whereby nuanced performances of mimicry and satire trouble stereotypes of race, gender, and sexuality.[22] Pérez's comparative fieldwork in Cuba and the United States reveals how economies of race, gender, and sexuality within Afro-Cuban religions include queer communities who express their own "fierceness" in performing spiritual and cultural work.

Afro-Cuban religious cultures place Yemayá at the center of discourses about race, gender, and homosexuality.[23] Yemoja is believed to

protect gays and lesbians, and her companion, the duck, *el pato*, is a telling figure in her cosmology. "*Pato*" is used as a derogatory term in Latin America and the Caribbean for a homosexual man, making it an especially interesting symbol to analyze in this regard. Aisha M. Beliso-De Jesús uses ethnography and cultural criticism to explore the epistemology of the duck in her illuminating piece, "Yemayá's Duck: Irony, Ambivalence, and the Effeminate Male Subject in Cuban Santería." Beliso De-Jesús reveals how representations of *el pato* and Yemayá in Santería create discourses of masculinity and homosexuality in the tradition—inside and outside the island.

In a similar vein, Solimar Otero shares her fieldwork and a close textual reading of Cabrera's *Yemayá y Ochún* in her piece "*Yemayá y Ochún*: Queering the Vernacular Logics of the Waters." Otero explores how ritual practices and mythological discourses found in the relationship between Yemayá and Ochún in Cuban Santería reveals coded knowledge about gendered and queered locations in the religion. She particularly looks at how vernacular speech genres, like gossip, can impart certain kinds of information about *orisa* religious knowledge through unauthorized, veiled, and infectious registers.

In a related manner, the transatlantic nature of Yemoja rituals and mythology highlight her important role as a symbol of a gendered traditionality in transnational postcolonial contexts. Issues of authenticity and hybridity in Afro-Atlantic religious terms also resemble Afro-Atlantic philosophical arguments about aesthetics, knowledge, and values in comparing Western and African epistemologies.[24] The questions that the idea of "authenticity" in Yemoja traditions evokes are at the very heart of how Latina/o and Afro-Atlantic religious communities are reconfiguring their beliefs about the nature of society, culture, and even personhood. This last point is a significant issue in terms of thinking how embodiment and subjectivities work in *orisa*-worshipping communities in terms of gender and agency.

Along these lines, there is a diversity of ways that Yemoja's gender roles are understood in Afro-Atlantic *orisa*-worshipping communities. Her roles among Yoruba communities in Africa are fluid as well; for example, Yemoja's role can shift between wife and mother with regards to her relationship to the *orisa Sango*.[25] This method of narrative transculturation in Yemoja's mythology appears in how religious cultures in diaspora are experienced and expressed. The two final chapters in this first section on gender and sexuality are "A Different Kind of Sweetness: Yemayá in Afro-Cuban Religion," by Martin Tsang, and "Yemoja: An Introduction to the Divine Mother and Water Goddess," by Allison P. Sellers. Both pieces wrestle with the tensions found in

transnational Yemoja religious practices that simultaneously value cultural fluidity, innovation, and the idea of tradition as the main grounds for ritual and mythological discourse. These two contributions illustrate the multiplicity of Yemoja's traditions in Africa and in the African Diaspora. Both Tsang and Sellers also reveal how the idiom of authenticity in religious rituals works to "traditionalize" much of the innovation, contradiction, and ambiguity found in *orisa* religious cultures. Their work is especially useful in extricating how ritual performances reinforce and subvert gendered scripts like mother and wife through differently gendered and sexed bodies.[26] This kind of performative play can especially be seen in the religious cultures of Cuban Santería and Brazilian Candomblé.[27] However, these religious traditions themselves illustrate a Yemoja-like fluidity in how they generate multiple transnational disaporas of practitioners.[28] As Yemoja traditions continue to move, so too will the ways that her religious practices embody subjectivity and negotiate place, gender, sexuality, race, nation, and culture in diasporic contexts.

The second half of the volume, "Yemoja's Aesthetics: Creative Expression in Diaspora" centers on how Yemoja's imagery offers a visual language through which to discuss slavery, colonialism, and history. Our first piece in the section traverses the borders between Chicana/o and Afro-Caribbean representations of the water goddess through theory, art, and poetry. In "'Yemaya Blew That Wire Fence Down': Invoking African Spiritualities in Gloria Anzaldúa's *Borderlands/La Frontera: The New Mestiza* and the Mural Art of Juana Alicia," Micaela Díaz-Sánchez explores Yemayá as a central figure in Chicana/o theory and art in the works of writer Gloria Anzaldúa and muralist Juana Alicia. Díaz-Sánchez's provocative chapter invites us to witness how Yemayá helps Anzaldúa obliterate the colonizing and objectifying "wire fences" that alienate women, queers, and people of color. Díaz-Sánchez explores the ways Anzaldúa contests indigenous/Spanish dichotomies by placing Yemayá on the Mexican-U.S. border. Díaz-Sánchez also argues that Alicia's artwork represents this important incorporation and moves Yemoja into new visual narratives. In this manner, communities of color that embrace Yemoja's hybridity and fluidity become connected through her spirituality.

In this regard, we can align Pérez-Sarduy's poem that opens the volume, "*En busca de un amante desempleado*/Searching for an unemployed lover," with the other creative expressions in this section because these pieces speak directly to how Yemoja's fluid aesthetics inform our understandings of the legacies of slavery and colonialism. These aesthetics are especially symbolized by the figure of Yemoja as the ocean. The image of the sea in the art, film, and literature discussed in this section

becomes a site for witnessing and healing the past in the specific historical and cultural terrains of an Afro-Caribbean-Atlantic imaginary.[29]

Two particular chapters in this section, "Dancing *Aché* with Yemaya in My Life and in My Art: An Artist Statement" by Arturo Lindsay and "What the Water Brings and Takes Away: The Work of María Magdalena Campos Pons" by Alan West-Durán, investigate how Yemoja art and imagery remembers peoples and cultures lost during chattel slavery. Lindsay's piece revolves around the idea of *desaparecidos*, or those who are missing, to explore the connections among Yemoja, Latin American political upheavals, and voices, lives, and histories lost during slavery. His artwork in this book re-imagines the faces and places lost to create spaces for remembrance, healing, and putting fractured communities back together again. His meditation on the similarities between missing loved ones and dispersal in Panamanian and the African diasporas is especially moving and apt. Likewise, West-Durán explores the visual and performance art of Cuban artist María Magdalena Campos Pons. Campos Pons' work resonates with Yemayá imagery, and her aesthetics of Santería traditions reflect issues of memory and history in the African Diaspora. West-Durán aptly invokes Edouard Glissant's writings on the sea to help us to place Campos Pons' oeuvre within a larger Caribbean aquatic imaginary. Again, meditations on loss and renewal center on Yemoja's ability to recover and regenerate through her cyclical fluidity, and artwork devoted to her forces us to question not only how we understand the past but also whose history is remembered.

In this regard, Teresa N. Washington explores the central nature of Yemoja imagery in a transatlantic framework in "'The Sea Never Dies' Yemoja: The Mother-Force Flowing Infinitely in Africana Literature and Cinema." This piece looks at how seminal works in Africana literature and cinema, like Toni Morrison's *Beloved* and Julie Dash's *Daughters of the Dust*, explore Yemoja's ocean symbology.[30] Washington's piece works nicely within other kinds of narratives that unpack Afro-Atlantic, especially African American, expressions of *orisa* worldview and symbolism in literature and film.[31] As with Lindsay's work, the *orisa* expressions Washington reveals through her interpretative work call on ritual histories to open up a creative space of remembrance for the lives lost during the Atlantic slave trade.

Yemoja's healing powers are renown in the Afro-Atlantic world, especially in Brazil, where children, people with AIDS, and other vulnerable communities turn to Yemoja for acceptance and dignity in *Candomblé* religious practices.[32] Indeed, Jamie N. Davidson and Nelson Eubanks explore Iemanjá as a formidable force in Salvador, Bahia, in their piece for the volume, "A Sonic Portrait with Photos of Salvador's Iemanjá

Festival." This chapter uses personal reflections and photos to give a rich and layered portrait of the Iemanjá festival. Their work focuses on how website construction opens up new ways of presenting ethnographic work, especially in the areas of religious street performance and ethnomusicology. The authors invite readers to interact with their work in the field by visiting their website.[33] The site is dedicated to a "sonic portrait" of the Festa de Iemanjá held in February every year in the Rio Vermelho neighborhood of Salvador, Bahia. Davidson and Eubanks followed the well-known religious group Filhos de Gandhy in 2010, 2011, and 2012, whose musical sounds dedicated to Iemanjá filled the streets in waves that mimicked the ocean. Their site adds a level of texture and resonance to our exploration of Yemoja, especially in terms of how deeply held traditions and beliefs about this fluid and transnational deity affect entire communities in Bahia's urban environment. Their focus on community building through a range of media, like music and virtual sites, allows us to see how the figurehead of Iemanjá acts as a conduit for forming kin in both traditional and innovative ways.

Another site of transcultural negotiation appears among alternative religious cultures in the United States. Erin Dean Colcord is an artist and neopagan priestess of the Come As You Are (CAYA) Coven headquartered in Berkeley, California. Her coven is an important site for religious admixture between African diasporic and neopagan religions.[34] Her piece "Yemaya Offering a Pearl of Wisdom: An Artist Statement" shares her experiences with Yemoja as a spiritual guide and artistic inspiration. The statement describes how spiritual and cultural exchanges deeply inform her artwork as a mode of religious work. Another piece of art by Colcord, "Mermaid Playing with Merbaby," vividly depicts a mermaid and a "merbaby" that Colcord created for her friend, a priestess of the American Magic Umbanda House in Oakland, California, as she prepared to dedicate her life to ritual service in the name of Yemoja. Colcord's art and statement reflect how Yemoja's fluidity inspires all kinds of vernacular religious cultures and how she opens up spaces for religious and cultural exchange and borrowing in the United States, especially among feminist, nonmainstream religious cultures. Here again, culture and art produced for Yemoja challenge us to think through and across the boundaries, borders, and contours of religious and artistic expression.

Considering the works in the two sections of this volume, we show how Latina/o and Afro-Atlantic cultural production surrounding Yemoja have been creolized, hybridized, and combined through creativity on a transcultural and transnational scale.[35] The chapters and art in this volume express a broad, integrated understanding of the

many avenues of expression touched by Yemoja. The connections among Africa, Latin America, North America, and the Caribbean explored in this book provide a rich commentary on the ways work and ritual about Yemoja require us to become more careful about how we contemplate history, religion, performance, art, and gender and their intersectionality. Components of Yemoja worship, and creative expressions about her, embed themselves in webs of negotiations that situate community identity through an aesthetic of fluidity that mirrors the waters. Like the sea, Yemoja traditions are constantly changing in a manner that provides a template for understanding social and cultural change, hybridity, and reconfiguration. Within these reconfigurations and negotiations, multiple aspects of gender are reflected through Yemoja's role in Yoruba diasporic mythology as a space for secrecy, creativity, and play in constructing subjectivities.

Yemoja: Gender, Sexuality, and Creativity in the Latina/o Afro-Atlantic Diasporas challenges rigid constructions of sexuality, gender, and race in profound ways. The conversations found here necessarily take into account historic and contemporary sociopolitical contexts and cultural realities, all of which contribute to unique expressions of Yemoja art and cultural practices. In highlighting the fluid nature of the figure of Yemoja, we emphasize the importance of *orisa* religions in creating a complicated public discourse with important ramifications for understanding especially Latina/o and Afro-Atlantic diaspora religions on a global scale. Yemoja traditions negotiate community identity in bold ways that emphasize the shifting nature of belief and cultural practice in our world today.

Notes

1. Audre Lorde, *The Black Unicorn: Poems* (New York: Norton, 1978), 6.
2. Lydia Cabrera, *Yemayá y Ochún* (Miami: Colección de Chichurekú, Ediciones Universal 1980), 20. All translations from Spanish to English in this introduction are those of the editors. "Yemayá" is the Cuban Lucumí spelling of "Yemoja."
3. *Orisa* here refers to Yoruba divinities found in Africa and the African Diaspora.
4. Sandra Barnes, ed., *Africa's Ogun*, 2nd ed. (Bloomington: Indiana University Press, 1997); Joseph Murphy and Mei Mei Sanford, *Osun across the Waters* (Bloomington: Indiana University Press, 2001); Toyin Falola, Joel E. Tishken, and Akintinde Akinyemi, eds., *Sango in Africa and the African Diaspora* (Bloomington: Indiana University Press, 2009); Arturo Lindsay, ed., *Santería Aesthetics in Contemporary Latin American Art* (Washington, DC.: Smithsonian Institute Press, 1996); Kamari Maxine Clarke, *Mapping Yorùbá*

Networks (Durham: Duke University Press, 2004); James Lorand Matory, *Black Atlantic Religion* (Princeton: Princeton University Press, 2005); Jacob K. Olupona and Terry Rey, eds., *Òrìsà Devotion as World Religion* (Madison: University of Wisconsin Press, 2008); Margarite Fernández Olmos and Lizabeth Paravisini-Gebert, *Creole Religions of the Caribbean* (New York: New York University Press, 2003).

 5. Olabiyi Babalola Yai, "In Praise of Metonymy: The Concepts of 'Tradition' and 'Creativity' in the Transmission of Yoruba Artistry over Time and Space," in *The Yoruba Artist*, ed. Henry Drewal et al. (Washington, DC: Smithsonian Institute Press, 1994), 111–15; Barry Hallen, *The Good, the Bad, and the Beautiful* (Bloomington: Indiana University Press, 2000), 65–112.

 6. Cabrera, *Yemayá*, 9–19, 55–69; Murphy and Sanford, *Osun Across*, 2.

 7. Henry John Drewal and Margaret Thompson Drewal, *Gelede: Art and Female Power among the Yoruba* (Bloomington: Indiana University Press, 1983), 3–18; Babatunde Lawal, *The Gelede Spectacle* (Seattle: University of Washington Press, 1996), 42–43, 60–61, 256.

 8. Lawal, *The Gelede*, 49; Drewal and Drewal, *Gelede*, 215; Oyeronke Olajubu, *Women in the Yoruba Religious Sphere* (Albany: State University of New York Press, 2003), 27–28; Benedict M. Ibitokun, *Dance as Ritual Drama and Entertainment in the Gelede of the Ketu Yoruba Subgroup in West Africa* (Ile Ife: Abafemi Awolowo University Press, 1993); Oyeronke Oyewumi, *The Invention of Women* (Minneapolis: University of Minnesota Press, 1997), 65.

 9. Oyeronke Olajubu indicates in *Women in the Yoruba Religious Sphere* (Albany: State University of New York Press, 2003), 27–28, that the Ifa divination verse, the Odu *Osa Odu Meji* sets the stage for thinking about women's ritual power in Yoruba religious discourses:

> Nigbati won nbo l'aye
> Awon obirnrin, won ko ri nkannkan yan
> La t'odo Olodumare . . .
> Olodumare lo gbe ase fun awon obinrin
> O ni awon aje ko gbodo maa lo lati
> Di 'ya je 'nikeni

> When women were coming to the earth
> Women had no powers from Olodumare . . .
> Olodumare promised them a power greater than that of men
> Olodumare gave women power over men
> Women were instructed not to use the power indiscriminately
> Olodumare endowed women with the power of aje.
> (translation Olajubu's)

 10. Jacqui M. Alexander, *Pedagogies of Crossing* (Durham: Duke University Press, 2005), 22–23.

 11. Karin Barber, *I Could Speak until Tomorrow* (Washington, DC: Smithsonian Institution Press, 1991); Margaret Thompson Drewal, *Yoruba Ritual* (Bloomington: Indiana University Press, 1992).

12. Oyewumi, *The Invention*; Oyeronke Olademo, *Gender in Yoruba Oral Traditions* (Lagos: Centre for Black and Africa Arts and Civilizations [CBAAC], 2009); Matory, *Black Atlantic*, 2005; 'Wande Abimbola, *Ifá Will Mend Our Broken World* (Roxbury: Aim Books, 2003); Clark, *Where Men*, xix–xx.

13. Oyewumi, *The Invention*, 1–30, 80–120.

14. Matory, *Black Atlantic*, 216.

15. Ibid., 188–90, 217–21.

16. Ibid., 25–46; Clark, *Where Men*, 143–48.

17. José Quiroga, *Tropics of Desire* (New York: New York University Press, 2000), 76–100; Alicia Arrizón, *Queering Mestizaje* (Ann Arbor: University of Michigan Press, 2006), 83–118; Randy P. Conner and David Hatfield Sparks, *Queering Creole Spiritual Traditions* (Binghamton: Harrington Park, 2004).

18. Lorde, *The Black*, 6–7; Michelle M. Wright, *Becoming Black: Creating Identity in the African Diaspora* (Durham: Duke University Press, 2004), 167–74; Cabrera, *Yemayá*, 44–47; Gloria Anzaldúa and Ana Louise Keating, eds., *The Gloria Anzaldúa Reader* (Durham: Duke University Press, 2009), 242; Gloria Anzaldúa, *Borderlands: La Frontera*, 2nd ed. (San Francisco: Aunt Lute Books, 1999), 3, 86; Edna M. Rodríguez-Mangual, *Lydia Cabrera and the Construction of an Afro-Cuban Cultural Identity* (Chapel Hill: University of North Carolina Press, 2004).

19. Clark, *Where Men*, xvi, xix–xx; Matory, *Black Atlantic*, 188–266.

20. Toyin Falola and Kevin Roberts, eds., *The Atlantic World: 1450–2000* (Bloomington: Indiana University Press, 2008); Stephen Palmié, *Wizards and Scientists* (Durham: Duke University Press, 2002), 345–54; Ennis B. Edmonds and Michelle Gonzalez, *Caribbean Religious History* (New York: New York University Press, 2010).

21. Frances R. Aparicio and Susana Chávez-Silverman, eds., *Tropicalizations* (Hanover: Dartmouth College, 1997); Michelle M. Wright, *Becoming Black* (Durham: Duke University Press, 2004), 136–82.

22. Jose Estaban Muñoz, *Disidentifications* (Minneapolis: University of Minnesota Press, 1999), 21–32, 135–41, 161–79; see also Judith Butler, *Gender Trouble* (New York: Routledge, 2006), 35–46.

23. Cabrera, *Yemayá*, 9–45; Conner and Sparks, *Queering*, 110, 118, 268.

24. Sarah Nuttal, ed., *Beautiful/Ugly* (Durham: Duke University Press, 2006), 6–29; V. Y. Mudimbe, *The Idea of Africa* (Bloomington: Indiana University Press, 1994), 38–70; V. Y. Mudimbe, *The Invention of Africa* (Bloomington: Indiana University Press, 1988), 5–7; Hallen, *The Good*, 1–12, 139–48.

25. Lawal, *The Gelede*, 43.

26. J. Lorand Matory provides useful insights into how the figure of Yemayá similarly troubles gendered discourses in Oyo, Nigeria. See *Sex and the Empire That Is No More* (Oxford and New York: Berghahn Books, 2005), 243–50, 253–64.

27. Clark, *Where Men*, xix–xx; Matory, *Black Alantic*, 224–66.

28. Aisha Beliso De-Jésus, "Reimagining the 'Global' versus 'Local': Religious Cosmopolitanisms and Transnational Santería," forthcoming; Raquel Romberg, *Witchcraft and Welfare* (Austin: University of Texas Press, 2003);

Sheila S. Walker, ed., *African Roots/American Cultures* (Lanham: Rowman and Littlefield, 2001).

29. Keith Sandiford, *Theorizing a Colonial Caribbean-Atlantic Imaginary: Sugar and Obeah* (New York: Routledge, 2011), 14–31; Solimar Otero, *Afro-Cuban Diasporas in the Atlantic World* (Rochester: University of Rochester Press, 2010), 111–39.

30. Toni Morrison, *Beloved* (New York: Knopf, 1987); *Daughters of the Dust*, directed by Julie Dash (New York: Kino International, 1991), DVD.

31. Heather Russell, *Legba's Crossing* (Athens: University of Georgia Press, 2009).

32. *Odo Ya! Life with AIDS*, directed and produced by Tania Cypriano (New York: Filmakers Library, 1997), DVD.

33. "Iemanjá Festival," Blue Throat Productions, accessed August 3, 2012, www.bluethroatproductions.com/iemanja.

34. Sabina Magliocco, *Witching Culture* (Philadelphia: University of Pennsylvania Press, 2004), 212–35.

35. Robert Baron and Ana Cara, eds., *Creolization as Cultural Creativity* (Jackson: University Press of Mississippi, 2011) 3–19.

References

Abimbola, 'Wande. *Ifá Will Mend Our Broken World*. Roxbury: Aim Books, 2003.

Alexander, M. Jacqui. *Pedagogies of Crossing: Meditations on Feminism, Sexual Politics, Memory, and the Sacred*. Durham: Duke University Press, 2005.

Anzaldúa, Gloria. *Borderlands: La Frontera. The New Mestiza*. 2nd ed. San Francisco: Aunt Lute Books, 1999 (1987).

Anzaldúa, Gloria, and Ana Louise Keating, eds. *The Gloria Anzaldúa Reader*. Durham: Duke University Press, 2009.

Aparicio, Frances R., and Susana Chávez-Silverman, eds. *Tropicalizations: Transcultural Representations of Latinidad*. Hanover: Dartmouth College, 1997.

Arrizón, Alicia. *Queering Mestizaje: Transculturation and Performance*. Ann Arbor: University of Michigan Press, 2006.

Barber, Karin. *I Could Speak until Tomorrow: Oriki, Women, and the Past in a Yoruba Town*. Washington, DC: Smithsonian Institution Press, 1991.

Barnes, Sandra, ed. *Africa's Ogun. Old World and New*, 2nd ed. Bloomington: Indiana University Press, 1991.

Baron Robert, and Ana Cara, eds. *Creolization as Cultural Creativity*, Jackson: University Press of Mississippi, 2011.

Bastian, Misty L. "Mami Wata, Mr. White, and the Sirens off Bar Beach: Spirits and Dangerous Consumption in the Nigerian Popular Press." In *Sacred Waters: Arts for Mami Wata and other Divinities in Africa and the Diaspora*, edited by Henry J. Drewal, 87–94. Bloomington: Indiana University Press, 2008.

Beliso De-Jesús, Aisha. "Reimagining the 'Global' versus 'Local': Religious Cosmopolitanisms and Transnational Santería." Forthcoming.
Butler, Judith. *Gender Trouble: Feminism and the Subversion of Identity.* New York: Routledge, 2006 (1990).
Cabrera, Lydia. *Yemayá y Ochún: Kariocha, Iyalorichas Y Olorichas.* Miami: Colección de Chicherekú, Ediciones Universal, 1980.
Clark, Mary Ann. *Where Men Are Wives and Mothers Rule: Santería Ritual Practices and Their Gender Implications.* Gainesville: University of Florida Press, 2005.
Clarke, Kamari Maxine. *Mapping Yorùbá Networks: Power and Agency in the Making of Transnational Communities.* Durham: Duke University Press, 2004.
Comaroff, Jean, and John L. Comaroff, eds. *Modernity and Its Discontents: Ritual Power in Postcolonial Africa.* Chicago: University of Chicago Press, 1993.
Conner, Randy P., and David Hatfield Sparks. *Queering Creole Spiritual Traditions: Lesbian, Gay, Bisexual, and Transgender Participation in African-Inspired Traditions in the Americas.* Binghamton: Harrington Park, 2004.
Daughters of the Dust. Directed by Julie Dash. New York: Kino International, 1991. DVD.
Drewal, Henry John. "Introduction: Charting the Voyage." In *Sacred Waters: Arts for Mami Wata and Other Divinities in Africa and the Diaspora,* edited by Henry John Drewal, 1–18. Bloomington: Indiana University Press, 2008.
Drewal, Henry John, and Margaret Thompson Drewal. *Gelede: Art and Female Power among the Yoruba.* Bloomington: Indiana University Press, 1983.
Drewal, Margaret Thompson. *Yoruba Ritual: Performers, Play, Agency.* Bloomington: Indiana University Press, 1992.
Edmonds, Ennis B., and Michelle Gonzalez. *Caribbean Religious History.* New York: New York University Press, 2010.
Falola, Toyin, and Kevin Roberts, eds. *The Atlantic World: 1450–2000.* Bloomington: Indiana University Press, 2008.
Falola, Toyin, Joel E. Tishken, and Akintinde Akinyemi, eds. *Sango in Africa and the African Diaspora.* Bloomington: Indiana University Press, 2009.
Fernández Olmos, Margarite, and Lizabeth Paravisini-Gebert. *Creole Religions of the Caribbean.* New York: New York University Press, 2003.
Hallen, Barry. *The Good, the Bad, and the Beautiful. Discourse about Values in Yoruba Culture.* Bloomington: Indiana University Press, 2000.
Ibitokun, Benedict M. *Dance as Ritual Drama and Entertainment in the Gelede of the Ketu Yoruba Subgroup in West Africa: A Study in Traditional African Feminism.* Ile Ife: Abafemi Awolowo University Press, 1993.
Lawal, Babtunde. *The Gelede Spectacle: Art, Gender, and Social Harmony in an African Culture.* Seattle: University of Washington Press, 1996.
Lindsay, Arturo, ed. *Santería Aesthetics in Contemporary Latin American Art.* Washington, DC: Smithsonian Institute Press, 1996.
Lorde, Audre. *The Black Unicorn: Poems,* New York: Norton, 1978.

Magliocco, Sabina. *Witching Culture: Folklore and Neo-Paganism in America.* Philadelphia: University of Pennsylvania Press, 2004.

Matory, James Lorand. *Black Atlantic Religion: Tradition, Transnationalism and Matriarchy in Afro-Brazilian Candomblé.* Princeton: Princeton University Press, 2005.

———. *Sex and the Empire That Is No More: Gender and the Politics of Metaphor in Oyo Yoruba Religion.* Oxford and New York: Berghahn Books, 2005 (1994).

Morrison, Toni. *Beloved.* New York: Knopf. 1987.

Mudimbe, V. Y. *The Idea of Africa.* Bloomington: Indiana University Press, 1994.

———. *The Invention of Africa: Gnosis, Philosophy, and the Order of Knowledge.* Bloomington: Indiana University Press, 1988.

Muñoz, Jose Estaban. *Disidentifications: Queers of Color and the Performance of Politics.* Minneapolis: University of Minnesota Press, 1999.

Murphy, Joseph, and Mei Mei Sanford, eds. *Osun across the Waters: A Yoruba Goddess in Africa and the Americas.* Bloomington: Indiana University Press, 2001.

Nuttal, Sarah, ed. *Beautiful / Ugly: African and Diaspora Aesthetics.* Durham: Duke University Press, 2006.

Odo Ya! Life with AIDS. Directed and produced by Tania Cypriano. New York: Filmakers Library Inc., 1997. DVD.

Olajubu, Oyeronke. *Women in the Yoruba Religious Sphere.* Albany: State University of New York Press, 2003.

Olademo, Oyeronke. *Gender in Yoruba Oral Traditions.* Lagos: Centre for Black and Africa Arts and Civilizations (CBAAC), 2009.

Olupona, Jacob K., and Terry Rey, eds. *Òrìsà Devotion as World Religion: The Globalization of Yorùbá Religious Culture.* Madison: University of Wisconsin Press, 2008.

Otero, Solimar. *Afro-Cuban Diasporas in the Atlantic World.* Rochester: University of Rochester Press, 2010.

Oyewumi, Oyeronke. *The Invention of Women: Making African Sense of Western Gender Discourses.* Minneapolis: University of Minnesota Press, 1997.

Palmié, Stephan. *Wizards and Scientists: Explorations in Afro-Cuban Modernity and Tradition.* Durham: Duke University Press, 2002.

Quiroga, José. *Tropics of Desire: Interventions from Queer Latino America.* New York: New York University Press, 2000.

Rodríguez-Mangual, Edna M. *Lydia Cabrera and the Construction of an Afro-Cuban Cultural Identity.* Chapel Hill: University of North Carolina Press, 2004.

Romberg, Raquel. *Witchcraft and Welfare. Spiritual Capital and the Business of Magic in Modern Puerto Rico.* Austin: University of Texas Press, 2003.

Russell, Heather. *Legba's Crossing: Narratology in the African Atlantic.* Athens: University of Georgia Press, 2009.

Sandiford, Keith. *Theorizing a Colonial Caribbean-Atlantic Imaginary: Sugar and Obeah.* New York: Routledge, 2011.

Sanford, Mei Mei. "Living Water: Osun, Mami Wata, and Olokun in the Lives of Four Contemporary Nigerian Women." In *Osun across the Waters*, edited by Joseph Murphy and Mei Mei Sanford, 237–250. Bloomington: Indiana University Press, 2001.

Walker, Sheila S., ed. *African Roots/American Cultures*. Lanham: Rowman and Littlefield, 2001.

Wright, Michelle M. *Becoming Black: Creating Identity in the African Diaspora*. Durham: Duke University Press, 2004.

Yai, Olabiyi Babalola. "In Praise of Metonymy: The Concepts of 'Tradition' and 'Creativity' in the Transmission of Yoruba Artistry over Time and Space." In *The Yoruba Artist: New Theoretical Perspectives of African Art*, edited by Henry Drewal, John Pemberton III, and Rowland Abiodun, 107–15. Washington, DC: Smithsonian Institute Press, 1994.

Part 1

Yemoja, Gender, and Sexuality

Invocación

Pedro R. Pérez-Sarduy

En busca de un amante desempleado

La Habana vive casi en penumbras
con su aire contaminado de turistas y disidentes insólitos
donde la joven oferta de un vestido ajustado
a las circunstancias de la última moda
cabalga de ironías por el malecón
entre aparentes cócteles exóticos
y la perenne indiferencia de un comisario
confuso también a la hora de persuadir.

De cualquier forma
La Habana estaba ahí,
mía y más sensual que de costumbre
asomada como siempre a sus balcones
mirando sin cansancio
hacia el mar de muchachas y muchachos en pretérito
sobre monturas de vinyl
y el reflejo de una discoteca prohibida
con aquella vertiginosa silueta oscilando la pelvis
frente a un rostro pálido improvisado y desconocido,
por supuesto, con ropas de ultramar.

Invocation

Pedro R. Pérez Sarduy

Searching for an unemployed lover[1]

Havana lives on the edge of darkness
with its air contaminated by tourists
and uncommon dissidents
where the young offer of a dress tightly fitting
the circumstances of the latest fashion trots ironically
along the sea front
among seemingly exotic cocktails
and the perennial indifference of a commissar
also confused when it comes to persuasion.

Whatever form it took
Havana was there mine and more sensual than usual
leaning out as always from her balconies
gazing tirelessly towards the sea of girls and boys of the
 past
dressed in lycra and the reflection of a forbidden disco
with that dizzy silhouette
facing a pale face unexpected and unknown
wearing foreign clothes, of course.

Invocación

Sin embargo
no hay tiempo qué perder para el pobre mendigo
que busca la ocasión propicia para el manoseo y el juego
 entre lenguas.

Después de todo
estamos en presencia de una época atormentada por tantas
 dolencias.

No hay tiempo qué perder tampoco
porque mañana por la tarde ya sería esta noche
y también otra madrugada tranquila
gratificada con una cena suntuosa
o sencillamente una cena sin atuendos importados
durante el tiempo que reine la austeridad
o una simple invitación atrevida.

En estos tiempos sólo *okana*
el dilogún solitario que presagia malos agüeros
ronda travieso por la tierra sedienta de tantas bondades
 desaprovechadas
incoherentes ofrendas y rogaciones mancilladas.

Hay escasez en la mirada
como aquella destinada a socorrer al desvalido
y tal parece que este lunes de hoy derrocha cierta soberbia
que nunca antes fue del todo racional.

Qué alegría si estuvieras conmigo ahora
O mío Reina del Mar!
Tú que te atreves de espumas a cabalgar sobre Taurus
entre ricas turquesas que adornan tu amable corona.
Tú que siempre desoyes el grito cómplice del iniciado
antes del crepúsculo y sigues de largo entre mis brazos
acompañada solamente por el sonido de cocos secos
que siempre permanecieron secos.

No volviste de la gran fiesta
y hablabas contigo misma
procurando satisfacer la frescura de la miel
en la punta de los senos
revolcando tu cuerpo fresco de aguas limpias

Invocation

However
there is no time to lose for the poor beggar
searching for the right moment for a quick feel
and the game between tongues.
After all
we are in the presence of an age tormented by so many
 ailments.

There is no time to lose either
because tomorrow afternoon would already be tonight
and also another peaceful dawn
rewarded with a sumptuous supper of simply a supper
with no imported frills
for as long as the reign of austerity lasts
or just a daring invitation.

In these times only *okana*
the solitary African conch who predicts ill omens
restlessly roams the earth thirsting for so many kind acts
wasted
incoherent offerings and sullied pleas
something is wanting in the look
like that aimed at assisting the needy
so much that today Monday seems to exude a certain
 arrogance
which was never before entirely rational.

What joy if you were with me now
O mio Queen of the Sea
You who dare to ride the waves mounted on Taurus
among precious turquoise gems which adorn gentle crown
You who are always ignore the secretly agreed cry of the
 initiate
before dusk and you keep going in my arms
accompanied only by the sound of dry coconuts
which have always been dry.
You did not return from the grand feast
and were speaking with yourself
endeavoring to satisfy the freshness of honey
on the tips of yours breasts
your body writhing fresh with clean waters

y así para penetrar en lo más íntimo de tu noche
allí donde el pudor se detiene asustado.

Antes de partir todas las sombras fueron ingenuas
y silenciosamente similares.

Invocation

penetrating the most intimate point of your night
there where shame halts frightened.

And before parting all the shadows
were innocent and silently similar.

Note

1. Translated by Jean Stubbs.

Chapter 1

Nobody's Mammy

Yemayá as Fierce Foremother in Afro-Cuban Religions

Elizabeth Pérez

In the writing on Afro-Cuban religions, Yemayá has been approached as both the prototype for and the deified paragon of maternal love. According to most accounts, not only does Yemayá birth fellow *orishas* and raise the divine twins, the Ibeyi, as her adopted children, but she also features prominently in the mythology of her son, Changó. Dozens of publications call Yemayá "the universal mother," implying a uniformity of ideal maternal traits across cultures; they define her sexuality primarily in terms of her desire to engender life as the "marine matrix" of the cosmos.[1] Such texts have cited the variety of creatures in the ocean—her preferred abode in Afro-Diasporic tradition—to illustrate the breadth and profundity of her generative force, as well as the vast resources available to her for supplicants' material nurturance. With her ample bosom, hips, and abdomen embodying the "eternal feminine," Yemayá has appeared to lend credence to "mother goddess" as a conceptual category capable of encompassing disparate figures from the Paleolithic period to the present day.[2]

Despite the widespread assumption that deities represent timeless, primordial essences, historical contingencies and culturally specific religious imaginaries have combined to produce the contemporary vision of Yemayá. Many of the images and narratives that dominate conventional understandings of this *orisha* originated in nineteenth-century Cuba, when motherhood was ineluctably shaped by local racial discourses, the practice of concubinage, and slavery as an economic, social, and politi-

9

cal institution. Yemayá is the *orisha* most often depicted as Black, an identification reflected in and reinforced by her correspondence with the Virgin of Regla, the only Marian icon in Cuba considered to be of direct African descent. Mainstream portrayals of Yemayá as "*de piel negrísima*" and "*negra como el azabache*" have long cried out for analysis, especially bearing in mind that every form of Cuban popular cultural media has perpetuated the caricature of the dark-skinned, thickset "mammy."[3] Indeed, considering Yemayá's association with both surrogacy and other physical characteristics attributed to the mammy, it is no exaggeration to say that this *orisha* has been caught between archetype and stereotype.[4]

While the biracial "mulatta" has not only served as the emblem of cultural hybridity for the Cuban nation, but also become something of a fetish for current scholarship, representations of the "negra"—both human and divine—have been left woefully undertheorized. At issue here is emphatically not whether certain women of color merit greater attention than others, but rather, the very fact that the *orishas* have been understood to occupy racialized female bodies, inhabit distinct subjectivities according to them, and privileged differentially. Following on the crucial insights of critical race theory and Black feminist and womanist thought with regard to Yemayá, I invoke Blackness as a quintessentially modern, gendered category of identity for which pigmentation and phenotype act as unstable signifiers. While underscoring Blackness as constituted within communities through shared experiences of racialization, usually entailing exposure to discriminatory practices, I also wish to emphasize the local modalities of Blackness found throughout the Afro-Atlantic world.[5] The multiplicity and "slipperiness" of "Black" can be said to mirror that of Yemayá herself.[6]

In what follows, I argue that analyses of Yemayá in the Black Atlantic world must take more rigorously to task folkloric generalizations about this *orisha* and look for her in the particularity of Afro-Diasporic experience. I begin by examining Yemayá's emergence in Cuba through her correspondence with Regla in Afro-Cuban Lucumí and Espiritismo Cruzado, as well as with her counterpart in Palo Monte, Madre Agua. I assert that the relationship between Regla and Yemayá has assisted in preserving countermemories of the Afro-Cuban past, maintained in opposition to the hegemonic "master narrative" personified by the mammy. I contend that within the transnational Afro-Atlantic context, Yemayá is best approached as a fierce "foremother figure," and I elaborate this claim with respect to two geographically and chronologically distant urban Lucumí communities. As a historian and ethnographer, I proceed methodologically by surveying the pertinent documentary evidence concerning Afro-Cuban traditions, before drawing on several years

of my own research on the South Side of Chicago. I conclude that to be acquainted with Yemayá's fierceness is to examine her manifestation within communities as they negotiate both their transatlantic religious legacies and the meanings of her Blackness.

Yemayá and Regla in Afro-Cuban Tradition

Four Marian figures from Spain became associated with Lucumí spirits in Cuba during the colonial period: the Virgins of Mercedes (Obatalá), Candelaria (Oyá),[7] Caridad (Ochún), and Regla (Yemayá), the only one to number among the Black Madonnas of Europe. According to legend, the original sculpture of Regla was created in Africa by none other than Augustine of Hippo, and it eventually made its way to Chipiona, near Cádiz—the port of choice for ships sailing to the Americas.[8] Owing to her reputation among priests and sailors, this image of Regla gained followings in several Spanish possessions.[9]

In Cuba, her iconography has stayed relatively consistent for over three centuries; she carries the infant Jesus in her arms, and he grasps a flower in his hand.[10] Regla's head is covered, but the Christ Child's is not. His face and hands are alabaster; hers are ebony. The connection between her Blackness and her power entered the historical record in the mid-eighteenth century when Bishop Pedro Augustín Morell de Santa Cruz visited her sanctuary in the ultramarine town of Regla, across the bay from Havana, built in 1692 on the property of a sugar mill.[11] The bishop wrote, "What distinguished this image as a prodigious effigy was that she had never accepted touch-ups with white color."[12]

Although in calling Regla "*vastantemente moreno*," Bishop Morrell employed the preferred racial term for a person with African ancestry on both sides, history does not record the precise moment at which her color (*negra*) became a sign of race (*Negro*). Nor do the archives assist us in determining precisely when Lucumí practitioners began to associate Regla with Yemayá.[13] Yet the pairing of Virgins and *orishas* was presumably encouraged by the Roman Catholic Church itself, eager to organize slaves and freedmen into the ethnically differentiated religious brotherhoods *cum* mutual aid societies called *cabildos de nación* and to catechize them by fostering bonds to Christian patrons that would replace any attachment to African gods. The use of images such as Regla held out both promise and danger for the Creole clergy: As "texts for the illiterate," pictures could communicate messages and narrate stories to masses of uneducated pagans but could also lead them to misunderstand inanimate objects as the divine presence.[14] While the Spanish

weighed the impact of realistic sculpture in the New World, they eventually resigned themselves to the necessity of multidimensional images as instruments of missionization.[15]

During the early nineteenth century, the town of Regla became, in the words of Miguel "Willie" Ramos, "Africa's heart in Cuba."[16] It was arguably also Yemayá's. Regla proved to be fertile ground for the establishment of *cabildos* and, far from dividing Africans according to geographical origin, language, ethnic affiliation, and legal status—as colonial administrators had intended—these institutions furnished a space for the collective development of innovative diasporic cultural practices. Regla saw the "birth" of the first lodge of the Calabar-inspired male sodality called Abakuá on Cuban soil in 1836. Creoles united with the African born to reconfigure deterritorialized traditions, synchronizing religious structures and consolidating pantheons that had previously assumed a much more fragmentary and diffuse form.[17] Spirits themselves underwent resignification. As David H. Brown has documented, the chromatic and figurative insignia used for Regla, its Marian patroness, and Yemayá developed symbiotically. The town lent its municipal devices and nautical emblems to the Virgin's iconography; both went on to influence the design of the vestments, vessels, ornamental panels (*paños*), and consecrated tools (*herramientas*) that today "belong" to Yemayá and her initiates.[18]

The town as well as the Virgin of Regla contributed to Yemayá's transition from goddess of the Ògùn River to ocean deity. This conflation of attributes has shaped not only Lucumí's aesthetic regime, but also the musical repertoires of Espiritismo Cruzado and the related ritual genre called Cajón al muerto.[19] Throughout the Americas, participants in ceremonies within the range of traditions collectively called Espiritismo have called upon Regla and Yemayá interchangeably to assist them in navigating the tempestuous seas of their social worlds.[20] Practitioners beseech Yemayá to cleanse them with her water and set the "spiritual current" flowing; one such song among many in Cajón runs, "*A remar, a remar, a remar/ Que la Virgen de Regla nos va acompañar*," meaning, "Row, row, row/ For the Virgin of Regla will accompany us." Nolan Warden explains that "*remar* can . . . be translated as *to toil* or *to struggle*."[21] In line with the idea that the most potent spirits have endured the greatest suffering, these rites stress the efficacy of both Regla and Yemayá with reference to their Africanity. One hymn entreats the *orisha* to ensure supplicants' victory in a "clarifying mission," labeling her with the ethnonym *arará*, used to denote Ewe/Fon descent: "*Yemayá africana/ yo te llamo a la misión,/ oye mi voz!/ Oh! misión despejadora/ Yemayá africana/ Yemayá vamo a vencer/ Yemayá arará.*"[22]

In the Bantu-inspired *reglas de Congo*, particularly in the religious formation called Palo Monte, Yemayá's equivalent is the *mpungu*, or spirit, called Madre Agua; she also goes by the names Baluandé and Siete Sayas, among others.[23] Yemayá shares colors, domains, favored objects such as metal pails and earthenware *tinajas*, and, not infrequently, initiates with Madre Agua.[24] Ritual specialists also refer to Madre Agua as Regla and vice versa, raising the question of Yemayá's relationship to the Palo pantheon.[25]

For instance, it has been interpreted in terms of *camino*, or "road," a term that refers to one of several personae manifested by most *orishas*, "born" in a specific divination verse.[26] In an interview with a musician, Nolan Warden writes,

> I brought up the fact that many of the songs in Cajón refer to deities almost synonymously, for example, the song that begins "Bendita eres Virgen de Regla, bendita eres mi Yemaya." His response was simply that the Virgen de Regla is the "camino Católico" of Yemaya, just as Madre Agua is her "camino en Palo" . . . [A]re they the same or are they two distinct things? [He] replied casually "dos cosas distintas" [two distinct things] then, after pondering briefly, stated emphatically "dos cosas en una!" [two things in one].[27]

While this does not furnish a definitive answer, it articulates a common understanding of *orishas*, *mpungus*, and their Catholic analogues as coemergent and conceptually convergent. Just as two heads are better than one at solving problems, Yemayá, Madre Agua, and Regla combine to bring complementary forces to bear on the intractable dilemmas of everyday life.

"La Negrita" and Yemayá

The inquiry that has yet to be broached is why Yemayá became so intimately associated with Regla. She absorbed qualities associated specifically with Black women, just as the Virgin of Charity, paired with Ochún, became assimilated to the mulatta. The contrast between the two is instructive, for not only are the distinctions between these *orishas* racialized in visual representations; they shape the spirits' very appetites, for the *orishas* are fed items commensurate with their status.[28] Ochún has long been portrayed as a "refined," "high yellow" woman able to "pass" as white and enter otherwise forbidden social spaces, due to her color,

physiognomy, and deportment.[29] Accordingly, Ochún craves caramel, syrup, and honey, a prized commodity, suggesting a life of leisure, while Yemayá receives food offerings strongly reminiscent of plantation rations and the slave diet, most notably unfiltered cane syrup and molasses. In popular cultural texts that owe less to *odu* than to nineteenth-century literary *costumbrismo*, Ochún stoops to the role of frivolous coquette, and Yemayá, that of noble drudge.[30]

The mulatta stereotype has served many masters since the colonial period, and within Lucumí, it has highlighted qualities that Ochún displays in a few of her most highly publicized caminos. But in more mainstream channels of circulation, representations of the mulatta have served to exploit and eroticize women deemed to have light complexions, some "European" facial features, and "good"—straight or curly rather than kinky—hair. Indeed, by the eighteenth century, the mulatta had already become "an ideological construct embedded within the specific cultural, political, and economic history of Cuba."[31] Born of two continents, the mulatta came to personify the "colorblind" unity among Cubans that independence from Spain would bring. Yet many elites throughout the colonial period cast the mulatta as a tainted, promiscuous agent of contagion, a vampiric figure dedicated to destroying white male youth, not least through venereal disease.[32] Mulattas bore witness to the inherent instability of racial signifiers and disrupted the categories used to determine "legal" color and thereby relegate Afro-Cubans to a subordinate position.

Whereas their cultural and social hypervisibility has historically rendered mulattas' bodies as sites of sexual abjection and violence, the near invisibility of women judged to be Black has operated to facilitate their abuse and marginalization as well. The hegemonic privileging of *mestizaje*, or racial mixture, often called *mulatez* in the Caribbean, implicitly affirms the value and normativity of whiteness and has militated against the construction of Blackness as a source of national identification for Afro-Cubans by systematically excluding oppositional Black voices.[33] While Blackness in Cuba theoretically encompasses all persons of African descent, it has objectively functioned as a pretext for nonrecognition of Afro-Cubans, more a negation of *mestizaje* as a viable ideological project than a space of enunciation.[34] The absence of Black bodies, especially those of women, from positive representations of *mulatez* underscores the extent to which they have been objectified, silenced, and stigmatized as a metonym for difference. As Alicia Arrizón demonstrates, Blackness has been constructed performatively at times as a means of reclaiming agency for persons of color, through explicit rejection of the imperative to *blanquear*, or "whiten," oneself, culturally and otherwise.

It is my conjecture that Regla came to represent Yemayá and that she became known as Black because the details of her image seemed to address important facets of Afro-Cuban historical experience. I have previously advanced the argument that Yemayá's mythology in colonial Cuba registered not only the shift in her identity from alluvial to oceanic deity but also the incidence of rape, sexual abuse, and physical violence suffered disproportionately by women of African descent, both enslaved and free.[35] Since female ritual specialists shouldered considerable responsibility for establishing Lucumí ritual protocols and oral traditions in the nineteenth century, I hypothesized that divination verses and other narratives about Yemayá have preserved "countermemories" that were either ignored or actively suppressed by dominant cultural texts.[36] Yet to understand the contemporary construction of Yemayá, it is vital to assess the impact of her longstanding correspondence with Regla on this *orisha's* reception within distinct interpretive communities. For almost two hundred years, this image was situated within a referential field that governed the way this symbol accrued meanings and contributed to the definition of individual as well as collective identities.

Perhaps both the most significant and empirically accessible component of this referential field lies in the history of coerced and meagerly compensated labor performed by women of African descent, particularly the range of domestic activities connoted by the Regla image.[37] During the colonial period, Afro-Cubans routinely entered white households as servants, maids, and nannies, and they were ordered to tend their masters' and bosses' offspring. Female slaves called *criolleras* raised generations of creoles in plantation nurseries, rearing others' children alongside their own.[38] Those designated as "breeders" shouldered a double burden: to toil in fields, mills, and slave quarters along with men—digging irrigation ditches, bundling sugarcane, hoeing soil—as well as to enlarge the population of their estates. The combination of responsibilities regularly resulted in miscarriage or death for pregnant slaves.[39] Nevertheless, the rape of Afro-Cuban women, whether enslaved or free, was not considered grounds for litigation.[40] Elites invariably accused victims of promiscuity, thereby denying the crime its name. They also tried to destroy a possible locus of resistance for caregivers and others perceived to be "privileged" within the colonial social hierarchy, since, according to Paulla A. Ebron, "rape has always involved patriarchal notions of women being, at best, *unwilling* accomplices."[41]

It should not be surprising, then, that Afro-Cuban women often gave birth to children lighter than themselves, fathered by white men, frequently from the same family that owned or had hired them. Hugh Thomas contends that, despite a dearth of statistics on the number of

white men involved in long-term affairs with Afro-Cuban women, "all the evidence of rumor and hearsay suggest[s] that [interracial concubinage] occurred on a lavish scale in both plantations and cities."[42] In any scandal involving a man and a female slave, it was inferred without fail that the latter had preyed upon the former, and the mother of a bastard sired by her owner became the target of resentment if not outright censure.[43] In the case of impregnation, with or without her consent, an Afro-Cuban woman had little chance of pressuring a white man to propose marriage. In the rare cases in which a white man resolved to wed his companion, his family—invariably opposed—could count on the burden of obtaining an official license for interracial marriage to pose an insurmountable obstacle, unless the couple resorted to elopement or the legal claim of "seduction."[44] Thus the courts conspired with social mores to push the woman of color onto the margins of society, first as servant, then as "concubine" or mistress, and finally, as head of an indigent household.[45]

Yet Afro-Cuban women had some incentive to enter such arrangements to pursue social mobility through the practice of *blanqueamiento*, or "whitening." Slavery had not only operated as a brutal system of forced labor but heightened social stratification by creating distinctions between groups on the basis of color, broadly construed.[46] After the abolition of slavery in 1886, color became a measure of one's proximity to, or distance from, the indignity of bondage.[47] Women of color built matrimonial alliances (and mésalliances) with elites in hopes of bearing children so light in pigmentation that they could pass as white and thereby increase their material welfare. The child seen as *casi blanco*, "almost white," enjoyed more auspicious prospects and, presumably, would be better equipped to fend for his mother in her dotage. The decision to "whiten"—or, in a telling euphemism, to "improve the race"—also had unintentional consequences, for instance, corroding solidarity between Afro-Cuban men and women.[48] In addition, whitening tended to ingrain discriminatory attitudes. For example, the daughter of a former slave, whose family was composed of different-colored members, noted that the fairer children often received preferential treatment from parents and siblings as well as the outside world.[49]

Free women of color supported themselves and their dependents by working as laundresses, food vendors, midwives, shop girls, seamstresses, and prostitutes.[50] According to a travelogue penned by the Countess of Merlín, they strode the streets of nineteenth-century Havana "cigar in mouth," bare-shouldered, and self-assured, despite inhabiting the hostile masculine realm of the public sphere.[51] But the countess also encountered "many Black women dressed in muslin, with-

out socks and without shoes, carrying in their arms creatures as white as swans."[52] During the transition to wage labor, slaves' legal status changed irreversibly, but women of color could still not negotiate their salaries or set their own hours.[53] Scores of former field slaves stayed on as cooks and domestics for former owners' families to remain close to male partners; others relocated and became au pairs for local whites, receiving visits from husbands still engaged in agricultural labor only sporadically, then cohabiting during the "dead season."[54] By the early twentieth century, the public sight of Black "shadow mothers" with fair-skinned toddlers on their hips had been naturalized, and it was to childcare work that innumerable Afro-Cuban women turned in lieu of better options.[55]

Most models of racial equality promoted prior to, and after, Cuban independence "systematically elided" the importance of Black women's labor "as an economic and a cultural reality."[56] Their commercial activity was perennially undervalued, since the occupations open to them paid little, and business concerning food, clothing, and children was mostly transacted within the private "feminine" sphere of the home.[57] In the case of live-in caregivers, the performance of their labor behind closed doors, along with the lack of accurate mainstream representation of it as anything but menial, rendered their drudgery invisible. Considered, according to Kate Haug, "everyone's nanny, granny and auntie," the nursemaid seldom had a moment's respite.[58] She shared an astonishing degree of familial intimacy with the offspring of the bourgeoisie and upper classes: maids and wet nurses sometimes slept in the same rooms as their wards, suckled them, toilet-trained them, dressed them, and, as Anne McClintock describes, "washed their vaginas and penises . . . punished them . . . told them stories and instructed them in their class 'manners.'"[59] But the measure of a job well done was, in part, the absence of its traces; with every mistress' claim that her servant was *just* another member of the family, her sweat-encrusted toil was effectively swept under the carpet.

From Shadow Mother to Mammy

From this nexus of power relations, economic institutions, and cultural practices arose the stereotype of the "mammy." Although Spanish stereotypes of North and West African women date from the Renaissance, the disparaging mammy figure became ubiquitous in the nineteenth century.[60] Her "uglified" face, shorn or covered hair, malapropos-peppered speech, and shabbily clad corpulence placed the mammy, at least

rhetorically, outside the realm of desirability.[61] Her exaggerated features, notes Maria St. John, "shor[ed] up the category 'white' " by exemplifying an essentialized Black phenotype and thereby lending credibility to the fiction of racial difference.[62]

The timing of her emergence in Cuba was no coincidence: the mammy enabled whites to downplay the frequency of interracial rape and other forms of sexual exploitation by insisting on Black women's unattractiveness, associated through enslavement with masculine brawn, dirt, and bodily impurity. The African-born mammy in particular was "ideologically constructed as essentially 'non-feminine' insofar as primacy was placed upon her alleged muscular capabilities, physical strength, aggressive carriage and sturdiness," according to Hilary Beckles.[63] Yet while the North American mammy figure was depicted steadfast and sexless, the Cuban version was lusty, even wanton, in her appetite for food and men.[64]

The Cuban mammy gained currency in nonverbal and visual forms, through myriad caricatures and in series of lithographs, called *marquillas*, sealed into bundles of cigars and cigarettes from the 1840s onward.[65] In the performing arts, the mammy appeared as a staple of dramatic genres such as zarzuela and blackface minstrelsy, including the one-acts called *negritos* and, later, the more elaborate productions of *teatro bufo*. Robin Moore notes that in the early twentieth century, white actress "Blanca Becerra, for instance, delighted audiences with her impersonation of a *negra lucumí*, or Yoruban [sic] woman from Africa, associated with 'witchcraft' and divination."[66] Plays showcased variations on the coffee-sipping, kerchief-sporting, tobacco-smoking character dubbed Mama Inés, whose grinning visage has continued to appear in theater and advertising in Cuba, Puerto Rico, and the Dominican Republic well into the twenty-first century as part of a career trajectory that parallels Aunt Jemima's in the United States.[67] The mammy acquired ever greater heft, both physically and symbolically, through representation in popular musical compositions and literary texts. "The trend of attributing extremely subservient and humiliating roles to the older slave women is perhaps the one most frequently employed in Cuban novels," writes Dawn Duke.[68]

Within this historical context, the Regla icon recalled not only the statistically significant number of Afro-Cuban caregivers rearing lighter complexioned children, but also the culturally resonant mammy figure. Yet the visual resemblance between the Madonna and the mammy was variously construed by different publics, with divergent agenda and interpretive schema shaped by such factors as their members' social locations, material conditions, and ideological commitments. For elites and others

with privileged access to dominant discourses that normalized racial and gendered inequalities, characteristic portrayals of Regla and the mammy figure undoubtedly dovetailed. For instance, hegemonic representations cast both as submitting voluntarily and contentedly to their superiors.[69] In Roman Catholic tradition, the Virgin Mary has never declined to serve as "Mother of Perpetual Help" and "Lady of Prompt Succor," and, according to conventional iterations of the mammy stereotype, neither has she.[70] Moreover, whether enslaved or free, the mammy has occupied a lower place in the social hierarchy than the youngest babe at her breast, an arrangement that parallels the doctrinal subordination of the Virgin to the Infant Jesus.

Regla still retains her sobriquet la Negrita, the "little Negress," among her followers. But while Regla was long implicated within the same structures of domination that the mammy undergirded, the evidence shows that Afro-Cubans saw themselves in the former and adopted her image to contest the racial order symbolized by the latter. To borrow Louis Althusser's terminology, Regla "interpellated" Afro-Cubans by virtue of her color, interpreted as a sign of race.[71] Regla effectively called on Afro-Cubans to recognize her as sharing the same racialized subject position.[72] For those of African descent or deeply engaged with Afro-Cuban cultural forms, the contrast between Regla's countenance and that of the mammy became more salient than their similarities. During the colonial period and long afterwards, Regla was one of the only positive, let alone sacred, likenesses of a dark-skinned woman. Regla's physiognomy was not distorted into a caricature, and perhaps more significantly, her chastity stood beyond reproach. She was thus not depicted as alone of all her sex, but as of all her race.[73] In this sense, she stood for everyone alienated by patriarchal construction of Black femininity epitomized by the mammy.[74]

For Afro-Cubans, embracing the image of Yemayá as Regla, a "fat African woman"—to use the words of one initiated elder—may have served as a means of reappropriating negative imagery and reinvesting it with liberatory potential.[75] Regla brings to mind the related Madama spirit, whose statues are easily confused with mammy figures by those ignorant of her status as an advisor, expert herbalist, and moral authority.[76] For Spiritists, the Madama's girth connotes not complacency, but formidable vigor and potency; her head tie indicates the binding of sacred power within her crown and forehead; her Blackness signifies sagacity gleaned through vital connection with the land of her ancestors.[77] Superficial comparisons of the Madama with Aunt Jemima may be unexpectedly apt, writes Joyce E. King:

> [T]he oral tradition identifies "Jemima women" as caring, commanding spiritual community mothers who descended from Ifa priestesses . . . In various locations, these women (Orixá) are called Yemaya, Yemanya, or Iemoja. According to the oral tradition, once these priestesses learned the truth about what was happening to those who were captured and sold into slavery, they voluntarily allowed themselves to be captured and sold so they could come to the Americas to look after and protect their people.[78]

While the biblical daughter of Job seems a more likely source for the phrase "Jemima women," King's point concerning countermemories of Yemayá's solidarity with the enslaved sings true and speaks to the development of both the Madama and Regla in the Afro-Atlantic religious imagination.

Yemayá as Warrior Queen

Perhaps the most famous example of one Afro-Cuban's interpellation by Regla would be José Antonio Aponte y Ulabarra, putative leader of the "Conspiracy of 1812." An artisan retired from the freedman's militia, Aponte featured Regla in his "Libro de Pinturas," which was discovered after his arrest on suspicion of fomenting a slave rebellion to overthrow the government. Under pressure from his interrogators, Aponte attempted to decipher the pictures found in his illustrated volume. These included a spectacular painting of Regla, depicted atop a column encircled by Afro-Atlantic luminaries: canonized patrons of *cabildos* in Spain and the Americas (such as San Benito of Palermo), saints, biblical figures, and personages featured in Afrocentric Egyptological and Ethiopianist lore. At Regla's feet, Aponte staged the coronation of Faith by a pair of Black men poised to defend this allegorical figure; on another pedestal to her right, Aponte placed an armless statue personifying Justice, with two dark-skinned men at its base. He also incorporated a lyric from the biblical Song of Songs 1:5 often applied to Black Madonnas, beginning, "Nigra suns [sic]." Then, claiming ignorance of Latin, Aponte translated the phrase in its entirety as, "Black, the most beautiful," rather than its literal meaning, "I am black, but beautiful."[79]

It is unadvisable to speculate further concerning Regla's importance for either Aponte particularly or Afro-Cubans more generally without returning to her correspondence with Yemayá. Aponte was allegedly a member of the legendary Lucumí cabildo Santa Barbara, Changó

Tedún. In fact, he may have led and hosted it in his residence or studio.[80] Regla's centrality in his "political theology" typifies Yemayá's position in Lucumí mythology; one may interpret Aponte's image as a royal family portrait, with Regla as Queen Mother, surrounded by her loyal clerical and aristocratic children.[81] Aponte's vision of Regla seems indebted to the *cabildo* tradition of accentuating the *orishas'* status as monarchs by converting their altars into "thrones" and by embellishing their consecrated objects with regal iconography; "Nigra suns" may be read as the motto of a fantastical, yet not wholly fictive, coat of arms.[82] Aponte literally elevates Regla as one to be served above the loftiest of heroes. Designed in part to sacralize and thus confer legitimacy on an alternative sociopolitical order based on Black Atlantic leadership, his incendiary images ultimately sent Aponte to the gallows. However, it would not be the last time that Regla would be rendered to underline her perceived African roots and solidarity with Afro-Cubans.

While countless individuals have borrowed Regla's image to exalt Yemayá, ritual performances may yield the greatest insight into their ability to inspire identification and galvanize Afro-Cuban sentiment. The most consistently documented of ceremonies remain the annual processions of the Regla icon on her feast day, September 7, in the town that bears her name.[83] These processions date from 1714 to 1961 and have recently enjoyed a revival. From the mid-1860s to the early 1890s, Afro-Cubans not only participated in these events, but they also organized them in conjunction with local *cabildos*. The most prominent was the *cabildo* of Yemayá founded by the legendary figure Ño Remigio Herrera, later bequeathed to his daughter, María Josefa "Pepa" Herrera. After a spate of repressive legislation resulted in the suspension of the processions, they resumed in the early twentieth century. At least as early as 1921, "Pepa" Herrera vied with the leader of a rival *cabildo* and daughter of Yemayá, Susana Cantero, for recognition as leader of the most lavish and auspiciously appointed cortège. While a racially diverse audience attended the processions, their organization stayed in the hands of Lucumí practitioners, whose annual public unveiling of their statuary also revealed Yemayá's racialized and gendered contours.[84]

On Regla's feast day, September 7, the *cabildos* paraded her image and those of other Virgins and saints throughout the town. Records of the proceedings leave little doubt that the relationship between Regla and Yemayá was openly indexed, even within the church, for the priests extended a blessing to both of the statues maintained by the *cabildos*.[85] Accompanied by sacred *batá* drums, Lucumí practitioners led fellow servants of the *orishas* as well as tourists and casual participants through the streets, crying, "Oh mío Yemayá!" or "Oh my/oh water Yemayá!"

They reinscribed the topography of the town with Yemayá's origin myth, beginning at the bay, then moving toward the town's two cemeteries, recalling the myth that the graveyard was originally Yemayá's domain and rendering tribute to its current owner, Oyá, as well as the "saltwater" Africans buried in the oldest plots. Senior *cabildo* members periodically threw pieces of coconut in divination to determine the acceptability of their actions and paused to pay homage at the homes of prominent priests. Lydia Cabrera writes of these processions as turning Regla into Yemayá, and while both public and private ritualization imbued the icon with divine power, the processions also succeeded in transforming their performers into receptacles for her sacred energy, or *aché*.[86]

This was not only the case for bearers of handbarrows mounted by *orishas* in possession as they carried statues of their saintly alter egos. The processions also transformed individuals into Regla's interpellated subjects. Casual attendees no doubt taught each other about Regla's qualities by trading stories about her miraculous cures, intercessory feats, and unique character. Yet among the most influential voices in the oral transmission of her lore came from the queens of the *cabildos*, whose transformative pedagogical practices conveyed the vision of Yemayá recognized within Lucumí communities. Pivotal figures such as "Panchita" Cárdenas remained invested in the *orisha's* worship and Regla's display in her sanctuary throughout the year; the same seamstresses hand-embroidered the finely wrought garments worn by the Virgin and the orishas' satiny *paños*.[87] And their influence on local understandings of Regla and Yemayá did not stop at appearances. As ritual specialists, they transmitted Odu recounting Yemayá's remedies for affliction and sacred authority. Many of these women had served as maids in white homes, and accounts of the processions indicate that while they praised Yemayá as the mother of all, they also conveyed the message that she was nobody's mammy.[88]

The historical record strongly suggests that Regla was used to counteract the fantasy promoted by the mammy image of Black passivity and consensual servitude, particularly after the so-called "race war" of 1912. This conflict pitted insurgents from the first Afro-Cuban political party, the outlawed Partido Independiente de Color (PIC), against not only the Cuban army but also the American Marines. Small-scale acts of agitation by the PIC for Black political representation and amnesties for jailed leaders incurred a brutally disproportionate response; at least three thousand people of color were slain in May and June 1912, mostly in the southeastern Oriente province. When the carnage reached Regla, Afro-Cuban families fled white militias on midnight ferries to Havana. The refugees included Pepa Herrera. "With tears in their eyes, they had

to abandon the piece of Cuban land on which they had been born and that held the beloved remains of their ancestors," wrote Regla historian Francisco M. Duque in 1925.[89] Racist violence again hit Regla's Afro-Cubans—an ever-smaller minority in the town, according to census records—in 1919, followed by a "brujo craze" in Havana and Matanzas that persecuted Blacks suspected of "witchcraft."

The annual procession for Regla was suspended in 1912, and only recommenced in 1921 after Pepa returned to her hometown.[90] The archival evidence supports an interpretation of these processions as rituals of resistance, public ceremonies that temporarily invert the social structure and constitute redressive, symbolic action.[91] To the consternation of some residents, many forced out after the "race war" returned for the processions and brought along other Black visitors; as the white Cuban journalist Eduardo Gómez Luaces wrote in a 1945 pamphlet on Regla, every year, his town was "invaded" by "strange faces" intent on adoring the Virgin "in their own manner or [according to their own] religion."[92] The processions furnished an opportunity for residents to reclaim the streets that had been the site of bigotry and racist violence, including lynching. They also gave participants a chance to cement ties with their allies, such as the liberal-populist mayor Antonio Bosch y Martínez, elected mayor in 1920, to whom Regla may owe its reputation as a haven for Afro-Cuban traditions.[93] The processions amounted to a public display of both sacred and secular power, unfurled before the *orishas'* watchful eyes.

Multiplicity and Motherwit

The regal and defiant vision of Yemayá offered by Aponte and the *cabildos* is seldom noted in mainstream publications; these writings exhibit a tendency to pigeonhole her as maternal—narrowly construed—and frame her color as a sign of domesticity and willing surrogacy, undoubtedly a conceptual residue of the "mammy" stereotype. Ironically, the earliest scholarly accounts of Yemayá in Cuba give a more varied impression of her attributes. Authors such as Fernando Ortiz and Rómulo Lachatañeré recognize her relationship with Regla, and they privilege her motherhood, yet they also allow for other character traits and attributes recognized by Lucumí initiates to influence their narratives. Ortiz writes, "She is a virtuous, chaste, and wise mother, but at the same time happy and charming [*sandunguera*], because the gods of the African Olympus do not deem virtue, wisdom, and charm [*sandunga*] incompatible."[94] In truth, the connotations of the term "sandunga" are difficult to convey

without reference to the dance of the same name; Alan West-Durán translates the term as "funky grace" to capture its sensuality and coolness.[95] Ortiz himself defined *sandunga* with reference to its etymology, writing that the term combined *sá*, Andalucian white salt, with *ndungu*, African black pepper; the vision of Yemayá he offers is, correspondingly, spicy.[96]

Lydia Cabrera's Yemayá was similarly mixed; in *Yemayá y Ochún: Kariocha, iyalorichas y olorichas*, she provided dizzyingly distinct stories of the *orisha's* emergence. Omise'eke Natasha Tinsley notes that Cabrera "spends several pages detailing Yemayá's many paths—as motherly, warriorly, feminine, masculine, indulgent, vengeful, stormy, calm—without explaining the *logique métisse* behind such plurality."[97] Cabrera expected her readers to draw the conclusion that Yemayá is not singular, but multiple, depending on her path and ritual variations between lineages. The exponential increase in publication of "Santería" exposés and "how-to" manuals for a wide audience, however, has rapidly accelerated the process that David H. Brown has dubbed "pantheonization," progressively systematizing the relationships between the *orishas* and condensing their features into rationalized mythobiographies.[98] In the interest of rendering Lucumí accessible and promoting it as a "world religion," contradictory aspects of the spirits have been artificially reconciled and inconveniently divergent "paths," paved over.

If in popular writings, a Yemayá materializes that often owes more to the mammy stereotype than has been previously recognized, among practitioners she assumes the role of a fierce foremother. Theorist Jacqueline K. Bryant builds on Alice Walker's concept of the literary foremother to describe fictional characters designed to subvert racist travesties of Black women through their integrity, wisdom, linguistic mastery, and embrace of African cultural forms. They are based on innumerable real-life figures known to have transmitted, according to Diane M. Spivey, their "mother wit," or practical judgment and intelligence, "through duties performed such as companion . . . housemaid . . . healer, cook, teller of tales, guide, and 'housegirl.' "[99] They turn their negative racialization and de- or hypersexualization around to their advantage; capitalizing on the low expectations of elite white interlocutors, they eventually prevail with grace and aplomb. Depictions of the foremothers identified by Bryant frequently show them grappling with an imperative completely elided in representations of the mammy—namely, to protect children of African descent not only from isolated instances of discrimination motivated by prejudice but also from the pernicious effects of structural and institutional racism.[100]

The "creative genius" of the foremother lies in finding means of combating oppression in a manner that ensures her charges' well-being and furthers the cause of their collective liberation.[101] Accordingly, Lucumí practitioners have credited Yemayá with delivering African captives safely to the Americas during the transatlantic slave trade, protecting them from fatal illnesses on voyages that frequently lasted many months.[102] Jean Stubbs writes that in the province of Oriente, Yemayá's foremotherly ferocity recalls that of Mariana Grajales, the mother of the Maceo brothers slain in the cause of Cuban independence; the *orisha's* warrior aspect comes explicitly to the fore in such paths as Okute, in which she fights battles—armed with a cutlass—beside Ogún.[103] In oral tradition, even Yemayá's maternity acquires a belligerent cast, as it emphasizes her impatience with wayward children, moodiness, exacting standards, and talent for punishment, rather than the acquiescence and docility conjured for some by the image of a Black woman in a head wrap holding a white baby. But the message sent by such stories remains consistent: whatever this foremother does, it is for her children's own good.

In 2003, I began to become acquainted with Yemayá as a fierce foremother in the context of an ongoing ethnographic research project. Ilé Laroye is a predominantly Black North American, working-class Lucumí community on the South Side of Chicago. Ilé Laroye is based in the private home of Nilaja Campbell, initiated in 1986 as a child of Elegguá, the deity of communications, master of the crossroads, and messenger of the *orishas*.[104] Nilaja had ordained nearly thirty "godchildren" as Lucumí priests at the time of this writing and garnered recognition as a praise singer for drum ceremonies, Spiritist medium, and elder in Palo Monte.[105] Nilaja has led the Ilé alongside her son Santi almost since the moment of his ordination at the age of thirteen. Santi lives and breathes through his mother in "*ocha*," Yemayá; while slender, graceful, and aquiline, he soon establishes himself as the most maternal presence in any room he enters. His patroness has been a conspicuous presence in the Ilé due not only to Santi's carefully wrought azure and cerulean living-room altars for her, but also to the many convivial children of Yemayá that number among his and Nilaja's protégés.

In crucial respects, Ilé Laroye's approach to Yemayá mirrors that of historical Cuban and Puerto Rican communities, reflecting its cooperation with local as well as Miami-based Latino houses of *ocha*. In the Cuban-style Espiritista rituals called *misas blancas*, African American mediums hewed to convention, referring to Yemayá as "Regla" when delivering advice from the spirits and singing such hymns as "Corre agua, Yemayá" and "O mí Yemayá, quítame lo malo, y échalo al mar."

In "Congo parties," Madre Agua danced alongside the other *mpungus*. The Ilé's African American priests declared, echoing their Latino counterparts, that children of Yemayá have a propensity to gain weight, because she wants those crowned with her *aché* to be well fed. Yet Black Lucumí practitioners have seen Yemayá through their own history as well, marked by the peculiarities of North American slavery and the Great Migration. Members of the Ilé sometimes remarked that her favorite foods—pork cracklings, sweet potatoes, black-eyed peas, salt-cured meat, grits—resemble Southern "soul food" to a greater extent than that of other orishas and bring to mind slaves' accomplishment in building a cuisine from their paltry, monotonous provisions, larded with scraps from the master's table.[106]

Yemayá Speaks

Fierceness is power. It is not, however, destructive power or deadly force—it is not savage, violent, ferocious, or terrible. Taken from the wordplay of African American Gay men in the Ballroom scene, fierceness is often expressed as charismatic authority that demands admiration.[107]

Yemayá has been understood, like soul food itself, to make the most of what is at hand, with a mighty flourish. Just as she allowed followers to substitute the Bay of Havana in Cuba for Yorùbáland's Ògùn River, and New York Harbor in Manhattan for the Bay of Havana, she has judged Lake Michigan—a body of water so vast that it bounds four states and resembles the ocean in its horizon-filling breadth—to be an acceptable proxy for the Atlantic. This is where, since 1997, Yemayá has received offerings from her landlocked children in an annual summertime celebration that rounds out the ritual calendar in Ilé Laroye. Originally conceived as a private event for Nilaja and Santi's godchildren, it now attracts members of other houses of *ocha*, not only in Illinois, but from throughout the Midwest. When the Ilé began holding the lakeside ceremony, Nilaja's husband 'Tunde would build a small wooden boat to fill with offerings, but in the last few years, the community has opted to create a large raft-like wreath by nailing together wooden boards and weaving leaves and flowers between the slats the previous night.

In 2007, the offering held for Yemayá at dawn resembled the others I have attended. Most participants brought flowers, as specified in the announcement sent via email and word-of-mouth by Ilé Laroye: lilies, carnations, multicolored daisies, chrysanthemums, roses, irises, feather-

duster-shaped hydrangea, and—appropriately—baby's breath. During the singing of praises to the *orishas*, priests arranged the flowers on the body of the wreath, wafted smoking incense over the center, then decorated it with pieces of mango, banana, fritters made from black-eyed-pea flour (*akará*), yam balls, a pineapple, and a small watermelon, its innumerable tiny seeds symbolic of Yemayá's fecundity. Nilaja and two other elders led over fifty participants in a round of praise songs for Yemayá as they danced slowly in a counterclockwise ring; unlike in a *batá* drum ritual, wherein only initiates would be welcome to join the circle intended to bring the *orisha* spinning into their presence, everyone at this event was urged to move in the human whirlpool. One African American man raised his voice to thank Yemayá for protecting both his ancestors during the Middle Passage and the efflorescence of the tradition that brought him to the water that morning.

Six men had volunteered to carry the raft out into the frigid current as far as they could go, and they led the procession across the sand as participants chanted. From the shore, one could see the outlines of the men entering the water, then, as well-defined yet featureless as paper dolls, their arms united in dispatching the craft. While the priests danced at waters' edge, Yemayá arrived in the body of a young male priest, whose cries of possession soon gave way to prostrations. She saluted, hugged, and caressed her devotees, calling them *omo mi*, "my children." Yemayá personally addressed them, referring to battles that will be won only after they are fought. She brought two women to her bosom and requested *asho*, or cloth, with which to cleanse them. Handed a white terry-cloth towel, she covered their heads, and the fabric trembled. Priests thronged around her as she dispensed advice, and some elders recommended that everyone else commence their retreat from the water in preparation for the communal meal. To their surprise, Yemayá sharply reproved them and ordered the uninitiated participants to return, protesting that the day was hers.

She pressed them to draw close, and as if teaching a master class, instructed two more priests with a raised index finger in full view of the gathering. Yemayá counseled self-preservation through defensive maneuvers and the tactical performance of cleansings called *ebó*, tailored to their different situations. She then delivered a stern lecture to the crowd, jotted down later that day in a combination of direct quotation and paraphrase:

> Health is most important. Health is most important. Sickness is all around! Clean. Clean. *Sara yeye bo kun lo, sara yeye ikú n'lo*. Those who have tools, use them. Those who know

> how to use water, clean with water. Those who know how to clean with fruit, clean with fruit. Those with orishas, take the offerings to the *orishas*; the rest, to *ilé Eshu* [the trash or the forest]. Remember the *egún*, they brought you here today. Remember: family, community, and ourselves, because if we don't take care of ourselves, no one will.

The first Lucumí words above are lyrics from a song to remove illness, premature death, and misfortune.[108] Because Lucumí mythology extols her witchcraft-medicine, instincts for communal self-preservation, and valor in defense of the vulnerable, Yemayá has been entrusted with the most intractable emotional, social, and physical problems; her possession mount seemed to be in the presence of several crises that day.

Similar in purpose to the ritual cleansings that occurred in the Espiritista ceremonies held in Nilaja's home, the type of personalized *ebó* that Yemayá advised were intended to eliminate negative energies caused by ruptures in social relationships, sorcery, and the influences of "purposive spirits," such as disgruntled ancestors nursing antique grudges.[109] It seems significant that Yemayá's list of ancestral, familial, and social commitments presented a vision of the world as structured by the obligation to honor agentive beings, primarily through commemorative action: "Remember." Yet the martial terminology used by her mount reinforced the hierarchical division of the world into allies and enemy forces, activating the dormant social critique in the statement, "if we don't take care of ourselves, no one will," one that confirms the self-image of practitioners as part of an oppositional group. In possession, she demonstrated that she not only bears witness to the suffering of her children, but also offers practical strategies for overcoming "sickness," including ailments caused by economic exploitation, racial discrimination, and patriarchal oppression.

Indeed, Yemayá is lauded as "fierce" in the contemporary "queer" sense of the term: intense, bold, and exceptional.[110] Fierceness—"charismatic authority that demands attention"—characterizes both the temperamental orisha as depicted in her mythology and the comportment and self-presentation of her human children, according to many practitioners. Yet it is important to emphasize that fierceness carries cultural weight not only as a personal trait or matter of idiosyncratic style; its flamboyant embodiment may be seen as a subversive act. Analyzing "fierceness" among the ethnically, racially, and sexually marginalized "as a disruptive strategy of performance," Madison Moore writes, "Because of its transgressive potential and deep connection to showmanship, fierceness allows its users to fabricate a new sense of self that

radiates a defiant sense [of] ownership through aesthetics, and in this way fierceness becomes a social, political, and aesthetic intervention."[111]

As in the ethnographic vignette above, Yemayá exercises her command of space to advocate for her listeners' self-possession and enhance their ability to heal themselves, however low their levels of religious training and limited their experience within Lucumí.

That Yemayá should be fierce well befits a spirit noted for her unwavering acceptance of gays and lesbians. As J. Lorand Matory writes, "Cuban and Puerto Rican adherents of Ocha have told me of the affinity of the goddesses Ochún and Yemayá with *addodis*, or penetrated men."[112] While some elders may dismiss any suggestion that the *orishas* could align themselves with humans on the basis of their erotic and affective proclivities, the popular understanding of Yemayá among practitioners maintains that she is not only tolerant but especially protective of her queer sons and daughters.[113] Anecdotal evidence abounds of Yemayá's protection of those ostracized for their sexuality or compelled to flout gendered norms. This aspect of her patronage became clear to me one afternoon, when a young woman in Nilaja's house was advised by a female peer to remove some "unsightly" body hair, and she rebuffed the suggestion in the following terms: "This is the way Yemoja made me. . . . This is my body; I have hair all over it; I'm not going to wax it!"[114] Yemayá gives her children license to be unapologetically fierce concerning their choices—and no one can ever be orphaned by her.[115]

Perhaps surprisingly, Yemayá can be severe toward even her most loyal servants. Although it has long been commonplace in initiates' narratives that their *orishas* forced them to pursue ordination, I found in my research that those initiated to Yemayá claimed to have undergone ordeals throughout their priesthood and felt the rough side of her tongue repeatedly in divination. One *iyalocha* related in an interview, "I can tell you: Yemayá's one of those orishas, she tests you hard. She wants to say, 'Yeah, you really want this?' For me—everybody's path is different. 'You really want this?' you know . . . I have to suffer for everything I get. I don't know why. My godmother always said, 'Just think if you didn't have the orishas,' and she's probably right . . . It's nothing but struggle for me."[116] Such testimony may seem ironic in light of Yemayá's reputation as nurturing and compliant. However, her behavior conforms to a parenting strategy often pursued by sociopolitically disadvantaged women: preparing children for the world's hardships by "toughening them up" at home.[117] One may consider this as another gauge of Yemayá's distance from the type of motherhood held up as universal and another point in favor of rooting any interpretation of her

actions in the historical situation of Afro-Diasporic religious actors. Her ferocity, like her tongue, is double-edged.

Conclusion

Over the last century, the icon of the Regla has overlapped to such a degree with the image of Yemayá that to gaze on one has been to catch a glimpse of the other, as in the case of superimposed transparencies. For this reason, I launched the preceding inquiry by delving into the Virgin's correspondence with the *orisha* in Lucumí, Espiritismo, and Palo Monte. I argued that both figures have contributed to Afro-Cubans' racial and gendered subject formation, not least by challenging the attitudes sedimented in the "mammy" stereotype. I contended that the mammy has obscured not only the domestic and maternal labor of Afro-Cuban women, but the vision of Yemayá as a fierce foremother conveyed through oral tradition; using the examples of Aponte's portrait and the Regla-based cabildos' annual processions, I limned a picture of Yemayá that is more majestic and militant than generally advanced. Finally, I reviewed salient features of her veneration by a contemporary African American community to demonstrate her continued development within the Afro-Atlantic world. Her Blackness there, as elsewhere, extends far beyond her iconography into mythology and ritual praxis, requiring us to seek her worshippers' histories if we aspire to see her face.

Notes

I owe my most sincere thanks to the members of a community I call Ilé Laroye in this chapter, especially those given the pseudonyms Nilaja and Santi Campbell, and to the *iyalocha* Yomí Yomí for their material assistance and extraordinary generosity.

1. Needless to say, the "universal mother" depicted in these texts is consistently cisgender-centric; that is to say, these texts do not entertain the possibility of men as mothers and assume that the only human mothers worthy of the name remain identified with inhabiting norms of feminine behavior and the gender they were assigned at birth (invariably female). Among recent citations, see Miguel Barnet, *AfroCuban Religions* (Princeton: Wiener, 2001), 50; Margarite Fernandez Olmos and Lizabeth Paravisini-Gebert, *Creole Religions of the Caribbean: An Introduction from Vodou and Santeria to Obeah and Espiritismo* (New York and London: New York University Press, 2003), 52; Alka Pande, *Ardhanarishvara, the Androgyne: Probing the Gender Within* (New Delhi: Rupa, 2004), 66; Owen Davies, *Paganism: A Very Short Introduction* (Oxford and New York: Oxford University Press, 2010), 83; Guillermina Ramos Cruz, "La

otra cara de Eva: diosas, sacerdotisas, sibilas, orishas: La mujer y lo sagrado," *Oráfrica: revista de oralidad africana* 5 (April 2009): 176; Radams Molina Montes, *Cuentos afrocubanos. Patakines.* (Barcelona: Linkgua Ediciones, 2007), 15; Armando Ferrer Castro y Mayda Acosta Alegre, *Fermina Gómez y la casa olvidada de Olókun* (La Habana: Editorial José Martí, 2007), 17; Antonio Núñez Jiménez, *Un mundo aparte: aproximación a la historia de América Latina y el Caribe* (Madrid: Ediciones de la Torre, 1994), 167; Tabaré A. Güerere, *Los babalawos: Curanderos, adivinos, dueños de los misterios* (Caracas: Los Libros de el Nacional, 1998); Edwin Barbosa da Silva, *Presença africana em religiões brasileiras* (Recife: FIDA Editorial Comunicação Especializada, 1980), 62; Pedro Iwashita, *Maria e Iemanjá—Análise de um Sincretismo* (S. Paulo: Ed. Paulinas, 1991), 194; and Rosa María Lahaye Guerra and Rubén Zardoya Loureda, *Yemayá a través de sus mitos* (Havana: Editorial de Ciencias Sociales, 1996), 66. For a more extended critique of the category of "mother goddess," see Rachel McDermott, "The Western Kali," in John S. Hawley and Donna M. Wulff, eds., *Devi: Goddesses of India* (Berkeley: University of California Press, 1996), 281–313, and Cynthia Eller, "White Women and the Dark Mother," *Religion* 30 (2000): 367–78.

2. Robert Farris Thompson writes in *Face of the Gods: Art and Altars of Africa and the African America*s (Museum for African Art and Prestel, Munich, 1993), 272–73, "Cuban poems underline her link with crockery (*Yemoja, mo wi Awoyó*), her queenly status (*ayaba*), her corpulence."

3. Mercedes Cros Sandoval, *La religión afro-cubana* (Madrid: Playor, 1975), 218; Miguel Barnet, *Cultos afrocubanos: La regla de ocha, la regla de palo monte* (La Habana: Ediciones Unión Artex, 1995), 55. "Azabache" not only denotes jet, a variety of lignite, but also the jet pieces worn as charms—typically on gold chains, along with crucifixes or Marian medals—to protect against volt-sorcery and the "evil eye."

4. For instance, quoting Agún Efundé's *Los secretos de la Santería* (Miami: Ediciones Universal, 1978), Michaelle Ascencio writes, "Para los devotos, Yemayá es una orisha negra con el pelo chicharrón, pegadito, pegadito: 'Yemayá es negra como el carbón y su pelo es pura pasa.'" Also see *Las diosas del Caribe* (Editorial Alfa, Caracas, 2007), 48.

5. See *White on White/Black on Black*, ed. George Yancy (Lanham, NJ: Rowman and Littlefield, 2005); Norman Whitten and Arlene Torres, *Blackness in Latin America and the Caribbean: Social Dynamics and Cultural Transformations*, 2 vols. (Bloomington: Indiana University Press, 1998); Manning Marable and Vanessa Agard-Jones, eds., *Transnational Blackness: Navigating the Global Color Line* (New York: Palgrave Macmillan, 2008); Percy C. Hintzen, Jean Muteba Rahier, and Felipe Smith, eds., *Global Circuits of Blackness: Interrogating the African Diaspora* (Champaign: University of Illinois Press, 2010); Stuart Hall, "Minimal Selves," Identity: "The Real Me"; Postmodernism and the Question of Identity (ICA Documents, No. 6, Institute of Contemporary Arts, 1987); Jalane D. Schmidt, "Locked Together: The Culture and Politics of 'Blackness' in Cuba," *Transforming Anthropology* 16, no. 2 (2008): 160–64; Patricia Hill Collins, *Black Feminist Thought: Knowledge, Consciousness, and the*

Politics of Empowerment (Boston: Unwin Hyman, 1990); Katie G. Cannon, *Black Womanist Ethics* (Atlanta: Scholars, 1988); Delores S. Williams, *Sisters in the Wilderness: The Challenge of Womanist God-Talk* (Maryknoll, NY: Orbis Books, 2005).

6. E. Patrick Johnson, *Appropriating Blackness: Performance and the Politics of Authenticity* (Durham: Duke University Press, 2003), 2.

7. In Brazil, the *oricha* Oyá is considered to have two distinct personalities: the seductive queen of lightning, represented by Our Lady of Candlemas, or *Candelaria*, and mistress of the dead, depicted as St. Teresa of Ávila. See Judith Gleason, "Oya in the Company of Saints," *Journal of the American Academy of Religion* 68, no. 2 (2000): 266.

8. For a fairly standard retelling of the medieval legend, see Rubén Vargas Ugarte, *Historia del culto de María en Iberoamérica y de sus imagines y santuarios más celebrados* (Madrid: Editorial Talleres Gráficos Jura, 1956), 322–23; and Eduardo Gómez Luaces, *Historia de Nuestra Señora de Regla. Sus fiestas, los cabildos, con datos ineditos y juicios criticos sobre Regla* (Regla, 1945).

9. In the Philippines, a version of the Virgin of Regla is venerated in Opon, but her child is also depicted as dark-skinned.

10. David Freedberg, *The Power of Images: Studies in the History and Theory of Response* (Chicago: University of Chicago Press, 1989), 120.

11. David H. Brown places the date at 1690 in "Garden in the Machine: Afro-Cuban Sacred Art and Performance in Urban New Jersey and New York" (PhD diss., Yale University, 1989), 339.

12. Quoted in María Elena Díaz, *The Virgin, the King, and the Royal Slaves of El Cobre: Negotiating Freedom in Colonial Cuba, 1670–1780* (Palo Alto, CA: Stanford University Press, 2000), 371n41; and Pedro Agustín Morell de Santa Cruz y de Lora, *La visita eclesiástica: Selección e introducción de César García del Pino* (La Habana: Editorial de Ciencias Sociales, 1985). See also Verena Martinez-Alier, *Marriage, Class, and Colour in Nineteenth-Century Cuba* (Cambridge: Cambridge University Press, 1976), 11–17.

13. He uses "Moreno" rather than "pardo," a term employed to describe a person with white ancestry on one side, a subset of which was mulatto. According to lettered clergy such as Fray Antonio de la Cruz, author of a hymn to Regla published in 1795, her color was not accidental; it was intended as an allusion to a famous line from the Song of Solomon, "Nigra sum sed formosa." Fray Antonio de la Cruz, *Novena de Nuestra Señora de Regla* (Cádiz, 1795), 49–60.

14. Pope Gregory the Great famously described paintings in churches as the "books of the illiterate." See Lawrence G. Duggan, "Was Art Really the 'Book of the Illiterate'?" *Word and Image* 5, no. 3 (1989): 227–51.

15. Where early colonists strove to eliminate the cults of goddesses and female spirits, as in Mexico and Peru, the Virgin Mary acquired great importance for impoverished and racially marginalized peoples. In the words of Nicholas Perry and Loreto Echeverría, *Under the Heel of Mary* (London: Routledge, 1988), 31, "Hispanic colonization was Marian colonization."

16. Miguel "Willie" Ramos, "The Empire Beats On: Oyo, Bàtá Drums, and Hegemony in Nineteenth-Century Cuba" (M.A. thesis, Florida International University, 2000), 9.

17. Andrew Apter, "Herskovits' Heritage: Rethinking Syncretism in the African Diaspora," *Diaspora: A Journal of Transnational Studies* 1, no. 3 (Winter): 235–60; Kamari Maxine Clarke, *Mapping Yorùbá Networks: Power and Agency in the Making of Transnational Communities* (Durham: Duke University Press, 2004), 97.

18. David H. Brown, *Santería Enthroned: Art, Ritual, and Innovation in an Afro-Cuban Religion* (Chicago: University of Chicago Press, 2003), 218.

19. Cajón al muerto may also be called *cajón para los muertos, cajón espiritual*, or simply Cajón.

20. For more concerning Espiritismo, see Racquel Romberg, *Witchcraft and Welfare: Spiritual Capital and the Business of Magic in Modern Puerto Rico* (Austin: University of Texas Press, 2003); and Romberg, *Healing Dramas: Divination and Magic in Modern Puerto Rico* (Austin: University of Texas Press, 2009).

21. Nolan Warden, "Cajón pa' los Muertos: Transculturation and Emergent Tradition in Afro-Cuban Ritual Drumming and Song" (M.A. thesis, Tufts University, 2006), 167.

22. Carmen María Sáenz Coopat and María Elena Vinueza, "Oral Traditions of Cuba," in *Music in Latin America and the Caribbean: Performing the Caribbean Experience*, ed. Malena Kuss (Austin: University of Texas Press, 2004), 39.

23. Jesús Fuentes Guerra and Armin Schwegler, *Lengua y ritos del Palo Monte Mayombe: Dioses cubanos y sus fuentes africanas* (Frankfurt and Vervuert/Madrid: Iberoamericana, 2005), 170; Martín Lienhard, "Kalunga o el recuerdo de la trata esclavista en algunos cantos afro-americanos," *Revista iberoamericana* 65, no. 188/189 (1999): 595–617.

24. Claire Garoutte and Anneke Wambaugh, *Crossing the Water: A Photographic Path to the Afro-Cuban Spirit World* (Durham: Duke University Press, 2007), 72. In "Garden in the Machine," 296n64, Brown writes that the identity of Lucumí practitioners' main Kongo patrons tends to be synchronized by *orisha* so that "Madre de Agua [is received by] Yemayás."

25. For example, in the song, "Bendita eres virgen sagrada/ Virgen de Regla reina del mar," Warden writes, "*Bendita* can be substituted with *Gloriosa*, and *reina del mar* can be substituted with *mi Yemaya*," 169.

26. In Lucumí, the metaphor of roads is privileged; for the different manifestations of *orishas*, the West African Yoruba use the image of rippling pools in a river, or *ibú*, that are named extensions of the same body of water. Karin Barber, " 'Oríkì,' Women and the Proliferation and Merging of 'òrìsà,' " *Africa* 60, no. 3 (1990): 313–37. The word "avatar" would seem at first glance to be a suitable translation, but the meaning of "descent" (specifically that of Vishnu into terrestrial form) would be misleading for gods that ascend into the body during possession and other ritual contexts.

27. Warden, 53. Among other statements made by practitioners, this comment recalls that of *santero, palero*, and Espiritista Charley Guelperin: "*Muerto pare Santo*: Death gives birth to the saints. All of the orishas are spirits . . . Madre Agua, Isn't she Yemaya? . . . It's not important what you call them. Bones are bones and bones are life." Quoted in Donald Cosentino,

"Conversations with Congo Manuel: Kings and Slaves in the Eschatology of Espiritismo," in *Activating the Past: History and Memory in the Black Atlantic World*, ed. Andrew Apter and Lauren Derby (Newcastle: Cambridge Scholars, 2010), 420.

28. John Mason, *Ìdáná Fún Òrìsà: Cooking for Selected Heads* (Brooklyn, NY: Yoruba Theological Archministry, 1999), 52.

29. An adage from colonial Brazil sums up the purported sexual division of labor in Cuba: "White women are for wedlock; African women, for working; and mulattas, for fucking." Gilberto Freyre, *The Masters and the Slaves: A Study in the Development of Brazilian Civilization* (New York: Knopf, 1964), 20.

30. Shloma Rosenberg, "Oshun," accessed April 5, 2007, http://mysticcurio.tripod.com/oshun.htm.

31. Vera Kutzinski, *Sugar's Secrets: Race and the Erotics of Cuban Nationalism* (Charlottesville and London: University of Virginia Press, 1993), 165. Raquel Mendieta Costa, "Exotic Exports: The Myth of the Mulatta," in *Corpus Delecti: Performance Art of the Americas*, ed. Coco Fusco (Routledge: London, 2000), 45, describes the Creole mulatta, not the African-born woman, as "the antithesis of the white woman; the latter being the very image of prudishness and virtue, to whom the male-dominated and racist Cuban society reserved the role of faithful wife and mother of the family."

32. Mercedes Rivas, *Literatura y esclavitud en la novella cubana del siglo XIX* (Sevilla: Imprenta E.E.H.A., 1990). See, for instance, the "great Cuban novel," Cirilo Villaverde, *Cecilia Valdés o la Loma del Ángel: Novela de costumbres cubanas* (New York: Imprenta de El Espejo, 1882).

33. See Alicia Arrizón, *Queering Mestizaje: Transculturation and Performance* (Ann Arbor: University of Michigan Press, 2007); Nancy Morejón and David Frye, "Cuba and Its Deep Africanity," *Callaloo* 28, no. 4 (2005): 933–51.

34. See Lourdes Martinez-Echazabal, "Mestizaje and the Discourse of National/Cultural Identity in Latin America, 1845–1959," *Latin American Perspectives* 25, no. 3 (1998): 21–42; Alejandro de la Fuente, "Race, National Discourse, and Politics in Cuba: An Overview," *Latin American Perspectives* 25, no. 3 (1998): 43–69.

35. Elizabeth Pérez, "The Virgin in the Mirror: Reading Images of a Black Madonna through the Lens of Afro-Cuban Women's Experiences," *The Journal of African American History* 95, no. 2 (2010): 202–28.

36. On women's contributions to *orisha* worship in Cuba, see Miguel "Willie" Ramos, "*La división de la Habana*: Territorial Conflict and Cultural Hegemony in the Followers of Oyo Lukumí Religion, 1850s–1920s," *Cuban Studies* 34 (2003): 38–70.

37. See Paul Ricoeur, *The Rule of Metaphor: The Creation of Meaning in Language* (London: Routledge, 2003 [1975]).

38. Flora González Mandri, *Guarding Cultural Memory: Afro-Cuban Women in Literature and the Arts* (Charlottesville: University of Virginia Press, 2006), 12. Díaz in *The Virgin, the King, and the Royal Slaves of El Cobre* writes, "In Cuba, during the nineteenth century, slave women returned to work forty-

five days after childbirth and the children were placed under the care of an older slave woman, while mothers worked in the fields," 398n98.

39. Manuel Moreno Fraginals, *The Sugarmill: The Socioeconomic Complex of Sugar in Cuba, 1760–1860*, trans. Cedric Belfrage (New York and London: Monthly Review, 1976), 143. In the words of Hazel Carby, "Black women gave birth to property and, directly, to capital itself in the form of slaves, and all slaves inherited their status from their mothers" (quoted in Joan Martin, *More Than Chains and Toil: A Christian Work Ethic of Enslaved Women* (Louisville, KY: Westminster John Knox, 2000), 94.

40. Documents from the period portray women of color as having no virginity to lose. Martinez-Alier, *Marriage, Class, and Colour in Nineteenth-Century Cuba*, 115.

41. Paulla A. Ebron, "Enchanted Memories of Regional Difference in African American Culture," *American Anthropologist* 100, no. 1 (1998): 101; emphasis added.

42. Hugh Thomas, *Cuba, or The Pursuit of Freedom* (New York: Da Capo, 1998 [1971]), 173.

43. K. Sue Jewell, *From Mammy to Miss America and Beyond: Cultural Images and the Shaping of U.S. Social Policy* (London: Routledge, 1993), 40.

44. Martinez-Alier, *Marriage, Class, and Colour in Nineteenth-Century Cuba*, 116. See also Gema R. Guevara, "Inexacting Whiteness: Blanqueamiento as a Gender-Specific Trope in the Nineteenth Century," *Cuban Studies* 36 (2005): 105–28.

45. Martinez-Alier, *Marriage, Class, and Colour in Nineteenth-Century Cuba*, 128.

46. Ibid., 11. In early nineteenth-century Cuba, elites formulated a complicated set of categories to contain the threat to the dominant order posed by the inherent instability of racial signifiers. For both Spaniards and Cubans of the colonial period, bodies had "phenotypical" as well as "legal" color. The term "phenotypical color" was meant to refer to physical appearance, genetically as well as environmentally determined, although one could always attempt to "pass" for white. As a synonym for "race," phenotypical color, in principle, performed a synecdochal function so that one could determine the socioeconomic status of any Cuban at a glance. However, phenotype eventually became an unreliable criterion since African blood mingled so frequently with the European. Recorded in baptismal registers as mandated by Spanish authorities, legal color theoretically established the racial status of both infants and parents, but in cases of interracial marriage and concubinage, the identity of the offspring would be far from certain. Initially imposed by Spanish administrators, the category of legal color became the alternative criterion by which Cubans determined racial status (in a court of law, for instance) when physical traits such as hair texture did not seem to match complexion—when, in short, the body failed to serve as "an unambiguous guide."

47. As an ideological effect of the transatlantic slave trade, whiteness came to connote ownership of property, whereas brownness signified that one's

ancestors had served as the property of others. Christopher Schmidt-Nowara, *Empire and Antislavery: Spain, Cuba, and Puerto Rico, 1833–1874* (Pittsburgh: University of Pittsburgh Press, 1999), 8.

48. Barred from moving "up" and across racial barriers through marriage or informal relations, many slaves and freedmen of color routinely faced rejection from otherwise available women "holding out" for white men.

49. Barbara Potthast-Jutkeit, "The Slave Family in the Caribbean: A Research Review," *Ibero-Amerikanisches Archiv* 24 (1998): 295. See María de los Reyes Castillo Bueno and Daisy Rubiera Castillo, *Reyita: The Life of a Black Cuban Woman in the Twentieth Century* (Durham: Duke University Press, 2000).

50. Pedro Deschamps Chapeaux, "People without a History," in *Afrocuba: An Anthology of Cuban Writing on Race, Politics, and Culture*, ed. Pedro Pérez Sarduy and Jean Stubbs (Melbourne: Ocean, 1993), 58–59, writes, "In Havana during the period 1820–1845, midwifery was in the main carried out by women of color, principally those classified as free *pardas* (mulatto women)."

51. Quoted in Luis Martínez-Fernández, "Life in a 'Male City': Native and Foreign Elite Women in Nineteenth-Century Havana," *Cuban Studies* 25 (1995): 30.

52. Quoted in Reynaldo González, *Contradanzas y latigazos* (Havana: Editorial Letras Cubanas, 1992), 168.

53. Martin, *More than Chains and Toil*, 4.

54. These configurations frequently proved unstable, however, and drove many to become Janes-of-all-trades, moving from site to site in the pursuit of employment. Rebecca J. Scott, *Slave Emancipation in Cuba: The Transition to Free Labor, 1860–1899* (Princeton: Princeton University Press, 1985), 242–43.

55. Cameron Lynne Macdonald, *Shadow Mothers: Nannies, Au Pairs, and the Micropolitics of Mothering* (Berkeley: University of California Press, 2010).

56. Kutzinski, *Sugar's Secrets*, 168.

57. Félix V. Matos-Rodríguez, "Street Vendors, Pedlars, Shop-Owners and Domestics: Some Aspects of Women's Economic Roles in Nineteenth-Century San Juan, Puerto Rico (1820–1870)," in *Engendering History: Caribbean Women in Historical Perspective*, ed. Verene Shepherd, Bridget Brereton, and Barbara Bailey (New York: St. Martin's, 1995), 176–96.

58. Kate Haug, "Myth and Matriarchy: An Analysis of the Mammy Stereotype," in *Dirt and Domesticity: Constructions of the Feminine: June 12–August 14, 1992*, Whitney Museum of American Art at Equitable Center (New York: Whitney Museum of American Art, 1992), 39.

59. Anne McClintock, *Imperial Leather: Race, Gender, and Sexuality in the Colonial Contest* (Routledge: New York, 1995), 85. For a late twentieth-century account of the mammy's role in teaching white children about the *orichas*, especially Yemayá, see Migene Gonález Wippler, *Santería: The Religion* (St. Paul: Llewellyn, 1999), 301–14.

60. Baltasar Fra-Molinero, "The Condition of Black Women in Spain during the Renaissance," in *Black Women in America*, ed. Kim Marie Vaz (London: Sage, 1995).

61. Haug, "Myth and Matriarchy," 48.

62. Maria St. John, "'It Ain't Fittin': Cinematic and Fantasmatic Contours of Mammy in *Gone with the Wind* and Beyond," *Studies in Gender and Sexuality* 2, no. 2 (2001): 138.

63. Hilary M. Beckles, *Centering Woman: Gender Discourses in Caribbean Slave Society* (Kingston: Ian Randle, 1999), 10.

64. Daniel E. Walker, *No More, No More: Slavery and Cultural Resistance in Havana and New Orleans* (Minneapolis: University of Minnesota Press, 2004), 115.

65. These scenes also appeared on cigar and cigarette wrappers "at least since the 1840s" (Kutzinski, *Sugar's Secrets*, 44). See also Antonio Núñez Jiménez, *Marquillas cigarreras cubanas* (Havana: Ediciones Tabapress, 1989).

66. Robin D. Moore, *Nationalizing Blackness; Afrocubanismo and Artistic Revolution in Havana, 1920–1940* (Pittsburgh, PA: University of Pittsburgh Press, 1997), 49.

67. Lisa Maya Knauer, "Consuming Slavery, Performing Cuba: Ethnography, Carnival and Black Public Culture," *Ethnicity and Race in a Changing World: A Review Journal* 1, no. 4 (2011): 3–25.

68. Dawn Duke, *Literary Passion, Ideological Commitment: Toward a Legacy of Afro-Cuban and Afro-Brazilian Women Writers* (Lewisburg: Bucknell University Press, 2008), 49. A number of composite fictional characters have had names and internal references tying them to both the *orisha* and the Virgin, from Cirilo Villaverde's María de Regla, to Regla the maid in Antonio Orlando Rodríguez's *The Last Masquerade: A Novel*, trans. Ernesto Mestre-Reed (New York: Rayo HarperCollins, 2005), Chantel Acevedo's *Love and Ghost Letters* (New York: St. Martin's Griffin, 2006), and Ruth Behar's novel-in-progress *Nightgowns from Cuba* (forthcoming). See Ruth Behar, "Honeymoon Nightgowns That a Black Woman Saved for a White Woman: A Perilous Journey into the Cuban Historical Imagination," *American Studies* 41, nos. 2, 3 (2000): 287–302.

69. Beckles, *Centering Woman*, 14. Kenneth W. Goings, *Mammy and Uncle Mose: Black Collectibles and American Stereotyping* (Bloomington: Indiana University Press, 1994), 64.

70. Jewell, *From Mammy to Miss America and Beyond*, 43.

71. Louis Althusser, "Ideology and Ideological State Apparatuses (Notes toward an Investigation)," in *Lenin and Philosophy*, trans. Ben Brewster (London: New Left Books, 1971), 174.

72. Ibid. In Althusser's hypothetical street scene, Regla plays the part of the authority figure, calling out, "Hey, you!" and waiting for the subjects within "earshot" to "turn around." In *Peau noire, masques blanques*, Frantz Fanon used a vicious slur as his point of departure for perhaps the most famous statement on the racial component of interpellation. Drawing on the writings of W. E. B. Du Bois and others, Fanon declared that the person of African descent is daily "battered down by tom-toms, cannibalism, intellectual deficiency, fetishism [sic], racial defects, slave-ships, and above all else, above all: 'Sho' good eatin'." *Black Skin, White Masks* (New York: Grove, 1967 [1952]), 113.

73. See Marina Warner, *Alone of All Her Sex: The Myth and Cult of the Virgin Mary* (New York: Random House, 1983).

74. Juan Antonio Hernández writes that "the Virgin was associated, without a doubt, by Afro-Cubans with their racial identity" ("Hacia una historia de lo imposible: La revolucíon haitiana y el "libro de pinturas" de José Antonio Aponte" (PhD diss., University of Pittsburgh, 2005), 241n190).

75. Interview with Latina Lucumí priestess, Chicago, May 29, 2001.

76. Angela Jorge, "La madama francesita: A New World Black Spirit," in *Global Dimensions of the African Diaspora*, 2nd ed., ed. Joseph E. Harris (Washington, DC: Howard University Press, 1993), 205–22; Derric Moore, *Maa Aankh: Finding God the Afro-American Spiritual Way, by Honoring the Ancestors and Guardian Spirits* (Liberal, KS: Four Sons, 2010). See also J. Lorand Matory, "Free to Be a Slave: Slavery as Metaphor in the Afro-Atlantic Religions," *Journal of Religion in Africa* 37 (2007): 398–425.

77. Carol B. Duncan, "Aunt(y) Jemima in Spiritual Baptist Experience in Toronto: Spiritual Mother or Servile Woman?" *Small Axe* 9 (2001): 97–122.

78. "If Justice Is Our Objective: Diaspora Literacy, Heritage Knowledge, and the Praxis of Critical Studyin' for Human Freedom," in *With More Deliberate Speed: Achieving Equity and Excellence in Education*, ed. Arnetha F. Ball (Malden, MA: Blackwell, 2006), 352–53.

79. This was allegedly drawn from a compilation of Marian prayers.

80. Stephan Palmié, *Wizards and Scientists: Explorations in Afro-Cuban Modernity and Tradition* (Durham and London: Duke University Press, 2003), 90.

81. Hernández, "Hacia una historia de lo imposible," 249.

82. David H. Brown, "Thrones of the Orichas: Afro-Cuban Altars in New Jersey, New York, and Havana," *African Arts* 26, no. 4 (1993): 44–59, 85–87.

83. Early sources such as Gómez Luaces, *Historia de Nuestra Señora de Regla*, 11, Lydia Cabrera, *Yemayá y Ochún: Kariocha, iyalorichas y olorichas* (Madrid: C and R, 1974), 17, and Vargas Ugarte, *Historia del Culto de María*, 322–23, cite the date of the processions as September 8, while later research—that of Brown, among others—insists that it was September 7. Each source is internally consistent.

84. Carrie Viarnes unpacks the term "a mi manera" in the course of documenting the contemporary Cuban processions for Regla. "All Roads Lead to Yemayá: Transformative Trajectories in the Procession at Regla," *E-misférica* 5, no. 1 (2008): http://hemi.nyu.edu/journal/5.1/eng/en51_pg_viarnes.html.

85. The *cabildos* rejected the image housed in the church, in favor of their own, laid to "sleep" in the sanctuary the night before the processions. Luis Alberto Pedroso, "La memoria de un cabildo," in *El último cabildo de Yemayá: Roberto Salas*, ed. Luis Alberto Pedroso and Rafael Acosta de Arriba (La Habana: Oficina del Historiador de la Ciudad, 2008), 2.

86. Cabrera, *Yemayá y Ochún*, 17.

87. Brown, *Santería Enthroned*, 221.

88. Ibid.

89. Francisco M. Duque, *Historia de Regla. Descripción Política, Económica y Social, Desde su Fundación Hasta el Día* (La Habana: Rambla, Bouza y Ca., 1925), 127.

90. By 1945, Regla's processions attracted more than a hundred thousand pilgrims to a town with a resident population of just over twenty-three thousand.

91. For comparisons, see William Beezley, Cheryl English Martin, and William E. French, *Rituals of Rule, Rituals of Resistance: Public Celebrations and Popular Culture in Mexico* (Wilmington, DE: Scholarly Resources, 1994).

92. Gómez Luaces, *Historia de Nuestra Señora de Regla*, 19.

93. City hall was one of the sites visited by the *cabildos* in procession. Palmié, *Wizards and Scientists*, 343n35.

94. "Es madre virtuosa, púdica y sabia pero a la vez alegre y sandunguera, pues por el Olimpo africano no creen que sea incompatible la virtud, la sabiduría y la sandunga." Fernando Ortiz, *Los bailes y el teatro de los negros en el folklore de Cuba* (Havana: Editorial Letras Cubanas, [1985] 1951), 247.

95. Alejo Carpentier, *Music in Cuba*, trans. Alan West-Durán (Minneapolis: University of Minnesota Press, 2001 [1946]), 192.

96. Fernando Ortiz, *La africanía de la música folkórica de Cuba* (La Habana: Editora Universitaria, 1955), 71.

97. Omise'eke Natasha Tinsley, *Thiefing Sugar: Eroticism between Women in Caribbean Literature* (Durham: Duke University Press, 2010), 212.

98. Joseph M. Murphy notes that anthropomorphic representation of the *orishas* "has theological and social implications," for instance, when Yemayá is included in galleries of female deities around the world as an "avatar . . . of a single goddess" (477). Murphy also writes, "The most common context for discussion of Òṣun or Yemoja was among other goddesses of the world, often with expressions of a faith that the òrìṣà were African names or avatars of a universal goddess who is also called Hathor or Artemis." Murphy, "Òrìṣà Traditions and the Internet Diaspora," in *Òrìṣà Devotion as World Religion: The Globalization of Yorùbá Religious Culture*, ed. Jacob K. Olupona and Terry Rey (Madison: University of Wisconsin, 2008), 478.

99. Diane M. Spivey, *The Peppers, Cracklings, and Knots of Wool Cookbook: The Global Migration of African Cuisine* (Albany: State University of New York Press, 1999), 190.

100. Jacqueline K. Bryant, "The Literary Foremother: An Embodiment of the Rhetoric of Freedom," in *African American Rhetoric(s): Interdisciplinary Perspectives*, ed. Elaine B. Richardson and Ronald L. Jackson II (Carbondale: Southern Illinois University, 2004), 73–85. Representations of Yemayá that draw upon Lucumí mythology as well as ritual practice to depict her, such as Cirilo Villaverde's María de Regla in *Cecilia Valdés o la Loma del Ángel: Novela de costumbres cubanas* (New York: Imprenta de El Espejo, 1882), unwittingly constitute exemplars of the foremother figure.

101. Bryant, "The Literary Foremother," 74.

102. Mason, *Ìdáná Fún Òrìṣà*, 52.

103. Jean Stubbs, "Social and Political Motherhood of Cuba: Mariana Grajales Cuello" in *Engendering History: Caribbean Women in Historical Perspective*, ed. Verene Shepherd, Bridget Brereton, and Barbara Bailey (New York: St. Martin's, 1995), 296–317; Miguel "Willie" Ramos, "Afro-Cuban Orisha Worship," in *Santería Aesthetics in Contemporary Latin American Art*, ed. Arturo Lindsay (Washington, DC: Smithsonian Institution Press, 1996), 68.

104. Laroye is one of Eleggua's praise names, and Nilaja's house is viewed as his abode, as much as his devotees'.

105. A hierarchy of ritual descent relates "godparents," or the senior ritual sponsors of initiates, to their "godchildren" through a process called *apadrinación*.

106. Mason, *Ìdáná Fún Òrìsà*, 52.

107. Mickey Weems, *The Fierce Tribe: Masculine Identity and Performance in the Circuit* (Logan: Utah State University Press, 2008), 29.

108. The term "*sarayeye*" may be used as a noun or a verb meaning "cleansing." "Tools" referred to consecrated objects that may be replenished to improve the condition of their owners.

109. Raymond Prince, quoted in Roberto Nodal and Miguel "Willie" Ramos, "*Let the Power Flow: Ebó* as a Healing Mechanism in Lukumi Orisha Worship," in *Fragments of Bone: Neo-African Religions in a New World*, ed. Patrick Bellegarde-Smith (Urbana: University of Illinois Press, 2005), 167.

110. Salvador Vidal-Ortiz, "Sexuality and Gender in Santería: Towards a Queer of Color Critique in the Study of Religion" (PhD diss., City University of New York, 2005); Randy P. Conner, "Rainbow's Children: Diversity of Gender and Sexuality in *African*-Diasporic Spiritual Traditions," in *Fragments of Bone: Neo-African Religions in a New World*, ed. Patrick Bellegarde-Smith (Urbana: University of Illinois Press, 2005), 148.

111. Madison Moore, "Tina Theory: Notes on Fierceness," *Journal of Popular Music Studies* 24, no. 1 (2012): 72.

112. J. Lorand Matory, "Sexual Secrets: Candomble, Brazil, and the Multiple Intimacies of the African Diaspora," in *Off Stage/On Display: Intimacy and Ethnography in the Age of Public Culture*, ed. Andrew Shryock (Stanford: Stanford University Press, 2004), 171.

113. Randy P. Conner and David Hatfield Sparks, *Queering Creole Spiritual Traditions: Lesbian, Gay, Bisexual, and Transgender Participation in African-inspired Traditions in the Americas* (New York: Harrington Park, 2004), 71–72; Terry Rey, "The Virgin's Slip Is Full of Fireflies": The Multiform Struggle over the Virgin Mary's Legitimierende Macht in Latin America and Its U.S. Diasporic Communities," *UC Davis Law Review* 33, no. 4 (2000): 955–72. Rey writes, "The Virgin Mary's assimilation in Cuban Santería of Ochun (as Caridad del Cobre) and Yemaya (as Our Lady of the [sic] Regla) opens a discursive locus of legitimacy for homosexual men in popular Cuban Mariology" (969).

In an address to the American Academy of Religion, African American scholar Ibrahim Farajajé-Jones boldly stated, "I call upon Yemaya, orisha of the sea and maternal compassion, mother of gay men, bisexual men and transgendered men[,] and of all persons living with HIV/AIDS." Elias Ibrahim

Farajaje-Jones, "Piercing Analysis/or In-to-body Travel/ or What Is All That Piercing Stuff?" unpublished lecture, American Academy of Religion Annual Meeting (Philadelphia, Fall 1995), quoted in Kenneth Lewis Hamilton, "The Flames of Namugongo: Postcolonial, Queer, and Thea/ological Reflections on the Narrative of the 1886 Ugandan Martyrdom" (PhD diss., Union Institute and University, 2007), 305.

114. Fieldnotes, April 14, 2005.

115. See José Esteban Muñoz, *Disidentifications: Queers of Color and the Performance of Politics* (Minneapolis: University of Minnesota Press, 1999).

116. Personal communication, August 13, 2007. See Fiona Buckland, *Impossible Dance: Club Culture and Queer World-Making* (Middletown, CT: Wesleyan University Press, 2002).

117. A number of scholarly volumes address this phenomenon as it influences African American family dynamics; for a relatively brief review of the state of research on this issue, see Ellen E. Pinderhughes, Kenneth A. Dodge, J. E. Bates, and Arnaldo Zelli, "Discipline Responses: Influences of Parents' Socioeconomic Status, Ethnicity, Beliefs about Parenting, Stress, and Cognitive-Emotional Processes," *Journal of Family Psychology* 14, no. 3 (2000): 380–400.

Chapter 2

Yemayá's Duck

Irony, Ambivalence, and the Effeminate Male Subject in Cuban Santería

Aisha M. Beliso-De Jesús

> The Duck, pepeyé or kuékueue, is sacrificed exclusively to Yemayá and Olokun. The duck is the elder bird sacrificed to Yemayá and is accompanied by the rooster. He is blindfolded when he is about to be sacrificed, and whoever plucks him must cover her nose and mouth with a handkerchief so as to not sully him with her breath. During this process, one must be silent. If he is plucked poorly, Omi Tomi believed that the life of the Iyalocha [priestess], or one of her family members, who plucked him would be in danger. Yemayá counts the feathers and is unforgiving if there is one missing. There are many stories that partially explain why Yemayá eats the duck. She hates him to the point that when he is sacrificed to her, he is covered with a blue cloth so she does not have to see him. . . . However, at the same time, Yemayá needs and desires him.
>
> —Adapted from *Yemayá y Ochún* by Lydia Cabrera, an ethnographer and literature writer on Afro-Cuban religions.[1]

Introduction

The ethnographer is a writer who composes nonfiction prose, a process that James Clifford and George Marcus describe as the convergence of the poetic and the political.[2] The politics of the poetic links and fixes discursive momentums, competing ambiguous meanings that situ-

ate and define parodies of self. African diaspora anthropology done by relatively elite North Americans[3] might be characterized as a series of efforts to splice and unify, to salvage and vindicate "the African" as an ingenious transformer and cultural porter who left her mark within transculturated,[4] colonial, nationalist modernities.[5] This chapter, however, is concerned with cynical optimisms situated within decades-long legacies of racialized religious-nationalistic homophobias—counternarratives of marginalized colonial heteronormativities, which, I argue, emerge within and through expressions of Santería masculinized nationalisms.

My protagonist in this parody is the "effeminate male"[6] *santero* or "*el pato*"[7]—not an actual person or *real* community, but rather the discursive religious subject—and his role in producing religious difference. I am intrigued and disturbed by the comedic reprieve and defensive tactic this masculine effeminate performs in everyday religious life. Homophobic discourses trouble understandings of religion and sex that engage in fixing affirmations. These discourses are mobile and in flux. They disrupt naturalizations even as they fix sexed and gendered subjects. Indeed, homophobic affirmations also perform declarations of truth. I focus on a few of the complex relations between productions of religious truths: the coming together of masculinity, nationalisms, and *dillogún* (Cuban cowry-shell divination) "signs" that form Santería scripts of human nature. By engaging these on a grid of mutual intelligibility,[8] this chapter explores religious acts of understanding self and other and the ways these afflictive and satirical solutions simultaneously (and often unconsciously) fix humans into naturalized sexiological positionalities.[9]

I feel a bit contrary in fastening my gaze on Yemayá's duck as a counterdiscourse—an entry into the sexual nationalisms that emerge in Santería relations of power. These ambiguous discursivities, like the Oricha Yemayá herself, compose and abate, like the lapping of waves on the shore. El Pato is as Miguelón, an *obá oriaté* (Santería officiator) from Havana described to me, a "cursed creature," one who as it has been told, had access to the secrets at the bottom of the sea. Yet, because he was a gossip (*chismoso*) who betrayed Yemayá, the duck was punished with a cacophonous quack and uncertain wobble and marked for his indiscretions with webbed feet. When sacrificed, the esophagus is cut out and blown on to remove curses. "Pato" and "bird" (*pájaro*) are also degrading aphorisms for an effeminate homosexual male in Cuba.[10] Indeed, the duck that is sacrificed to Yemayá is always white, an interesting relationality that highlights how homosexuality is envisioned in African diaspora practices as a "white, male" North American deviance from traditionality.[11] Seen as similarly "marked" by a sway of

hip or feminized mannerism, the homosexual *santero* is simultaneously imagined as both a cursed *and* necessary subject in Afro-Cuban Santería.

In this chapter, I briefly examine the power of Santería masculine religiosities through the imperious female ocean deity Yemayá and her relationship with her coveted drudge—a dupe and pansy—the male duck: an object of both disdain and affection. Traveling to Cuba in the 1990s for religious practices and then for research since the early 2000s, I can remember hearing stories of the "prowess" of Cuban *santeros'* masculinity.[12] How the "*maricones*" (fags) left in the 1980s and came to the states. Practitioners in Cuba described American Santería as "perfumed" and "effeminate." During conversations with Cuban priests in my field research, it became clear that the Americans who appeared in Cuba for Santería rituals in the 1990s only served to confirm suspicions that American Santería was an "inadequate replica."[13] Still, in research with Santería practitioners in the United States, some of the same nationalist discourses of masculinity that confirmed Cuban notions of American inadequateness[14] formed pools of discourse that naturalized presumptions of masculinity and heteronormativity. These nationalized sexualities formed religious "truths" that explained who people were, how they acted, and the life paths they traveled.

Since the 1959 Cuban Revolution and large exodus of Cuban émigrés to the United States, Santería emerged in both countries as two isolated sets of practice (both stigmatized as witchcraft, hidden and underground—with practitioners similarly judged as backwards and superstitious).[15] Currently, in the early twenty-first century, these two communities are becoming increasingly interconnected. Santería is emerging discursively as a new "world religion," what Ebron (2002) has described as transnational *personalistic* economies.[16]

In this chapter, I explore Yemayá's effeminate male duck subject as a counterpositionality that I suggest participates both in the circumscribing of Cuban nationalistic masculinities and simultaneously produces multiple forms of Santería religious subjectivities. I am particularly interested in the roles of irony, satire, and ambivalence as expressions of "nation" that emerge through transnational Santería discourses of human nature and perceived "susceptibilities" of sexual weakness. How does the divine designation of "real men"[17] in heteronormative traditions produce homosexual modernities? What conceptualizations of sex, nature, and religion fix female deities such as the Oricha Yemayá and her male duck as signifiers of effeminate masculinities? Rather than reproduce the binaries that posit the acceptance of homosexuality as American liberation and homophobia as Cuban patriarchy, I am interested in complicating these assumptions to examine them instead as

strings of attachment and religious associations, that is, negotiations that reconfigure sites of sexual-national politics. It is in these *disidentifications*[18] where we might explore how practitioners draw upon, critique, and yet continue to reproduce the very problematic discourses that define them as undesirable subjects. In *Lucumí*, the "language of the Oricha,"[19] there is a proverb that says, "All waters by their actions pay tribute to the owner of the sea."[20] While masculinity is hard to maneuver, it is also fluid. As scholars, it is important that we pay attention to an epistemology of Yemayá's duck, where droplets trickle into forceful flows of subjectivity, breaking through dams of the subject within paths of the normal.

"Only Birds Fly": The Politics of Homosexual Nationalisms

> The duck was *akeru*, a messenger, a "*cachanchán*" [confidant or helper] of Yemayá. She trusted in him and sent him with an important message and the duck betrayed her. Out of spite, Kuekueye [the duck] intentionally distorted the answer to a very important question. Since Yemayá had depended and trusted the duck, she ate him, and made him her enemy.
>
> —Adapted from Lydia Cabrera's *Yemayá y Ochún*.[21]

"Those faggots [*maricones*] left with their perfume and the clothes on their backs,"[22] Polo tells me, wiping the accumulation of sweat off his dark, round face with a red and white handkerchief, and afterwards taking another swig of Cristal beer, Cuba's national favorite (¡La preferida de Cuba!). It was July 2005. I watched the smoke as he puffed the cigar, distracted; my gaze followed the smooth white circles. Focusing for a moment on his round belly, I was drawn to the hints of gold on his two canines—the glimmers of "bling" stark against yellow-white teeth.[23] Wandering down to the layers of thick gold chains around his neck, I saw a two-and-a-half-inch gold figure of Saint Barbara dangling like a pendulum. I could not pay attention to this interview; I really disliked this man. The homophobic rants couched in Cuban communist rhetoric and anti-capitalism had taken its toll.

"Cuban-American" Santería practitioners are all "faggot imperialists," his voice trailed off. "Even if they aren't *maricones*, they are *maricones*. . . . All of their elders are *maricones*." Tired of this conversation, I had tried unsuccessfully to ask a question, trying to invoke my inner Lydia Cabrera, the self-made queen of Afro-Cuban ethnography.[24] The

house was teeming with activity: a mechanic repaired Polo's car (a rare luxury in socialist Cuba), and young drummers walked in and out, stopping to touch the floor at Polo's feet, "Iburu, Iboya," the customary Ifá greeting. He talked at me. This was only my second interview in Cuba; I felt inadequate. Berated. I stared blankly at the beautiful veranda, a luxurious home in the wealthy Mira Mar neighborhood in Havana, decorated elaborately with French motifs. Trying not to look annoyed, trying to be a worthy anthropologist—I failed.

When I tuned back in, Polo was talking about people like *me*—"Cubanosamericanos" and their godchildren—American Santería practitioners, who were taught the religion by "perfumed faggots." "They fled [in the 1959 revolution] to save their asses. . . . They knew they could never go up against us." Noticing that I was not really paying him much attention, he commanded me, "Listen, you don't know a thing! This is a religion for men, for kings. Whatever you think you learned, just forget it; it's worthless." His wife interrupts; he is going to be late for his gig. I silently rejoiced! A tall drummer with a hook nose, wearing a bright yellow Rocawear t-shirt, white and red Nike sneakers, tight, dark jeans with red and gold rhinestones and yellow embroidery, a thick gold bracelet that matched his mouthful of gold teeth, and a lot of perfume, gestured to me and asked Polo, "Is this your new girlfriend?" as Polo's wife exited the room. Shaking his head, Polo said, "No, an anthropologist interviewing me." Pleased, Rocawear asks, "Do you want a Cuban boyfriend?" I make a mental note to not return for another interview. Rocawear continues, "I'll be your boyfriend." Irritated, Polo disciplines his drummer: "What? You want a passport? Are you a pato?" Then, as if to reiterate the homophobic insinuation and scold those who desire to leave he tells him, "Only birds fly." They both laughed at the commonly told joke.

For Polo, only "birds" left the island. Historical narratives depict the first two "waves" of Cuban émigrés to the United States after the 1959 Revolution as a different *breed* of Cuban. Those who flew the nationalist "coop," were elite, perceived mostly as whites. The Santería that was practiced in the States was, quiet, mostly hidden. It was not until the mass exodus from Mariel in 1980 that a "third wave" of over 120,000 Cubans was allowed to leave the island.[25] Picked up by yachts of Cuban Americans expecting to receive friends and family members, a darker and poorer population of a "different" persuasion entered the U.S. mainstream.[26] Cuban American "exiles" felt duped by Fidel Castro at the Mariel Boatlift. Castro notoriously opened prisons and infirmaries allowing those seen as rejecting Cuban socialist ethics and morals, perceived "social deviants," to leave the island.[27] Incidentally, many

had been jailed for being outspoken against the Cuban state, for being criminals, mentally ill, or for homosexuality.

Many Marielitos openly and visibly practiced Santería in the United States. As a result, during the 1980s and 90s a lucrative religious economy of Santería emerged. Religious stores known as *botánicas*[28] catering to Santería and other New Age religions flourished.[29] The mostly secretive, American Santería was partially incorporated in "New Age" religion trends, where rituals and initiations began to be practiced across different social, economic, ethnic, racial, and gendered backgrounds, alongside other African-, Native-, and indigenous-inspired practices.[30] Santería, like other similar practices, has been hailed by Afrocentric and Latino-nationalist groups in the United States as a site of pride, an alternatively imagined spirituality that is seen to combat marginalization and poverty and critique U.S. imperialism *from within*.[31]

Until the 1990s, Cuban and U.S. Santería developed relatively isolated from each other.[32] The end of the Soviet bloc created an economic crisis that forced the Cuban state to rely, albeit reluctantly, more heavily on the tourism industry.[33] For the first time in ten years, Marielitos were able to return to Cuba bringing with them newly initiated American godchildren (*ahijados*). A new transnational religious dynamic ensued that changed the face of Santería in both places. American adherents were thirsty for interaction with their religious-diasporic "homeland." On the island, the Cuban state had become more tolerant of religion in general and developed specific projects to enhance the marketing of Santería heritage and promote cultural (including religious) tourism to the island.[34] Santería priests in Cuba also began to practice more publicly.[35] An influx of American religious "children" and "grandchildren" (*nietos de santo*) aided in the formation of new transnational economies.

Growing up within Cuban Santería in the United States made my encounter with Santería in Cuba in the 1990s and 2000s a complicated experience. While in both countries Marielitos are infamously depicted as social deviants, criminals and homosexuals,[36] in my field research in Cuba I found "the Marielito" to be the main protagonist in imagined versions of "American" Santería. For instance it had seemed perfectly normal to me, that my father, a heterosexual Puerto Rican-American initiated to the female deity Ochun in California in 1980, could have a White, gay, male[37] Cuban as a godfather. When I first began traveling to Cuba this fact was pointed out to me as a strange, "unfortunate" occurrence. I was told, "white," "gay," "Cubanosamericanos" had taken over and "infected" Santería in the United States, and people like us were the sad result. While this was not the assumption by all Cuban priests, official discourses tended to read the influx of "Americanos" in

Cuba as a result of "bad Santería" practiced by "antisocial," "queer," elite, *gusanos* ("worms" who had hid in Cuban soil)—"defectors" of the revolution.

Polo's homophobic assertions of birds and worms, American *santeros* "perfuming" everything, similarly invoked a discourse of effeminate pollution that penetrated the scent of American Santería. His critique encapsulates a machista Cuban reading of American capitalist materialism and excessiveness linked to a Santería diaspora in the United States. For Polo, Cuban Santería and Ifa's traditionality came in direct reference to American "modernity"—a modernity that allowed a "liberal" attitude toward homosexuality. He told me proudly, "None of my godchildren are *maricones*."

Homosexual practitioners in Cuba, particularly effeminate males, are thus in many ways situated and produced in relation to an imagined "gay" exiled defector subject, perceived as underground, homosexual "worms" hidden or in need of being taken away from the island by the "birds" that left. A 1965 quote in *El Mundo* newspaper depicts how the model revolutionary "man" lacks "feathers": "No homosexual represents the Revolution, which is a matter for men of faith and not feathers, or courage and not trembling, of certainty and not intrigue, of creative valor and not sweet surprises."[38]

Constant threats from CIA subversion (including the internal recruitment of homosexuals and other Cubans on the island), along with systematic covert attacks from the United States, increased Cuban state militarization, surveillance, and national paranoia toward anyone perceived of as socially deviant during the 1960s and 1970s. Ironically, this also included racialized practitioners of Santería and other Afro-Cuban religions.[39] As noted by Tanya Saunders: "Between 1965 and 1968 those deemed homosexual, Afro-Cuban religious practitioners, Jehovah's Witnesses, hippies, rockers, and other groups characterized as "antisocial," bourgeois, and possibly counterrevolutionary, were sent to forced labor camps called Military Units for the Aid of Production (UMAP)."[40] The postrevolutionary reeducation of social deviants thus tightly bound Santería practitioners and homosexuals as disparate subjects of Cuban state social control. However, while racialized and sexualized undesirables were produced in the policing of "private" social spaces),[41] it was also within this paradox that the epitome of Cuban machismo emerged linked to a defiant nationalist spirit celebrated in a history of imagined Black rebelliousness.

Until the 1950s in Cuba, Santería was underground, considered a "black" problem of criminal witchcraft recuperated in a postcolonial anxiety.[42] The stigma and repression of Santería continued in the

Cuban state's transition to socialist atheism.[43] During the 1970s and 1980s with the Cuban state's role in African wars for independence, secularized manifestations of Santería came to the forefront of national identity projects aimed at underscoring African heritage in Cuba's revolutionary history.[44] Santería music and iconography became prolific in popular culture; however, religious aspects remained clandestine.[45] Black Cuban sexual prowess emerged as an idealized nationalist sexuality contrasted explicitly with imperialist effeminate masculinities.[46] Fidel Castro described Cuba as inhabited by an inherently "Afro-Latin" people.[47] The virile, macho, (black) Cuban subject, the exslave who never succumbed to colonial and then imperial penetration, was positioned as the antecedent of the ideal Revolutionary man.[48]

Internationally, the mass exodus of homosexual Cubans to the U.S. after the 1959 Revolution also produced a specifically anticommunist rhetoric positing the United States as a "gay" liberatory space vis-à-vis Cuba as a sexually oppressive "traditional" patriarchy.[49] The contrariness between Afro-Cuban heritage, Santería, and masculine nationalisms became especially poignant during the late 1990s and early 2000s when a resurgence of sex tourism, religious tourism and "gay travel" emerged simultaneously.[50] This produced particularly visible shades of sexual-religious national difference.[51] Jafari Sinclaire Allen's important ethnography on gay sex tourism in Havana discusses how same-sex male sex labor markets were driven by strongly held popular notions of, "hyperactive Cuban masculinity (machismo), romance, and sexual organs of legendary proportions" intermixed with "Cuban achievements in music and art."[52] He describes, "dancing, singing and hospitable 'natives' " as a national product, and I would add to that Cuban machismo, which, like the sensual and welcoming mulata,[53] is also a cultural and social export and desired commodity.

Although male-homosexual priests have historically been part of the formation of Cuban Santería,[54] since the 1990s, special period of economic hardship, both gay visibility, representation, and organization alongside an explosion of Santería has participated in what many homosexual Cubans have referred to as a social *modernización*.[55] While some scholars have seen Cuban Santería as a "liberatory" religious space,[56] one that "welcomes" homosexual practitioners,[57] I follow those who nuance the sinews of power that stretch along lines of religion, race, sexuality, and nation.[58] It is important to keep in mind the historical precedence of masculine rhetorics that complicate this imagined site of transcendental solidarity. Indeed many Cuban Santería practitioners like Polo, who align themselves with Cuban revolutionary politics, actively construct a traditional patriarchal hailing of Afro-Cuban religious discourses that fortify rather than disrupt hypermasculine heteronormative

nationalisms. This not only means actively distancing themselves from "feathered" social deviants, but also drawing upon Santería religious truths that conspicuously support these machista assertions. I suggest that Santería religious and spiritual prowess forms part in an informal market for Cuban patriarchal masculinity transnationally. Religiously, this dynamic situates strings of masculine association within and across different nationalized structures of knowledge, feeling, and power.

Religious Masculinities and Dialogic Vacillations

> It is also said that as trusted confidante and companion to Yemayá, the duck would tell her private matters: "He would gossip to Obatala, and he spoke so much about her hidden treasures, gave so many details that robbers overheard the tales and were plotting to steal from her." Elegua told Olofi [the Creator], who sent the warriors, Elegua, Oggun and Ochosi to find Yemayá. Olofi also demanded the duck, who was all white, be summoned. Olofi told Yemayá: "They have betrayed you and they plan on robbing the treasure that you have hidden in a cave in the reefs." Yemayá responded, "Who could have betrayed me if only the duck knew?" Elegua brought the duck out. He had a look of shock and innocence. Olofi, told the traitor: "For punishment, you will never again be able to speak." From that day forward, the duck lost its right to speak. It can now only make unpleasant noises.
>
> —Adapted from Lydia Cabrera's *Yemayá y Ochun*.[59]

How are we to analyze the vacillation and proliferation of religious sexualities, even in the brief examples deployed? What does Yemayá's role as patron saint of "the queer," "the inverted," or "backwards" and her possessive need and hatred of the duck tell us about religious nationalisms and sexuality? I address these questions by tracing short vignettes of Santería masculinities: discourses of sex and religion that are supposed to construct guiding principles of nature and affirm unifying principles of belief, where "tolerance" is a marker of modernist "advancement" (*desarollo*), and, in certain cases, intolerance a marker of traditionality.

"El babalao" and "el santero": Divining "Real Men"

Most introductions to Afro-Cuban Santería (ethnographic, touristic, even journalistic) describe the traditional diviner-priests, "*babalaos*" (or *babalawos*) who have maintained "African-inspired" Ifá practices in Cuba

and provide coveted ritual services such as consultation with Orula and speedy resolutions to life's problems. Cuban *babalaos* are often confused, but in many cases synonymous, with the "*santero*." The *santero* is envisioned as more hybrid (syncretic or mestizo), a "lesser" priest on a hierarchy of status and access.[60] Indeed, the Santero officiator known as "*oriaté*," the owner of the head, also "*obá*" (King of the crown), is oftentimes presumed homosexual.[61] The idea is that any "worthy" (i.e., heterosexual) man would pass to Ifá and join the brotherhood of "real men." Thus the relationship between "*babalao*" and "*santero*" discursively becomes one of masculinity. However, the religious identity categories of "*babalao*" and "*santero*" are blurred upon closer examination. For instance, most Cuban *babalaos* are first initiated as *santeros* and, therefore, hold both titles. These two subjects function in a binary, often competing with each other and also within their respective groups, for legitimacy, hierarchy, and religious power and authenticity.

"*Santero*," like other terms used to racialize and demonize particular marginalized practices, comes heavily loaded with a racist colonial history. Originally coined by overseers who made fun of African slaves as not understanding true (read: Catholic) saint worship, the term "Santería" was pejorative, described a false idolatry, and carried a loaded double entendre as "witchcraft." Only until very recently (since the mid-1990s) was the *santero* subject in Cuba decriminalized.[62] Still the "*santero/a*" is a home-grown Cuban product that exists through and within Cuban nationalisms; it refers to those priests who have undergone the pantheon-style initiation to *oricha*, consolidated at the turn of the nineteenth century in Havana and Matanzas, Cuba, and now practiced across the globe.[63]

"*Santera*" in the feminine addresses women: priestesses who are hierarchically ranked by age of initiation.[64] Whereas in Cuban Ifá the initiation of women is not allowed,[65] the fact that women in Santería hold the same rank further diminishes the male *santero* subject. Even the coveted predominantly male role of *oriaté* who officiates Santería initiation ceremonies has recently been challenged by a small number of priestesses.[66] Yet not all "*santeros*" identify by this term. Many feel it is patronizing or too Christian, preferring to call themselves in Lukumi (Afro-Cuban creole), *iyalocha* (female), *babalocha* (male), or *iworo* (non-gendered specific).[67] The terms are often interchangeable. To add to the ambiguity, affiliations, networks, geography, and even the conversation partner can influence the claiming of terms used.

Babalaos (also *awo*—keeper of secrets) are often described as the epitome of masculinity, as "real men."[68] They are seen as studious and scholarly, as embracing superior moral habits, and as not engaging in

"sexual deviancies" such as sex with men or oral sex with women.[69] As with most imagined subjectivities, the actions and behaviors of many *babalaos* often contradict these highly held standards. For instance, some *babalaos* confidentially admitted to me ways they might "get around" the "oral sex taboo." I was told that cunnilingus could occur in times of religious abstinence (not close to ritual preparations) and could be reserved for only stable wives, or *"la mujer de la casa."* One *babalao* I spoke with told me that many Cuban Ifá priests feared their woman might cheat or leave them if they never performed oral sex. In anonymity, another good friend told me, "If it's done, we have to clean our mouths with palm oil and guinea pepper. It really shouldn't be done, but there are ways. We especially cannot do it if it's before a *plante* [initiation ritual]." Indeed several women I spoke with confirmed having received cunnilingus from *babalaos*, and a few were not the official "women of the house."

While the transgression of male-to-female oral sex is considered deviant, it is still passably acceptable, even if most priests do not publicly acknowledge it. However, unlike cunnilingus, homosexuality is absolutely taboo in Cuban Ifá, and those engaging in it face tragic repercussions.[70] There is a well-known story that circulated in Cuba of a *babalao* who ignored certain "signs" his son was *débil* (weak) because of the *babalao's* desire to have his son follow in his path. He had his son initiated to Ifá when he was only a child, hoping that becoming a *babalao* would help "straighten him up." However, during adolescence, the son was caught having sex with a man, and the *babalao* community the young man had been raised in, including his father, "mourned him in life": a term indicating that he was now considered religiously "dead," exiled from the community.

The Cuban *babalao* operates as a cache subject of nationalistic masculinity, a divine acknowledgment or "proof" of Cuban *hombrilla* or, heteronormative maleness. This religious status is especially attractive to up-and-coming young men, who wish to bypass the religious "age" hierarchy in Santería. By becoming a *babalao*, a priest with only a few days, months, or years initiated can hail access to a higher position in relation to *santeros* with many more years of priesthood.[71] The hostility of this "bypass" was reflected in an interview in November 2007 with Beto, a "straight," Puerto Rican santero-*oriaté* in Miami with over twenty-six years initiated to Chango.

Beto criticized the lack of respect for age, knowledge, and hierarchy that was occurring in what he called the "*babalao* fad" of people going to Cuba for Ifá initiations: "Everyone wants to go to Ifá now and with a couple hundred dollars in Cuba, they make santo and then

pass without even doing their *iyaworage* [year in white]. They think they know, but they're a dime a dozen. These little kids, don't respect their elders. They have to sell coke because no one is making real money off of *mano de Orula* [Ifá "hand" ritual]. They marry a santera [female priestess] and are still making their money off of Santería." As Beto pointed out, Cuban *babalaos*' practices are intimately tied to Santería initiations. Most practice a hybrid in which Ifá and Santería are practiced simultaneously and interconnectedly.[72]

Beto's reference to selling drugs or "marrying a Santería" to supplement income from Ifá rituals references a complicated dynamic in these personalistic economies. Referring to the economic capacities of religious initiation rituals, the "real cash" earned (approximately USD$12,000–$21,000) for Santería priesthoods in the United States compares significantly with the potential earnings from Ifá initiations, which are limited given the restrictions of who can become a *babalao*. Since essentially almost anyone can be initiated to Santería, and these ceremonies can only be done by a Santería priest, many *babalaos* marry *santeras* who function as the "Madrinas" (godmothers) initiating the majority of the godchildren and clients, or those worthy and unworthy to pass to Ifá. This makes female *santeras*, as Beto indicated, significant income producers in a religious matrimonial "house" of Ifá.[73] Beto's reference to women being the primary breadwinners of Ifá houses was a quip undermining the masculinity of *babalao*, whom he described as "arrogant for no reason."

A primary distinction between *babalao* and *santero* is that many men who engage in homoerotic relationships become *oriaté*, the officiators of Santería priesthood initiations; it must be noted that not all *oriaté* are homosexual. Still, the *obá oriaté* is the highest role that a homosexual man can openly occupy in Afro-Cuban religious subjecthood. For several heterosexual *oriaté* I spoke with in Matanzas, Cuba, the idea that all *oriaté* are homosexual is a huge problem. Raudel, a black Cuban drummer, priest of Oggun, member of an Abakua society, and a practitioner of Palo Mayombe (both Abakua and Palo are known for strictly adhering to heterosexual regulations for initiation), is also a spiritual "horse" who is "mounted" by his Palo-Congo spirit and the Oricha Oggun. He was studying to be an *oriaté* when I interviewed him in 2006. Raudel explained the difference of Havana and Matanzas in terms of Havana's misunderstanding of homosexuality and spiritual possessions:

> I'm an omo aña [drummer] and my Oggun comes. He's a brute, and likes rum and women. He can stay for a long

time when he comes. In Havana, they think that when the santo comes you are weak. That you cannot be a man and be mounted. This is not true. Look at all of the men, real men, who when their Congo comes they eat glass and play with fire without a scratch. No one argues they are men . . . We are the same. We don't need Ifá to talk to our santos.

Raudel had explained that on one trip to Havana he had gotten into an altercation because, after drumming, the Babalaos criticized him because he was later possessed by the Oricha Oggun. Throughout our conversation, Raudel never mentioned the word "gay" or "homosexual," but the term "real men" and "weakness" insinuated this presumption. He told me that they "had made accusations."

In certain strict sects of the heterosexual male Abakua society, such as the one of which Raudel is a member, an outright accusation of homosexuality is call for a retribution that, in the past, could carry with it a fight to the death. Only wafts or hints of sexual deviancy contain enough discursive power to disturb the heteronormative sedimentation of "real men." Still, the relationship between the *babalao* and *santero* is a complicated tug-of-war over the ownership of legitimate Cuban masculinity. These religious masculinities reinforce divination as the "all-knowing eye" that can see into a practitioner's "true nature," a hidden or occult weakness or penetration that allows "real men" to pass to Ifá and those men who are less secure to stay a *santero*. Together these positionalities create a mutual codependency around nationalized religious masculinities and the inherent positionalities occupied in relation.

While it would seem that these discourses are split neatly along religious lines with the polarization of homophobia as Cuban-communist and homosexuality as liberal-American, it is my goal in the remaining sections to complicate this binary construction. Field research with Santería practitioners in Havana, Matanzas, New York City, Miami, Los Angeles, and the San Francisco Bay Area showed me that notions of masculinity and religion existed differently with often contradictory positionalities based on self-definition, local family history, language, class, ethnicity, and the like. Indeed, religious consciousness was often uncertainly defined, vacillating between multiple, concurrent understandings of human nature. Like Yemayá's duck, both cursed and desired, I suggest that Santería understandings are situated on "grids of intelligibility"[74] that create ambiguous spaces of sexual religiosities. I interrogate how discursive battles for Cuban autonomy and U.S. imperialisms emerge transfigured through religious sexualities that produce new Santería subjects. Indeed, these narratives, where Cuban Santería practitioners

secure hypermasculine nationalisms in relation to the effeminization of American Santería, are in many ways disrupted by the performance of "queering" Santería bodies.[75] To explore this contrariness, I examine these subjects of religious power and identity relationally.[76]

Los hijos de Yemayá

Voodoo Woman, a controversial 2008 documentary, depicts a Columbian film director's consultation with a Santería priest in Cuba that leads him to "come out" as a gay man and then undergo a sex change. The film's director, "Carlos," transforms on-screen to Carolina. In the film, Carlos is first given a Santería consultation and told that he is a child of Yemayá, that he must stop hiding, and that he must learn to be himself.[77] Carlos interprets the Cuban Santería priest's words as a sign to not only admit that he is homosexual but also to admit that he is really a woman and should undergo a sex change.[78]

Voodoo Woman is about Carolina's transition as well as her newfound commitment and initiation in Afro-Cuban religions. The use of the term "voodoo" highlights the often problematic, uncontextualized associations depicting African diaspora practices within Euro-American cultural fears of mystical slave uprisings, magic, witchcraft, and racial exoticism popularized in early American horror films. Coupled with tropes of a "real" or *natural* woman, the title *Voodoo Woman* plays with the mystical queering of bodies and religion. For Santería practitioners that I spoke with in Cuba who had viewed the documentary, it touched many points of contention and issues of Carolina's misappropriation of Santería.

I originally found out about and watched this documentary in Havana in 2008 with a group of *babalaos* and *santeras* who were all strictly heterosexual and self-proclaimed traditionalists. They were appalled and disgusted by what they saw to be Carolina's pretransformation "misinterpretation" of the reading given by the *babalao* and accused the director of using Santería for "his" own "gay imperialist agenda." Besides being disturbed by the term "voodoo" used in the title to describe Santería, Onasi, a priest of *ochun*, suggested that the director had coopted "the religion" for personal gain and politics (*la política*). He excitedly argued that Carolina (pretransformation) had not truly listened to the consultation: "The *santos* would never tell anyone to change how Olofi [the Creator] had brought them to this earth." Tlakechi, a priest of Chango and *babalao*, attributed this "error" to the commercialism that had taken over the island where, he claimed, "Anyone would do

and say anything for a dollar." He blamed the Cuban priest in the film for allowing the confusion to take place. Marlenis, a priestess of *Obatala*, and *Apetebi Ayafá* (the wife of one of the *babalawos*) stated simply: "*Así son los hijos de Yemayá, invertidos y confundidos*" (That's how Yemayá's male children are, inverted and confused).

In everyday religious interactions, practitioners situate their identities in relation to generalized characteristics of the deities, discernable in the way one acts, thinks, feels, and expresses him- or herself as children of a specific deity: "*Los hijos de Chango son fuertes*," literally, "children of Chango are strong," and, by extension, stubborn and masculine. Whereas sons of Yemayá are described as needy, weak, or bad lovers, "daughters of Yemayá" are known for being dominant, gossipy, controlling, and mothering. What often goes without saying is that there are specific presumptions of sexual, gendered, and even racial differences between different types of "*hijos de santo*," children of the saints. For instance, I was once told that children of Oricha Aganyu were *indios* or *colorados*, literally "red-skinned" people, while children of Obatala are white (or with white hair) and children of Oggun, Chango, and Yemayá are normally imagined as black. Ochun, of course, is the mother of the mulato. The deity that owns an individual's head is also used to express one's personality, desires, or characteristics.

Like the duck, male children of Yemayá are often criticized as being twisted, cursed, or unnaturally marked by displays of femininity.[79] Some even argue that no male child of Yemayá should be allowed to become a *babalao* because of an *odu* (divination sign) where Yemayá learned too many of Orula's secrets and became too powerful. Nelson "Poppy" Rodriguez, a Puerto Rican *oriaté* and priest of Yemayá in New York City, told me proudly of how in the sign Eyila Chebora, Yemayá Achabá, Orula's first wife, began consulting behind his back. As Poppy put it, "Orula was abusive, and Yemayá needed to support herself."[80] Poppy mentioned how Orula had been notorious for only giving partial information to keep his clients dependent and that Yemayá, a skilled diviner, resolved the client's needs through her *ebbos* (offerings).

One day, Orula caught Yemayá divining, walking in the room when there were "twelve mouths" on the mat. Orula told Yemayá, "*hasta ahí*," she could go no further. According to Poppy, that is why *santeros* can only read signs from one (*okana*) through twelve (*eyila*), even though Ifá *odu* goes up to sixteen.[81] Through Yemayá's treachery and rebellion, some (but not all) of Orula's secrets were "stolen," and knowledge was scattered throughout the world (see also the sign, Ogbedi).

Thus, it is through Yemayá's transgression of Ifá knowledge that her children in *oricha* diasporas have access to cowry shell divination

and *odu*. The divination system of Cuban Santería is therefore directly connected to the transgression of Ifá *odu* by Yemayá's *atrevimiento*, brazenness. As we can see from Marlenis' comment about male children of Yemayá being "confused" and "inverted," one can pay for this divinized brazenness. "*Hijos de Yemayá*," similar to other male practitioners of female *oricha*, occupy tenuous sites of masculinity enabled through naturalized characteristics of intra-religious sexuality that massage spiritual nuances of difference.

"El descarado" and "el invertido"

> Yemayá sent the duck to ask Olofi for an object to make a protection charm. The duck placed the object in his bill and returned to Yemayá, swimming calmly. Something frightened him—a fish suddenly jumped or maybe it was the shadow of a bird. The duck swallowed the object. When he met Yemayá, the object was stuck at the bottom of his esophagus in his crop. Iya Omi, Yemayá grabbed him by the neck and tried to squeeze the precious amulet from the base of his neck, but it was useless. Despite even the duck's efforts, they could not expel the object. Yemayá—known for being violent—assaulted and insulted him. The duck was left ashamed and bruised. His vocal chords became weak from being jerked around by the neck, and they stopped working. He never spoke again. They say that you might find a small stone in the bag of the duck's crop. It is said to be "one of Yemayá's best" protection charms, and, before plucking him, the Iyalochas (priestesses) look for a stone in the duck's crop.
>
> —Adapted from Lydia Cabrera's, *Yemayá y Ochun*.[82]

The story of the battered and abused duck, weak and voiceless but still one of Yemayá's prized possessions—provides an insightful entry into the politics of the effeminate homosexual male subject in Santería. For those men who occupy or lay claim to a homoerotic subjectivity, the performance of the parody of homosexuality is often a double-edged sword.[83] Neraldo, a tall, handsome, dark-skinned, black Cuban man with long braids and beautiful almond eyes initiated to the Oricha Elegua, was dressed in his finest white linen suit with gleaming gold rings on every one of his fingers the day I arrived to interview him. He lived in the United States but traveled every other month to Cuba to initiate priests. He talked with me about living as a "respectful gay" *santero* and how he had managed to have a good relationship with many people

because of his *comportamiento* (demeanor or behavior): "When I do Santería, I'm a professional. I've earned my reputation and have friends and godchildren who are men—I mean *Ecovios* [Abakua] of the most seriousness, and they know who I am. People don't judge me or care about my private life. It's private."

During our conversation, the phone rang, and Neraldo took the call. He became very angry and loudly yelled at the person on the other end, "He said what? How dare he! If anyone has a broken asshole, it's him. That bitch should shut his mouth!" When he hung up, he was obviously flustered, and he wiped his face. He must have felt compelled to provide me an explanation; he told me: "No matter how hard you try to stay out of the gossip and not get into drama with people, the envy and jealously is just too much." Frustrated, he muttered how people loved to "drag him through the mud."

Like Neraldo, there are many homosexual priests who live a religious life of "gay respectability," which means not flaunting their same-sex practice and not being "too flamboyant." In many cases this means invoking a sanctimonious life and portraying an outward modesty. At times, effeminate male *santeros* in Cuba occupy feminine positionalities. For instance, they perform "women's work" such as plucking chickens, cooking, or cleaning (see also Landes 1940, for a similar case in Brazilian Candomblé). While this is not always the case, gay males who operate as "men" in the role of *oriaté*, for instance, are preferred only when they are "respectful gays," which, like Neraldo described to me is a learned not-to-effeminate performance, which also means being very careful to not show public displays of same-sex affection. If one cannot necessarily "pass" as "men," at the very least, to be a "respectful gay" is to come as close to that representation as possible.

Yiya, a priestess of Yemayá, described sexuality in terms of choices. She told me, "There are those that because of their *naturaleza* are born that way and cannot help it; those people are understandably the way they are and not to blame." This differed dramatically from what she called the "*descaro*," or insolent gay who is "normal" but then "turns" *invertido*, or inverted. She further clarified, "Someone who is *morboso* [sick] or weak and allows themselves to be corrupted by a flamboyant."

The "flamboyant gay," an unfortunate "duck" born into its disrepute, is, like the tales of the duck itself, a pitied creature, one who cannot help its character. However, still suspect, he is a traitor by nature. The gay subject is a perpetrator, tricking the unsuspecting "potentially weak" into changing their disposition. Divination signs speak directly of the danger of the "queer." In the divination sign Ordi Melli (represented numerically as 7–7), Yemayá and Olokun talk of the individual being

"corrupted" from one's true path. The sign warns of trouble with family, adultery, addictions, corruption, avariciousness, and, finally, the hole or grave. It speaks of an individual who is a natural spiritualist, who can "read" or consult without the need of the oracle.

However, Ordi is also, as I have been told, a "person who does not do things correctly." Advice given in this sign is to "not change your customs or habits" and to be "respectful" of the saints and one's elders. In certain combinations, I have witnessed *oriaté* telling new initiates (iyawos) to "be careful of half-breeds, albinos, or red-skinned peoples," as well as to "be careful of sexual perversions" and of "being freaky." They are warned of being accused of child abuse or sexual assault and to be careful with "homosexuals," "being accused of being gay," or of being "turned out." In one instance that I witnessed in the United States, the *iyawo* was a gay male, and the *oriaté* told him to be careful of being accused of "trying to seduce" a straight person.

In the negative of the sign, Osogbo Ano or Ikú, (tragedy by sickness or death), this sign is said to speak of venereal diseases and AIDS as well as nervous disorders, mental derangement, psychosis, and death by drowning or suffocation.[84] It warns the client to be careful of the ocean. Ocha Ni Lele, in his book *The Secrets of Afro-Cuban Divination: How to Cast the Dillogun, the Oracle of the Orishas*, states of Ordi: "Venereal disease runs rampant in the orientation of ano or ikú: Gonorrhea, syphilis, human papillomavirus, and AIDS are not unusual, and if the client lives frequently among the gay community, many of his friends could die within the next seven years."[85] In September 2011, in a communication with my father, Piri De Jesus, an *oriaté* and *olubata* (owner of *fundamento aña* drums), he related a story told to him by our elder, Alfredo Calvo Cano, Oba Tola (*ibae*) of the sign Ordi Irosun (7–4). He told me: "Even the duck who is close to Yemayá needs to come up for air. Don't overdo anything; don't go too deep. Swim and catch your breath. In Ordi Irosun it means to take time out of life and breathe. The song begins for Yemayá, 'Bolo bolo sún oñi Yemayá. Bolo Bolo sún oñi kuekuellé': If you hold your head underwater too long, you will drown. Learn from the duck."

Are homosexual priests simply "*atrevidos*"—brazen and audacious, challenging Santería heteronormativities? Does homophobia (an intense hatred or fear of "homosexuals") explain the divination consultations, ritual protocols, religious nationalisms that function on a globalized platform of *oricha* diaspora religions? I would argue no. Instead, my challenge is to try to understand the complex practices of self-making whereby Santería priests are formed and in conversation with lines of association—that is, how divine sexualities frame consciousness and

meanings in expressions of everyday life. Like the signs themselves that balance ambiguously between life's positive and negative happenings, discourses of sex, nature, and religion, these sites are productive aspects of self in the politics of the poetic.

"No pasa nada": Kill Two Birds with One Stone

I met Junco, a thirty-two-year-old (self-proclaimed) gay priest of Chango (whose mother was Yemayá, *"oñi oñi"* he made sure to let me know),[86] in Havana in 2005 while I was interviewing a friend of his, Amaury, another homosexual priest. Junco walked in the room wearing a tight, red spandex tank top that hugged his caramel-colored skin. His sleek, acid-washed jeans were cuffed up at the ankles, revealing a metal chain around his left ankle that hung loosely across the top of his Converse sneakers as he smoked a cigarette. He had dyed his normally dark, short cut, kinky hair a golden blond, framing his head like a halo. Around his wrist, he wore a red-and-white-beaded *ilde*, marking him as a priest of Chango, along with a thin gold chain, normally worn around the neck but instead wrapped in the Havana-*vieja* fashion as a bracelet so it could not be as easily stolen. Junco seemed to have taken an immediate liking to me and wanted to take me out that night to show me "his Havana." When he left, the "respectable gay" that I was interviewing warned me, "You don't want to go out with him. He's too gay. People will talk about you." This cautioning, coming from my interlocutor—a homosexual priest and friend of Junco's—intrigued and disheartened me.

I was not able to go out with Junco. The people I was staying with made sure of that; however, I did get to talk to him on several more occasions. During our conversations, he told me about the *chupapingas* (dick suckers) of Havana Santería. A common phrase "*no pasa nada*" kept recurring at the end of a statement or story. Literally translated, it means "nothing happened," but, in the streets of Havana, it was more akin to "that meant nothing to me" or "there's nothing to worry about."

Referring to Amaury, Junco said, "This *puta* [bitch/slut] says I don't know how to act." "No pasa nada," Junco finished, slapping his hands together to emphasize the finality of the statement. "One day they want me to fuck them in the ass, and the next day they don't know my name," he said, referring to the Babalaos who sought him out for illicit same-sex affairs, "no pasa nada." Junco's "no pasa nada" was a brushing-off tactic to deal with his own ambivalence toward life in machista Cuba as a homosexual *santero*, an outwardly effeminate man.

It succinctly described his outlook towards people's judgment of him. Yet, while he outwardly claimed an "it doesn't bother me" approach, these experiences did affect him. They made him cautious and wary. The assertion that they did not matter or did not happen revealed how aware he was of their impact and the pain involved in what were deemed masculine transgressions.

Junco is what Yiya had called homosexual from *naturaleza*: born that way. He told me that since he was young, people could spot his homosexuality. His dad was a roughneck (*guapo*) in central Havana, had been in jail many times, and was also a Palero. His mother was a priestess of Obatala. "[My father] tried his best to change me, and when they made me to Chango, my dad thought maybe it had worked. Then púm, *el signo*, and they found out I was gay—no pasa nada."

Junco's father was angry when he found out. His father went back to jail, and they spoke only a few more times before he died. "No pasa nada" Junco told me. Junco's mother took care of his *santos*, and he lived *putiando* (slutting) around Havana looking for *yumas* (foreigners), as he told me, just having a good time. "The hardest part is that I do love the *santos*, and I'm a *subidor* [a horse]." Then Amaury jumped in: "When his Chango comes, watch out, he rubs all over women and is more manly than the *omo aña* [drummers]." Junco rolled his eyes, "No pasa nada."

The *descarado* (shameless, literally "with no face"),[87] the "natural" homosexual, and the "respectful gay" are subjects of ambivalence and performativity in Santería. Like Yemayá's duck, they are both detested and necessary elements of social-spiritual difference. Strategically, Junco laid claim to the othered positionality, constructed as a sick and twisted masculinity—the flamboyant, the *pajaro*, was for him a recuperated relationality that he hailed, rejected, and transgressed simultaneously. Similar to Jose Muñoz's (1999, 4) *disidentifications* or survival strategies that "the minority subject practices" to negotiate a "phobic majoritarian" that continuously "elides or punishes the existence of subjects who do not conform to the phantasm of normative citizenship," Junco embraced and performed the parody of effeminate masculinity, even as he critiqued and rejected the impact of this very same discourse in his everyday life. In these instances, Muñoz points out how comedy is not independent from rage.

When I asked my father about the song that is sung during the feeding of Yemayá's duck, "Kuekuellé adofa golo golo abeya mi," he told me that it refers to how fishermen who were out at sea and needed water would cut out the duck's esophagus because there was fresh water inside. He told me that besides "removing curses," *santeros* cut out and

breathe on the esophagus during the feeding of the duck to Yemayá so that, "even in the hardest times you can find sweetness. The sweetness is in the duck's neck." The sweetness in the duck's neck and the positioning of homosexual men in Santería form a dual function of abjection and attraction. The effeminate homosexual *santero* subject disciplines Santería masculinity, creating a context for Otherness that is a necessary element of pragmatic neocolonial rituality. These subjectivities are not simply neoliberal or American impositions in Afro-Cuban religions but rather, formative aspects that draw upon and inform religious divinatory, subjective, and phenomenological praxis *within* the formation of sexual-national imperialisms.

"No pasa nada," is a satiric rhetorical, an ambivalent mechanism and dialogic queer interlocutor in the negotiations of sexuality and nation in everyday Santería religious practice. The unfortunate battered duck, constitutive of Santería religious consciousness, constructs Yemayá as an abusive (and battered) feminine, one who covets and lays claim to her possession, the insolent duck, but in the end cannot fully control his nature. The effeminate homosexual *santero*, much like Yemayá's duck, is both victim and traitor to his own discursive "bad luck," managing through circumstance and habilitation to exist in the violent imperialisms of tumultuous waters as a complicated, ambiguous conundrum. Indeed, these fluidities are contingent and contextual, operating diagonally, as they create sites of spiritual prowess and religious masculinities occupied by effeminate bodies who, whether male or female, are embodied sites of Yemayá. "No pasa nada."

Conclusion

> Despite everything that occurred between Kuekuellé and the owner of the sea, he continued to accompany her. He is her faithful servant. Many times, Yemayá demands that her children have ducks in their homes. And, if the goddess forbids, they are not allowed to be sacrificed. The ducks are pampered and forgiven for any nonsense and discretion because they are Yemayá's property. Even they [ducks] are conscious of the privileges they receive as a result of Yemayá's favor.
>
> —Adapted from Lydia Cabrera's *Yemayá y Ochun*.[88]

Lydia Cabrera's first story introduced us to how the plucking of the ducks feathers must be done in earnest. Yemayá counts each one, and, if a single feather is missing from her precious bird, she will release

her wrath on the unsuspecting devotee. Her prized possession happens to be a creature whose nature she can never fully possess and whose will she can never truly conquer, even as he is her faithful companion. While I have made the argument that the metaphors of Yemayá's duck are useful entries into understanding the positioning of nationalized heteronormative religious masculinities, I also wish to pause momentarily on a diagonal gaze of these stories, to read them not only through the cajoled sensibilities of Yemayá, but rather instead through the epistemology of her faithful servant: the hotheaded and unwieldy plumed undesirable. In the context of imperialist masculinities, where he occupies the despised, the duck has managed to continuously undermine reigning exploits of power, to find disdain in normalcy, and to balk at the all-powerful divinities time and time again. He is a rogue figure, contorting masculinities, allowing for (even if only a glimpse) the performance of alternative positionalities, disrupting (and reifying) naturalized truths. This subject in many ways owns various different ambivalent epistemologies of sex, nation, and religion.

The competing articulations in *oricha* diasporas are to a greater extent couched in nationalist terms, where practitioners pit Cuban Santería and Ifá, Brazilian Candomblé, and Nigerian Ifá and their United States diasporas against each other in complex nodes of ritualistic associations, disagreements, and connectivities.[89] Even as these broader scopes of African diaspora religious contexts are brought into zones of interaction, it is within specific religious networks and affiliations, such as the discussions over Cuban and American Santería where everyday ethos and consciousness and the phenomenology of rituality construct religious subjectivities of idealized subjecthood.

As Salvador Vidal-Ortiz points out, many Santería practitioners openly discuss sexuality as part of their religious praxis and ethos. Rather than "gay" versus "straight," Santería sexualities are often contextualized within naturalized religious associations with the different *oricha* also described in sexual terms.[90] Still, we cannot overlook the importance of historical Cuba-U.S. conflict and the nationalized masculinities out of which Santería sexualities emerge and engage. And yet the modus operandi of being a "gay" Santería practitioner is problematic and contingent where homosexual priests are expected to perform "respectability." However, the masculine effeminate, "flamboyant queen" *el pato,* does have a role religiously, albeit problematically within Santería narratives. The "gay *santero*" forms a countermasculine religious subject where for instance, charges of Yemayá (Ochun and Oya's) male children (particularly those who become "mounted" by them in possession) form part in Santería spiritual performativity (the same cannot be said for instance of the butch or masculine female).[91]

Divinized sexualities construct different axes of truth and power. They are spiritually charged and meaningful subjectivities that operate in the everyday lives of Santería practitioners. Religiously, the "duck," or effeminate homosexual *santero* subject, is naturalized as an uncertainty of nature. It simultaneously produces "gay" diasporas and imperialisms, naturalizing and resituating masculine Cuban nationalisms. These religious readings scrape the sediments of the nationalist ocean floor, dredging up particles of association that occupy powerfully ambivalent heteronormativities where *oricha* are (re)constructed within social-nationalist articulations. The desired and cursed duck, servant of the violent feminine mother Yemayá, warns of the painful daily realities of her children's plight. It demonstrates the negotiations fraught with curses of gossip, violation, and rejection—and the "no pasa nada" approach that some of her children take as they encounter the brute daily realities where "only birds fly" and "real men" are ascertained by the throwing of shells. But the duck, plumed villain and hero of the sick and twisted, reigns unabashedly in the face of pain and destruction with both sweetness and sorrow in his throat.

Notes

I would like to thank first and foremost all of the generous priests—flamboyant and respectable—who lent their stories and input to this poetics: Elpidio "Oba Ofun" Alfonso (*ibae*), Cristobal "Arabi" Puertas (*ibae*), Roberto "Aña bi Osun" Clemente (*ibae*), Diane "Egbin Kolade" Mc Elhiney (*ibae*), whose presences are always decidedly disruptive and cherished in death. Thank you to Piri De Jesus, Bashezo Boyd, Nelson "Poppy" Rodriguez, El Gordo, Jay Somileke Perez, Danilo Elegua, and Obangoche for their knowledge and making this a challenging chapter to write. Thank you also to Solimar Otero for taking the escapades of *"el pato"* seriously.

1. Lydia Cabrera, *Yemayá y Ochun* (Madrid: Colección del Chicherukú en el exilio, Impreso por Forma Grafica, S.A, 1974), 278. I adapted Lydia Cabrera's stories about Yemayá's duck from Yemayá y Ochun so that they would flow cohesively in English. I tried to maintain consistency of meaning and the force that Cabrera gives, but I changed some narrative style to be more conducive given what I read to be Cabrera's often deliberately convoluted ethnographic scripts.

2. James Clifford and George Marcus, eds., *Writing Culture: The Poetics and Politics of Ethnography* (Berkeley: University of California Press, 1986). This chapter follows anthropologists who critique the imperialist tendencies of traditional ethnographies by disrupting subjects as contained "peoples" who inhabit exotic "places." See George Marcus, *Ethnography through Thick and Thin* (Princeton, NJ: Princeton University Press, 1998), 3; Kamari Maxine Clarke and Deborah A. Thomas, eds., *Globalization and Race: Transformations in the Cultural Production of Blackness* (Durham, NC: Duke University Press), 2006:

Akhil Gupta and James Ferguson, eds., *Culture, Power, Place: Explorations in Critical Anthropology* (Durham, NC: Duke University Press, 1997); Jacqueline Nassy Brown, *Dropping Anchor, Setting Sail: Geographies of Race in Black Liverpool* (Princeton: Princeton University Press, 2005).

3. See Melville Herskovits, *The Myth of the Negro Past* (Boston: Beacon, 1941); Melville Herskovits, *The New World Negro*, Frances S. Herskovits, ed. (Bloomington: Indiana University Press, 1966); William Bascom, *Sixteen Cowries: Yoruba Divination from Africa to the New World* (Bloomington: Indiana University Press), 1980; William Bascom, "The Focus of Cuban Santería," *Southwestern Journal of Anthropology* 6, no. 1 (1950): 64–68; Sidney W. Mintz and Richard Price, *An Anthropological Approach to the Afro-American Past* (Philadelphia: Institute for the Study of Human Issues, 1976); Michael Atwood-Mason, *Living Santería: Rituals and Experiences in an Afro-Cuban Religion* (Washington, DC: Smithsonian Books, 2002); Mary Ann Clark, *Where Men Are Wives and Mothers Rule: Santería Ritual Practices and Their Gender Implications* (Gainesville: University of Florida Press, 2005); and Mary Ann Clark, *Santeria: Correcting the Myths and Uncovering the Realities of a Growing Religion* (Westport, CT: Praeger, 2007).

4. Cuban anthropologist Fernando Ortiz intervenes in anthropologist Melville Herskovits' notions of acculturation and syncretism found in *The Myth of the Negro Past* (1941). Ortiz suggests acculturation is inadequate to describe "New World" cultural transfers, arguing that it relies upon a unilateral format of cultural exchange, where the "minority" group must adhere (but does not contribute) to the "dominant" culture in *Contrapunteo cubano del tabaco y el azúcar* (Madrid, España: Ediciones Cátedra, 1987), 124. In revision, Ortiz proposes "*transculturation*," or the process of giving and receiving between cultures, a process where both sides become modified by the interaction and a new reality emerges. (Ortiz, *Contrapunteo*, 125). Ortiz demonstrates transcultural relationships in what he calls the *contrapunteo cubano*, the "Cuban counterpoint," which he describes as the relationship between sexed and gendered national subjects of sugar, tobacco, and rum. For Ortiz, the black male "Don Tabaco" consorts with the white female "Doña Azucar," and together they produce the mixed-race (mulato) Cuban Rum (Ortiz, *Contrapunteo*, 137). Ortiz's dialectical protagonists are a disturbing misrepresentation of colonial miscegenation and the historical rape and concubinism that occurred between white, male masters and their black female slaves—not the utopic black Cuban phallus and its penetration of the white virginal female (i.e., cigars and processed sugar) that he would like us to imagine. Still Ortiz's powerful anecdote has been extremely successful in the reproduction of a harmonious narrative that culminates in the *ajiaco*: a "stew" or cultural "melting-pot" of Cuban identity.

5. Aisha Khan, "Isms and Schisms: Interpreting Religion in the Americas," *Anthropological Quarterly* 76, no. 4 (2003): 761–74; Gupta and Ferguson, *Culture*; Stuart Hall, *Representation: Cultural Representations and Signifying Practices* (Thousand Oaks: Sage, 1997); Marcus, *Ethnography*.

6. The use of the term "gay" (and the appropriateness of terms such as "homosexual" or "lesbian") has been critiqued by scholars who have rightly

argued against imposing North American terms and values that do not appropriately reflect the nuanced positionalities same-sex encounters occupy in different social contexts, particularly in transnational, or marginalized communities. See Lourdes Arguelles and Ruby Rich, "Homosexuality, Homophobia, and Revolution: Notes toward an Understanding of the Cuban Lesbian and Gay Male Experience, Part I," *Signs* 9, no. 4 (1984): 683–99; Randy P. Conner and David Hatfield Sparks, *Queering Creole Spiritual Traditions: Lesbian, Gay, Bisexual, and Transgender Participation in African-Inspired Traditions in the Americas* (Binghamton: Harrington Park Press, 2004); Roger Lancaster, "Comment on Arguelles and Rich's 'Homosexuality, Homophobia, and Revolution: Notes toward an Understanding of the Cuban Lesbian and Gay Male Experience, Part II," *Signs* 12, no. 1 (1986): 188–92; Ian Lumsden, ed., *Machos, Maricones and Gay: Cuba and Homosexuality* (Philadelphia: Temple University Press, 1996); Jose Estaban Muñoz, *Disidentifications: Queers of Color and the Performance of Politics* (Minneapolis: University of Minnesota Press, 1999). I will continue to use the term "gay" only when identifying either discourses of North American sexual imperialism or self-claimed alignments with particular types of "gay" unity discourses as deployed by my interlocutors.

7. See also "*pajaro*," literally "bird." Both plumed references are used interchangeably and pejoratively to reference visibly effeminate males. See Lawrence La Fountain-Stokes, "Travel Notes of a Queer Puerto Rican in Havana," *Gay Lesbian Quarterly* 8, no. 1 (2002): 20.

8. Ann L. Stoler, *Race and the Education of Desire: Foucault's History of Sexuality and the Colonial Order of Things* (Durham, NC, and London: Duke University Press, 1995).

9. Judith Butler, *Gender Trouble: Feminism and the Subversion of Identity* (New York and London: Routledge, 1990); Michelle Z. Rosaldo, "Woman, Culture and Society: A Theoretical Overview," in *Woman, Culture and Society*, ed. Michelle Z. Rosaldo and Louise Lamphere (Stanford, CA: Stanford University Press, 1974), 1–16; Gayle Rubin, "Thinking Sex: Notes for a Radical Theory of the Politics of Sexuality," in *Pleasure and Danger*, ed. Carole S. Vance, (Kitchener, Ontario: Pandora *Press*, 1984), 267–319. Sylvia Yanagisako, "Sexuality and Gender and Other Intersections," in *Das Dreifache Dilemma der Differenz*, ed. Sabine Strasser (Vienna: Wiener Frauenverlag, 1997); Sylvia Yanagisako and Carol L. Delaney, *Naturalizing Power: Essays in Feminist Cultural Analysis* (New York: Routledge, 1995).

10. This contrasts with "*pinguero*," which literally references "*pinga*" (i.e., "dick") or those men who have sex with men but are understood as sexual "tops." The idealized heteronormativities of "top" versus "bottom" has been critiqued as much more complicated. See Jafari Sinclaire Allen, "Means of Desire's Production: Male Sex Labor in Cuba 1," *Identities* 14, no. 1/2 (2007): 183–202. However, the *pinguero*, unlike the *pato/pajaro* is seen as representing the majority of male-to-male sex tourism interactions in Cuba, even if this is not necessarily the case. Indeed, the *pinguero*, like many other examples of Latin Ameircan and Latino homoerotic behavior, is not perceived of as homosexual as he is the "giver," a distinction noted in other contexts as well.

See Ruth Landes, "A Cult Matriarchate and Male Homosexuality," *A Journal of Abnormal and Social Psychology* 35, no. 3 (1940): 386–97. See also Derrick Hodge, "Colonization of the Cuban Body: The Growth of Male Sex Work in Havana," *NACLA Report on the Americas* 34, no. 5 (2001): 20–24. Hodge has argued that the *pinguero* represents a "true" form of Cuban nationalism, which imagines male same-sex intimacy as an idealized aggressive penetrating "macho," and, therefore, reinforces Cuban patriarchal masculinity. The *pato/pajaro* conspicuously disrupts this macho penetrating discourse within Cuban nationalism. For a critique of Hodge and queer sex tourism and travel in Cuba see La Fountain-Stokes, "Travel Notes," 20.

11. Kamari M. Clarke, *Mapping Yorùbá Networks: Power and Agency in the Making of Transnational Communities* (Durham, NC: Duke University Press, 2004), 262. While most roads of Yemayá are fed the duck, only Yemayá Okuti, the "warrior," a more masculine road who wields a machete (*la machetera*), does not consume the duck.

12. This chapter was part a larger research project, conducted between 2004 and 2010, that examined the transnational circulation of Santería tourism, media, and the relationships between practitioners in the United States and Cuba. I specifically chose multisited ethnography to disrupt the fixing of Santería practices with any one place and developed a method to examine the links between religious practitioners in different translocal sites. Through three lenses (religious tourism, video-travelogues, and online ethnography), I worked with Cuban and U.S. Santería practitioners, religious tourists, and Cuban and U.S. religious associations and house temples. I did so in Spanish, Lukumi (Afro-Cuban Creole), and English. I conducted in-depth and group interviews, participant observation of rituals and tourist sites, and the video recording and watching of ritual media in Havana and Matanzas, Cuba, and New York City, Miami, and the San Francisco Bay Area. I focused on transnational dynamics between practitioners and the formations of subjects and subjectivities in personalistic economies.

13. I chose subjects that crossed ethnic, national, gender, and class lines to disrupt the common association of Santería practices with only Latino or Afro-Cuban subjects including practitioners who self-identified as African American, Latino, Asian American, Afro-Cuban, Asian Cuban and white Cuban social and political backgrounds. I also conducted numerous informal interviews both on- and off-line to expand the site that constituted my "field." See Gupta and Ferguson, *Culture, Power, Place*. It was important for me to construct an ethnographic "map" that did not limit Santería subjects based on race or ethnicity, but rather to instead track how subjects form common presumptions about race, gender, sexuality, and ethnicity across these intersectionalities.

14. So as not to undermine the theoretical projects within Latino/a studies that reclaim "the Americas" as three continents rather than a single (North American) national location, it is also important to note how the term "America" functions politically as a signifier of racialized, sexed, and gendered economic power globally within specific contexts. See Edna Acosta-Belen and

Carlos Santiago, "Merging Borders: The Remapping of American," in *The Latino Studies Reader*, ed. Antonio Darder and Rudolfo Torres (Malden, MA: Blackwell, 1998), 29–42. Following the work of Inderpal Grewal, who examines the transnational connectivities that produce "America" as a coveted and despised transnational subject, I have opted to hail the term as my interlocutors used it, highlighting how it operates as a strategic locationality of power between Cuba and the United States. See Inderpal Grewal, *Transnational America: Feminisms, Diasporas, Neoliberalisms* (Durham: Duke University Press, 2005). I, therefore, refer to "American" practitioners as those who reside in the United States (even if they are not nationalized U.S. citizens) to demonstrate how they are perceived and situated within Cuba once they are identified with this nationalist affiliation, particularly poignant given the history of mistrust and hostility between the two countries.

15. Brandon, *Santeria from Africa to the New World* (Bloomington: Indiana University Press, 1997; David H. Brown, *Santería Enthroned: Art, Ritual, and Innovation in an Afro-Cuban Religion* (Chicago: University of Chicago Press, 2003); Clark, *Where Men*; Conner and Sparks, *Queering Creole*; M. A. de la Torre, *Santería: The Beliefs and Rituals of a Growing Religion in America* (Grand Rapids, MI: Eerdmans, 2004).

16. Jacob K. Olupona and Terry Rey, eds., *Òrìsà Devotion as World Religion: The Globalization of Yorùbá Religious Culture* (Madison: University of Wisconsin Press, 2008).

17. See Fernandez-Robaina, "Cuban Sexual Values and African Religious Beliefs," in *Machos, Maricones and Gays*, ed. Ian Lumsden (Philadelphia: Temple University Press, 1996), 205–08. For instance, in discussing gender, sexuality, and spiritual possession, Fernandez-Robaina, both a Cuban scholar and Santería practitioner, says that "women and homosexuals tend to be possessed by male and female *orishas*, whereas men are rarely possessed by female *orishas*" (208; emphasis in original). In this quote, Fernandez-Robaina reproduces Cuban discourses of masculinity that reserve the term "men" for only heterosexual males. By distinguishing "homosexuals" from the category of "men," he effectively excludes these males and signals its use in Cuban heteronormative patriarchy.

18. Muñoz, *Disidentifications*.

19. Victor Betancourt Omolófaoló Estrada, *La Lengua Ritual Lúkúmí* (Caracas, Venezuela: Colección Ediciones Orunmila, 2005); Kristina Wirtz, *Ritual, Discourse, and Community in Cuban Santería: Speaking a Sacred World* (Gainesville: University of Florida Press, 2007).

20. John Mason, *Olóòkun: Owner of Rivers and Seas* (Brooklyn: Yoruba Theological Archministry, 1996), 35.

21. Cabrera, *Yemayá*, 278–79.

22. In this instance, I translated "*maricón*" as "faggot" to identify the hatred and distrust that was depicted as a specific form of North American imperialist sexuality in Cuba.

23. Among the many Americanisms used in Cuban Spanish is the more recent incorporation of the African American hip-hop term "bling-bling," which

Cubans use to similarly refer to shiny, eye-catching conspicuous demonstrations of wealth through the wearing of gold (on their teeth) and other jewelry on their bodies.

24. Lydia Cabrera was an upper-class white Cuban woman. She was Fernando Ortiz's sister-in-law and a self-taught ethnographer and literature writer who published works from 1940 to 1984 on Afro-Cuban religions. She is rumored to have been in a long-term, same-sex relationship. She wrote most of her works while exiled from Miami based on memories of her discussions with priests in Cuba. Cabrera's works are controversial for what they reveal and yet are still considered "sources" of Afro-Cuban religious knowledge by scholars and practitioners alike. Cultural theorist Edna Rodríquez-Mangual, in *Lydia Cabrera and the Construction of an Afro-Cuban Cultural Identity*, distances Cabrera from Ortiz, arguing that Cabrera's notion of transculturation is more nuanced than his and also arguing that Cabrera influenced Ortiz's shift toward a more "inclusive project of national identity" (Chapel Hill: University of North Carolina Press, 2004), 11–12.

25. Clark, *Where Men*, 8; de la Torre, *Santería*, 180.

26. Ballard Campbell, *Disasters, Accidents, and Crises in American History: A Reference Guide to the Nation's Most Catastrophic Events* (New York: Facts on File, 2008); Tony Kail, *Magico-Religious Groups and Ritualistic Activities: A Guide for First Responders* (Boca Raton, Florida: CRC Press; Taylor and Francis), 2008.

27. Campbell, *Disasters*, 368–70; Kail, *Magico-Religious Groups*, 2008, 42.

28. While botanicas (predominantly spiritual/religious based stores that sell herbs, candles, and other items) have existed historically as mutual-aid sites within Nuyorican communities in the United States and Latin America, after the large influx of Cubans to the United States during Mariel, Santería-based botanicas increased significantly. This influenced the face of existing botanicas, which also began to cater to this burgeoning and lucrative Santería clientele.

29. De la Torre, *Santería*, 203; Brown, *Santería Enthroned*, 377; Michelle Gonzalez, *AfroCuban Theology: Religion, Race, Culture and Identity* (Gainesville: University Press of Florida, 2006), 72.

30. Brown, *Santería Enthroned*; Clark, *Santería*, 27; Clarke, *Mapping*.

31. Afrocentric diaspora and nationalist-inspired practices have emerged as part of a larger critique of U.S. identity politics in the early 1960s. For example, Kamari Clarke notes how in 1959 Serge King, an African-American "soon-to-be-founder" of the Oyotunji *orisa* voodoo village in South Carloina, traveled to Matanzas, Cuba, with his Cuban American friend, Chris Oliana, to be initated (See Clarke, *Mapping*, 72). They are known to be the first two Americans to be initiated in Cuba to the Oricha Chango. Little is known on how homosexuality has played out in Afrocentric nationalist Santería practices in the United States; however, Orisa, Vodun, Candomblé, Santería and other African-inspired practices have become popular with Black and Latino groups in the United States as alternative sites of power-forming niche groups of practice. See George Brandon, *Santeria*; Salvador Vidal-Ortiz,"Sexuality and Gender in Santeria," in *Gay Religion*, ed. Scott Thuma and Edward Gray (Lanham, MD: Rowman and Altamira,

2005), 115–38. The majority of these groups tend to follow Cuban, Nigerian, or even U.S heternormative understandings of sexuality. For instance, Clarke describes how in Oyotunji, homosexuality was percieved of as a "white male homosexual deviance," while polygamy was celebrated as *authetically* African. See Clarke, *Mapping*, 262. Similar to other trends, thus homosexuality has been seen as neither appropriate nor traditional. See Melissa Wilcox, "Same-Sex Eroticism and Gender Fluidity in New and Alternative Religions," in *Introduction to New and Alternative Religions in America*, ed. Eugene Gallagher and W. Michael Ashcraft (Westport, CT: Greenwood, 2006), 254. Clarke also notes how gender deviances, such as women wanting to drum, have been seen as inappropriate or as signs of potential homosexuality (see Clarke, *Mapping*, xix). However, Conner and Sparks have noted a growing tendency of gay and lesbian Lukumi and Ifá practitioners in the United States to form alternative "houses" that challenge heteronormative restriction. See Conner and Sparks, *Queering Creole Spiritual Traditions*; see also Donna D. Daniels, *When the Living Is Prayer* (Ph.D. thesis, Stanford University, 1998). While this is accepted differently in a house-by-house basis, there is nevertheless an on-going contention surrounding the initiation of women and homosexual men to Ifá; see Moyo Okediji, "The Semioptics of Africana Art History," in *The African Diaspora and the Disciplines*, ed. Tejumola Olaniyan and James Hoke Sweet (Indiana: Indiana University Press, 2010), 252. A highly visible exception of more recent American-based Ifá groups can be seen in Philip Neimark. Oluwo Fagbamila, a white American Babalao who started the Ifá University, does not adhere to any restrictions for Ifá initations (Conner and Sparks, *Queering Creole*, 136). These groups are often criticized and ostracized as "fake" or "modern" by self-proclaimed "traditionalists" who follow heteronormative and gendered restrictions based on Cuban, Brazilian, or Nigerian distinctions. See Louis Nicolau Parés,"The Nagoization Process in Bahian Candomblé," in *The Yoruba Diaspora in the Atlantic World*, ed. Toyin Falola and Matt D. Childs, (Indiana: Indiana University Press, 2004), 198; Wilcox, "Same Sex," 254.

32. Delgado 2009; Hernandez-Reguant 2009; Knauer 2009, Routon 2010.

33. Michael H. Erisman, *Cuba's Foreign Relations in a Post-Soviet World* (Gainesville: University Press of Florida, 2000); María Dolores Espino, "Cuban Tourism during the Special Period," in *Cuba In Transition—Volume 10* (Washington: Association for the Study of the Cuban Economy, 2000), 360–73; Sujatha Fernandes, "Fear of a Black Nation: Local Rappers, Transnational Crossings, and State Power in Contemporary Cuba," *Anthropological Quarterly* 76, no. 4 (2003): 575–608.

34. Katherine Hagedorn, *Divine Utterances: The Performance of Afro-Cuban Santeria* (Washington: Smithsonian Institution Press, 2001); Adrian H. Hearn, "Afro-Cuban Religions and Social Welfare: Consequences of Commercial Development in Habana," *Human Organization* 63, no. 1 (2004): 78–87.

35. Brandon, *Santeria*; Hearn, "Afro-Cuban Religions," 78–87; Carlos Moore, "Congo or Carabalí: Race Relations in Socialist Cuba," *Caribbean Review* 15, no. 2 (1986): 12–15.

36. The use of the term "Cuban American" became popular after the "Mariel Crisis," as it was known in Miami, as a way for earlier Cuban émigré waves to distinguish themselves from the unsavory reputation of Marielitos. Ricardo Ortiz, *Cultural Erotics in Cuban America* (Minnesota: University of Minnesota Press, 2007), xv. "Cuban American" circumscribed previous migrants' political power in the restructuring of local Floridian power, which was being undermined by zealous anti-immigrant sentiments and nationalist groups who were concerned about the Marielito problem; see Alejandro Portes and Alex Stepick, *City on the Edge*, (Berkeley: University of California Press 1993). During the 1980s, lamenting over the loss of their standing as the "model Latino" immigrants, Cuban Americans looked to politics, running for local offices, and re-zoning voting districts in order to secure authority over their tarnished reputations.

37. I invoke the term "gay" here, particularly in this case, because the individual lived and subsequently died in the United States and often self-identified as "gay."

38. Cited in Derrick Hodge, "Colonization," 21.

39. Lourdes Arguelles and Ruby Rich, "Homosexuality," 690; Alejandro de la Fuente, *A Nation for All: Race, Inequality, and Politics in Twentieth-Century Cuba* (Chapel Hill: University of North Carolina Press, 2001); Tanya Saunders, "Grupo OREMI: Black Lesbians and the Struggle for Safe Social Space in Havana," *Souls* 11, no. 2 (2009): 167–85.

40. Saunders, "Grupo OREMI," 171.

41. Scott Larson, "Gay Space in Havana," in *The Politics of Sexuality in Latin America*, ed. Javier Corrales and Mario Pecheny (Pittsburgh: University of Pittsburg Press, 2010), 334–48; Lumsden, *Machos*. Particularly problematic were the development of militarized forced labor camps UMAPS used to "re-educate" homosexuals in the late 1960s. See Arguelles and Rich, "Homosexuality, 691; Alejandro de la Fuente, *A Nation for All* (Chapel Hill: University of North Carolina Press, 2001); La Fountain-Stokes, "Travel Notes,"18; Saunders, "Grupo OREMI,"171.

42. Christine Ayorinde, *Afro-Cuban Religiosity, Revolution, and National Identity* (Gainesville: University Press of Florida, 2004); Christine Ayorinde, "Santería in Cuba: Tradition and Transformation," in *The Yoruba Diaspora in the Atlantic World*, ed. Toyin Falola and Matt D. Childs (Indiana: Indiana University Press, 2004), 209–30; Miguel Barnet, *Afro-Cuban Religions* (Kingston, Jamaica: Ian Randle Publishers, 2001); Patrick Bellegarde-Smith, *Fragments of Bone: Neo-African Religions in a New World* (Chicago: University of Illinois Press, 2005); Rodriquez-Mangual, *Lydia Cabrera*.

43. Brandon, *Santeria*; de la Fuente, *A Nation for All*, 291–95.

44. Ayorinde, *Afro-Cuban Religiosity*; Ayorinde, "Santería," 209–30; de la Fuente, *A Nation for All*, 324.

45. De la Fuente 2001, *A Nation For All*, 4. As scholars have noted, Cuban Santería formed at the margins in the shift of late nineteenth- and early twentieth-century nation building and was persecuted as a criminal "problem" of black subjects in colonial and postcolonial Cuba. See Ayorinde, *Afro-Cuban Religiosity*; Ayorinde, "Santería," 209–30; Brandon, *Santeria*. Until the 1980s,

when the large "third wave" of Marielito Cuban migration to the states occurred, Santería was hidden, practiced in very quiet enclaves of white, upper-class, Cuban American communities, with some Puerto Rican and African American practitioners. See M. A. de la Torre, *Santería: The Beliefs and Rituals of a Growing Religion in America* (Grand Rapids, MI: Eerdmans, 2004).

46. Arguelles and Rich, "Homosexuality, Part I"; Lourdes Arguelles and Ruby Rich, "Homosexuality, Homophobia, and Revolution: Notes toward an Understanding of the Cuban Lesbian and Gay Male Experience, Part II," *Signs* 11, no. 1 (1985): 120–36. La Fountain-Stokes, "Travel Notes," 7–33; Kaifa Roland, "Tourism and the Negrificación of Cuban Identity," *Transforming Anthropology* 14, no. 2 (2006): 151–62. In pre- and early revolutionary Cuba, a pattern of homosexual migration to Havana has been noted by Arguelles and Rich in response to a compulsory "patriarchal" Afro-Latin rurality, where those who stayed in Cuba's prerevolutionary villages were cast as the role of "village queer—the homosexual version of the village idiot" (Arguelles and Rich, "Homosexuality, Part I," 686). While I do not agree with Arguelles and Rich's Marxist provincializing of rural versus urban modernity, it is important to note the historical peripheralizing discourses of Afro-Cuban policing and masculinist sexualities that occur in the regional spheres of homophobic discourses in early twentieth-century Cuba.

47. De la Fuente, *A Nation for All*.

48. Kenneth Routon, *Hidden Powers of the State in the Cuban Imagination* (Gainesville: University of Florida Press, 2010).

49. Arguelles and Rich, "Homosexuality, Part II."

50. Hodge, "Colonization," 20–24; Lumsden, *Machos*; Rolan, "Tourism," 151–62; Saunders, "Grupo OREMI," 167–85.

51. Campos; La Fountain-Stokes, "Travel Notes," 7–33; Larson, "Gay Space," 334–48; Hodge, "Colonization," 20–24; Noelle M. Stout, "Feminists, Queers and Critics: Debating the Cuban Sex Trade," *Journal of Latin American Studies* 40, no. 4 (2008): 721–42.

52. Sinclaire Allen, "Means," 197–98.

53. Vera M. Kutzinski, *Sugar's Secrets: Race and the Erotics of Cuban Nationalism* (Charlottesville: University of Virginia Press, 1993).

54. Clark, *Where Men*; Conner and Sparks, *Queering Creole*; Fernandez Robaina, "Cuban Sexual Values," 205–08; Vidal-Ortiz, "Sexuality Discussions in Santería: A Case Study of Religion and Sexuality Negotiation," *Sexuality Research and Social Policy* 3, no. 3 (2006): 52–66.

55. For example, recently, Raul Castro's daughter, Mariela Castro, has instituted a new socialist project to be more inclusive of gender and sexuality issues. This campaign is aimed at shifting homophobic attitudes in Cuba along with legalizing sex-change operations for transgendered citizens. In a recent statement posted online on May 7, 2011, Mariela Castro stated: "In the context of the emancipating process of the Cuban Revolution, we invite society at large to take part in the development of an educative strategy and welfare campaign for the respect for a free sexual orientation and gender identity as an exercise of social justice and equity" (found online at *Cuba Debate: Contra el*

Terorismo Mediático Website. May 7, 2011). "Mariela Castro at the Day against Homophobia: 'Let's Do Away with All Forms of Discrimination.'" Mariela Castro's opening speech at the "Sexual Diversity without Discrimination" panel discussion, at the Movie House *La Rampa*, Vedado, Havana. Accessed October 20, 2011. http://www.walterlippmann.com/docs3180.html.

56. Clark, *Where Men*.

57. Arguelles and Rich, "Homosexuality, Part I," 688; Conner and Sparks, *Queering Creole*; Fernandez-Robaina, "Cuban Sexual Values," 206; Lumsden, *Machos*.

58. Saunders, "Grupo OREMI," 167–85; Roland, "Tourism," 151–62. There have also been several recent Cuban soap operas (*telenovelas*) that depict gay, lesbian, and bisexual romances and topics. These socialist sexuality projects mentioned previously have taken the island by storm, with many people commenting in the streets about how television is no longer "family friendly." One woman I overheard while standing in a store line in August 2011 discussing the latest soap opera, *Bajo el Mismo Sol*, which features a lesbian romance, told her friend that she would not let her son view the program as she was worried that he would think it was acceptable to "become gay." Still, with the overwhelmingly popular response of this and other Cuban soap operas like it, it might be said that, since the 2000s, both gay youth and Santería religious practices have gone through a "coming out" (tongue in cheek) in the social and cultural spaces formerly disallowed to them in post-soviet socialist Cuba.

59. Cabrera, *Yemayá*, 279.

60. Clark, *Where Men*; Victor Betancourt Omolófaoló Estrada, *El Babalawo Medico Tradicional: Yorubas y Santería* (Caracas, Venezuela: Colección Ediciones Orunmila, 2004).

61. Stephan Palmié, *Wizards and Scientists: Explorations in Afro-Cuban Modernity and Tradition* (Durham, NC: Duke University Press, 2002), 345.

62. Brandon, *Santeria*.

63. Brown, *Santería Enthroned*, 19–20.

64. Clark, *Where Men*.

65. In a not yet published article, I examine a Cuban national debate that gained international attention in 2004 coined "The Iya Onifa Debate," which condemned the initiation of women to Ifá or Iya Onifa (also, Iyanifa) as "new-age" feminisms attempting to "infiltrate" Cuba's African Ifá traditions. Cuban Babalawos who initiated women were blacklisted, pitted against each other, exiled from their religious communities, and even persecuted by the Cuban government for conducting these ceremonies.

66. See Clark, *Where Men*. While I cannot talk in detail here, several studies have mentioned that, historically, female priestesses formed a central role in Santería initiations—even at certain times performing the roles of *oriaté* and also training their male godchildren in the ritual practices. See Clark, *Where Men*; J. Lorand Matory, *Black Atlantic Religion: Tradition, Transnationlaism and Matriarchy in the Afro-Brazilian Condomblé* (Princeton: Princeton University Press, 2005); Natalia Bolívar Aróstegui, *Los Orishas En Cuba* (Havana: Editions Union, 1990); and Brandon, *Santeria*. Since the 2000s there have been several

American women who have also controversially claimed this position Clark, *Where Men*; Conner and Sparks, *Queering Creole*. The role of female *oriaté* is debated similarly to the previous descriptions of female initiations to Ifá, where female Oba's (jokingly called "Obasas" or "King-girls") are seen as American liberalisms trying to disrupt Cuban traditionality.

67. See note 22.

68. Estrada, *El Babalawo*, 2004.

69. Clark, *Where Men*.

70. Tomas Fernandez Robaina described an example of how a *babalao* who was initiated as a child and who later became homosexual, could be able to "get around" the homosexuality taboo in Ifá and be able to retain his title (see Robaina, "Cuban Sexual Values," 208). However, it is important to note that in the few cases known to have occurred, the *babalao* is expected to "retire" as an Ifá priest and would not be allowed to practice within the community of Cuban *babalaos*. The other issue here is that because Ifá Odu is supposed to be able to detect if there is a potential "weakness" and therefore not allow someone to pass to Ifá unless he "worthy," the divinatory transgression could impact the legitimacy of the priests who had initially conducted the initiation. If someone initiated at a young age "turns" homosexual, as in the case indicated by Fernandez-Robaina, to "save face," the priests who initiated the individual might justify Ifá's "mistake" by describing the person as not truly homosexual but rather a sexual "deviant" who was "corrupted." In either instance, the homosexual *babalao* is still shunned within Cuban Ifá communities, and any person who associates with him is also dually policed. Therefore, Fernandez-Robaina's assertion that they would retain their role of *babalao* is not necessarily accurate. Technically, they might still be initiated to Ifá (as this ceremony can never be revoked or removed), but they would not be able to actively function religiously or socially as *babalaos* in Cuban Ifá.

71. Clark, *Where Men*.

72. Along with Ifá and Santería, many adherents also practice other Afro-Cuban religions simultaneously and alongside multiple religious traditions, such as Palo Mayombe, Abakua, Espiritismo, other forms of popular Catholicism, certain Vodun influences from Haiti, and others. There are also a growing number of Jewish and Buddhist practitioners who also practice Santería.

73. There are still many houses, particularly in Matanzas, that refuse to work with *babalaos*. See Brandon, *Santeria*. In these cases, the *oriaté* is "king," performing all the ceremonies such as the sacrifices (*matanzas*), that Babalaos have increasingly performed in Havana-style Santería.

74. Stoler, *Race*; see also Stuart Hall, "Race, Articulation and Societies Structured in Dominance," in *Black British Cultural Studies*, ed. Houston A. Baker Jr., Manthia Diawara and Ruth H. Lindeborg (Chicago: University of Chicago Press, 1980), 16–60.

75. Elizabeth Lapovsky Kennedy and Agatha Beins, eds., *Women's Studies for the Future: Foundations, Interrogations, Politics* (Piscataway, New Jersey: Rutgers University Press, 2005); Bernedette Muthien, "Queerying Borders," *Journal of Gay and Lesbian Studies* 11, no. 3/4 (2007): 321–30.

76. Inderpal Grewal and Caren Kaplan, *An Introduction to Women's Studies: Gender in a Transnational World* (Boston: McGraw-Hill, 2002); Chandra Talpade Mohanty and M. Jacqui Alexander, eds., *Feminist Genealogies, Colonial Legacies, Democratic Futures* (Bloomington: Indiana University Press, 1997); Ella Shohat, "Area Studies, Gender Studies, and the Cartographies of Knowledge," *Social Text* 20, no. 3 72 (2002): 67–78.

77. Carlos "Carolina" Valencia first did a documentary, *Two Cubas*, about the lives of two gay men. Being a self-identified "closeted" gay man, he had originally planned a documentary on Santería but changed to track his own personal story of transformation into a woman and a Santería practitioner.

78. Taken from an interview with *Voodoo Woman*'s director and star, Carolina Valencia, found online at Youtube. Accessed October 2011. http://www.youtube.com/watch?v=D8CkMxO20AQ.

79. Palmie, *Wizards*, 354.

80. In a personal communication in October 2011 with Nelson "Poppy" Rodriguez, Obá Oriaté Rodriguez told of how the sign Eyila in cowry shell divination (*dillogun*) is born, which is the last odu Yemayá is able to read. Orula was *abusador de las mujeres*—a womanizer and batterer. As he told it, Yemayá Achaba was the original *apetebi*, wife of Orula, but he left her alone, and "*ella pasaba hombr,*" (she was hungry). Orula, therefore, did not fulfill his husbandly duties. As a result, she began to consult. Rodriguez said Orula "*tenia el costumbre de chismoso,*" he was known to be conniving and told people only partial solutions to their problems so they would have to return for more help. However, when Yemayá would mark *ebbos* (sacrifices), they would work better, and people would find resolutions. When Orula caught Yemayá, he found her with Eyila on the floor, and he told her, "*Hasta ahí,*" (you can go no further than twelve).

81. In another *odu*, Oche Melli (5–5), Rodriguez spoke of how Yemayá was able to get revenge on Orula for throwing her out of the house and replacing her with her sister Ochun. In the story, Yemayá worked the fields and was treated as a slave by Orula. Ochun had lost everything and came to live with Yemayá and Orula, but he ended up falling in love with Ochun and threw Yemayá out with the shackles she wore from the field (referencing her enslavement and the replacement of the black woman for the highly coveted mulatta). Yemayá landed in the town of Obba; she owned the key that could unlock Yemayá's shackles. Obba gave Yemayá her freedom and asked Yemayá to take over the ruling of Obba's town in return for the favor of helping Yemayá get free. As the new ruler, Yemayá decided to return to Orula's kingdom to get revenge, and she brought a *chekere* (a beaded gourd) with her. While Orula was throwing a *tambor*, Yemayá began to shake the *chekere,* and soon all of the people in Orula's party left to follow Yemayá. However, when they got to the gates, Yemayá told the crowd, "Only those who are fertile can pass through the eye of the needle." With this, she sent all of the "sterile" children, those priests who cannot "birth" *caracol* in the sign Oche Melli, back to Orula. And that was how Orula was left with the sterile children of *dillogun*. Phone interview with author, October 11, 2011.

82. Cabrera, *Yemayá*, 279–80.

83. Ruth Landes (1940) identified a similar dynamic in her article, "A Cult Matriarchate and Male Homosexuality," where "passive homosexuals" in Brazilian Candomble practices were both condemned for their feminitiy and also incoporated as "women." She also noted how while passive effeminite homosexual men are often ridiculed, even by their male lovers, they are still considered a threat. For instance, they are often assumed to be sexual predators who can lure unsuspecting heterosexual men with their wiles. Nevertheless, as Landes identifies, they occupy important roles in African-inspired religions such as Candomble.

84. Personal libreta of *dillogun* given to me by my father, Olubata Obá Oriaté, Piri De Jesus, Obinde Omo Llesa, from Obá Oriaté Nelson "Poppy" Rodriguez, Omi delu (NYC). Also, personal notes and libreta in 2003 from my Padrino, Olubata, Obá Oriaté Alfredo Calvo Cano, Oba Tola (*ibae*).

85. Ocha'Ni Lele, *The Secrets of Afro-Cuban Divination: How to Cast the Diloggún, the Oracle of the Orishas* (Rochester, VT: Destiny Books. 2000), 190.

86. When a priest is a child of both Yemayá and Chango, he or she is described as "*oñi oñi*," or two honeys, referencing the intimate relationship between these two deities where Yemayá invites Chango to eat with her. They are always "fed" together, and it is said, wherever Yemayá is, so is Chango.

87. See also, "descarado," someone with out shame. The way it was described was that these types of gays were literally "un descaro," (a shameless act) making the term used in both the active verb, as an offense, as well as an individual characteristic or noun, that is, descarado, a shameless person.

88. Cabrera, *Yemayá*, 280.

89. Clarke "Transnational Yoruba Revivalism and the Diasporic Politics of Heritage," *American Ethnologist* 34, no. 4 (2007): 721–34. Clarke and Thomas, *Globalization*; Olupona and Rey, *Òrìsà Devotion*.

90. Vidal-Ortiz, "Sexuality Discussions," 52–66; Clark, *Where Men*.

91. While for the purposes of this chapter I cannot address the issue more extensively, the relative absence of a homosexual female subject in Santería religious positions is an interesting counterpoint that needs more investigation. In the 2010 Latin American Studies Association meetings, sociologist Salvador Vidal-Ortiz gave an excellent paper on the invisibility of the "butch" or "dyke" in Santería. He compared the veritable "absence" of this female subject to the highly visible and notorious position of the effeminate gay male in Santería. Although the homosexual female is described as Alacuata in *odu*, and seen as a child of the Oricha Inle, she occupies no Santería positionality outside of being referenced in very few stories of abnormality and has no job within religious roles. See also Conner and Sparks, *Queering Creole*, 326; Vidal-Ortiz, "Sexuality," 115–38; and Salvador Vidal-Ortiz, "Sexuality Discussions,"52–66. Unlike the *Adodi*, or effeminate male, who, as we have discussed, has legitimate religious subjectivites, such as the position of Oba, the Alacuata, by contrast, is imagined as a confused hailing of masculinity. Indeed, during my research I have been told by several openly identified lesbian priestesses that during their intiatory life-plan consultations (*itá*), they were told to "become women," "have children

with men," and "get married to a man" as well as forced to wear skirts and shawls. See also Saunders, "Grupo OREMI," 167–85, for an excellent critique on the negligence of lesbian women in sexuality studies in Cuba.

References

Acosta-Belen, Edna, and Carlos Santiago. "Merging Borders: The Remapping of American." In *The Latino Studies Reader: Culture, Economy and Society*, edited by Antonio Darder and Rudolfo Torres, 29–42. Malden, MA: Blackwell, 1998.
Atwood-Mason, Michael. *Living Santería: Rituals and Experiences in an Afro-Cuban Religion*. Washington, DC: Smithsonian Books, 2002.
Arguelles, Lourdes, and Ruby Rich. "Homosexuality, Homophobia, and Revolution: Notes toward an Understanding of the Cuban Lesbian and Gay Male Experience, Part I." *Signs* 9, no. 4 (1984): 683–99.
———. "Homosexuality, Homophobia, and Revolution: Notes toward an Understanding of the Cuban Lesbian and Gay Male Experience, Part II." *Signs* 11, no. 1 (1985): 120–36.
———. "Reply to Lancaster." *Signs* 12, no. 1 (1986): 192–94.
Ayorinde, Christine. *Afro-Cuban Religiosity, Revolution, and National Identity*. Gainesville, FL: University Press of Florida, 2004.
———. "Santería in Cuba: Tradition and Transformation." In *The Yoruba Diaspora in the Atlantic World*, edited by Toyin Falola and Matt D. Childs, 209–30. Indiana: Indiana University Press, 2004.
Barnet, Miguel. *Afro-Cuban Religions*. Kingston, Jamaica: Ian Randle Publishers, 2001.
Bascom, William R. "The Focus of Cuban Santería." *Southwestern Journal of Anthropology* 6, no. 1 (1950): 64–68.
———. *Sixteen Cowries: Yoruba Divination from Africa to the New World*. Bloomington: Indiana University Press, 1980.
Bastide, Roger. *African Religions in Brazil*. Baltimore: John Hopkins University Press, 1978.
Bellegarde-Smith, Patrick. *Fragments of Bone: Neo-African Religions in a New World*. Chicago: University of Illinois Press, 2005.
Bolívar Aróstegui, Natalia. *Los Orishas En Cuba*. Havana: Editions Union, 1990.
Brandon, George. *Santeria from Africa to the New World: The Dead Sell Memories*. Bloomington: Indiana University Press, 1997.
Brown, David H. *Santería Enthroned: Art, Ritual, and Innovation in an Afro-Cuban Religion*. Chicago: University of Chicago Press, 2003.
Brown, Jacqueline Nassy. *Dropping Anchor, Setting Sail: Geographies of Race in Black Liverpool*. Princeton: Princeton University Press, 2005.
Butler, Judith. *Gender Trouble: Feminism and the Subversion of Identity*. New York and London: Routledge, 1990.
Cabrera, Lydia. *Yemayá y Ochun*. Madrid: Colección del Chicherukú en el exilio. Impreso por Forma Grafica, S.A., 1974.

Campbell, Ballard. *Disasters, Accidents, and Crises in American History: A Reference Guide to the Nation's Most Catastrophic Events.* New York: Facts on File Publishing, 2008.
Campos, Ana Alcázar. « Turismo Sexual, Jineterismo, Turismo De Romance. Fronteras Difusas En La Interacción Con El Otro.» [*Sexual Tourism, Prostitution, Romance Tourism. Diffuse Borders in the Interactions with the Other.*] *Gazeta De Antropologia* 25, no. 1 (2009): Articulo 16. Accessed October 20, 2011: http://hdl.handle.net/10481/6856.
Clark, Mary Ann. *Santeria: Correcting the Myths and Uncovering the Realities of a Growing Religion.* Westport, CT: Praeger Publishers, 2007.
———. *Where Men Are Wives and Mothers Rule: Santería Ritual Practices and Their Gender Implications.* Gainesville: University of Florida Press, 2005.
Clarke, Kamari Maxine. *Mapping Yorùbá Networks: Power and Agency in the Making of Transnational Communities.* Durham, NC: Duke University Press, 2004.
———. "Transnational Yoruba Revivalism and the Diasporic Politics of Heritage." *American Ethnologist* 34, no. 4 (2007): 721–734.
Clarke, Kamari Maxine, and Deborah A. Thomas, eds. *Globalization and Race: Transformations in the Cultural Production of Blackness.* Durham, NC: Duke University Press, 2006.
Clifford, James, and George Marcus, eds. *Writing Culture: The Poetics and Politics of Ethnography.* Berkeley: University of California Press, 1986.
Conner, Randy, and David Sparks. *Queering Creole Spiritual Traditions: Lesbian, Gay, Bisexual, and Transgender Participation in African-Inspired Traditions in the Americas.* New York: Harrington Park Press, 2004.
Daniels, Donna D. *When the Living Is Prayer: African Based Religious Reverence in Everyday Life among Women of Color Devotees in the San Francisco Bay Area.* PhD Thesis, Stanford University, 1998.
de la Fuente, Alejandro. *A Nation for All: Race, Inequality, and Politics in Twentieth-Century Cuba.* Chapel Hill: University of North Carolina Press, 2001.
de la Torre, M. A. *Santería: The Beliefs and Rituals of a Growing Religion in America.* Grand Rapids, MI: William B. Eerdmans Publishing Co, 2004.
Delgado, Kevin M. 2009. "Spiritual Capital: Foreign Patronage and the Trafficking of Santería." Ariana Hernandez-Reguant, ed. *Cuba in the Special Period: Culture and Ideology in the 1990s.* New York: Palgrave Macmillan. 51–66.
Ebron, Paulla. *Performing Africa.* Princeton, NJ: Princeton University Press, 2002.
Erisman, H. Michael. *Cuba's Foreign Relations in a Post-Soviet World.* Gainesville: University Press of Florida, 2000.
Espino, María Dolores. "Cuban Tourism during the Special Period." *Cuba in Transition—Volume 10.* Washington: Association for the Study of the Cuban Economy, 2000: 360–73.
Estrada, Victor Betancourt Omolófaoló. *El Babalawo Medico Tradicional: Yorubas y Santería* [*The Babalawo Traditional Doctor: Yorubas and Santeria*]. Caracas, Venezuela: Colección Ediciones Orunmila, 2004.

———. *La Lengua Ritual Lúkúmí* [*The Ritual Tongue Lukumi*]. Caracas, Venezuela: Colección Ediciones Orunmila, 2005.
Fernandes, Sujatha. "Fear of a Black Nation: Local Rappers, Transnational Crossings, and State Power in Contemporary Cuba." *Anthropological Quarterly* 76, no. 4 2003: 575–608.
Fernandez Robaina, Tomas. "Cuban Sexual Values and African Religious Beliefs." In *Machos, Maricones and Gays: Cuba and Homosexuality*, edited by Ian Lumsden, 205–208. Philadelphia: Temple University Press, 1996.
Font, Mauricio A. and Alfonso W. Quiroz, eds. *Cuban Counterpoints: The Legacy of Fernando Ortiz*. Lanham, MD: Lexington Books, 2004.
Gonzalez, Michelle. *Afro-Cuban Theology: Religion, Race, Culture and Identity*. Gainesville: University Press of Florida, 2006.
Grewal, Inderpal. *Transnational America: Feminisms, Diasporas, Neoliberalisms*. Durham: Duke University Press, 2005.
Grewal, Inderpal and Kaplan, Caren. *An Introduction to Women's Studies: Gender in a Transnational* World. Boston: McGraw-Hill, 2002.
Gupta, Akhil, and James Ferguson, eds. *Culture, Power, Place: Explorations in Critical Anthropology*. Durham, NC: Duke University Press, 1997.
Hagedorn, Katherine. *Divine Utterances: The Performance of Afro-Cuban Santeria*. Washington: Smithsonian Institution Press, 2001.
Hall, Stuart. "Race, Articulation and Societies Structured in Dominance." In *Black British Cultural Studies*, edited by Houston A. Baker, Jr., Manthia Diawara, and Ruth H. Lindeborg, 16–60. Chicago: University of Chicago Press, 1980.
———. *Representation: Cultural Representations and Signifying Practices*. Thousand Oaks, Sage Publications Ltd, 1997.
Hearn, Adrian H. "Afro-Cuban Religions and Social Welfare: Consequences of Commercial Development in Habana." *Human Organization* 63, no. 1 (2004): 78–87.
Hernández-Reguant, Ariana. 2009. *Cuba in the Special Period: Culture and Ideology in the 1990s*. New York: Palgrave Macmillan.
Herskovits, Melville J. *The Myth of the Negro Past*. Boston: Beacon Press, 1941.
———. *The New World Negro: Selected Papers in Afroamerican Studies*. Edited by Frances S. Herskovits. Bloomington: Indiana University Press, 1966.
Hodge, Derrick. "Colonization of the Cuban Body: The Growth of Male Sex Work in Havana." *NACLA Report on the Americas* 34, no. 5 (2001): 20–24.
Kail, Tony. *Magico-Religious Groups and Ritualistic Activities: A Guide for First Responders*. Boca Raton, Florida: CRC Press; Taylor and Francis, 2008.
Khan, Aisha. "Isms and Schisms: Interpreting Religion in the Americas." *Anthropological Quarterly* 76, no. 4 (2003):761–74.
Knauer, Lisa Maya. 2009. "Audiovisual Remittances and Transnational Subjectivities." In *Cuba in the Special Period: Culture and Ideology in the 1990s*. Ariana Hernández-Reguant, ed. Pp. 159–177. New York: Palgrave Macmillan.
Kutzinski, Vera M. *Sugar's Secrets: Race and the Erotics of Cuban Nationalism*. Charlottesville: University of Virginia Press, 1993.

Landes, Ruth. "A cult matriarchate and male homosexuality." *A Journal of Abnormal and Social Psychology* 35(3): 386–97, 1940.
La Fountain-Stokes, Lawrence. "Travel Notes of a Queer Puerto Rican in Havana." *Gay Lesbian Quarterly* 8, no. 1 (2002): 7–33.
Lancaster, Roger. "Comment on Arguelles and Rich's 'Homosexuality, Homophobia, and Revolution: Notes toward an Understanding of the Cuban Lesbian and Gay Male Experience, Part II.'" *Signs* 12, no. 1 (1986): 188–92.
Lapovsky Kennedy, Elizabeth, and Agatha Beins, eds. *Women's Studies for the Future: Foundations, Interrogations, Politics*. Piscataway, New Jersey: Rutgers University Press, 2005.
Larson, Scott. "Gay Space in Havana." In *The Politics of Sexuality in Latin America: A Reader on Gay, Lesbian, Bisexual and Transgender Rights*, edited by Javier Corrales and Mario Pecheny, 334–48. Pittsburg: University of Pittsburg Press, 2010.
Lumsden, Ian, ed. *Machos, Maricones and Gays: Cuba and Homosexuality*. Philadelphia: Temple University Press, 1996.
Marcus, George E. *Ethnography through Thick and Thin*. Princeton, NJ: Princeton University Press, 1998.
Mason, John. *Olóòkun: Owner of Rivers and Seas*. Brooklyn: Yoruba Theological Archministry, 1996.
Matory, James Lorand. *Black Atlantic Religion: Tradition, Transnationlaism and Matriarchy in the Afro-Brazilian Condomblé*. Princeton, NJ: Princeton University Press, 2005.
Mintz, Sidney W., and Richard Price. *An Anthropological Approach to the Afro-American Past: A Caribbean Perspective*. Philadelphia: Institute for the Study of Human Issues, 1976.
Mohanty, Chandra Talpade, and M. Jacqui Alexander, eds. *Feminist Genealogies, Colonial Legacies, Democratic Futures*. Bloomington: Indiana University Press, 1997.
Moore, Carlos. "Congo or Carabalí: Race Relations in Socialist Cuba." *Caribbean Review* 15, no. 2 1986: 12–15.
Muñoz, Jose Esteban. *Disidentifications: Queers of Color and the Performance of Politics*. Minnesota: University of Minnesota Press, 1999.
Murphy, Joseph. *Santería: An African Religion in America*. Boston: Beacon Press, 1993.
Muthien, Bernedette. "Queerying Borders." *Journal of Gay and Lesbian Studies* 11, no. 3/4 (2007): 321–30.
Nassy Brown, Jacqueline. *Dropping Anchor, Setting Sail: Geographies of Race in Black Liverpool*. Princeton, NJ: Princeton University Press, 2005.
Neimark, Philip John. *The Way of the Orisa: Empowering Your Life through the Ancient African Religion of Ifá*. San Francisco: Harper, 1993.
Ocha'Ni Lele. *The Secrets of Afro-Cuban Divination: How to Cast the Diloggún, the Oracle of the Orishas*. Rochester, VT: Destiny Books, 2000.
Okediji, Moyo. "The Semioptics of Africana Art History." In *The African Diaspora and the Disciplines*, edited by Tejumola Olaniyan and James Hoke Sweet, 234–55. Indiana: Indiana University Press, 2010.

Olupona, Jacob K., and Terry Rey, eds. *Òrìsà Devotion as World Religion: The Globalization of Yorùbá Religious Culture*. Madison, WI: University of Wisconsin Press, 2008.

Ortiz, Fernando. *Contrapunteo cubano del tabaco y el azúcar [The Cuban counterpoint between tobacco and sugar]*. Madrid, Espana: Ediciones Cátedra, 1987.

Ortiz, Ricardo. *Cultural Erotics in Cuban America*. Minnesota: University of Minnesota Press, 2007.

Parés, Louis Nicolau. "The Nagoization Process in Bahian Candomblé." In *The Yoruba Diaspora in the Atlantic World*, edited by Toyin Falola and Matt D. Childs, 185–208. Indiana: Indiana University Press, 2004.

Palmié, Stephan. *Wizards and Scientists: Explorations in Afro-Cuban Modernity and Tradition*. Durham, NC: Duke University Press, 2002.

Portes, Alejandro and Alex Stepick. *City on the Edge: The Transformation of Miami*. Berkeley: University of California Press, 1993.

Rodríguez-Mangual, Edna M. *Lydia Cabrera and the Construction of Afro-Cuban Cultural Identity*. Chapel Hill: The University of North Carolina Press, 2004.

Roland, Kaifa. "Tourism and the Negrificación of Cuban Identity." *Transforming Anthropology* 14, no. 2 (2006): 151–62.

Rosaldo, Michelle Z. "Woman, Culture and Society: A Theoretical Overview." In *Woman, Culture and Society*, edited by Michelle Z. Rosaldo and Louise Lamphere, 1–16. Stanford, CA: Stanford University Press, 1974.

Routon, Kenneth. *Hidden Powers of the State in the Cuban Imagination*. Gainesville: University of Florida Press, 2010.

Rubin, Gayle. "Thinking Sex: Notes for a Radical Theory of the Politics of Sexuality." In *Pleasure and Danger: Exploring Female Sexuality* edited by Carole S. Vance, 267–319. Kitchener, Ontario: Pandora Press, 1984.

Saunders, Tanya. "Grupo OREMI: Black Lesbians and the Struggle for Safe Social Space in Havana." *Souls* 11, no. 2 (2009): 167–85.

Shaffer, Kirwin R. *Anarchism and Countercultural Politics in Early Twentieth-Century Cuba*. Gainesville: University of Florida Press, 2005.

Shohat, Ella. "Area Studies, Gender Studies, and the Cartographies of Knowledge." Social Text 20, no. 3 72 (2002): 67–78. doi:10.1215/01642472-20-3_72-67.

Sinclaire Allen, Jafari. "Means of Desire's Production: Male Sex Labor in Cuba." *Identities* 14, no. 1 /2 (2007): 183–202.

Stoler, Ann L. *Race and the Education of Desire: Foucault's History of Sexuality and the Colonial Order of Things*. Durham, NC and London: Duke University Press, 1995.

Stout, Noelle M. "Feminists, Queers and Critics: Debating the Cuban Sex Trade." *Journal of Latin American Studies* 40, no. 4 (2008): 721–42.

Vega, Marta Morena. *The Altar of My Soul: The Living Traditions of Santería*. New York: Ballantine Books, 2001.

Vega, Marta Morena, and Cheryll Y. Greene. *Voices from the Battlefront: Achieving Cultural Equity*. Trenton, NJ: Africa World Press, 1993.

Vidal-Ortiz, Salvador. "Sexuality and Gender in Santeria." In *Gay Religion*, edited by Scott Thuma and Edward Gray, 115–38. Lanham, MD: Rowman and Altamira, 2005.

———. "Sexuality Discussions in Santería: A Case Study of Religion and Sexuality Negotiation." *Sexuality Research and Social Policy* 3, no. 3 (2006): 52–66.

Wilcox, Melissa. "Same-Sex Eroticism and Gender Fluidity in New and Alternative Religions." In *Introduction to New and Alternative Religions in America: African diaspora traditions and other American innovations*, edited by Eugene Gallagher and W. Michael Ashcraft, 243–65. Westport, Connecticut: Greenwood Publishing Group, 2006.

Wirtz, Kristina. 2007. *Ritual, Discourse, and Community in Cuban Santería: Speaking a Sacred World*. Gainesville: University of Florida Press.

Yanagisako, Sylvia. "Sexuality and Gender and Other Intersections." In *Das Dreifache Dilemma der Differenz* [The Dilemma of Three Times the Difference], edited by Sabine Strasser. Vienna: Wiener Frauenverlag, 1997.

Yanagisako, Sylvia and Carol L. Delaney. *Naturalizing Power: Essays in Feminist Cultural Analysis*. New York: Routledge, 1995.

Chapter 3

Yemayá y Ochún
Queering the Vernacular Logics of the Waters

Solimar Otero

> Sería imposible al hablar de Yemayá en la Isla de Cuba, silenciar y menos separar de ella, a la popularísima Ochún, con quien comparte el dominio de las aguas.
>
> It would be impossible to talk about Yemayá in the island of Cuba by silencing and separating her from the popular Ochún, with whom she shares dominion over the waters.
>
> —Lydia Cabrera, *Yemayá y Ochún*.[1]

> Lydia Cabrera's *El Monte* (1954) is one of the queerest books ever written by a Cuban author.
>
> —José Quiroga, *Tropics of Desire*.[2]

The above quotes by Cabrera and Quiroga serve as useful points of entry to consider the queer nature of the performance of spiritual identities in the contexts of Afro-Cuban religious cultures. They relate how representations of Afro-Cuban religion can occur in contexts where the order of the binary is subverted by their performance. In this piece, I want to use fieldwork done with practitioners of *Santería* to investigate how vernacular discourses about gender, embodiment, and the past reorder these very categories. In the same vein, I want to reread Lydia Cabrera's work *Yemayá y Ochún: Kariocha, Iyalorichas y Olorichas* in a queer man-

ner that will also open up these categories to broader interpretations.³ As Cabrera merges ethnography with fiction and reported speech within a form of play that troubles the authorial voice, her writing is an invitation to question how we think about what we know about Afro-Cuban religious culture. This is especially true in her representations of the water deities Yemayá and Ochún, and it is the case in how practitioners describe these deities and their relationship to them. In both instances, we see that crossing boundaries and borderlands, especially in terms of kinds of water (salty/sweet), is reinscribed with a kind of play that challenges fixed notions of subjectivity. Thus, the relationship between Yemayá and Ochún, as demonstrated in the idea of a devotee being a "child of both waters / *hijo/a de las dos aguas*" exists as an insider category that is open, multifaceted, and not fixed.

As a folklorist, I offer this noted vernacular relationship between especially women and their female deities as a productive place to start thinking about the spaces in between categories of subjectivity that entail gender, race, nation, and embodiment. In using the terms "women" and "female deities," I also am suggesting that both Cabrera and my collaborators in the field provoke a more complicated reading of gender and embodiment than the accepted binaries surrounding these subjects. The way that Afro-Cuban religion reconstitutes itself—through writing and praxis—makes us understand that certain kinds of agency are found in liminal spaces. These in-between spaces can be found in many sites of symbolic and cultural production: between waters, deities, subjectivities, and genres of writing. How these domains meet and merge in Cuban *Santería* also expands our thinking about the nature of Afro-Atlantic religious cultures, their temporality, as well as how we perceive diasporic paradigms of religious performance like song, dance, divination, *pataki* (a traditional mythological narrative), and so on. This piece, then, asks us to think about the relationship between Yemayá and Ochún as providing a template for understanding the intersectional practices that Afro-Cuban religious discourse performs.

Of course, the ritual, mythological, and discursive creativity surrounding Yemayá and Ochún that I am exploring in Afro-Cuban religious cultures has parallel expressions in Africa and other parts of the African Diaspora. For example, in Nigerian Aladura churches, where ritual creativity and co-penetration exists between Yoruba traditional religion (*esin ibile*) and Christianity, it is believed that Olorun (God) divided the waters in two: into the salty and sweet water realms of Yemoja (Yemayá) and Osún (Ochún), respectively.⁴ Also, according to R. C. Abraham's classic *Modern Dictionary of Yoruba*, variations exist in Yoruba mythology, ritual, and belief as to whether it is Yemoja (Yemayá)

who gives birth to Osún (Ochún) or if it is Osún (Ochún) who gives birth to Yemoja (Yemayá).[5] In Brazil, there is also a good deal of creativity and fluidity in how the relationship between Yemanjá (Yemayá) and Oxum (Ochún) is described, understood, and made into religious praxis.[6] As a continuation of this Afro-Atlantic conversation exploring the boundaries, qualities, and fluidity between Yemayá and Ochún, I investigate how practitioners and scholars of Afro-Cuban religious cultures have a unique contribution to make in terms of questioning rigid categories of gender and embodiment through this special connection.

As indicated, this piece explores the connections between the deities, the *orichas*, Yemayá and Ochún as expressed in Afro-Cuban belief. I am interested in troubling the notion of bounded relationships between deities, vernacular religious expressions, notions of embodiment, and gendered personhood. *Los hijo/as de las dos aguas* is an open designation given to devotees of both *orichas* that signifies a fluid connection between the two divinities that is expressed in ritual knowledge and the performance of religious history through storytelling. This set of relationships serves as a model for how to understand discourses of incorporation especially within women's religious work that focuses on boundary play.[7] The relationship between these two entities highlights an openness to religious interaction in the history of the African Diaspora in light of new ways of thinking about how ritual creativity performs at the borders of race, gender, and sexuality.[8] This is especially the case in terms of how the connectedness of the Afro-Catholic manifestations of Yemayá and Ochún may also be read as sites of boundary play that defy notions of ritual and ethnic purity through the symbolic interplay between La Virgen de Regla and La Caridad del Cobre, respectively.[9]

My initial fieldwork in Cuba on Afro-Cuban religions began in 1999. As a Cuban-American returning to Havana's neighborhoods of Arroyo Apolo and Mantilla where my mother was raised, Claudina Abreo González and Mercedes Zamora Albuquerque, the women priestesses discussed briefly in this chapter, have served as my mentors, collaborators, and spiritual consultants.[10] These women play the role of *madrinas* or godmothers for many seeking spiritual and religious guidance and their ritual activities provide a central conduit in creating and maintaining spiritual kin networks.[11]

Yemayá and Ochún Revisited

Claudina Abreo González is a priestess of Ochún who has been practicing the religious traditions of *Santería, Palo,* and *Espiritismo* for over thirty

years.¹² Here I want to examine how Abreo González, as a daughter of Ochún, understands her relationship to Yemayá through traditional narrative and vernacular criticism of these narratives in ways that help us question whom gets to create, interpret, and situate knowledge in Afro-Cuban religious contexts.¹³ These vernacular aesthetic sensibilities, as metafolklore and as a form of oral literary criticism, abound in the performance of Afro-Cuban traditional narrative and ritual.¹⁴

Abreo González told me a *pataki* that exemplified for her the relationship between Yemayá and Ochún. In her version of the story, Yemayá and Ochún are sisters who trade physical attributes to help each other. Here is how she phrased the tale:

> Ochún era una mulata muy linda, tenía un cuerpo muy elegante, muy bonita. Pero, no tenía pelo. Ella tenía el pelo muy cortito, no tenía pelo, no. Entonces, ella le dice a Yemayá, 'Mira, tan linda como yo soy, y sin embargo no tengo tu pelo.' Yemayá tenía el pelo largo, [gesto a la cintura], y de lo más bonito. Y Yemayá le dice, 'Mira, para que seas feliz completa yo te voy a dar mi pelo.' Y le da el pelo a Ochún.
>
> Ochún was a very beautiful *mulata*; she had a very elegant figure, very pretty. But she had little to no hair. She wore her hair very short; she really didn't have any hair. One day she says to Yemayá, "Look at me. Even though I am considered beautiful, I don't have your hair." Yemayá had long hair [gestures down to her waist],¹⁵ and really very beautiful. And so Yemayá tells her, "Look, so you can be completely happy I will give you my hair." And, she gives her hair to Ochún.¹⁶

Part of the impetus for telling me this story was to provide a figurative response to my questions about the relationship between the two water deities. Cabrera places their relationship in the stories she collected and wrote as one of sisterhood as well, and, like Abreo González, she sees Yemayá as the elder sibling that cares for Ochún.¹⁷ Such storytelling is the rich register by which Afro-Cuban religious instruction is performed. In this rendering of the tale we see modes of reported speech and indications of themes and tropes important to popular belief in Afro-Cuban religion. The exchange between the two water goddesses here indicates a sharing of aesthetics and attributes that connect them not only in terms of narrative but also through ritual. In folklore, Yemayá's long hair and other attributes connect her with the mermaid traditions found both in Europe (motifs B81 and B81.9.1) and in Africa, with

the latter finding a symbolic interrelationship between Yemayá/Yemoja's mermaid form and the mermaid forms of the Mami Wata traditions.[18] By bestowing her hair on Ochún, Yemayá gives a part of her magical power to Ochún (though Yemayá also keeps her long beautiful hair) as a mode of generosity, a way of making a bond between their realms. In Cabrera's reading of the relationship between the two water deities, Yemayá often acts as the older, wiser, and indulgent sibling of Ochún who is willing to either clean up Ochún's messes or give her, and by extension her sons and daughters, a magical hand.[19]

What the story world of Abreo González's story offers us, then, is a mythological configuration of how attributes like generosity and beauty might be handled, shared, and understood by the community through the *orichas*' examples. The story worlds of *patakís* also tell of what *not* to do: what to avoid in terms of mistakes made by the deities.[20] This story, like others found in Afro-Cuban religious belief, give us a template for thinking about ritual reciprocity between the two deities through the vernacular concept of *los hijo/as de las dos aguas*. Indeed, Cabrera finds a mythological transformation between the two kinds of water when she describes the *pataki* of how Yemayá turns the salt waters into sweet waters for her sister Ochún.[21] However, before I unpack those potential exchanges, I would like to discuss how the above story also gives a metaphorical rendering of the way that Yemayá and Ochún are connected—not only through their shared element of water but also through gendered and racial representations of the two in Cuba's postcolonial context.

I want to focus for a moment on how Abreo González's story begins with a description of Ochún's beauty, body, and *mulatez*. Her representation of Ochún is typical of how both practitioners and Cuban popular culture describe the river deity. Kutzinski and Arrizón both write about how Afro-Cuban women's bodies, especially those of the *mulata*, do the symbolic work of negotiating Cuban identity by embodying race and gender in particular ways.[22] Ochún's location as a *mulata* in Abreo's story is particularly hybrid because of the range of racial, cultural, and religious associations she symbolizes. As a *mulata*, she is, of course, mixed race. As Ochún, she is both Cuban and Yoruba in terms of culture. As associated with La Virgen de la Caridid del Cobre, she can also be located on a vernacular Catholic register. It is interesting to note on the last point here that La Virgen de la Caridad del Cobre, the patron saint of Cuba, is also represented as a mixed-race virgin in church and vernacular iconography.[23] In terms of Ochún's hybrid subjectivities, I am inclined to see her body in Abreo González's story as a site that is shifting, as a project that Yemayá helps her reconfigure and recreate.

I am not suggesting that we accept this depiction of Ochún's *mulata* body uncritically. However, I do want to suggest that this *mulatez* can be a potential source of agency rather than a solely racialized, sexualized, and gendered subjectivity that always does the work of reinforcing colonial, racial, and patriarchal hegemonies. In other words, as Arrizón aptly observes about the performance of *mulata* embodiment, "As a hybrid body, which can *perform* whiteness and blackness, the *mulata's* subaltern agency becomes a reinscription of the divided and hyphenated self."[24] In this formulation of the *mulata*, her body disrupts the stereotypical racial dyadic by reinscribing *mulatez* in a manner that disidentifies the binary categories that seek to make it solely transgressive, to mark it as a racial abjection.[25]

I would also add that Ochún's multiplicity is incorporated by her devotees, where embodying the goddess becomes an act that necessarily queers questions of personhood in terms of another kind of disidentification. The *mulata* body, and the kind of *mulata* body Ochún represents in Abreo González's story, needs to be re-thought with these considerations in mind when it comes to vernacular religious folklore, practice, and discourse. This is because the contexts in which practitioners are negotiating living texts, practices, and discourses are also a shifting terrain of hybrid subjectivities and negotiations.

In Abreo González's tale, Ochún is indebted to Yemayá for giving her the attributes that perfect her beauty. The long, beautiful hair that Yemayá gives to Ochún is related to both of the deities' manifestations as mermaids, water sirens, and aquatic sprites.[26] Here the conversation is extended to the physical attributes of beauty and allure found in the folklore of these kinds of beings from all over the world. According to Stith Thompson's *Motif-Index of Folk-Literature*, motifs for both dark-skinned (B81.9.5.2) and fair-skinned (B81.9.5.1) mermaids are found in Indo-European folklore and mythological traditions.[27] These contain motifs where mermaids have physical attributes such as large breasts (B81.9.2), long flowing hair (B81.9.0), and "wooly" hair (B81.9.1).[28] In African debates surrounding the mermaid form of Mami Wata, there is much discussion as to the origins and aesthetic characteristics of this water spirit.[29] In all of these instances, female water deities have multiple characteristics that make a systematic classification of their attributes elusive at best.

In examining how some women understand their agency within Afro-Cuban vernacular religion, we also necessarily invoke traditions of secrecy and hidden female power inherited from Yoruba religious discourses.[30] Yet, these traditions of secrecy also resemble queer strategies of evading categorization of knowledge and the self through performances

that code, mimic, and keep hidden key aspects of recognition. This allows for a privileging of information that is rooted in many different kinds of performance strategies that subvert racial, gendered, and cultural orders that are often part of a colonial legacy, especially in Cuba.[31] In terms of Cuba and the relationship of secrecy to Afro-Cuban religion and queer identities, the saliency of what is not revealed affirms that, according to José Quiroga, "circuitousness, evasion, and avoidance are modes of praxis and not necessarily forms of denial."[32] That is, as we will see with Cabrera's texts that deal with Afro-Cuban queer manifestations of *orichas* like Yemayá, the point is not one of secrecy, but of particular ways of performing, in code, the fluidity and ambiguity of gender and sexuality, even within a mythological-religious context.

In terms of vernacular speech and linguistic form, Cabrera's texts about the ambiguous and separate nature of sexuality and gender among the *orichas* take the form of reported speech, most frequently as *chisme* (gossip). This genre of narrative has often been queered in terms of being thought of as the "talk" of women and gays and by being rendered as a volatile and suspicious category for acquiring information in literature and society.[33] *Chisme*, as Cabrera describes it in relation to the *orichas* in *Yemayá y Ochún*, is also infectious and irresistible to her reader. *Chisme* and gossip are popular and pleasurable ways of imparting vernacular histories for different communities of color because of their porous and sometimes subversive narrative frames.[34]

Practitioners identify Yemayá and Ochún as having the ability to work together through both oral tradition and ritual praxis. The implication here is that their relationship can serve as a model of cooperation for different *oricha*-worshipping communities not only in Cuba but across the African Diaspora as well.[35] Yet I do not want to imply that this idea of a model is one that is fixed or always consistent among practitioners. In other words, the idea of a connection between Yemayá and Ochún should serve as a starting point for considering how social and spiritual agency can be negotiated through the lens of these two deities in their connected aspects. That is, how do we navigate the flow of culture from a specific source to a larger body of multiple manifestations that, like the flow between the rivers and the ocean, has a tendency to feed back upon itself?

The regenerative quality of spiritual ingenuity, innovation, and ritual hybridity through experimentation with forms borrowed from literature, popular culture, the internet, film, and international networks makes Afro-Cuban religiosity a thriving and mutable force in Afro-Atlantic religious traditions today.[36] However, within the practice of innovation and borrowing is a discourse of authenticity that mirrors

ritual play and asserts the new in traditional practices.[37] The relationship and mutual admiration between Yemayá and Ochún as understood by adherents is one way to think through the dilemma of locating practice within this vast terrain of fluidity and multiplicity. People who identify as *hijo/as de las dos aguas* (children of "both waters") offer an interesting palette with which we can see how difference appears where (aquatic) borderlands meet, yet allow for these very boundaries to be blurred in ritual and discursive assertions. It is within the zones of contact where the *hijo/as de las dos aguas* operate, between the sweet and salty waters, that practitioners perform the crossing of borders in a way that has implications for how race, gender, and personhood are also mutable in pervasive, mestiza ways.[38]

Abreo González describes the characteristics of those who share a ritual responsibility of showing reciprocity between Ochún and Yemayá in this manner:

> But, they [Yemayá and Ochún] always get along very well. And, for the most part, we daughters of Ochún care greatly for Yemayá. We have to really care for her, really have to adore her. Take myself for example, everything that I offer to Ochún, who is my *mama*—I have to offer to Yemayá. It is as if she is my mama. And that's the way it is, the two waters are one in the same. I often have to go to where the river and the sea meet in order to pray to Ochún and Yemayá, and that is where I put my offerings. That is where one can worship them. That is where you can find both fresh water and salt water.[39]

Here we see Abreo González explain the relationship she has to both Yemayá and Ochún through examples of mutual devotion, ritual reciprocity, and connection to the physical representation of the natural worlds these deities represent for believers. Her relationship to Yemayá operates through Ochún, her mama, meaning the *oricha* that governs her head, who has chosen her as a devotee. Though Ochún is her primary *oricha*, Abreo González finds a second mama in Yemayá. Indeed she feels devotees of Ochún have a special duty to respect, honor, and give offerings to Yemayá. And, in the example above, this may even take on the role of making a joint offering. This makes sense since as Abreo González says, "the two waters are one in the same,"[40] meaning that the differentiation between these two *orichas* can become blurred, combined, and creatively conjoined in ritual, performance, and the construction of material culture honoring them.[41]

In *Yemayá y Ochún*, Cabrera's reading of the close religious proximity of devotees of both *orichas* acknowledges their play with their personalities, as well as proclivities toward protecting the same devotee in the religious discourse. As Cabrera puts it:

> Con los hijos de Yemayá y de Ochún hay que indagar meticulosamente a cual de las dos divinidades pertenecen, porque Yemayá acostumbra robarse los hijos de Ochún, haciéndoles favores. Los acompaña y complace tanto que siembra la confusión . . .
>
> With the children of *Yemayá* and *Ochún*, one has to meticulously investigate which one of the two deities they really belong to, because *Yemayá* has the tendency to try to steal away *Ochún*'s children by doing them favors. She [*Yemayá*] looks after them and pleases them so that it plants a seed of doubt . . .[42]

Cabrera goes on to say that even the adept *santero/a* may have some problems determining the lineage of a child of two waters. Here, I am interested in how Cabrera's description of these converging and negotiated boundaries between the water deities serves as a kind of model for her text.

Yemayá y Ochún is certainly a book that combines a range of narrative forms: ethnography, ethnology, reported speech, folktale, *chisme*, and mythology. It is to be expected from Cabrera's own play on genre that literary critics like José Quiroga and Edna Rodríguez-Mangual have already analyzed Cabrera's seminal work *El Monte*.[43] I want to take Cabrera's lead here and think about how the boundary play between Yemayá and Ochún for devotees is one that opens up possibilities for engaging religiosity and personhood on multiple levels. For Cabrera, avatars of Ochún, Ochún Akuara or Ochún Ibu manifest between the waters: They "vive entre el mar y el río / live in between the sea and the river."[44] Accordingly, Cabrera quotes one of her collaborators, the *santero* Gaytán, as relating that the dualistic avatar of Yemayá, Yemayá Akuara exists in the meeting of the rivers and the sea, where "se encuentra con su hermana Ochún / she meets up with her sister Ochún."[45]

Thus, the boundary play works in both ways for the two water deities. Adding to this sense of negotiated confluence, as we see above, is the popular belief that Yemayá is willing to confuse, help, and conflate this boundary, acting in a form of play herself. This vernacular logic acts as a kind of coding for a whole aesthetic of ritual play that can be learned, taught, and inherited in a variety of ways. In a sense, these

narrative and ritual interpretations of *Ocha* reflect the complicated nature of a religious culture that is discursively fluid and relies on devotees' own ability to semiotically unpack and repack their religious expressions.

The ability to move in between the waters, as Abreo González and others do, is a metaphoric representation of how devotees creatively perform their spiritual selves by using liminal ritual frames.[46] This creative boundary play can open a space for ceremonial agency, especially for devotees like Abreo González, who perform their shifting and fluid relationships at the very sites that physically represent these spaces, that is, the meeting of the river and the sea. Also, this kind of boundary play and confluence between deities and ancestors within *oricha* worship is not unique to Yemayá and Ochún—nor to Cuba, as we see similar kinds of negotiations in ritual contexts in Nigeria and Brazil.[47]

However, Abreo González's story and personal reflections, as well as Cabrera's observations, show other avenues for the expression of agency that move in directions other than ritual and praxis. Narratives, beliefs, and practice all reveal a level of meta-analysis that offers several kinds of discursive agency. The epistemological basis for creating knowledge about Yemayá and Ochún in these contexts allows for a level of naming of various divine subjectivities and the natural and magical worlds that these subjectivities control that encourages a level of play with these very elements. Elsewhere I have written about how the Yoruba word for the act of play, *asere*, as understood by Drewal and Yai in ritual contexts, is fundamental to understanding the ontology of Afro-Caribbean-Latino cultural production and identity that centers around the worldview of *Santería*.[48] Similarly, Abreo González's and Cabrera's assessments of how they understand the fluidity of the worlds and knowledge that Yemayá and Ochún create are made with the kind of expertise that mimics the very play, flow, and form of these water goddesses' shifting and shared paradigms of being and becoming. That is, they move toward and away from each other in multiple stages of subjectivity that allow for a symbolic dance to be performed along their aquatic borders. Furthermore, this river/sea borderland serves as a site that embodies the very discourses of negotiating ritual and social power for many women practicing Afro-Cuban religions, but especially for those who identify with being one of *los hijo/as de las dos aguas*.

Yemayá priestess Mercedes Zamora Albuquerque, like Cabrera and Abreo González, identifies Yemayá and Ochún as being attached to each other in symbiotic ways. Albuquerque feels a special attachment to Ochún in her own devotional practices. This is how she describes the tendency for a connection with Ochún from the perspective of the children of Yemayá:

> Bueno, se considera que Ochún es hermana de Yemayá. Y entonces casi siempre las hijas de Yemayá tenemos tendencia ser *hijas de las dos aguas* . . . Hijas de Yemayá, y hijas de Ochún. Las de Ochún practican en el río. Y las de Yemayá practican en el mar. Pero hay veces que se unen en la diluvia del río en el mar. Por eso se dice, que somos *hijas de los dos aguas*. Pero es porque tenemos tendencias en el campo espiritual y en al campo material con Ochún y con Yemayá.
>
> Well, Ochún is considered to be Yemayá's sister. And almost always we daughters of Yemayá have a tendency to be *hijas de las dos aguas* . . . daughters of Yemayá, and daughters of Ochún. The ones that belong to Ochún practice in the rivers. And, the ones that belong to Yemayá practice in the sea. But there are times when they are united as the river flows over into the sea. Because of this we are called *hijas de las dos aguas*. But it is really because we have tendencies [to work] with Ochún and with Yemayá in spiritual and material camps [of the religion].[49]

Here we see Albuquerque speaking about her conception of the relationship between Yemayá and Ochún that bleeds into the ritual association of *los hijo/as de las dos aguas*. Albuquerque emphasizes the idea that Yemayá and Ochún are sisters and that their daughters, specifically, have a tendency to share a reciprocal relationship with the river and the sea in terms of performing religious work.

Again, we observe the metaphor of the river flowing into the sea acting as a visual reminder for the metaphysical connection expressed between the two entities for believers. The very idea of *los hijo/as de las dos aguas* offers a meditation on how we can redefine personhood and community through the idea of reciprocity. By focusing on gender here, Mercedes illustrates how women, specifically daughters of Yemayá and Ochún, develop a creative and consistent language to discuss the parameters among deities, practice, and theology within the religion of *Santería*. However, the fluidity of movement found between Yemayá and Ochún in how practitioners play with boundaries bleeds into how distinctions between religious cultures in Cuba are negotiated as well.

As the sea receives the overflow of the rivers, so too do the daughters of Yemayá, according to Albuquerque, understand this merging as a starting point for developing a rich and layered spiritual life where she can embody a range of subjectivities to express and extend her agency in a variety realms. Her commentary specifically points out how spiritual and

material spheres interact in the relationship between Yemayá and Ochún in an intersectional way. In so doing, she reveals that the idea of *los hijo/as de las dos aguas* is much more than an emic label used by practitioners to describe a set of practices and beliefs. Here, the idea of *los hijo/as de las dos aguas* becomes an opening point for understanding the interrelatedness of different kinds of spiritual identities performed in a range of registers. Similarly, Cabrera's *Yemayá y Ochún* recodifies, mimics, and extends these registers in how she writes Afro-Cuban religion with a multitude of voices and conventions of genre. Like Cabrera, practitioners' registers are also negotiated within the larger framework of different Afro-Cuban religious cultures. In the case of how practitioners balance the intersectional traditions of *Santería*, *Palo*, and *Espiritismo*, there also exists a large amount of boundary play, ritual innovation, and discursive creativity.[50]

Embodiment, Gender, and Sexuality

I had several conversations with women and men about how gender is conceived and lived in Afro-Cuban vernacular religions. These discussions about gender necessarily involved an exploration into the meaning of embodiment and the construction of the self. Since Afro-Cuban religions are intersectional, the traditions of *Santería*, *Palo*, and *Espiritismo* all contain some level of spirit possession that are reflexive of, compete with, and also refer to each other.[51] The attitudes toward what constitutes a bounded being are fluid.

In terms of the performance of gender, for example, it is not unusual that a person who is gendered one way in society to be gendered ambiguously or differently in ritual and possession. That is, one's body can inhabit several selves that are constructed in a broad range of ways in terms of gender, race, culture, and even time period.[52] It is important to note that spiritual beings are also part of the selfhood of different practitioners, as noted above for Abreo González, because these relationships are thought of as reciprocal. What seems to be clear here, then, is that it is the *performance* of an identity in Afro-Cuban religion that sets the parameters of *who* or *what* a practitioner is or is signifying. In this manner the practitioner can call upon these identities as varying parts of the self—and this means that she can shift between different registers of embodiment during ritual: male, female, black, white, Chinese, nun, gypsy, *oricha*, healer, ancestor, relative.

Not everyone has access to any or all identities, but most people have access to several ways of performing their spiritual selves. Again, these performances become part of the practitioner's known (or poten-

tial) identities within the community. This kind of fluidity of embodiment mirrors the relationship between Yemayá and Ochún in the places where they meet and overflow into each other: the sea and the rivers. Yet, like the relationship between the two deities, there are complex layers of differentiation that overlap to create a mosaic that constitutes the self in Afro-Cuban religious experiential performances of being.

This cultural phenomenon is not an unusual or surprising site for creating and performing identities when we look at how Latina/o *mestizaje* and difference are embodied through cultural performances that locate race, gender, and sexuality in a range of configurations. Here I am thinking of how queer theorists like José Estaban Muñoz, through his idea of disidentification, and Alicia Arrizón, through her idea of transculturation as performance, have argued for understanding the Latina/o gendered and racialized subject as always in flux and as signifying multiple realities that refer historical configurations of these subjects.[53] This seems very close to the performances I have witnessed in the expression of possession pasts and selves in my work with Afro-Cuban religious communities as a whole.

Interestingly, these performances are both bounded and fluid, again like the merging and splitting of the two kinds of waters that make up Yemayá and Ochún. For example, a female priestess whose "head" or main *oricha* is male incorporates this identity into her sense of personhood. She also performs this "male" identity during specified rituals. A *santera, palera,* and/or *espiritista* may embody, hear, and communicate other beings through her own thoughts and actions: a doctor, a former nun, a Congo slave. Some of these beings are gendered as male, some as female, and some as ambiguous. All of these characters play an important role in creating the spiritual menagerie necessary to conduct the work that Afro-Cuban vernacular religion performs socially and culturally. That is, this variegated social imaginary creates a template for performing a version of history that comments on colonialism, slavery, and transculturation.[54] The politics of who becomes whom and why are at the heart of how we understand the relationships among race, spiritual power, and nation-building in contemporary Cuba.[55] And, the idea of *los hijo/as de las dos aguas* represents a specific manifestation of how this ontological process is performed and discursively understood through the symbology of Yemayá and Ochún.

In looking at Cabrera's readings of the *orichas* in *Yemayá y Ochún*, *orichas* may also manifest queer sensibilities in terms of both gender and sexuality. In Cabrera's text, as Quiroga clearly marks for *El monte*, we find talk about the *orichas*' fluid identities in terms of gender and sexuality. Information that queers deities is often divulged in a polyphonic

manner, through a dialogic interplay that uses rumor and reported speech to convey these qualities.[56] This is where Cabrera's text mimics the discursive mode of vernacular speech and folklore, where the oral becomes a vehicle for imparting as permissible what is usually unspeakable. That is, her talk about the gendering and sexing the *orichas* often takes the form of hearsay: as unofficial knowledge that could neither be confirmed nor denied.

For example, Cabrera speaks about Yemayá's relationship with queer avatars of the *orichas*: Obatala, Orula, and Inle.[57] She describes Orula as an "*adodi*," a male with a sexual preference for males, who leaves Yemayá for Ogun.[58] In speaking about instances of same sex love between the divinities, she writes, "It [same sex love] is not such a terrible mark of shame for Orúmbila: Obatalá Odua also had love affairs with another *Adó* [gay male being] and lived with him in the shade of a cottonwood tree."[59]

Cabrera also asserts on the same page, "Yemayá was madly in love with the androgynous, gorgeous Inle."[60] It is important to note Cabrera's positioning of Yemayá in her roles as a protector and a lover of these *orichas*. Note Yemayá's affinity for friendship for and infatuation with queerly gendered and sexualized spiritual beings.[61] For Cabrera, writing as a queer (and lesbian) subject herself, her text gives the character of Yemayá access to a kind of power that transforms static notions of gender and sexed bodies, as well as the kinds of love and affection that can be expressed through these performances of embodiment. Cabrera, like a true *hijo/a de las dos aguas*, also positions Ochún as having a sexual relationship with the androgynous Inle, one that rivals Yemayá's passion for the fish deity.[62] In this manner, Cabrera depicts the fluidity of Yemayá and Ochún as also extending to aspects of their sexuality, passion, and emotional selves. In these very important senses, then, the two refuse to be located in fixed, rigid categories in terms of how they choose to express their intimacy with other beings.

Through this rendering of Yemayá (and of Ochún), Cabrera provides a coded guide for understanding queer entities that is complicated and layered. She even has Yemayá perform her own queerness when she writes, "Yemayá liked to hunt, to cut, to wield the machete. In this *camino* she is *marimacho* and dresses like a man . . . Yemayá is at times so masculine that she becomes a man."[63] Cabrera's use of the term *marimacho*, tomboy or masculine woman, is significant because it has been appropriated by Chicana/Latina queer theorists like Gloria Anzaldúa and Alicia Arrizón to represent a kind of lesbian location that signals a performance of what we could call a "butch" aesthetic.[64]

The use of *chisme* and rumor as the tone for Cabrera's consideration of gender and sexuality among the *orichas*, as in the example above, illustrates a subversive mode of world making in terms of both women's speech and subaltern knowledges that cannot be verified in conventional, official ways.[65] These *chismes* about the deities perform an alternate history, a queer history that wants to resist a heteronormative and patriarchal domestication of the deities. In the end, we see that Cabrera situates Yemayá's gender and sexuality in the realm of performance, allowing her to be feminine, masculine, and queer. This queer positioning of the *orichas* in Cabrera's text is not limited to this coded text. Rather, Cabrera gives us clues as how to read the variegated nature of the performance of gender and sexuality in religious communities that stem from intersectional beliefs and practices.

I want to emphasize that Afro-Cuban religions also have a template for reconstructing gender and sexuality in a manner that can destabilize *machista* or patriarchal enforcements of practice.[66] And the popular and multifaceted deities of Yemayá and Ochún are the perfect starting points for investigating fluid renditions of gender and personhood that defy easy classification. There is a dislocation and relocation of gendered, racialized, and transgendered subjects in performances that reinscribe the body through possession. This is especially so for Yemayá and Ochún because of their many avatars that can be embodied, performed, and expressed in Afro-Cuban religious contexts. Add to the multiplicity of Yemayás and Ochúns the vernacular Catholic iconography of La Virgen de la Caridad del Cobre and La Virgen de Regla, and one gets two Catholic saints whose iconography of the embodiment of the divine is one of two women of color.[67]

These cultural performances and images are rooted in the postcolonial historical context of Cuba in a manner that creates interesting allegories to how queer and gendered subjects are understood to emerge.[68] For example, some processes of queer and gendered embodiment as performance as described by Judith Butler and José Estaban Muñoz highlight the play with signifiers that the performance of possession suggests.[69] In addition, these performances are linked to the social conditions that coordinate how *santeras* manage the power play in the gendered, racialized, and sexualized identities that they are *expected* to perform for the spiritual community. Quiroga rightly observes that Afro-Cuban religions' intersectionality displays a hermeneutics that combines coexisting aspects that can be performed in a "simultaneous manner."[70] I would add that the Afro-Cuban religious subject's ability to disidentify and perform a multitude of intersecting selves that are ambiguous and

hard to locate in a rigid manner makes these traditions apt for queering. In thinking about how these vernacular sets of practices are woven into the discourse of how selfhood and the world are understood, we realize that like Yemayá and Ochún meeting where the two waters meet, contemporary Afro-Cuban religious contexts can meet the global challenge and lead the call toward recognizing a fluidity of gender, race, and sexuality found in experience-centered religious traditions.

Conclusion: Reading Vernacular Religious Agency and Lydia Cabrera's Codes

A Yemayá Olokun, inmensamente, inagotablemente rica, le debe Ochún, su hermana menor, la amable y pródiga dueña del Río, del Amor, del Coral y del Ambar, su proverbial riqueza. . . . Es mucho lo que Ochún debe a Yemayá.

The immensely, inexhaustibly rich Yemayá Olokun owes to Ochún, her younger sister, the kind and prodigious queen of the River, of Love, of Coral, of Amber, her proverbial richness. . . . It is much that Ochún owes to Yemayá.

—Lydia Cabrera, *Yemayá y Ochún*.[71]

With Lydia Cabrera nothing is hidden, but then again nothing is explained.

—José Quiroga, *Tropics of Desire*.[72]

I want to come full circle in closing this piece on the fluid relationship between Yemayá and Ochún by thinking about how vernacular logics in Afro-Cuban religion are expressed by a range of practitioners in a plethora of genres of expression: personal experience narratives, ritual praxis, material culture, ethnographic writing, fiction, plastic arts, and so on. In doing so I also want to call attention to how Cabrera's writing mimics the agency that Afro-Cuban religious boundary play affords in its ability to defy categorization and rigidity. Adept practitioners like Abreo González and Zamora Albuquerque negotiate the fluid discourses that allow for the porous, and sometime contentious, coexistence of *Santería*, *Palo*, and *Espiritismo* in their ritual and narrative expressions.[73] Similarly, Cabrera creates a textured bricolage in *Yemayá y Ochún* by playing with the boundaries of textual form. Her use of reported speech, *chisme*, ethnographic writing, interview excerpts, and storytelling make

this text, like *El Monte*, a work that mimics the vernacular logics of hybridity found in the traditions she is describing and recoding for her readers.⁷⁴ As Quiroga notes above for Cabrera's work, she codes her text in a manner that performs the representation of Afro-Cuban religions in layers, in many different voices that create a heteroglossia, a polyphonic text for readers.⁷⁵

Like with rituals of spirit possession, we find that it takes multiple sets of ears to decipher the variegated voices embedded in Cabrera's *Yemayá y Ochún*. Some hear the nostalgic voice of a prerevolutionary Cuba; others hear the gossip of the gods themselves; and still others hear the loud, converging sound of an animated conversation written in a Cuban vernacular. Yet, in all these instances, whether reading Cabrera's text or deciphering the message of a mounted Yemayá or Ochún, a bit of translation as a creative process within itself is required. That is, both Cabrera and Afro-Cuban religious discourses invoke a kind of active, participatory listening that reorders our sensibilities toward both ritual and text.

Take as an example of a coded, loaded message the following passage from *Yamayá y Ochún*:

> Era increíble, cuando nos marchamos de Cuba el 1960, el número de Iyalochas, babalochas, babalawos, Padres Inkisa, "gangulueros," espiritistas, ñáñigos, todos erróneamente calificados de brujos, que vivían en paz bajo del manto de "Mama Azul," a la vera del santuario [de La Virgen de Regla].
>
> It was incredible, when we left Cuba in 1960, the number of Iyalochas, babalochas, babalawos, Padres Inkisa, "gangulueros," espiritistas, ñáñigos, all erroneously classified as sorcerers, that lived in peace under the mantle of the "Mama Azul" [Blue Mother], on the outskirts of the sanctuary [of Our Lady of Regla].⁷⁶

This passage requires that readers engage and code switch in a range of linguistic and religious registers.⁷⁷ In it, Cabrera combines aspects of diasporic nostalgia, religious cross-coding between distinct Afro-Cuban religious cultures, and a lightly veiled reference to the syncretism between Yemayá and La Virgen de Regla. The phrasing also suggests a critique of the racist, colonial, and stereotypical gaze that renders all practitioners of Afro-Cuban religions "sorcerers."

In addition, the image of Yemayá/La Virgen de Regla as the unifying figure of "Mama Azul" is presented as a benefactor to the

cacophony of religious practitioners living near her shrine(s). Yet these images and their phrasing, as layered and mellifluous as they seem, are also deceptive in certain kinds of coding by Cabrera. For example, the above "Iyalochas, babalochas, babalawos, Padres Inkisa, 'gangulueros,' espiritistas, and ñáñigos" that Cabrera separates from "brujos/sorcerers" are also indeed embedded as sources of knowledge for performing magical acts in other chapters in the text. For example, one particular chapter of *Yemayá y Ochún*, "*Itaná idi ochiché. Velas, ligámenes y trabajos de Santería / Itaná idi ochiché. Candles, Binding Spells, and Works of Santería,*"[78] is entirely dedicated to describing in detail how to work with herbs, stones, powders, and other ingredients that can heal, bind lovers, harm an enemy, and perform other kinds of conjure.[79] Thus, the above quote, when taken as a part of the whole text of *Yemayá y Ochún*, resonates with the negotiation of uncovering yet also hiding certain kinds of information, resonances, and connections between the different sectors of Afro-Cuban religions that Cabrera is seeking to perform, as Quiroga would agree, in her text.

This performativity lies at the heart of understanding how *los hijo/as de las dos aguas* manifest themselves in multiple and varying ways. In this chapter we heard from a daughter of Ochún and a daughter of Yemayá, Claudina Abreo Gonzalez and Mercedes Zamora Alburquerque, who approached their ritually symbiotic relationships to Yemayá and Ochún in a similar fashion. By utilizing the natural imagery of the sites where the rivers flow into the ocean, both priestesses expressed the inherent fluidity found in their boundary play in regards to their devotional acts toward the water deities. Also, a proclivity toward another kind of boundary play alluded to by Cabrera above that combines elements of *Santería, Palo,* and *Espiritismo* moves entities like Yemayá into different discursive frameworks and realms of praxis. Like Cabrera, practitioners push the boundaries of differentiation and incorporation through a performative coding that is then actively reinterpreted and added to by the religious communities as a whole.

A major aspect that Cabrera and practitioners' codes of performing Afro-Cuban religions reveals is the fluidity of subjectivity because of the shifting nature of embodiment and selfhood. As with the many switches of voice in the text *Yemayá y Ochún*, so too are different selves, names, titles, and voices expressed by practitioners of Afro-Cuban religions as they create who they are in religious, cultural, and social contexts. Indeed, a tendency exists toward multiplicity in constructing and performing especially gendered and sexualized identities. Yet this is complicated by the ramifications of Cuba's postcolonial past in how embodying history through possession rituals also marks the body in

specific ways, such as within racial and ethnic parameters that need to be critically assessed. In this regard, representations of Yemayá and Ochún are profoundly marked mythological figures that display these ethnic, racial, and gendered tensions. However, the fluidity attributed to these representations marks a kind of agency that also challenges the stereotypes used to describe them as sexualized women of color. Like Cabrera's text, images of Yemayá and Ochún described by practitioners carry their own codes that can undo, confuse, and deconstruct themselves.

Notes

The fieldwork conducted in Cuba for this piece was made possible by funding from the Harvard Divinity School's Women's Studies in Religion Program. Many thanks to my collaborators in this chapter, Claudina Abreo González and Mercedes Zamora Albuquerque, who generously spoke with me about Yemayá and Ochún during this visit.

1. Lydia Cabrera, *Yemayá y Ochún* (Miami: Colección de Chichurekú, Ediciones Universal 1980), 55. All translations from Spanish to English are my own.

2. José Quiroga, *Tropics of Desire* (New York: New York University Press, 2000), 76.

3. Cabrera, *Yemayá*, 21–41; Quiroga, *Tropics*, 76–78; Edna M. Rodríguez-Mangual, *Lydia Cabrera and the Construction of an Afro-Cuban Cultural Identity* (Chapel Hill: University of North Carolina Press, 2004), 59–98.

4. Mei Mei Sanford, "Living Water," in *Osun across the Waters*, ed. Joseph Murphy and Mei-Mei Sanford (Bloomington: Indiana University Press, 2001), 240.

5. Roy Clive Abrahams, *Dictionary of Modern Yoruba* (London: University of London Press, 1958), 528.

6. J. Lorand Matory, *Black Atlantic Religion* (Princeton: Princeton University Press, 2005), 247–48.

7. Mary Ann Clark, *Santería: Correcting the Myths and Uncovering the Realities of a Growing Religion* (Westport, CT: Praeger, 2007); Mary Ann Clark, *Where Men Are Wives and Mothers Rule* (Gainesville: University of Florida Press, 2005).

8. Oyeronke Olajubu, *Women in the Yoruba Religious Sphere* (Albany: State University of New York Press, 2003); Oyeronke Olademo, *Gender in Yoruba Oral Traditions*, Lagos: Centre for Black and Africa Arts and Civilizations (CBAAC), 2009; Jacob K. Olupona, "*Orisa Osun*: Sacred Kingship and Civil Religion in Osogbo, Nigeria," in *Osun across the Waters*, ed. Joseph Murphy and Mei Mei Sanford (Bloomington: Indiana University Press, 2001), 47–67; Babatunde Lawal, *The Gelede Spectacle* (Seattle: University of Washington Press, 1996), 42–43, 49, 256; Rachel Elizabeth Harding, "What Part of the River You're In," in *Osun across the Waters*, ed. Joseph Murphy and Mei-Mei Sanford (Bloomington: Indiana University Press, 2001), 165–88; Matory, *Black Atlantic*,

151, 247–48; J. Lorand Matory, *Sex and the Empire That Is No More* (Oxford and New York: Berghahn Books, 2005); Cabrera, *Yemayá*, 43–46; Rodríguez-Mangual, *Lydia Cabrera*, 13, 90–93; Quiroga, *Tropics*, 76, 81; Randy P. Conner and David Hatfield Sparks, *Queering Creole Spiritual Traditions* (Binghamton: Harrington Park, 2004), 108–09; 235–37.

 9. See Natalia Bolívar, *Los Orishas en Cuba* (Havana: Unión, 1995). The connections among La Virgen de Regla, La Caridad del Cobre, Yemayá, and Ochún in Cuba are particularly felt in the sphere of the island's public culture on the contiguous Catholic feast days of September 7 for La Virgen de Regla and September 8 for La Caridad del Cobre, where celebrations in honor of the two Catholic saints and the two *orichas* are vigorously and elaborately expressed. For more on these connections see Cabrera's *Yemayá*, 9–19, 55–69.

 10. All excerpts of Mercedes Zamora Albuquerque and Claudina Abreo González in this chapter are taken from interviews that took place in November 2009. Both women were interviewed in their homes in Havana, Cuba.

 11. *Iyalocha* can be translated as "mother of the gods." For more on race, religion, and gender in Havana, see Solimar Otero, "The Ruins of Havana: Representations of Memory, Religion, and Gender," *Atlantic Studies* 9, no. 2 (2012): 143–63.

 12. Claudina Abreo González, Interview with author, Havana, Cuba, 2009.

 13. This is similar to how Yoruba traditional orature also has an oral literary criticism and accepted aesthetic based on quotation. For more on this point see Karin Barber's essay, "Quotation and the Constitution of Yoruba Oral Texts," *Research in African Literatures* 30, no. 2 (1999): 1–17.

 14. Alan Dundes, "Metafolklore and Oral Literary Criticism," in *The Meaning of Folklore*, ed. Simon J. Bronner (Logan: Utah State University Press, 2007), 80–87.

 15. Yemayá is associated with mermaids and her long hair in the tale may be related to the folk literature motif B81.9.1, *Mermaid's hair reaches her waist*, found in Stith Thompson's, *Motif-index of Folk-Literature* (Bloomington: Indiana University Press, 1955–58), 370–71.

 16. Abreo González, interview, Havana, Cuba, 2009.

 17. Cabrera, *Yemayá*, 70, 83.

 18. Thompson, *Motif-index*, 370–71; Henry John Drewal, ed. *Sacred Waters* (Bloomington: Indiana University Press, 2008), xii–xvii, 1–18.

 19. Cabrera, *Yemayá*, 55, 70, 83; Isabel Castellanos, "A River of Many Turns: The Polysemy of Ochún in Afro-Cuban Tradition," in *Osun across the Waters,* ed. Joseph Murphy and Mei-Mei Sanford (Bloomington: Indiana University Press, 2001), 27, 41.

 20. Cabrera, *Yemayá*, 117–99.

 21. Ibid., 83–84.

 22. Vera M. Kutzinski, *Sugar's Secrets: Race and the Erotics of Cuban Nationalism* (Charlottesville: University of Virginia Press, 1993) 5, 75, 165–66, 174–79; Alicia Arrizón, *Queering Mestizaje: Transculturation and Performance* (Ann Arbor: University of Michigan Press, 2006), 101–06.

23. For more on the connections between Ochún and *La Virgen de la Caridad del Cobre* see Joseph Murphy, "Yéyé Cachita: Ochún in a Cuban Mirror," in *Osun across the Waters*, ed. Joseph Murphy and Mei-Mei Sanford (Bloomington: Indiana University Press, 2001), 87–101.
24. Arrizón, *Queering*, 117.
25. Jose Estaban Muñoz, *Disidentifications* (Minneapolis: University of Minnesota Press, 1999), 31–33.
26. Cabrera, *Yemayá*, 79.
27. Thompson, *Motif-index*, 371.
28. Ibid.
29. Drewal, *Mami Wata*, 1–18.
30. Barber, *I Could Speak until Tomorrow* (Washington, DC: Smithsonian Institution Press, 1991); Olajubu, *Women*, 27–30; Olademo, *Gender*, 105–09.
31. Clark, *Santería*, 131–44; Clarke, *Where Men*, xix–xx.
32. Quiroga, *Tropics*, 81.
33. David Samper, "Cannibalizing Kids: Rumor and Resistance in Latin America," *Journal of Folklore Research* 39, no. 1 (2002): 1–32; Paulette Silva Beauregard, "La feminización del héroe moderno y la novela en 'Lucía Jerez' y 'El hombre de hierro,'" *Revista de Crítica Literaria Latinoamericana* 26, no. 52 (2000): 135–51; Juan Pablo Dabove, "Los pasquines como alegoría de la disolución de la ciudadanía en 'La mala hora, de Gabriel García Márquez,'" *Revista de Crítica Literaria Latinoamericana* 26, no. 52 (2000): 269–87; Adam Jaworski and Justine Coupland, "Othering in Gossip: 'You Go out You Have a Laugh and You Can Pull Yeah Okay but Like . . .'" *Language in Society* 34, no.5 (2005): 667–94; Gloria Anzaldúa, *Borderlands: La Frontera*, 2nd ed. (San Francisco: Aunt Lute Books, 1999), 76.
34. Laura Alexandra Harris, "Queer Black Feminism: The Pleasure Principle," *Feminist Review* 4 (1996): 3–30.
35. See Harding, "What Part," 165–88.
36. Kamari Maxine Clarke, *Mapping Yorùbá Networks* (Durham, NC: Duke University Press, 2004), 257–78.
37. Beliso De-Jesús, Aisha, "Reimagining the 'Global' versus 'Local': Religious Cosmopolitanisms and Transnational *Santería*." Forthcoming.
38. See Micaela Sánchez-Díaz chapter in this volume, " 'Yemaya Blew that Wire Fence Down': Invoking African Spiritualities in Chicana Cultural Production," for more on mestiza representations of Yemayá.
39. Abreo González, interview, Havana, Cuba, 2009.
40. Ibid.
41. Ysamur Flores-Peña, " 'Overflowing with Beauty': The Ochún Altar in *Lucumí*Aesthetic Tradition," in *Osun across the Waters*, ed. Joseph M. Murphy and Mei-Mei Sanford (Bloomington: Indiana University Press, 2001), 114–16, 20; David HilaryBrown, *Santería Enthroned* (Chicago: University of Chicago Press, 2003), 218–19, 224; Cabrera, *Yemayá*, 114–15.
42. Cabrera, *Yemayá*, 115.
43. Quiroga, *Tropics*, 76–78, 80; Rodríguez-Mangual, *Lydia Cabrera*, 96–104. See also for an example containing Yemayá, Cabrera, *El Monte Igbo*

Finda Ewe Orisha. Vititi Nfinde (Miami: Colección de Chicherekú en el exilio, Ediciones Universal, 1983), 41–42.

44. Cabrera, *Yemayá*, 70–71.

45. Ibid., 22, 29.

46. Arnold van Gennep, *The Rites of Passage* (New York: Routledge, 2010), 166–72; Victor Turner, *The Ritual Process* (Piscataway, NJ: Transaction, 1995), 94, 96, 102–18, 189.

47. Karin Barber, "Oríkì, Women and the Proliferation and Merging of *Orisa*," *Africa* 60, no. 3 (1990): 313–37; Pierre Fatumbi Verger, "Trance and Convention in Nago-Yoruba Spirit Mediumship," in *Spirit Mediumship and Society in Africa*, ed. John Beattie and John Middleton (New York: Africana, 1969), 50–66; Ruth Landes, *The City of Women* (Albuquerque: University of New Mexico Press, 1994), 231–34; Matory, *Black Atlantic*, 64–70, 220–24, 265; Matory, *Sex*, 215–23.

48. Solimar Otero, "Spirit Possession, Havana, and the Night: Listening and Ritual in Cuban Fiction," *Western Folklore* 66, no. 1/2 (2007): 61–64; Margaret Thompson Drewal, *Yoruba Ritual* (Bloomington: Indiana University Press, 1992), 12–28; Olabiyi Babalola Yai, "In Praise of Metonymy: The Concepts of 'Tradition' and 'Creativity' in the Transmission of Yoruba Artistry over Time and Space," in *The Yoruba Artist*, ed. Henry Drewal et al. (Washington: Smithsonian Institute Press, 1994), 113–14.

49. Mercedes Zamora Albuquerque, interview with author, Havana, Cuba, 2009.

50. Kali Argyriadis, *La religión à la Havane* (Paris: Éditions Archives Contemporaines, 1999); Kamari Maxine Clarke, *Mapping*, 52–58, 72–73.

51. Raquel Romberg, "'Today, Changó Is Changó': How Africanness becomes a Ritual Commodity in Puerto Rico," *Western Folklore* 66, no.1/2 (2007): 75–106; Viarnés Carrie, "Cultural Memory in Afro-Cuban Possession: Problematizing Spiritual Categories, Resurfacing 'Other' Histories," *Western Folklore* 66, no. 1/2 (2007): 127–60.

52. Kamari Maxine Clarke and Deborah A. Thomas, eds., *Globalization and Race* (Durham: Duke University Press, 2006), 3–4, 10–14; Raquel Romberg, *Witchcraft and Welfare* (Austin: University of Texas Press, 2003), 205–07.

53. Muñoz, *Disidentifications*, 8–11, 21–23; Arrizón, *Queering*, 88–91, 95–99, 177–78.

54. Viarnés, "Cultural Memory," 129–30, 150–53; Christina Ayorinde, *Afro-Cuban Religiosity, Revolution and National Identity* (Tampa and Miami: University Press of Florida, 2004), 40–43, 64–69, 144–45.

55. For an example of how *Yemayá* becomes a vehicle for similar kinds of negotiations surrounding gender and ritual power in Nigerian contexts see Matory, *Sex*, 243–50, 253–64.

56. Quiroga, *Tropics*, 85–88; Mikhail Bakhtin, *The Dialogic Imagination*, ed. Michael Holquist, trans. Caryl Emerson and Michael Holquist (Austin: University of Texas Press, 1982), 273, 278–93, 324–25, 399.

57. Cabrera, *Yemayá*, 44–45.

58. Ibid., 44–45; Rodríguez-Mangual, *Lydia Cabrera*, 91–92.

59. Cabrera, *Yemayá*, 45.
60. Ibid.
61. Ibid., 44–45.
62. Ibid., 87.
63. Ibid., 45–46.
64. Anzaldúa in Arrizón, *Queering*, 158.
65. Anzaldúa, *Borderlands*, 1999, 76–79; Arrizón, *Queering*, 160–75; Samper, "Cannibalizing," 1–32; Yvonne Yarbro-Bejarano, "Traveling Transgressions," in *Reading and Writing the Ambiente*, ed. Susana Chávez-Silverman and Librada Hernández (Madison: University of Wisconsin Press, 2000), 200–38; Rodríguez-Mangual, *Lydia Cabrera*, 60–99.
66. Rodríguez-Mangual, *Lydia Cabrera*, 91, 100–12; Clark, *Where Men*, xix–xx.
67. Cabrera, *Yemayá*, 20–44, 69–91, 112–19; Joseph M. Murphy, "Yéyé Cachita," in *Osun across the Waters*, ed. Joseph Murphy and Mei-Mei Sanford (Bloomington: Indiana University Press, 2001), 87–101.
68. Jafari Sinclaire Allen, "Means of Desire's Production: Male Sex Labor in Cuba 1," *Identities* 14, no. 1/2 (2007): 183–202.
69. Judith Butler, *Excitable Speech* (New York: Routledge, 1997), 71–73, 93, 99; Judith Butler, *Bodies That Matter* (New York: Routledge, 1993), 139–68, 169–85; Muñoz, *Disidentifications*, 12–13, 80, 92, 189–93.
70. Quiroga, *Tropics*, 79.
71. Cabrera, *Yamayá*, 55.
72. Quiroga, *Tropics*, 77–78.
73. Viarnés, "Cultural Memory," 127–60; Romberg, "Today Changó," 75–106; Julyanne E. Dodson, *Sacred Spaces and Religious Traditions in Oriente Cuba* (Albuquerque: University of New Mexico Press, 2008), 7–8, 81–103, 124–46.
74. Rodríguez-Mangual, *Lydia Cabrera*, 59–98.
75. Quiroga, *Tropics*, 80–84; Bakhtin, *The Dialogic*, 270–72, 300–02, 430.
76. Cabrera, *Yemayá*, 16.
77. Kristina Wirtz, *Ritual, Discourse, and Community in Cuban* Santería (Gainesville: University Press of Florida, 2007); Isabel Castellanos, "From Ulukumí to Lucumí," in *Santería Aesthetics in Contemporary Latin American Art*, ed. Arturo Lindsay (Washington and London: Smithsonian Institute Press, 1996), 39–50.
78. Cabrera translates the *lucumí* phrases *Itaná, idi, ochiché* in Spanish as *velas, amarres*, and *hechizos*, respectively. See Cabrera, *Yemayá*, 290n184.
79. Cabrera, *Yemayá*, 290–341.

References

Abrahams, Roy Clive. *Dictionary of Modern Yoruba*. London: University of London Press, 1958.

Abreo González, Claudina. Ethnographic Interview, Havana, Cuba, November 10, 2009.
Allen, Jafari S. "Means of Desire's Production: Male Sex Labor in Cuba 1." *Identities* 14, no. 1/2 (2007): 183–202.
Argyriadis, Kali. *La religión à la Havane: Actualités des représentations et des pratiques cultuelles [sic] havanaises*. Paris: Éditions Archives Contemporaines, 1999.
Arrizón, Alicia. *Queering Mestizaje: Transculturation and Performance*. Ann Arbor: University of Michigan Press, 2006.
Anzaldúa, Gloria. *Borderlands: La Frontera. The New Mestiza*. 2nd ed. San Francisco: Aunt Lute Books, 1999 (1987).
Aparicio, Frances R., and Susana Chávez-Silverman, eds. *Tropicalizations: Transcultural Representations of Latinidad*. Hanover: Dartmouth College, 1997.
Ayorinde, Christina. *Afro-Cuban Religiosity, Revolution and National Identity*. Tampa and Miami: University Press of Florida, 2004.
Bakhtin, Mikhail. *The Dialogic Imagination*. Edited by Michael Holquist, Translated by Caryl Emerson and Michael Holquist. Austin: University of Texas Press, 1982.
Barber, Karen. *I Could Speak until Tomorrow: Oriki, Women, and the Past in a Yoruba Town*. Washington, DC: Smithsonian Institution Press, 1991.
———. "Oríkì, Women and the Proliferation and Merging of *Orisa*." *Africa* 60, no. 3 (1990): 313–37.
———. "Quotation and the Constitution of Yoruba Oral Texts." *Research in African Literatures* 30, no. 2 (1999): 1–17.
Barnet, Miguel. "Cuba: Tres Disquisiciones Etnologicas." *Ibero Americana* 13, no. 2 (1984): 61–76.
Beauregard, Paulette Silva. "La feminización del héroe moderno y la novela en 'Lucía Jerez' y 'El hombre de hierro.'" *Revista de Crítica Literaria Latinoamericana* 26, no. 52 (2000): 135–51.
Behar, Ruth, and Lucía M. Suárez, eds. *The Portable Island: Cubans at Home in the World*. New York: Palgrave Macmillan, 2008.
Beliso De-Jesús, Aisha. "Reimagining the 'Global' versus 'Local': Religious Cosmopolitanisms and Transnational *Santería*." Forthcoming.
Bolívar, Natalia. *Los Orishas en Cuba*. Havana: Unión, 1990.
Brown, David Hilary. *Santería Enthroned: Art Ritual and Innovation in an Afro-Cuban Religion*. Chicago: University of Chicago Press, 2003.
Butler, Judith. *Bodies That Matter: On the Discursive Limits of "Sex."* New York: Routledge, 1993.
———. *Excitable Speech: A Politics of the Performative*. New York: Routledge, 1997.
Cabrera, Lydia. *El Monte: Igbo Finda Ewe Orisha Vititi Nfinda*. Miami: Colección de Chicherukú, Ediciones Universal, 2006 (1954).
———. *Yemayá y Ochún: Kariocha, Iyaloichas Y Olorichas*. Miami: Colección de Chicherekú, Ediciones Universal, 1980.
Castellanos, Isabel. "From Ulukumí to Lucumí: A Historical Overview of Religious Acculturation in Cuba." In *Santería Aesthetics in Contemporary*

Latin American Art, edited by Arturo Lindsay, 39–50. Washington and London: Smithsonian Institute Press, 1996.
Clark, Mary Ann. *Santeria: Correcting the Myths and Uncovering the Realities of a Growing Religion*. Westport, CT: Praeger, 2007.
———. *Where Men Are Wives and Mothers Rule: Santería Ritual Practices and Their Gender Implications*. Gainesville: University of Florida Press, 2005.
Clarke, Kamari Maxine. *Mapping Yorùbá Networks: Power and Agency in the Making of Transnational Communities*. Durham: Duke University Press, 2004.
Clarke, Kamari Maxine, and Deborah A. Thomas, eds. *Globalization and Race: Transformations in the Cultural Production of Blackness*. Durham: Duke University Press, 2006.
Conner, Randy P., and David Hatfield Sparks. *Queering Creole Spiritual Traditions: Lesbian, Gay, Bisexual, and Transgender Participation in African-Inspired Traditions in the Americas*. Binghamton: Harrington Park, 2004.
Dabove, Juan Pablo. "Los pasquines como alegoría de la disolución de la ciudadanía en 'La mala hora, de Gabriel García Márquez.'" *Revista de Crítica Literaria Latinoamericana* 26, no. 52 (2000): 269–287.
Dodson, Julyanne E. *Sacred Spaces and Religious Traditions in Oriente Cuba*. Albuquerque: University of New Mexico Press, 2008.
Drewal, Henry John. "Introduction: Charting the Voyage." In *Sacred Waters: Arts for Mami Wata and Other Divinities in Africa and the Diaspora*, edited by Henry Drewal, 1–18. Bloomington: Indiana University Press, 2008.
Drewal, Margaret Thompson. *Yoruba Ritual: Performers, Play, Agency*. Bloomington: Indiana University Press, 1992.
Dundes, Alan. "Metafolklore and Oral Literary Criticism." In *The Meaning of Folklore*, edited by Simon J. Bronner, 80–87. Logan: Utah State University Press, 2007.
Flores-Peña, Ysamur. "'Overflowing with Beauty': The Ochún Altar in *Lucumi* Aesthetic Tradition." In *Osun across the Waters*, edited by Joseph M. Murphy and Mei-Mei Sanford, 113–27. Bloomington: Indiana University Press, 2001.
Harding, Rachel Elizabeth. "What Part of the River You're In." In *Osun across the Waters*, edited by Joseph M. Murphy and Mei-Mei Sanford, 165–88. Bloomington: Indiana University Press, 2001.
Harris, Laura Alexandra. "Queer Black Feminism: The Pleasure Principle." *Feminist Review* 4 (1996): 3–30.
Jaworski, Adam, and Justine Coupland. "Othering in Gossip: 'You Go out You Have a Laugh and You Can Pull Yeah Okay but Like . . .'" *Language in Society* 34, no. 5 (2005): 667–694.
Kutzinski, Vera M. *Sugar's Secrets: Race and the Erotics of Cuban Nationalism*. Charlottesville: University of Virginia Press, 1993.
Landes, Ruth. *The City of Women*. Albuquerque: University of New Mexico Press, 1994 (1947).

Lawal, Babtunde. *The Gelede Spectacle: Art, Gender, and Social Harmony in an African Culture.* Seattle: University of Washington Press, 1996.

Matory, James Lorand. *Black Atlantic Religion: Tradition, Transnationalism and Matriarchy in Afro-Brazilian Candomble.* Princeton: Princeton University Press, 2005.

———. *Sex and the Empire That Is No More: Gender and the Politics of Metaphor in Oyo Yoruba Religion.* Oxford and New York: Berghahn Books, 2005, (1994).

Muñoz, Jose Estaban. *Disidentifications: Queers of Color and the Performance of Politics.* Minneapolis: University of Minnesota Press, 1999.

Murphy, Joseph M. "Yéyé Cachita: Ochún in a Cuban Mirror." In *Osun across the Waters*, edited by Joseph Murphy and Mei-Mei Sanford, 87–101. Bloomington: Indiana University Press, 2001.

Olajubu, Oyeronke. *Women in the Yoruba Religious Sphere.* Forward by Jacob Olupona. Albany: State University of New York Press, 2003.

Olademo, Oyeronke. *Gender in Yoruba Oral Traditions.* Lagos: Centre for Black and Africa Arts and Civilizations (CBAAC), 2009.

Olupona, Jacob K. "*Orisa Osun*: Sacred Kingship and Civil Religion in Osogbo, Nigeria." In *Osun across the Waters*, Edited by Joseph Murphy and Mei-Mei Sanford, 47–67. Bloomington: Indiana University Press, 2001.

Otero, Solimar. "The Ruins of Havana: Representations of Memory, Religion, and Gender." *Atlantic Studies* 9, no. 2 (2012): 143–63.

———. "Spirit Possession, Havana, and the Night: Listening and Ritual in Cuban Fiction." *Western Folklore.* 66, no. 1/2 (2007): 45–74.

Paravisini-Gerbert, Elizabeth, and Margarite Fernandez-Olmos. *Creole Religions of the Caribbean. An Introduction from Vodou and Santería to Obeah and Espiritismo.* New York: New York University Press, 2003.

Quiroga, José. *Tropics of Desire. Interventions from Queer Latin America.* New York: New York University Press, 2000.

Rodríguez-Mangual, Edna M. *Lydia Cabrera and the Construction of an Afro-Cuban Cultural Identity.* Chapel Hill: University of North Carolina Press, 2004.

Romberg, Raquel. " 'Today, Changó Is Changó': How Africanness becomes a Ritual Commodity in Puerto Rico." *Western Folklore* 66, no. 1/2 (2007): 75–106.

———. *Witchcraft and Welfare. Spiritual Capital and the Business of Magic in Modern Puerto Rico.* Austin: University of Texas Press, 2003.

Samper, David. "Cannibalizing Kids: Rumor and Resistance in Latin America," *Journal of Folklore Research* 39, no. 1 (2002): 1–32.

Sanford, Mei Mei. "Living Water." In *Osun across the Waters*, edited by Joseph Murphy and Mei-Mei Sanford, 237–250. Bloomington: Indiana University Press, 2001.

Thompson, Stith. *Motif-index of Folk-Literature: A Classification of Narrative Elements in Folk-Tales, Ballads, Myths, Fables, Mediaeval Romances, Exempla, Fabliaux, Jest-Books, and Local Legends.* 6 vols., Rev. ed. Bloomington: Indiana University Press, 1955–58.

Turner, Victor W. *The Ritual Process: Structure and Anti-Structure*. Forward by Roger Abrahams. Piscataway, NJ: Transaction, 1995 (1969).
van Gennep, Arnold. *The Rites of Passage*. New York: Routledge, 2010 (1977).
Verger, Pierre Fatumbi. "Trance and Convention in Nago-Yoruba Spirit Mediumship." In *Spirit Mediumship and Society in Africa*, edited by John Beattie and John Middleton, 50–66. New York: Africana, 2010 (1977).
Viarnés, Carrie. "Cultural Memory in Afro-Cuban Possession: Problematizing Spiritual Categories, Resurfacing 'Other' Histories." *Western Folklore* 66, no. 1/2 (2007): 127–60.
Wirtz, Kristina. *Ritual, Discourse, and Community in Cuban Santería: Speaking a Sacred World*. Gainesville: University Press of Florida, 2007.
Yai, Olabiyi Babalola. "In Praise of Metonymy: The Concepts of 'Tradition' and 'Creativity' in the Transmission of Yoruba Artistry over Time and Space." In *The Yoruba Artist: New Theoretical Perspectives of African Art*, edited by Henry Drewal, John Pemberton III, and Rowland Abiodun, 107–15. Washington: Smithsonian Institute Press, 1994.
Yarbro-Bejarano, Yvonne. "Traveling Transgressions: *Cubanidad:* Performances of Carmelita Tropicana and Marga Gomez." In *Reading and Writing the Ambiente: Queer Sexualities in Latino, Latin American and Spanish Culture*, edited by Susana Chávez-Silverman and Librada Hernández, 200–17. Madison: University of Wisconsin Press, 2000.
Zamora Albuquerque, Mercedes. Ethnographic Interview, Havana, Cuba, November 12, 2009.

Chapter 4

A Different Kind of Sweetness
Yemayá in Afro-Cuban Religion

Martin Tsang

Àgòlona o ìyálé,
Ìyalé, ìyá ìlú mi o.
Ìyalé oní abe,
Ayaba omi o.

Make way for the senior wife,
Senior wife, mother of my town.
Senior wife, owner of the reproductive organs,
Queen of water.

—Traditional Afro-Cuban praise song for Yemayá[1]

Yemayá is the regal matriarch: the sovereign mother, whose dignity transcends all human afflictions. It is this queenly resplendence that commands the respect of all *orishas*. She is the supreme head of the Ìyáàmi/Àje and of the Gèlèdé and Efe masquerading traditions. She is the bringer of children and the great monarch sought out for fecundity and equally feared for her wrath. In song, she is said to fashion her crown from the woes and tragedies of her children. The mother and warrior of indisputable reputation and respect, she answers to no one and is solely interested in the welfare and betterment of her devotees. This chapter will interrogate the evolving nature and unique character of Yemayá within Afro-Cuban religious practice (Lukumí or La Regla de Ocha) in Cuba and the wider diaspora. The following draws on years

of fieldwork conducted in Cuba and the United States among *orisha* devotees, as both anthropologist and priest. My involvement in the Lukumí religion came before my official entry into the world of social science and academe. I began learning about the *orisha* at the age of fourteen, and in 2001 I was initiated as a priest of Erinle, which, in the Lukumí system as described below, is ritually conducted under the auspices of Yemayá. This dual-sided, personal-academic approach has aided me in being able to spot gaps in the existing literature devoted to the *orishas*. One such interstice is the paucity of in-depth information published on the myriad and detailed aspects of Yemayá, her paths, or avatars, and also the lesser-known deities that accompany her. Perhaps the richest sources of information to which we have access are the oral divinatory narratives that explain the lives and interactions of the deities, which harmonize what could be, at some points, disjointed and, at others, overlapping spheres of knowledge and boundaries attributed to the different deities. These are invoked in this chapter to help us further understand the range and reach of Yemayá's domain, her unique status among the pantheon of *orishas*, and the qualities that she encompasses.

The Lukumí[2] and their descendants logically saw the sea as the largest and most comprehendible symbol of Yemayá, and, as such, it has become her primary symbolic abode for worshippers in the Americas. From the Middle Passage onward, the sea became a core motif within the lives of Lukumí in Cuba: the watery abyss that claimed countless lives en route from Africa as well as a symbol of regeneration, repletion, and continuity. Salt water covers more than 70 percent of the earth's surface, making it an impressive testament to Yemayá's expansiveness. As the eldest and most revered of Olókun's daughters, Yemayá is venerated in *oríkì* (praise poetry), as *omiró* (salt water) and Arugbá Olókun, the carrier of the calabash of Olókun's power. As owner of water, she is responsible for all life on earth as all chemical reactions in the body happen in the presence of water.

Yemayá holds an exalted position within Lukumí worship. She is the guardian of divination, having given to the world the means of prophecy by use of cowry shells or *dilogun*, often called the "mouthpiece" of the *orishas*. As will be discussed here, she is the sole female *orisha* given authority and entrusted to speak for other male *orishas*, who, for reasons of dogmatic inhibition, have no voice of their own. Another epithet names Yemayá queen of the world, whose authority and word on earth are equaled only by Obatalá and Olodumare. Ideas of gender and sexuality within Lukumí tradition will be discussed here in which Yemayá is described as feminine but one who labors like a man. This is an austere and nuanced characteristic attributed only to this deity. Yemayá is in

charge of fertility, the midwife, of motherhood and matrimony. Yemayá is the supreme head of the secret sorority of Ìyáàmi, or guild of feminine *ashé*, and of the Gèlèdé (Thompson 1971). She, above all other *orishas*, is the protector of homosexual men and women (Cabrera 1975). Furthermore, Yemayá's followers come from and are located on every continent; she is the essence of maternal power and instinct. She is the *orisha* of life and the bastion of tradition. The mother, in all its aspects and meanings, is conveyed in Yemayá. Water is her fundamental element, which in turn has become a metaphor for life, health, and stability.

Popular culture has at times rendered Yemayá as a matronly, domestic figure, connoted with La Virgen de Regla, the patron of the town in Havana that bears her name. Often what is not conveyed in such stereotypes is her brute strength and capacity to resolve the problems of her adherents in a resolutely sangfroid manner. Her devotees will attest that Yemayá's attention can be severe and that she does not readily excuse or forgive unwarranted or unjust malicious behavior, especially if it is directed at one of her devotees. Indeed, at times it may seem that Yemayá is turning her back to her devotee; however, such a position is due to the profundity of her power and the intensity by which she is working on behalf of her child. In such circumstances discipline and strength are of paramount importance. Her priests will often tell you that Yemayá never directly requires an offering or demands sacrificial attention, insofar that the devotee, through divination, is more often than not instructed to attend to another *orisha*, such as Shangó or Oshun.

This, at the surface level, may seem like a laissez-faire or uninterested countenance on Yemayá's behalf, yet nothing could be farther from the truth. Yemayá displays the qualities and characteristics of a truly selfless and loving matriarch. She wishes to see her children succeed in life, and she is constantly supporting those whose lives are not going well, Ultimate responsibility for the well-being of the devotee rests at Yemayá's feet, something that she never shies away from. Yemayá is tireless in defending those that have been abused or marginalized, and it is in these circumstances that we see Yemayá's power in action. The tears that the person cries are like her own, and she is the source not only of comfort and succor but of revolution. Yemayá as mother acts in the best interests of her children. As a mother figure, she moves to resolve and to change that which is needed and required, as opposed to that which is wanted or desired. In so doing, Yemayá's action may seem harsh, even brutal, yet ultimately for the greater and necessary good.

It is said that wherever water is, Yemayá is present. Impressive and majestic, the sea is a comforting and awe-inspiring sign of Yemayá's greatness. Being the owner of all waters, Yemayá doled out specific

aquatic domains to her children and other related deities: Oshun, Oya, Oba, Iyewa, and Erinle received freshwater streams and deep water tributaries in which to repose. Olókun resides in the depths of the vast oceans. Nana Buruku dwells in freshwater lagoons and mountain springs. Orisha Abatán received the ponds and marshlands, and Olosa, the saltwater lagoons. Water chemistry and physics are similarly meted out by Yemayá. Boromu oversees underwater currents. The waves of the sea and the treasure they bring to the surface are governed by Olókun and Yemayá in her aspect as Ibú Mojelewu. Despite the co-opting of domains, Yemayá is the true sovereign of all waters and all activity that takes place therein. Along with Oshumaré, the rainbow deity, Yemayá Ibú[3] Sanma is the *orisha* of the raindrop, necessary for the cycle of life on earth to continue. From the ocean to the teardrop to the water contained in every living cell, Yemayá is present, and her life-affirming force is necessary.[4]

Yemayá in Afro-Cuban Thought

Yemayá is a complex constellation of metaphor, action, and power and is readily identifiable with cognate deities found in Cuba. Yemayá is known as the Dahomean *vodún*, Afreketé among the Arará in Matanzas, and as Kalunga or Madre de Agua in the Kongo and Bantu-derived religions of Palo Monte. For many, she is likened to and sometimes transposed as La Virgen de Regla, the patron of Havana. Within the Lukumí religious tradition, Yemayá is pluralized into several aspects or distinct roads that deepen knowledge of her.[5] The Lukumí distinguish between a number of avatars of Yemaya, each affording a different understanding of this multifaceted deity. Often called roads (caminos), they are avenues along which different functions and metaphors of Yemayá can be explored and expounded upon. These avatars are avenues by which the entirety of Yemayá becomes better understood. Obatalá, Yemayá's king consort, similarly contains multiple roads for understanding this great *orisha* or "*orishanla.*"

Yemayá Ibú Ogunte, wife of Ogun Alagbede, bears the sobriquets of "la machetera," (she who wields a machete) and "la brava" (the brave one.) In this manifestation, she lives in the forest, hitches up her skirts for battle, and wears *mariwo* (a fringe made from palm fronds shared with other warrior deities) so that she can accompany her husband in the many chores traditionally assigned to the male role. Offerings of ice and rum are made to her in times of war, more often associated with male deities such as Ogun. Yemayá does not conform to gendered

divisions in offerings; she is able to utilize the arsenal of tools, symbols, and power doled out to her children, the other *orisha*, eloquently communicating her exalted status and rank.

Yemayá Ibú Okoto is the treacherous current within the otherwise seemingly calm water, known as the underwater assassin who is said to be responsible for accidents and tragedies at sea. Her reputation is intrinsically linked with her name, which comes from the *òkòtó* shell, a small red seashell that washes up on the beach in great numbers. Its red color makes the beach look as if it is drenched in blood. Red, the color of danger, war, power, and ultimately life is similarly conveyed in her sacred vessel. Her consecrated metal implements within her shrine are kept in water that is allowed to become rusty, turning the water red. She is also the sovereign of the Red Sea. This aspect of Yemayá is also connected with the Gèlèdé masquerading tradition and with humanity's ability to appease negative unseen destructive forces. Babatunde Lawal reports that the "first Gèlèdé anklets were reportedly made of seashells (*òkòtó*): hence, Gèlèdé's epithet '*Olókun dé é é é é é o; Àjàró ò ò ò Òkòtó*' 'Here comes the sea goddess Olókun, the roaring eddy of seashells!'" (Lawal 1996, 68).

Another manifestation of Yemayá connected to the masking traditions is Ibú Mojelewu, original owner of the mask given to Olókun. Such a mask used to be danced at the turn of the nineteenth century in Cuba's Olókun worship; however this tradition no longer survives on the island. It may have died out due to an unwillingness of the keepers of the Olókun mask to teach successive generations the secrets of the dance. Senior priestesses, such as Fermina Gómez, presided over Olókun worship (Castro and Alegre 2007); they restricted junior priests and the uninitiated from access to the Olókun shrine and related ceremonies as they were thought to be unprepared to attend to the unfathomable and massive force of this deity.

Yemayá Ibú Aró received the colors of the rainbow from Oshumaré, which is reflected in the beaded necklaces that adorn her devotees. Her shrine is surrounded by *ìkòkò aró méje* (seven pots of indigo), the blue pigment that denotes royalty and is used ceremonially. She is the patron of *àdìre* cloth makers, known as *àdìre eleko*. The cloth is treated with indigo and cornstarch to produce traditional patterns called Olókun and Eja or "fish."

Yemayá Ibú Asesu is one of the more austere paths of Yemayá: She is the queen of the dead and aids Olókun in transitioning the souls of the departed from heaven to the bottom of the sea. She is owner of the swan, whose fabled song is similar to Asesu's role of informing Olókun that a soul will soon be passing. In this avatar, she plays games

of selective memory to confuse and cause despair to her adversaries in times of war.

Alongside Yemayá, there are other *orishas* connected to her worship. Otin, specifically important for children of Yemayá, came to Cuba from the Okuku and Inisha areas of Yorùbáland. Otin imparts stability and balance in a person's life. This *orisha* guides and transmits Yemayá's *ashé* represented by consecrated emblems known for their durability and stability, physically representations of the characteristics Otin imparts to the worshipper.[6] Priests of Yemayá receive the consecrated vessel of Otin and also may, as divination advises, receive other members of the family that constitute Yemayá and Olókun's court, including Ayarakotó and Aje Shaluga.

Yemayá as Divine and Divinatory Authority

Yemayá has the unique position of and ability to speak for other male *orishas*: namely, Erinle, Orisha Oko, and Olókun. Within the Lukumí divination system, Elegba and Òrúnmìlà are the male *orishas* who act as intermediaries and advocate for all the *orishas*. Ifá, the potent deity of wisdom and divination, is joined with Igba Odu, the calabash of existence, also known as Olofin, a female entity that encompasses wisdom and knowledge disseminated through divination and imparted to humans. Eshu Elegba is the messenger, the voice of all the *orishas*, and he is entrusted with effective communication. He ensures that prayers and sacrifices are delivered to the *orishas*. Elegba's *dilogun* are consulted regularly by *olorisha*, and it is Elegba's *dilogun* that are used for quotidian consultations.

In addition to divining with Elegba's *dilogun* or Ifá's *ikin* (palm nuts) and *opele* (divining chain), each *orisha* has his or her own set of dilogun, mouthpieces that are born with the other physical embodiments of the *orisha* during the initiation process. In those instances where the *orisha* does not have the ability to speak directly through his or her own *dilogun*, Yemayá is the sole female *orisha* that holds this key position as delegate.[7] Orisha Oko, Erinle, and Olókun speak through Yemayá. These three *orishas* are an interesting triumvirate of powers for what they each represent and the profundity by which this relationship is marked. The initiation of persons whose tutelary *orisha* is Orisha Oko, Erinle, or Olókun is performed through the intermediary Yemayá. Several reasons are given for this. It should also be noted that these three are connected in different ways to either androgyny or gender variance. This dynamic of "female" *orisha* Yemayá having the

ability to speak for other "male" *orishas* is poorly understood within the confines of masculine and feminine roles. It can be argued that just as Yemayá transcends notions of gendered understandings of deities, the *orishas* routinely transcend such dichotomies.

The Lukumí priesthood is comprised of priests, called *olorisha*—literally those that have *orisha*. Divination determines which particular *orisha's* priesthood a person will be initiated. Within the Lukumí worldview, a person's *eledá* (spiritual) head collects his or her own personal destiny in heaven before coming to the world. Eshu Elegba and Òrúnmìlà are present at this choosing, witnessing the process and recording the destiny, which enables them to aid the adherent in life through divination. This destiny is likened to a calabash that the person brings with him into the world, filled with certainties (fate), probabilities as well as yet undetermined or chance happenings, and karmic and spiritual ties from past lives. Upon choosing one's individual destiny, one *orisha* steps forward as the person's *alaleyo* (principal) guardian *orisha*. This match of person and *alaleyo* is necessary to manifest the best possible permutations of the destiny the person chose before birth (Abimbola 1976, 148).[8] Through establishing a complementary relationship with the guardian *orisha*, heeding divination, and making sacrifice, the person safeguards against possible misfortune and negative outcomes and aligns himself with the best of life's possibilities.

The union of a person with her or his *alaleyo* is achieved through initiation. During this process, the person undergoes a series of ritual elements that spiritually links the person to the *ashé* of the guardian *orisha*. It is often euphemistically termed being "crowned" as the tutelary deity that is to be connected to the person is literally seated to the person's physical manifestation of *eledá* (head). The head is ritually prepared by being shaved, bathed, nourished, painted, and charged with the herbal *ashé* of the *orisha*, creating a bond that is undone only upon the death of the person. The process calls on the community of priests to be carried out, wherein each *olorisha* takes turns to add his or her spark of *ashé* to the new initiate. Along with the person's own particular deity that is to be crowned, the person will also receive several other *orishas*. A priest of Yemayá receives the physical attributes and *ashé* of Yemayá as well as Elegba, Oshun, Obatalá, Shangó, and possibly others.

Current religious protocols are based on reforms that occurred at the hands of priestesses in the nineteenth century. One such priestess was Ña Rosalía Abreú Efunshe Warikondo, who traveled to Cuba as a free African woman (Matory 2005, Brown 2003). Efunshe, Timotea Albear Ajayí Lewú Latuán, Ma Monserrate González Obá Teró, and several other female initiates are credited with ratifying the process of initiation,

which still broadly follows the same framework today. By receiving several *orishas* rather than solely their tutelary *orisha*, the person would be thus equipped to function as a priest and to initiate future priests of each of the *orishas* received, further safeguarding from the demise of the religion in its inception in Cuba. The person also receives the *ashé* and blessings of all of these *orishas* and will have a hand in protecting and nurturing the new priest.

Olókun God/dess of the Sea

Olókun (owner of the sea) is the androgynous *orisha* of the depths of the ocean, said to reside in Yemideregbe, the Yorùbá term for the Atlantic Ocean. Olókun's sex is the most contested aspect of his or her worship within the Lukumí tradition.[9] No other *orisha's* gender is as consistently debated and contested as Olókun's. The Odu Ifá Irosun, in which Olókun appears and speaks is heralded by the refrain "no one knows what lies at the bottom of the ocean" and is invoked in such debates as to signal the futility of ever reaching a consensus to this paradigm. For want of a specified gender, the conferral of a consecrated and ritually presented vessel of Olókun is one of the most frequent ceremonies of worshippers, both for priests and nonpriests. Olókun's sacred vessel is prepared by an *olorisha* for someone who, according to divination, needs to receive the deity for health reasons and/or for general physical and spiritual well-being. Just as the water at the bottom of the ocean is calm and still, Olókun mimetically mirrors and imparts emotional stability within the person's life.

Historically, there are two recognized sources of Olókun worship in Cuba from which all of the present day lineages of Olókun worship in Cuba and the diaspora descend. One line of tradition begins in Regla, Havana, with Ña Ines Garcia, whose initiatory name was Yenye T'Olókun; the other is rooted in Matanzas with Fermina Gómez, whose initiatory name was Osha Bi.[10] Both were priestesses of Yemayá and operated in the nineteenth century. They built and maintained impressive religious empires, overseeing large families of initiates and were fundamental not only in preserving and disseminating the worship of Olókun in Cuba but also helped lay the foundations of a distinctly Afro-Cuban form of *orisha* worship. The house where Fermina Gómez lived still survives as a center of worship and is known today as La Casa de Olókun. It is home to Fermina's Olókun as well as the only set of Olókun or "Egbado" drums in Cuba, which are played at the Olókun festival every year on September 7.

Erinle

Erinle is a male riverine *orisha*: He is a hunter, fisherman, and medic of the Lukumí pantheon. His myths describe his romantic liaisons with several *orishas*, including Oshun, Yemayá, and Oshosi. As such, his narratives speak of sexual ambiguity and homosexuality. He is said to be androgynous in appearance, and he is described in terms of refined beauty and elegance. Erinle[11] is a calm, wise *orisha* that engages intelligence, wisdom, and strategy in his endeavors. A person who is inducted into Erinle's priesthood undergoes a ceremony called "Yemayá oro Erinle." In this instance, "oro" can be translated as "in contemplation of," or "to oversee with scrutiny." The phrase hints at the close relationship these two *orishas* share.

Yemayá oro Erinle indicates a treatise whereby Yemayá is the mediator by which a priest is initiated and Erinle is given the prestigious, ultimate, or crowning position. This is different to other forms of priesthood initiation whereby the person is "crowned" directly with his or her tutelary divinity; both the incantation sequence sung and the ceremony conducted can be carried out without an intermediary. This is witnessed in the priesthood initiations of Obatalá, Oshun, Shangó, and Yemayá's own children. The person who is to be initiated to Erinle requires the mediation of Yemayá. During *ojo ita*, the third day of initiation, the person will receive advice from Yemayá and Erinle through the *dilogun* (divinatory mouth) of Yemayá herself. As Erinle is an *orisha* that does not speak directly through his own set of *dilogun*, Yemayá speaks for him, and it is her *dilogun* that are cast, and the *odu* that results is said to be that of Erinle.

One very popular story explains Erinle's loss of speech.[12] In this narrative, Yemayá and Erinle fell in love. They lived in the sea where Yemayá taught him all that she held dear. She taught him divination and the secrets of magic, healing, and water. Erinle found himself falling in love with the land and with Oshun, the owner of sweet waters. Yemayá, enraged by jealousy and betrayal, cursed Erinle to eternal silence by leaving him aphonic, preventing him from betraying the privileged information she gave to him. From then on, Erinle was dependent on the Mother of Fishes. In the Cuban diaspora, the initiation for children of Erinle is conducted solely through the *ashé* of Yemayá.

Ties and connections between the *orishas* are explained in myths through the trope of marriage. As members from one geographically separated *orisha* cult came into contact with others, both in Africa and in Cuba, eligible deities were connected in narrative through familial acts of marriage. An example of this is the narrative that Otin is one

of the four wives of Erinle (along with Yemayá, Oshun, and Oba). In present day Nigeria, Erinle has seven distinct qualities, or paths, and Otin is said to be the legitimate wife of each one of them.[13]

Orisha Oko

Orisha Oko is known as the chief of Ìràwo. Before he was deified, he is said to have lived as a guinea fowl trapper and is deemed the progenitor of agricultural practices. Cornelius Adepegba writes that Orisha Oko worship was very popular among the agricultural workers to the North of Nigeria (Adepegba 1991). His emblem from this region, the Opa Orisha Oko, or staff of Orisha Oko, is easily identifiable due to its large phallic shape (Oko can be punned to mean penis) and its decorations of copper, which are tightly wound around its handles. The copper symbolizes the harvested crops; the word for copper in Yorùbá is *bàbà*, which is also the name of the crop guinea corn or sorghum.

Scholars have speculated about whether Orisha Oko is a male or female *orisha*. The gender confusion can, in part, be explained by the fact that women are the custodians of Orisha Oko's cult in Ìràwo and Yorùbáland as a whole. Like many traditional roles and guilds among the Yoruba of Nigeria, agriculture is organized along gendered lines and was traditionally very much within the jurisdiction of women. Orisha Oko's ceremonies and sacrifices are almost exclusively the domain of female priests, and women were primarily called to the priesthood of this *orisha*. In the palace as on the farm, the shrine for Orisha Oko is traditionally located in the wives' quarters, and it is the *ayaba* (the senior royal wife) or courtier's duty to tend to the Oko shrine. Furthermore, female initiates are known as Iyawo (wife of) Orisha Oko. "Oko" itself also means "husband" in Yorùbá. Furthermore, Yorùbá language, due to its tonality, possesses the tantalizing ability to change the meaning of a given word according to the tones employed. This introduces the possibility of punning and flattering, as with the word "*oko*," which can invariably mean "farm," "husband," and "penis." These are all equally applicable to the worship of Orisha Oko, intimating layered and nuanced meaning that seeks to define by essence and invoke energy.

Orisha Oko acts as judge within the *orisha* pantheon. In Nigeria, those accused of witchcraft, which are mainly women, are taken to Orisha Oko to be put on trial. Orisha Oko's important capacity in ensuring peace in the community and in keeping undesirable, malefic forces at bay, brought wealth to his worshippers; his cult became wealthy

and prominent. Trials overseen by Orisha Oko were regarded as fair and without the least amount of bias. If a person was acquitted, there would be no lingering doubt; he or she would almost certainly join the rank and worship of Orisha Oko to some varying degree in gratitude.

In Cuba, Orisha Oko is a popular deity, revered not only as a deity of agriculture, but also as one that is wise and who gives health. He is worshipped along with his father Ìràwo and brother Korinkoto to ensure that ire, or the blessings of God and the universe, come into fruition. For the Lukumí, Orisha Oko is a deity that also governs fertility and wealth, and he defends against malefic witchcraft. He is resolutely worshipped as a male deity in Cuba. However he is said to change his appearance: during the day he is envisioned as a handsome man, and at night he takes on a ferocious appearance and the persona of witch-finder general.[14]

Odu Ifá, Sex, and Procreation

Ifá divination is the cornerstone of the Lukumí divination. Everything that exists is catalogued within the constellation of *odu*: containers of meaning and experience accessed through verses and oral recitation. *Awo Ifá*, *oluwo*, and *babalawos* are priests of the *orisha* Òrúnmìlà and are entrusted as diviners within Afro-Cuban religious traditions. *Babalawos* receive initiations and training to manipulate palm nuts and other tools to access *odu* on behalf of the client. Through his training, the *babalawo* is able to mediate between the world of the humans and that of the *orisha* through Òrúnmìlà and Eshu, communicating with these deities to ensure that the person continues to be aligned with their destinies received before birth. Through incantation and manipulation of these divination tools, one of sixteen possible *odu*, is recorded. This is recorded and the process repeated in order to arrive at a second *odu* that is paired with the first *odu* (sixteen multiplied by sixteen, called an Omodu). This permutation is the signature divination sign that pertains to the querent. *Babalawos* give advice and prescriptions according to which Omodu fell as well as their direction with regard to ire[15] and *osobo* that the person currently faces. *odu* is also seen as living, constantly being updated as new experiences are added to the corpus.[16]

Indeed, Yemayá is the owner of the divination instrument of the *olorisha*, the *owo eyo*, *dilogun*, or cowries. Yemayá is owner of the *merindinlogun*, the sixteen cowry shells used by her and the other *orishas* to bring *odu* to their devotees. Yemayá is not only the owner and

benefactress of dilogun for humanity, she is so well versed in *odu* that she traverses the male-only world of Ifá divination through the use of Òrúnmìlà's own tools. Yemayá is a diviner par excellence, and the *odu* Ifá Oyekun Oshe tells us that not only is she owner of the cowries, but it is here that Yemayá Ibú Ashaba "tiró el opele para consultar Ifá" or "threw the [*babalawo's*] divining chain to consult Ifá."[17] By doing this, Yemayá demonstrated her mastery of all forms of divination and her ability to understand and help her devotees. Transgressing gendered boundaries in work, ritual, and initiation, Yemayá demonstrates the unparalleled generation and manipulation of *ashé*.

Odu pinpoint the coming into creation every instance of human experience. Yemayá as owner of the divination system attests to the "birthing" of every aspect of life. *Odu* tells us that she herself comes into being in the Odu Odi, wherein the seas were also born. *Odu* are the containers for worldly and religious experience, past, present, and future. Within the realm of divination, we find much salient information: not just on religious rebirth and sacrifice, but also on sex, intimacy, and pleasure, which all fall within the realm of Yemayá's purview.

The institution of marriage is found in Odi Obara (Odibara), and the Odu Irosun Iwori bestows love to humanity. Family is born in Oyekun Iwori (Oyekun Piti), and twins, the desired offspring, are located in Oyekun Meji. Sex and sexuality are dealt with in explicit detail in Odu Ifá. For procreation, we learn that the sexual act, called in Lukumí "*ofikale otrupon*," is born in Ogbe Irete (also known as Ogbe Ate), which specifically explains why it is performed at night. Man first appears in Iwori Meji, the penis and testicles come into existence in Ogbe Ika, and the erection is recorded in Ogunda Meji. The female genitalia are born in Odi Meji, and menstruation appears in Iwori Oyekun. Odu is also replete with the pleasures of sex and with sexual acts fall outside the remit of procreation.

Sexual pleasure appears in Osa Ejiogbe (Osalofogbeo) as well as the arousal of erogenous zones, such as the nipples, in both men and women. Desire appears several times in Odu, including wild, unbridled sex, as well as erotic fetishism in Odi Otura (Odi Tauro) and what has been described as "fire in the loins" appearing in Ika Otrupon. The act of anal sex is located in Okana Oyekun. There are relatively few hindrances or prohibitions to sex; the most notable exceptions are the taboo against Babalawo performing oral sex on their partners in Otura Irosun (Otura Roso Mun). Sexually transmitted infections are indicated in Obara Irosun (Obarakoso). The significance of sex and relationships is found in Ogbe Odi (Ogbedi), and the ceremony of the Babalawo having anal sex with his partner is located in Okana Owani.

Yemayá is mother of humanity, through physical birth by women and spiritual rebirth by initiation. The *osun*, the seal or signature of the *orisha* that is painted on the shaved head of the initiate leaves the indelible mark of all the *orishas* present that crown the head. Yemayá is present within the painting and sealing of the head through the color blue, or *aro*, made from indigo, which is sacred to Yemayá and contained within all *osuns* for every *orisha* initiation. From that moment on, the person is reborn through Yemayá and becomes a repository and conveyor of her *ashé*. The painting of the initiate's head and other ritual acts of initiation signals this rebirth and affirms the importance and pact made between these *orisha* and the person, steadfast through the entire life of the initiate.

Blood, Honey, and Molasses: Oshun and Yemayá

The balance between the energies of Yemayá and Oshun are referred to as Las Dos Aguas, found in the Odus Odi Oshe and Oshe Odi wherein both goddesses claim ownership of the devotee's head as their own. A person who has this *odu* marked through initiation will venerate both of his or her mothers equally and be careful not to show favoritism lest he or she may invoke animosity or rivalry between these two equally protective deities. Oshun and Yemayá share many ideals of motherhood and affection. Oshun is also linked to the womb, sexuality, and fertility. Oshun, goddess of sweet water and of the river, is also a warrior and commands great authority.

Afro-Cuban and other Afro-diasporic religions, such as Brazilian Candomble and Haitian Vodou, have readily embraced and celebrated their lesbian, gay, bisexual, transgendered, and queer (LGBTQ) populations. While there are several excellent ethnographies that have explored sex and gender in Afro-Brazilian religions (see Landes 1947 and Matory 2005), there are few works that have given the same emphasis to Afro-Cuban religious traditions and fewer still that treat Haitian Vodou (see Lescot and Magloire 2002). The lack of data on the presence and contribution of LGBTQ persons in these traditions is lamentable and needs to be addressed. Randy Conner is one scholar who is paving the way for the study of sex and gender performance within Afro-diasporic traditions (Conner 2004). Afro-Cuban religious practice both in Cuba and its diaspora has relatively well developed and prominent networks of LGBTQ practitioners, the particularities of which warrant further, careful examination. Yemayá is deemed the patron of gay men and women. This title has been appended to Oshun; however, historical narratives

inform us that Oshun, in a moment of vanity, expressed her disbelief that a man could become such a beautiful woman and a woman could take on the attributes of a man.

The Lukumí offer Yemayá watermelon, and like the *elégédé*, the calabash gourd sacred to Oshun is gravid with seeds and swollen like the pregnant womb, which is symbolic of the children for which one supplicates the *orishas*. In addition to this, it is said that the gourd is Oshun's purse and contains her wealth. Oshun Ibú Doko and Orisha Oko govern the fertilization of the soil and pollination. Orisha Oko's messenger, the bee, gave to Oshun one of her most striking attributes: honey. Yemayá's elixir is *melão*, cane syrup, and a type of molasses called *omíreke*. Honey and *melão* are perfect tropes for the action and countenance of these *orishas*. Honey, like Oshun, has the ability to soothe and heal; if handled incorrectly, honey can also be acerbic and "cut."[18] The Lukumí ritually use honey in very specific ways. It is administered to *orishas* directly after blood sacrifices to balance the hot, vital life force and to channel the *ashé* released to produce action and positive change.

Melão is a dark and viscous product of labor and toil and is a bittersweet concoction that speaks of enslavement, indenture, and blood. The ubiquitous product of the sugar mill, *melão*, whose etymological stem is from the Latin for honey (mel), is produced when young sugar cane is first crushed and boiled. Along with molasses, violence and exploitation were by-products of the sugar industry of the eighteenth and nineteenth centuries, intimately connected with the bringing of the *orishas* to Cuba and other parts of the Caribbean and Latin America. It is by this route that *melão* was introduced into Lukumí ritual. Offerings of *melão* are made to Yemayá to remove struggle and obstruction. Molasses crucially acts as an antidote to the bitterness; it is used to fortify the person against trauma and loss. As it pours into the sea, so do the prayers offered to Yemayá to bring about resolution and hope for contentment. *Melão* is a strikingly potent symbol that links the past, the history and echoes of struggle and oppression, with the will to survive and the possibility of positive transformation.

Conclusion

Yemayá holds a position of unparalleled authority within the Lukumí tradition, a status that transcends existing understandings of gender and sex. Being the epitome of understanding, power and motherhood, Yemayá is both god/dess in action. As supreme matriarch of the *orisha* pantheon and mother of humanity, the responsibility for human survival

and continuity ultimately rests in her hands. As elder and sovereign, Yemayá has the ability to enforce rules that allow for order and peace. In times of war, she may trouble the water for the greater good. She possesses the ability to transgress boundaries in the name of revolution and resolution. Her actions belie the importance of wisdom and experience in knowing and navigating the future of her adherents, her family, and her people. These relations are protected, to ensure the safety and to guarantee the greatest potential for her children. In so doing, she opens up terrain for discourse on gender variance and androgyny and the ability and necessity of birth, both physically and religiously. Yemayá as progenitor of divination with *dilogun* shares with the world the tools for birth, salvation, and success. She is also privy to the secrets of sex, the body, and pleasure, as well as countenance and endurance. She is the irreproachable spark of creation that comprehends and embraces humanity in its myriad forms.

Notes

1. A popular song for Yemayá, translated from Lukumí to English by the author.

2. I refer to the Afro-Cuban *orisha* religious traditions as Lukumí within this chapter. Other names include Santería, La Regla de Ocha, or simply "la religion" or "*ocha.*"

3. Ibú refers to an expanse of water; it can also refer to a deep aquatic spot in a river or pool. It is used in reference to the roads or qualities of Yemayá, Oshun, and Erinle. Each Ibú incorporates individual praise poetry. Karin Barber notes that the Ibú for an *orisha* are collectively *eníbúmbú, olódò-odò, olómi-omi* or "all you pools, all you rivers, and all you waters" (Barber 1981, 733).

4. For more information on Yemayá's roads, see Pierre Verger (1957) and Lydia Cabrera (1980).

5. Some texts have reported the number of roads of Yemayá to be seven (see Cabrera 1980 and Verger 1982). This may be poetic license as the number seven is ritually associated with her. From observations and discussions with priests in Yemayá in Cuba and the diaspora, in practice there are many more roads than this number. Some identified and commonplace roads include Ibú Agana, Ibú Mojelewu, Ibú Ogunte, Ibú Asesu, Ibú Ashagba, Ibú Konla, Ibú Aro or Alaro, Ibú Okoto, Ibú Okun, Ibú Sanma, Ibú Oleyo, Ibú Oro, Ibú Asaba, Ibú Ataramagba, Ibú Gunle, and Ibú Akere.

6. Several *orisha* have accompanying deities that are part of their individual pantheon. Within the Shangó family, there is Aina, *orisha* of fire, and Oge, the horns given to him by Oya. Obatalá has Ogan, Ogbon, and Ogboni, who once accompanied Ogun, that now act as sentinels for the children of Obatalá, ensuring that no malice reaches the worshipper.

7. Personal communication with Alexander Fernandez, Ala Leke, February 26, 2011. Ala Leke is a priest of Obatalá Ajaguna and Obá Oriaté, master of the Lukumí ceremony and divination. I thank Alexander Fernandez for bringing my attention to this important information.

8. For more on this, see Abimbola's (1976, 148) consideration of the importance of the *alaleyo* in regards to human destiny.

9. Solimar Otero cogently notes that Olókun is similarly ambiguous in Nigeria: "In contemporary Cuba, as in contemporary Lagos, Olokun represents a deity of the ocean, either male or female" (Otero 2010, 83).

10. Oshabí was a Creole, born on a Cuban sugar plantation where her mother, María Elena Gómez (Balagún), had been brought as a slave from Calabar, West Africa. Balagún was ordained to Oshosi in Cuba by Monserrate González, Obá Tero. Oshabí's father, Florentino Gómez, was an Egbado.

11. Erinle is translated as "Elephant in the Earth." His name is often elided in songs as "Inle."

12. Cabrera (1980, 45) relates a "*patakí*" or narrative wherein Yemayá cuts out Inle's tongue to prevent him from speaking. However, olorisha in Cuba that may not have had access to Cabrera's material maintain that Yemayá silenced Inle through magic, stating that she was deeply in love with him as reason for not physically harming him in such a way as stated by Cabrera.

13. Specific paths or qualities of Erinle found in Yorùbáland and some that are found in the Lukumí Diaspora include: Ibú Ojútù [Ibojuto in Lukumí], Ibú Alámo, Ibú Owáálá, Ibú Abátàn (Abata in Lukumí), Ibú Ìyámòkín, and Ibú Àánú.

14. See McKenzie (1997, 152) for a description of the trials of witches at Ìràwo by priests of Orisha Oko.

15. The *odu* cast for an individual will indicate the current and future situations of importance the querent faces. The diviner ascertains if the *odu* is accompanied by *ire*, which can be translated as blessings or positivity balance. *Osogbo*, also known as *ibi* indicates something that may be troubling a person's life, imbalance that can take many forms. It is the skill of the diviner that is required to prescribe efficacious remedies and sacrifices to turn an *osogbo* situation to one of *ire*.

16. The names of the major *odu*, or *olodu* of Ifá are Ogbe, Oyekun, Iwori, Odi, Irosun, Owani, Obara, Okana, Ogunda, Osa, Ika, Otrupon, Otura, Irete, Oshe, and Ofun. The *odu* of *dilogun* are determined by the number of cowry shells that, when cast, appear with the mouth or opening landing face up (indicated by parentheses). They are (1) Okana, (2) Ejioko, (3) Ogunda, (4) Irosun, (5) Oshe, (6) Obara, (7) Odi, (8) Ejiogbe, (9) Osa, (10) Ofun, (11) Owani, (12) Ejila Shebora, (13) Metanla, (14) Merinla, (15) Marunla, and (16) Merindilogun. When none of the cowries land face up, this is called *opira*. Two *olodu*, are combined in a reading, such as Obara Ogunda, and the advice attached specifically to this combination, called the *omodu* is applied to the person for whom the divination is performed.

17. Personal communication with Daisy Fernandez, Omi Dina. New York City March 12. Omi Dina is a priestess of Yemayá Ibu Ogunte, initiated October 25, 1975.

18. A Lukumí song for Oshun extols the properties of honey, *oñi abe*, or honey that cuts like a knife (Thompson 2001).

References

Abimbọla, Wande. *Ifá: an exposition of Ifá literary corpus*. Ibadan: Oxford University Press Nigeria, 1976.

Adepegba, Cornelius Oyeleke. *Yorùbá metal sculpture*. Ibadan: Ibadan University Press, 1991.

Barber, Karin. "How Man makes God in West Africa: Yorùbá Attitudes towards the Orisa." *Africa*. 51 (1981): 724–745.

Brown, David H. *Santería Enthroned: Art, Ritual, and Innovation in an Afro-Cuban Religion*. Chicago: University of Chicago Press, 2003.

Cabrera, Lydia. *El monte: Igbo, finda, ewe orisha, vititi nfinda: notas sobre las religiones, la magia, las supersticiones y el folklore de los negros criollos y el pueblo de Cuba*. Miami: Ediciones Universal, 1975.

Cabrera, Lydia, and Rosario Hiriart. *Yemayá y Ochún: Kariocha, Iyalorichas y Olorichas*. New York: Eliseo Torres, 1980.

Conner, Randy P., and David Hatfield Sparks. *Queering Creole Spiritual Traditions: Lesbian, Gay, Bisexual, and Transgender Participation in African-inspired Traditions in the Americas*. New York: Harrington Park, 2004.

Drewal, Henry John, and Margaret Thompson Drewal. *Gẹlẹde: Art and Female Power among the Yoruba*. Bloomington: Indiana University Press, 1983.

Ferrer Castro, Armando, and Mayda Acosta Alegre. *Fermina Gómez y la casa olvidada de Olókun*. [Caracas, Venezuela]: Fundación Editorial el Perro y la Rana, 2006.

Landes, Ruth. *The City of Women*. New York: Macmillan, 1947.

Lawal, Babatunde. *The Gẹlẹde Spectacle: Art, Gender, and Social Harmony in an African Culture*. Seattle: University of Washington Press, 1996.

Lescot, Anne, and Laurence Magloire. *Of Men and Gods Des hommes et des dieux*. Watertown, MA: Documentary Educational Resources, 2002.

Matory, James Lorand. *Black Atlantic Religion: Tradition, Transnationalism, and Matriarchy in the Afro-Brazilian Candomblé*. Princeton, NJ: Princeton University Press, 2005.

McKenzie, P. R. Hail Orisha! A Phenomenology of a West African Religion in the Mid-nineteenth century. Leiden: Brill, 1997.

Otero, Solimar. *Afro-Cuban Diasporas in the Atlantic World*. Rochester, NY: University of Rochester Press, 2010.

Rey, T., and Richman K. "The Somatics of Syncretism: Tying Body and Soul in Haitian Religion." *Studies in Religion-Sciences Religieuses* 39, no. 3 (2010): 379–403.

Thompson, Robert Farris. *Black Gods and Kings: Yoruba Art at UCLA*. Bloomington: Indiana University Press, 1976.

———. "Orchestrating Water and the Wind: Oshun's Art in Atlantic Context." In *Òṣun across the Waters: A Yorùbá Goddess in Africa and the Americas*.

Edited by Joseph M. Murphy and Mei-Mei Sanford. 251–260. Bloomington: Indiana University Press, 2001.

Verger, Pierre. *Orisha: les dieux yorouba en Afrique et au nouveau monde.* Paris: A.M. Métailie, 1982.

———, and Théodore Monod. Notes sur le culte des Orisa et Vodun à Bahia, la Baie de tous les saints, au Brésil et à l'ancienne Côte des Esclaves en Afrique. Dakar: Institut Français d'Afrique noire, 1957.

Chapter 5

Yemoja

An Introduction to the Divine Mother and Water Goddess

Allison P. Sellers

Yemoja is a river and ocean goddess of the *òrìsà* spiritual tradition practiced by the Yorùbá of West Africa and their descendants across the Atlantic. Once deconstructed, her name in Yorùbá means "Mother of Fish."[1] Worshipers also call her by other names, all derivatives of Yemoja[2]—Yemaja,[3] Yemonja,[4] and Yemanja[5] in West Africa and the Americas; Yemayá[6] in Cuba; and Emanje[7] in Trinidad.[8] Like other deities whose worship crosses oceans and continents, Yemoja's traditions have shifted over time in response to the needs of her followers. However, discrepancies in her mythology and adjustments in religious practices associated with her have not altered the fundamental aspects of her role among the Yorùbá. She is first and foremost their mother goddess, and *òrìsà* practitioners in West Africa and the Americas consistently turn to her when seeking fertility, good health, and abundance in general. In this chapter, I will examine Yemoja's position in the Yorùbá pantheon and her evolution as she crossed the Atlantic. Synthesizing the contributions of scholars such as A. B. Ellis, Ulli Beier, William Bascom, Babatunde Lawal, and Lydia Cabrera, my goal is to provide a comprehensive (if not exhaustive) analysis of Yemoja's nature, her place in the *òrìsà* tradition, and her significance among the Yorùbá and their descendants in the Americas.

In West Africa, *òrìsà* number in the hundreds—the estimate most often agreed to is four hundred.[9] Some of these deities are ubiquitously acknowledged and honored in Yorùbá culture, while many are unique

to certain regions and might even be worshipped in just one village. In the Americas, the number of òrìsà reduces dramatically to just a few dozen of the most powerful and culturally significant.[10] They are divided into two groups: "hot" and "cool." The "hot" òrìsà, such as Sàngó and Ògún, are known to be temperamental and fierce, while the "cool" òrìsà are milder and more stable. Yemoja belongs to this latter group,[11] the òrìsà funfun ("white deities").[12] These hot and cool forces are complimentary, and likewise hot and cool òrìsà balance each other. For example, at the end of a Sàngó festival, worshipers sometimes sing a praise song to Yemoja, whose cooling effects are supposed to ensure that the ritual proceedings do not get overheated due to their focus on Sàngó.[13] When referring to individuals, the concept of coolness in Yorùbá culture translates to composure. The ability to remain stoic when excitement and sentimentality would be appropriate—whether in a positive or negative context—is considered both admirable and attractive. In terms of the community, coolness is understood as stability.[14] Worshipers often call upon the òrìsà funfun specifically to bring their cooling effects in times of turmoil and to reinforce peace and cohesion.

Who Is Yemoja?

All òrìsà are capable of conferring virtually anything upon their devotees (such as children, wealth, or solutions to problems), but they are still distinct individuals with unique histories, specialized talents, and particular associations.[15] Devotees universally associate Yemoja with water, and therefore she carries universally recognized traits. Water is the source of life, and as such it extends to fertility and good health. As a result, Yemoja is believed to make human mothers fertile and help heal the sick.[16] Because of her connection to motherhood, she is sometimes equated with Onile, also known as Odua, the Earth Mother[17] She is caring, nurturing, protective, and the guardian of the community.[18] Her place as both a primordial deity and one of the òrìsà funfun also makes her the goddess of intelligence and rationality.[19]

Worshipers in different regions identify Yemoja with particular bodies of water. In Nigeria, Yemoja is the goddess of the river Ogun specifically, which flows into a lagoon near Lagos.[20] More generally, she is the goddess of brooks and streams and can be represented by a female figure, yellow in color and dressed in blue beads and white cloth.[21] It is also fairly common for devotees to represent their òrìsà in less direct ways, often preferring to symbolize them with abstractions such as colored flags, beads, soperas, and other ritual objects rather than with physical

semblances. For example, in Afro-Cuban ritual altars, several òrìsà are represented using flags of their associated colors.[22]

Afro-Cuban thrones are constructed for celebratory or otherwise spiritually significant occasions, such as initiation rituals and òrìsà birthdays (the anniversary of a devotee's initiation into a particular òrìsà's worship). The cloth, beads, and other symbols used articulate the devotee's understanding of an òrìsà's nature—satin and velvet for royalty (Obàtálá, Yemayá), for instance, or brimmed hats and branches for warriors (Esu, Ògún).[23]

Devotees believe that Yemoja, like other river spirits and deities in general, controls the abundance of fish and helps to prevent the capsizing of canoes and other river accidents.[24] Worshipers also generally consider Yemoja the most senior of the river goddesses, and she is therefore perceived as the water of life itself. Perhaps most importantly, however, is that she is often described as the great mother goddess who gave birth to all (or many) other òrìsà.[25]

In Latin America and the Caribbean, Yemoja remains a water goddess strongly associated with fertility and motherhood.[26] However, in the course of her migration from West Africa, she became the goddess of the sea and saltwater. As a result, she is sometimes portrayed in the Americas as a dark-skinned mermaid.[27]

Although overwhelmingly characterized positively, Yemoja is not all warmth and kindness. Like all mothers, she can lose her temper with her children, and like her fellow òrìsà, she is known to lash out at both humans and other deities when offended. The Yorùbá sometimes consider her presumptuous, haughty, and inflexible when doling out punishment.[28] When fighting those who displease her, she can cause stomach aches or carry offenders away in a river.[29] (One wonders how severe an offense must be committed to incite the latter!) Similarly, in Cuba, Yemoja (Yemayá) is believed to rule over intestinal illness and tuberculosis.[30]

The Mythology of Yemoja

To understand the characters and tendencies of the òrìsà, and therefore often the best ways to ensure their good will, practitioners recall their lives and deeds in myth and song. Their stories are mimed and danced within the cult, and òrìsà are said to experience the successes, failures, joys, and sorrows of everyday life, just as humans do.[31] As is true of most oral traditions, there are naturally many discrepancies. Myths adapt to meet the needs of the community over time, and without benefit of

a written tradition for many centuries, it is not unusual for many variations to exist concurrently. This is not to say that written traditions are without contradictions or conflicting narratives, but rather that tracking changes can be a greater challenge without a written record. Therefore, stories of Yemoja's origins as a deity, her character as an individual, her relationships with other *òrìsà* and her place in the pantheon are many and varied. She has been said to be one of the primordial *òrìsà*, present from the beginning, while other myths depict her transcendence from the mortal realm to the supernatural. Depending on the story, she is Sàngó's mother or his wife. She has also been married to Ògún and Orunmila. She has been Òsun's mother, cowife, and sister. What is important to remember is not such inconsistencies, but rather how these tales serve the people who tell them and what the mythology teaches us about that community. (For instance, in the Americas, where African women's roles are redefined to correspond to Western norms, Yemoja's character is likewise adjusted.)

In keeping with this understanding, because Yemoja is so strongly associated with fertility and motherhood, it seems appropriate to begin with a story that tells how she became mother to many other *òrìsà*. This myth is significant for several reasons. It cements Yemoja's place as not simply a maternal figure, but one of the first great mothers and one of the first *òrìsà*. In addition, it provides an origin story for many of her fellow *òrìsà* and for the founding of the sacred town of Ife, the proverbial cradle of Yorùbá civilization. (It is noteworthy, however, that this tale is not universally accepted among the Yorùbá, and several details have been the subject of some dispute.) The story goes that Yemoja was the daughter of Obàtálá, the creator of man and god of the heavens, and Odudua, the earth goddess. She married her brother Aganju (a deity associated with the wilderness) and bore a son, Orungun. As a young man, Orungun fell in love with his mother. One day, in his father's absence, he ravished her after she refused to listen to his "guilty passion." Afterward, Yemoja fled from him in sadness and shame. He pursued her, telling her that he could not live without her and that no one need know about their secret love. He tried to persuade her of the benefits of having two husbands—one acknowledged in public, and one, in secret. As he gained on her, he reached out to seize her and she fell.[32] Yemoja's body then swelled to an incredible size, and two streams began to flow from her breasts, forming a lagoon. From her body issued Sàngó, god of thunder; Oya, Òsun, and Oba (three river goddesses, who later became wives of Sàngó); Olókun, god of the sea; Olosa, lagoon goddess; Orishako, farm god; Oke, god of the hills and mountains; Dada, vegetable god; Aje Shaluga, god of wealth; Ògún, god

of war; Oshori, the hunters' god; and Shopono, god of smallpox. It is also said that the town of Ife was built at the site of this catastrophe.[33]

Again, it is worth noting that there are details in this myth that have been contested. For instance, Sàngó is sometimes said to be of independent origin, and Odudua, in this account is Yemoja's mother and in others is one of her offspring. In some versions, the first man (Obalofun, "the Lord of Speech,") and the first woman (Iya, "Mother") are said to have been among her children and were the first to settle and reproduce in Ife. As we have said, such discrepancies do not render the myth meaningless. It is still an origin story, and the different interpretations may simply reflect the myth's relatively recent development in the mythology.[34]

Although the above myth is very popular, Yemoja is not always depicted as one of the first òrìsà. In fact, Beier gives another famous myth concerning Yemoja that specifically describes her transition from human to deity. The story goes that she had once been a beautiful woman who had a terrible secret—she had only one breast. Self-conscious about her deformity, she remained alone, never marrying or having children. Walking home from the market one day, she lamented aloud that she had no family. Ògún, the god of war and iron, who happened to be walking the same path, overheard her and suddenly felt a desire to marry her. He seized her and asked her not to fear him, promising then and there to protect her and look after her. His only condition was that she never mock his famously bloodshot eyes. She agreed and confessed her secret to him, asking in return that he never touch her only breast. They married, keeping their promises for a long time and bearing many children together.

One day, Ògún went into the kitchen to make soup for Yemoja to please her. However, unaccustomed to women's work, he dropped the soup pot and broke it. Yemoja, who had been sleeping, awoke to the commotion and stormed into the kitchen. She asked angrily "What are you doing in my kitchen?! You with your bloodshot eyes!" At that, Ògún lost his temper and struck Yemoja to the ground. Immediately remorseful, he knelt beside her and stroked her breast. She began to tremble, then turned to water and slipped through his fingers. Ògún was sad to lose her, but said to himself, "Gentleness is not for me." He left his house and went on to fight many wars, as he used to.[35]

The relevance of the story is two-fold. The first is naturally that it reveals how and why Yemoja first became an òrìsà. More significant, however, is that it reflects one of the norms of Yorùbá culture. Yemoja was a beautiful woman with a shameful secret, a physical defect. In Yorùbá society, withstanding humiliation and demonstrating humility

are often believed to have positive results. In the case of Yemoja, it is the catalyst for her transcendence. She endured deformity, sadness, and humiliation, and then she was able to transform and leave this world behind.[36]

How Yemoja came to be associated with the Ogun River in particular is a story of its own. It shares some similarities with the previous two—namely, that Yemoja is still Sàngó's mother and that she becomes a river after being shamed and then struck by her husband. According to the story, Yemoja came from near Bide in Nupe territory to old Oyo. Some versions say she worked selling meat, some that she dyed cloth, and still others that she shelled melon seeds. Regardless of her occupation, she eventually married the king, Oranmiyan, with whom she begat Sàngó. She later left him and married Okere, chief of the town Shaki. However, at some point in their marriage, he insulted her breasts, and when she fled, he knocked her down. She then turned into the Ogun. (Versions of this myth differ, but it is still widely cited as the reason why successors of Okere must cover their faces when they cross the Ogun on their way to Oyo.)[37] Note here the similarities to the previous myth, which illustrate that continuity by no means implies the absence of change. The mythology persists precisely because it adapts.

On a related note, stories that claim that Yemoja came from Nupe also sometimes claim that she was Muslim. These narratives generally reflect a historically significant connection between the Muslim states of North Africa and Oyo. These territories supplied much of Oyo's wealth and equestrian power, which allowed the kingdom to spread to the south. It makes sense that such an important relationship would find its way into Yorùbá mythology. Such myths also may reflect an attempt to impress and establish cultural ties to Muslims in postcolonial Oyo, whom the British held in higher esteem than "pagan" Yorùbá and who were therefore more powerful at that time.[38] The incorporation of an economically and politically significant group is in this sense a strategic move—an effort on the part of the Yorùbá to identify with Muslim prestige and therefore legitimize their own position.

There are various other myths that simply depict how Yemoja became *a* river, while not specifying the Ogun. Such tales generally include other river goddesses, like Òsun, and serve to explain the origin of them all in one fell swoop. One tells how Yemoja, along with Òsun and Yemoji, was a wife of Sàngó. One day, Ifa advised Sàngó to sacrifice a parrot tail feather that he prized and wore on special occasions. Ifa warned him that if he failed to do so, he would lose three valuable possessions, but Sàngó ignored the prediction. Some time afterward, a festival for all deities came, but Sàngó's wives were not invited. Insulted

and angry, the three reacted by having their own separate festivals. Such festivals were measured by the number of attendees, so to ensure that hers was greatest, Yemoja decided to wear Sàngó's' feather to attract people. As she hoped, her festival outshone the others, and her possession of the feather implied that she was Sàngó's favorite wife. Òsun and Yemoji were outraged and decided to leave Sàngó. When he heard of their desertion, Sàngó realized what Ifa's prediction meant and pursued them so he could try to explain. As he approached them, however, they turned into rivers on the spot. Yemoja, after hearing what had happened, decided to follow the example of her fellow wives. She, too, became a river rather than be happy as Sàngó's only wife.[39]

A Case Study in Mythology: Santería

While elements of many African healing and spiritual traditions can be found throughout the Americas, wherever Yorùbá and Dahomeyan slaves represented a large number of the slave population, their cosmology and ethnomedical systems eventually dominated. Therefore, òrìsà worship and mythology thrived in Latin America and the Caribbean. It is represented by such spiritual traditions as Candomblé and Batuque of Brazil, Sàngó of Trinidad, Vodoun of Haiti, and Santería of Cuba.[40] As one might expect, however, the òrìsà transported across an ocean and incorporated into the spiritual lives of an enslaved community did not survive without some adjustment and often even took new forms in order to meet the needs of the Yorùbá diaspora. Santería is a case in point.

The conceptualization of a deity rarely, if ever, results in a monolithic interpretation. Yemoja is certainly no exception—her mythology varies both within and without West Africa. In the Americas, some of the greatest divergences in the understanding of Yemoja's nature and her relationship to other òrìsà can be found in Cuba. These differences primarily concern sex and sexuality. For instance, in Cuban mythology, Yemayá is often said to be hermaphroditic. This is not terribly surprising. In Yorùbá tradition, many òrìsà are depicted with ambiguous sexualities. While Yemoja is most often referred to as female, she is no exception to this tendency. In Santería, she has a *camino*[41] called Olocun or Olókun. Generally recognized among the Yorùbá outside Cuba as a separate deity and the god of the sea,[42] Olocun in this case is essentially an alternative, male personality of Yemayá. He is a "strong saint" and during ritual dancing devotees representing or possessed by him wear a mask adorned with seashells. Legends persist that some devotees who have danced

him were overcome by such violent shaking that it killed them.[43] In addition to this sexual ambiguity, Yemayá is more often portrayed as a seductress than a wife in Santería mythology. Even her reputation as a maternal figure to other òrìsà regularly becomes secondary to her place as a sexual partner, as we will see in the myths that follow.

Increased sex drive aside, Yemayá nonetheless remains the mother goddess she has always been. In Cuba, she is known almost exclusively as Sàngó's mother. This fact is played out and reiterated in several myths, and therefore how she came to be his mother is of particular interest. One day, Yemayá was busy with chores when the sky opened up in a rush of thunder and lightning. As the lightning flashed, she looked up and saw a red dot falling toward her. She opened her skirt to catch it, and when it finally landed it knocked her to the ground. Yemayá looked up to find a child standing before her. She asked him who he was. He replied that he was Obàtálá's son, Sàngó (or Changó). Yemayá believed she had been blessed with a divine gift, so she adopted him. He was a demanding child, and although Yemayá gave him everything he wanted—shoes, food, and drums to entertain him—he remained unsatisfied. She told him to tell her the thing he most wanted and that would be most difficult to obtain and promised that she would get it for him. Sàngó carefully considered this offer, and finally asked for Obàtálá's divining tray. True to her word, Yemayá set off to get it.

Yemayá traveled far across a treacherous landscape until she finally reached Obàtálá's house. Weary from her arduous journey, she collapsed at the doorstep. When she awoke, she found Sàngó standing over her, holding the divining tray. He chided her for being so slow that he had to get the tray for himself, and he left her there. She lay there until Obàtálá returned. Obàtálá asked her what she was doing at her door, and Yemayá confessed everything. As punishment, Yemayá spent forty days in servitude to Obàtálá. At the end of that time, Obàtálá gave her the divining chain to give to Sàngó and sent her home. Sàngó threw the chain onto the tray, and after describing everything that had happened to her, he then gave her solutions to all her problems.[44]

A related tale manages to highlight both Yemayá's role as Sàngó's mother and her sexual proclivities in Santería mythology. In this story, Sàngó grew up to be a powerful young man but still kept close to his mother's house. He would often sleep through the hottest part of the afternoons there, and Yemayá would stay with him. One day, she found herself attracted to her son. She lay next to him and stroked him, becoming more and more aroused. He finally awoke, and when he realized what Yemayá was doing, he pushed her away in anger. He dressed and left her house, running across the savannah to a palm tree

he loved and climbing to the top. Yemayá pursued him, begging him to take her. She began to make a scene, writhing obscenely and caressing her body. Fearing that she would humiliate herself further this way, Sàngó decided to come down and gave in to her pleas. Since then, Yemayá has loved her son.[45]

Yemayá's powers of seduction also play a pivotal role in several stories in which she is not the central figure, but where her actions still drive all or part of the story. Two examples come to mind. The first serves to explain how her adopted son, Sàngó, came to be master of the drum. Obàtálá had a plantation of sacred yams that always grew well, regardless of the quality of the soil or the amount of rain that fell, because she possessed secret knowledge. She wanted to hire someone to help her plant, but she did not feel there were many men she could trust. She believed that men's lust for women made them weak and more likely to give away her secrets in exchange for physical pleasure. However, Obàtálá finally found a man renowned for his chastity. His name was Orisaoco (or Orisha-Oko). She hired him and told him everything about planting the yams, and he worked very hard for her.[46]

Meanwhile, it was well known that Sàngó had long asked Obàtálá to give him her ritual drums, but she had continuously refused. His mother, Yemayá, stepped in to help. She devised a plan to charm Orisaoco, get Obàtálá's secrets, and then give them to Sàngó. One day, she approached Orisaoco, but he rejected her advances. She persisted, however, and eventually seduced him. She asked him to tell her all he knew about the sacred yams, which he quickly divulged, and promised him that their illicit romance would continue. Yemayá then gave the prized information to Sàngó, who began to cultivate the yams. Distracted by his love affair, Orisaoco neglected Obàtálá's fields, and they soon were barren. One day, Sàngó came to Obàtálá with his yams. She asked how they had come into his possession, and he told her he knew her secrets and could grow them himself. He offered to trade the yams for the drums, and Obàtálá complied. Thereafter, Sàngó was known as their sole owner and master.[47]

The second tale concerns why worshipers, when possessed by Obàtálá, shiver and ask for shawls or blankets when they approach a river. At one time, Ògún used the women who traveled through his part of the forest very roughly, forcing himself upon them and then ordering them to leave his domain. Yemayá, a beautiful woman, heard stories about Ògún and became intrigued by him. She sought him out, and of course, he took her. When he sent her away, Yemayá did not want to leave and asked her sister Òsun for help, confessing that she had fallen in love with Ògún. Òsun told her to go to her house and wait while

she went out to find him. She approached Ògún and tantalized him by rubbing a magic honey on her body and dancing seductively before him. After teasing him in this way for some time, she finally satisfied his lust. This time, however, Ògún was eager for more. Òsun told him that it would be better to go to her house and convinced him to follow her.

By this time, it had become very dark. Òsun led Ògún to Yemayá's house and into her bed. During the night, she crept out of bed, Yemayá took her place, and the two had intercourse again. When morning came, Ògún was furious that he had been deceived. He beat Yemayá severely and left the house in a rage. He ran into Obàtálá and, still overcome by his anger, he began to strike her, too. She ran away and threw herself into a river to escape him. Obàtálá hid at the river bottom until he left. When she finally emerged, she trembled with cold and went in search of a blanket, which she eventually found and wrapped around her shivering body. This story explains why now, when Obàtálá possesses her devotees, they tremble when they approach any river.[48]

The final myth we will explore explains why women cannot use oracles or the divination systems of Ifa, a belief that is peculiar to Santería. In this story, Yemayá was the wife of Orula (known alternatively as Orunmila or Ifa, the god of divination), but their marriage was a tumultuous one. While Orula was away one day, he heard rumors of a female seer in his town who was making a fortune giving prophecies. He disguised himself and returned home to find his house full of people. He paid the fee and waited his turn, and when he finally came before Yemayá, she said, "You are my husband, but I wasn't going to die here of hunger." Outraged, Orula cast her out of his house, but she continued to prophesy. When Orula discovered that she was using his divining board (*tabla*), he became furious that she had touched what he had forbidden. He declared a woman could not know more than he, and he would be the only seer in his home. Since then, women have been forbidden to use his divining chain or table.[49]

This story is significant primarily because the assertion that women cannot participate in the Ifa divination process does not exist in West Africa. According to legends in Nigeria, one of Orunmila's children, a female, learned to divine, and women who practice Ifa divination are known as *iyanifa* ("mothers who own Ifa"). It is true, however, that men (known as *babalawo*, or "fathers of the secret") outnumber women in this profession. Few women can afford to combine their domestic responsibilities with the rigorous training required by Ifa divination. Those who can often practice in conjunction with their husbands, who almost without exception are also Ifa practitioners. (It is said that because the *iyanifa* are the custodians of tradition, only men with equal knowledge are fit to marry them.)[50]

All of the preceding Santería tales illustrate a dramatic shift in the understanding of Yemoja's nature, and in particular, the perception of her as a woman. This shift was exemplified dramatically in the Americas among the Yorùbá enslaved by the Spanish, and especially so in Cuba. Therefore, female òrìsà under this influence came to embody several classic Western female archetypes: the mother (Yemayá as Sàngó's devoted mother); the temptress (as Orisha-Oko's lover); the wife (as the wife of Orula); and the once "pure woman" who is corrupted and ultimately suffers as a result (Ògún's lover). There is much more to this shift than a simple case of stereotyping.

Consider Yemoja's evolving role in the mythology. In precolonial West African tales, as a wife and mother, she is distinctly feminine. However, she is not dominated by masculine will, nor are her strengths subordinate to masculine endowments. Rather than suffer physical violence at the hands of her rapacious son Orungun or her temperamental husbands Ògún or Okere, she chooses to transform herself. Rather than endure a perceived insult by Sàngó, she and her fellow wives exercise independence and act in opposition to him. Yemoja is even capable of reproduction without male interference, as when she gave birth to many of her fellow gods.[51]

Enter colonial authority and slavery, and we find that the situation changes. Although still capable of independent action, Yemayá's choices more consistently revolve around preserving or securing relationships with male figures, frequently in spite of their abuse. In those instances where her will comes into conflict with that of a man, she suffers immensely. In her relationship with her adopted son, Yemayá's needs and desires are subordinated to a demanding and unforgiving Sàngó. In spite of her efforts to please him, his derision never subsides (although, after her punishment for failing to meet his demands, he graciously solves her problems for her.) When Sàngó grows up, Yemayá is alternatively a source of corruption and one of shame (when she seeks an incestuous liaison) or his accomplice in deceiving another woman (Obàtálá). Turning to Ògún, his violent temper and reputation as a rapist, rather than horrifying her, arouse her and causes her to seek him out, even to the point of tricking him into abusing her a second time. Finally, in response to her skill and ingenuity as a diviner, her jealous husband, Orula, casts her out of his house and forbids all women to use his divining implements.

In the above examples, we see the gender norms of Western culture (and in this case, Spanish Catholicism specifically) assert themselves clearly in the mythology, revealing a dramatic change not simply in the histories of the òrìsà but also in the understanding of African women's roles in society.

Praise Poetry

The mythology of Yemoja and her fellow deities is often included in Yorùbá praise poetry—collectively termed "*oríkì òrìsà*"—which forms a significant part of *òrìsà* worship on both sides of the Atlantic. It serves primarily to honor and please the *òrìsà*. It is generally recited or sung in third person, referring to rather than directly addressing the subject, and often recalls myths like those previously discussed. It also consists of proclamations of the intended recipient's deeds, character, appearance, status, power, likes and dislikes, and many praise names. Most *òrìsà* are called or referred to by a variety of names—personal, praise, and attributive (short statements about the *òrìsà* that are used in the same manner as names). For example, in Cuba, Yemayá is referred to by her praise name *Yemayá Saramaguá* during prayers and ritual dances.[52] In West Africa, one of Yemoja's attributive names is *Omi Aríbúsolá* (or "Water, she-who-makes-the-deep-a-place-of-honor").[53] *Òrìsà* names are also derived from the animal world (such as Leopard or Ram), can be titles derived from social institutions (Queen, War Chief, etc.), or can describe relationships between the *òrìsà* and either humans or other *òrìsà* (Son of, Our Mother, etc.).[54] Although each *òrìsà* is different, they do share some common attributes, which surface in the *oríkì*. All of them have royal status, for instance, and their devotees reflect that status in ritual performance. Yemoja's priestesses, for example, dress as queens. They wear crowns with fringes of pearls that cover their faces, the very same that are normally reserved for Yorùbá high kings. *Òrìsà* are also concerned with moral order, which stems more from their power to inflict punishment on transgressors than their ability to be models of good conduct (as we have seen in the mythology surrounding Yemoja). Along the same lines, they possess extraordinary medical powers. "Medicine" as it is conceived in this case can be good or bad, refers to magical devices and herbal remedies, and is concerned with both the physical and mystical realms.[55]

In the following Brazilian praise song, we find the singer honors Yemoja with attributive praise names, a potent reminder of her significance in the lives of her worshipers. It also discusses the obligations of devotees to acknowledge her and treat her with respect. Doing so ensures her good favor.

Ba uba-a	If we do not meet her,
Ba uba-a	If we do not meet her,
A woyo	Though we look for her long,
Sarele	We shall hasten to humble ourselves
Yewashe	Before our mother, the lawgiver.

Awade	We have arrived,
Iyade lode	Our mother is outside.
Ba uba	Should we not meet her?
Onibo to ile	One who nourishes and protects the house
Aya onibo to ile	The wife of one who protects the house
Onibo iyawa	One who nourishes the queen
Iya nibo ile	The mother who nourishes the household.[56]

Similarly, a simple praise song entitled "Yemayá's Song" pays homage to the goddess and can be found at both Santería and Vodoun ceremonies.

Siento un voz que me llama	I hear a voice that calls me
De lo profundo del mar	From the deep of the sea
Es la voz de mi madre	It is the voice of my mother
Di mi madre, Yemayá.	Of my mother, Yemayá.[57]

Oríkì are often much longer than the preceding examples. They naturally form an integral part of religious ceremonies, such as festivals and initiation rites, and are central to daily worship. In the course of honoring the *òrìsà* and asking for their assistance, they also usually refer to myths surrounding their pasts. As the myths we have discussed illustrate, such mythology is full of overlap, contradiction, and is open to adjustment and interpretation as needed. It is also true that some myths are the sacred property of the *òrìsà's* devotees, and access to certain knowledge is restricted. As a result, some *oríkì* can be completely unintelligible to those who lack knowledge of the accompanying myths, and full interpretations are in some instances known only to initiates.[58]

Worshiping Yemoja

A defining characteristic of the *òrìsà* tradition is that practitioners are primarily concerned with happiness and success in this life and in this world, rather than with securing a happy afterlife in another world. *Oríkì* are a prime example of devotees' attempts to persuade *òrìsà* to open paths to prosperity and good health. Initiates also show respect in other ways, such as observing taboos and offering material sacrifices.[59] They erect shrines and perform sacred dances and rituals. It is not surprising, therefore, that altars for *òrìsà* worship can be found wherever the Yorùbá and their descendants have settled—in Nigeria, and throughout the Americas (in Cuba, Puerto Rico, Venezuela, Florida, New York, and California, to name a few such places).[60]

Yemoja's symbols, sacred objects, and favorite sacrifices change in the migration from West Africa to the Americas, adjusting to new interpretations of her character and the availability of materials. In Nigeria, her primary symbols are the calabash, which are carried by her female priesthood,[61] and small, river-worn stones, through which sacrifices are offered to her.[62] Her favorite foods are mashed corn, yam loaf, yam porridge, goats, hens, ducks, and fish. Her taboos are ochre, other stew leaves, and dogs. (It is widely believed that any dog that eats a portion of her sacrifice will die.) Many of her devotees also observe the taboos of her powerful son, Sàngó, which include the red-flanked duiker, rats, and sese beans.[63]

Water shrines are commonly erected for Yemoja on the banks of rivers in West Africa as a place to deliver sacrifices and perform spiritual rituals.[64] For instance, her shrine typically contains a pot from which water is given both to newborn babies and to women who come to beg for children. During her annual festival, carved wooden figures that decorate her shrine are carried on the heads of devotees to a nearby river, and as they carry bowls of water back to the shrine, the devotees are then believed to be possessed by Yemoja.[65] This exclusively female activity is a metaphor for containing the substance of divinity in their heads.[66] They must not speak or spill a drop of the sacred water as they dance through town.[67]

There is also an annual Yemoja festival in the Yorùbá town of Ayede. The ritual enlists Yemoja's aid in revitalizing the king's power, replenishing the body politic with fertile women, abundant crops, and a strong, healthy king. Yemoja's power is mediated by officiating priestesses. At the climax of the ceremony, the high priestess, known as Yeyéolókun, carries the sacred calabash of Yemoja balanced on her head from the bush to the palace. The calabash is the embodiment of female power through its identification with her and carries many meanings—the womb of motherhood, the head of good destiny, the crown of the king, the integrity of the town, and the cosmological closure of sky and earth.[68] As a crown, as it is principally conceived in this ritual, it first deposes and then regenerates the king. It contains the concentrated powers of kingship (*ase*), an explosive and polluting force that must be controlled with incantations and medicines. The priestess who carries it approaches the king, but turns away from him three times before finally allowing him to place his hands on her and symbolically absorb the female power of the calabash. This action recharges him with *ase* for the coming year.[69]

The positive aspects of the ritual—empowering the king, promoting fertility, subduing witchcraft and fortifying the town—are not the

only ones that matter. The surface of the calabash is decorated with signs of the negative powers within, specifically red parrot feathers. It can represent the broken womb, miscarriage, bad destiny, a headless/crownless king, political discord, or the cosmos in chaos. Such themes are rarely voiced in public but are potential interpretations that can be invoked when necessary to incite opposition to the status quo.[70] This more disturbing countertext of mortality and the king's deposition as a prelude to regeneration is also a potent reminder of the price of fertility. Here, as in the early mythology of Yemoja, female and male power are balanced and complimentary. Male authority is legitimized by and dependent upon female support and cooperation. When the king receives the calabash, he embodies the paradoxical condition of his own reproduction and the precarious position of his authority.[71] In order to be reborn, one must die.

Meanwhile, across the Atlantic in the United States and Cuba, initiates honor Yemoja in their own way. Ritual dances celebrating and honoring Yemoja in the Americas typically involve repetitive swirling and circling, similar to the swirling of the waves (especially so since initiates dress in blue and white). The purpose is also to reiterate the life cycle present in Yorùbá thought and personified by Yemoja. In Brazilian and Cuban dances, the steps are relatively easy to master, and perfection comes quickly. It seems even when asking her children to dance for her, Yemoja is eager to build their confidence and nurture their talents.[72]

When making sacrifices, Afro-Cubans offer Yemoja *coco dulce* (grated coconut with brown sugar), *melão* (molasses or cane syrup), and blended sweet potatoes.[73] Also in Cuba, her special day is Saturday, her sacred number is seven, and her colors are navy blue and white. Other sacrificial offerings include maize, pigeon, ducks, rams, and cocks. Some of her other New World symbols include seashells and stones found near the sea (rather than near rivers), and she is further symbolized by a sword, a fan, the half-moon, an anchor, or a silver or other white metal sun.[74] In Trinidad, her sacrificial foods are fish and aquatic fowl. Her flag colors are blue, blue and white, or blue with white dots, and her sacred day is Thursday.[75]

Where Roman Catholicism has dominated, Yemoja has come to be associated with certain Catholic saints. Under pressure to reject their "heathenism" and embrace Christianity, many *òrìsà* devotees began identifying their deities with Christian religious figures. This hybridization, which often began as a way to maintain their traditional beliefs in secret, eventually meant that aspects of the two religions became interchangeable and ultimately fused to become part of a new religion, such as Santería or Candomblé. Such adaptation was not (and is not) incompatible with

Yorùbá religious belief. The integration of new concepts adds to the tradition, not compromises it. In the case of Yemoja, she has been associated with three different saints in the Americas. In much of the formerly Spanish Empire (Latin America), she is tied primarily to the Virgin Mary.[76] In Cuban Santería, however, she is more often associated with the Virgen de Regla, the so-called "black Madonna," and patron saint of the Bay of Havana whose statue looks to the sea.[77] In Trinidad, she is equated with St. Anne, the mother of Mary.[78] It is worth noting that even in her transformation under Catholicism, in all three cases she has remained a maternal figure.

In terms of representing Yemoja and associating devotees with her worship, color has been the most consistent marker. Blue and white consistently appear as Yemoja's primary colors, and her shrines and worshippers are easily identified by them. In Nigeria, initiates wear clear glass beads and white and blue dresses.[79] In Brazil, Candomblé dancers wear beads that are iridescent blue, green, or crystal to represent her.[80] Initiates in Brazil also wear blue and white dresses, which Omari describes as worn by devotees within sacred spaces, during initiation rituals, or while celebrating festivals.[81]

Conclusion

Yemoja, though she has been known by many names and in various incarnations, has always retained an important place as a mother and water goddess in the Yorùbá pantheon. Sometimes hypersexualized and often victimized in the mythology that surrounds her, she has nonetheless been a source of great comfort to her followers both in West Africa and in the Americas. It is precisely the ability to modify their understanding of Yemoja that has allowed the Yorùbá to bring her with them. She is a deity whose favor is sought by would-be mothers longing for children, kings hoping for fertile crops, and slaves in need of solace. While some aspects of her worship and even her mythology have changed over time, none of Yemoja's many transformations has altered her essential character: protector, healer, and nurturer—the eternal mother.

Notes

1. A. B. Ellis, *The Yoruba-Speaking Peoples of the Slave Coast of West Africa* (Oosterhout, Netherlands: Anthropological, 1966), 43.

2. William Russell Bascom, *The Yoruba of Southwestern Nigeria* (New York: Holt, Rinehart, and Winston, 1969), 88.

3. Stephen S. Farrow, *Faith, Fancies, and Fetich, or Yoruba Paganism* (New York: Negro University Press, 1969), 45.

4. Joni L. Jones, "Yoruba Diasporic Performance: The Case for a Spiritually—and Aesthetically—Based Diaspora," in *Òrìsà:Yoruba Gods and Spiritual Identity in Africa and the Diaspora*, ed. Toyin Falola and Ann Genova (Trenton, NJ: Africa World, 2005), 324.

5. Ulli Beier, *Yoruba Myths* (Cambridge: Cambridge University Press, 1980), 45; Yvonne Daniel, *Dancing Wisdom: Embodied Knowledge in Haitian Voudou, Cuban Yoruba, and Bahian Candomble* (Urbana: University of Illinois Press, 2005), 277.

6. Daniel, 139.

7. James T. Houk, *Spirits, Blood, and Drums: The Orisha Religion in Trinidad* (Philadelphia: Temple University Press, 1995), 145.

8. For the sake of consistency and because it is easily recognized and commonly used in both West Africa and the Americas, I will use Yemoja throughout this article (with the exception of discussions concerning Cuba, where Yemayá is used almost exclusively).

9. Robert Voeks, "African Medicine and Magic in the Americas," *Geographical Review* 83, no. 1 (January 1993): 71; William Bascom, *Ifa Divination: Communication between Gods and Men in West Africa* (Bloomington: Indiana University Press, 1969), 103.

10. Voeks, 71.

11. Thomas Lindon, "Oriki Orisa: The Yoruba Prayer of Praise," *Journal of Religion in Africa* 20, Fasc. 2, (June 1990): 214.

12. Andrew Apter, "On African Origins: Creolization and Conoissance in Haitian Vodou," *American Ethnologist* 29, no. 2 (May 2002): 236.

13. P. R. McKenzie, "Yoruba Òrìsà Cults: Some Marginal Notes concerning Their Cosmology and Concepts of Deity," *Journal of Religion in Africa* 8, Fasc. 3 (1976): 193.

14. Robert Farris Thompson, "An Aesthetic of the Cool," *African Arts* 7, no. 1 (Autumn 1973): 41.

15. McKenzie, 198.

16. Lindon, 211.

17. Peggy Harper, "Dance in Nigeria," *Ethnomusicology* 13, no. 2 (May 1969): 282.

18. Daniel, 139, 268.

19. Margarite Fernandez Olmos and Lizabeth Paravisini-Gebert, eds., *Creole Religions of the Caribbean* (New York: New York University Press, 2003), 43.

20. Farrow, 46.

21. Ellis, 44.

22. See for example the image of a throne in David H. Brown, "Thrones of the Orichas: Afro-Cuban Altars in New Jersey, New York, and Havana," *African Arts* 26, no. 4 (October 1993): 46. This throne has Yemayá's colors, blue and white, represented at the top.

23. Ellis, 46–50.
24. J. Omasade Awolalu, *Yoruba Beliefs and Sacrificial Rites* (Brooklyn NY: Athelua Henrietta Press, 1996), 46.
25. Beier 77–78.
26. Funso Aiyejina and Rawle Gibbons, "Orisa (Orisha) Tradition in Trinidad," *Caribbean Quarterly* 45, no. 4 (December 1999): 37.
27. Olmos and Paravisini-Gebert, 43.
28. Ibid.
29. Bascom, 88.
30. Voeks, 71.
31. Lindon, 212.
32. Ellis, 43–44.
33. Farrow, 45–46.
34. Ellis, 88–89.
35. Beier, 45–46.
36. Ibid., 77–78.
37. Bascom, 88.
38. J. Lorand Matory, "Rival Empires: Islam and the Religions of Spirit Possession among the Oyo-Yoruba," *American Ethnologist* 21, no. 3 (August 1994): 506.
39. Joseph M. Murphy and Mei-Mei Sanford, eds., *Òsun across the Waters: A Yorùbá Goddess in Africa and the Americas* (Bloomington: Indiana University Press, 2001), 104.
40. Voeks, 69–70.
41. *Camino*: a persona that an *òrìsà* can adopt which reflects a specific incident or action that occurred at an important juncture in his or her life and can be recalled under the appropriate circumstance; also referred to as an *avatar*.
42. Olmos and Paravisini-Gebert 43.
43. Romulo Lacahateñeré, *Afro-Cuban Myths: Yemaya and Other Orishas*, trans. Christine Ayorinde (Princeton NJ: Weiner, 2003), 152–53.
44. Ibid., 19–23.
45. Ibid., 60–62.
46. Harold Courlander, *Tales of Yoruba Gods and Heroes* (New York: Crown, 1973), 222–23.
47. Ibid.
48. Ibid., 219–20.
49. Olmos and Paravisini-Gebert, 44.
50. Oyeronke Olajabu, "Seeing through a Woman's Eyes: Yoruba Religious Tradition and Gender Relations," *Journal of Feminist Studies in Religion* 20, no. 1 (Spring 2004): 57–58.
51. Mercedes Cross Sandoval, *Worldview, the Orichas, and Santería: Africa to Cuba and Beyond*, (Gainesville, FL: University Press of Florida, 2006), 255.
52. Lacahateñeré, *Afro-Cuban Myths*, 153.
53. Apter, "On African Origins," 242.
54. Lindon "Oriki Orisa," 206–07.
55. Ibid., 215–18.

56. Courlander, *Tales*, 229.
57. Nancy B. Mikelsons, "Homage to Eva Fernandez Bravo, Espiritista Cruzado," in *Fragments of Bone: Neo-African Religions in a New World*, ed. Patrick Bellegarde-Smith (Urbana: University of Illinois Press, 2005), 228.
58. Lindon, 209.
59. Voeks, 71.
60. Brown, 44.
61. Matory, 504.
62. Bascom, 88.
63. Ibid., 84, 88.
64. Awolalu, 115.
65. Bascom, 88.
66. Matory, 501.
67. Bascom, 88.
68. Apter, 237.
69. Eugenia W. Herbert, *Iron, Gender and Power: Rituals and Transformation in African Societies* (Bloomington: Indiana University Press, 1993), 158.
70. Apter, 237.
71. Herbert, 158.
72. Daniel, 268, 277.
73. Brown, 51.
74. Olmos and Paravisini-Gebert, 43–44.
75. Houk, 145, 148.
76. Voeks, 67.
77. Olmos and Paravisini-Gebert, 43–44.
78. Houk, 187.
79. Mikelle Smith Omari, "The Role of the Gods in Afro-Brazilian Ancestral Ritual," *African* Arts 23, no. 1 (November 1989): 59.
80. Daniel, 41.
81. Omari, 59.

Part 2

Yemoja's Aesthetics
Creative Expression in Diaspora

Chapter 6

"Yemaya Blew That Wire Fence Down"

Invoking African Spiritualities in Gloria Anzaldúa's *Borderlands/La Frontera: The New Mestiza* and the Mural Art of Juana Alicia

Micaela Díaz-Sánchez

> 1,950 mile-long open wound
> dividing a *pueblo,* a culture,
> running down the length of my body,
> staking fence rods in my flesh,
> splits me splits me
> *me raja me raja*
>
> This is my home
> this thin edge of
> barbwire.
>
> But the skin of the earth is seamless.
> The sea cannot be fenced,
> *el mar* does not stop at borders.
> To show the white man what she thought of his
> arrogance,
> *Yemaya* blew that wire fence down.
>
> This land was Mexican once,
> was Indian always
> and is.
> And will be again.
>
> —Gloria Anzaldúa, *Borderlands/La Frontera: The New Mestiza*[1]

> Yemoja, the wind that whirls with force into the land.
> Yemoja, angered water that smashes down the metal bridge.
>
> —Yoruba praise song[2]

As Gloria Anzaldúa interrogates Chicana/o sociopolitical histories in the essays and poems that constitute her foundational work, *Borderlands/La Frontera: The New Mestiza*, she makes explicit references to West African diasporic spirit-practices.[3] In the above excerpt, she invokes the Yoruba female *orisha* of the salt waters, Yemayá, as the resistant elemental force who transcends the violent imposition of borders between Mexico and the United States. Yemayá is the riverain deity of fresh water in West Africa who became the "goddess of the sea" during the genocide of the Middle Passage. When African slaves threw themselves overboard in the Atlantic Ocean, their lives became offerings to this underwater force as they leapt into the arms of Yemayá rather than live as captives in the Americas. Contemporary practitioners of Santería continue to honor this diasporic spiritual figure as the mother of the Yoruba pantheon, and she is consistently reimagined in representations by feminist cultural producers across disciplines.[3]

Employing Anzaldúa's passage as a discursive springboard, this chapter also interrogates a set of images by internationally renowned Chicana visual artist Juana Alicia who not only incorporates African and African American diasporic spiritual iconography in her work, but also vigorously contextualizes her work as rooted in multiple ethnic and racial communities, predominately immigrant Latina/o, Chicana/o and African American. In particular, I focus on Alicia's portrayal of Yemayá in the monumental "Maestrapeace" mural on the Women's Building in San Francisco's Mission District; her mosaic ceramic mural "SANARTE: Diversity's Pathway" at the Ambulatory Care Clinic of University of California, San Francisco's Medical Center; and another Mission District-based mural entitled "La Llorona's Sacred Waters."

The invocation of African diasporic images and spiritualities in the provocatively groundbreaking writing of Gloria Anzaldúa and the immense visual renderings of Juana Alicia complicate the indigenous-centric discourses in Chicana cultural production and criticism. Specifically, I am interested in how Anzaldúa and Alicia construct diaspora through these divergent representations and how these notions of diasporic consciousness work to reconfigure "border discourse" prominent in scholarship about Chicana aesthetic practices. Working in different genres, these artists position their work as imperative assertions that render historically

silenced communities visible. In their aesthetic manifestations of subaltern subjectivities (feminist, queer, working-class, immigrant, differently-abled, etc.), spirituality functions as an epistemic framework facilitating ways in which subjects employ, M. Jacqui Alexander, "spirit knowledge/knowing as the medium."[4] In their work, Anzaldúa and Alicia position the sacred as a praxis of resistance and methodology: not a grand mythical or disembodied notion of transcendence. Mobilizing these epistemic notions of spiritual representations, these artists create spaces in which they negotiate racialized, gendered, classed, and sexualized subjectivities. This work is driven by the critical need for an interrogation of African diasporic representations and histories—corporeal and iconographic/material and spiritual—in this multidisciplinary body of work.[5]

"Re-imagining the Borderlands": Trans-Atlantic Crossings and Hemispheric Meditations

Since its publication in 1987, Anzaldúa's multi-genre formulation of "*mestiza* consciousness" in *Borderlands* has been enthusiastically venerated and incisively critiqued, becoming not only a canonical Chicana/o text but also a major source traveling in a myriad of disciplinary fields.[6] Influential Chicana/o academicians have engaged with *Borderlands* through extensive articulations of Anzaldúa's border consciousness such as Yvonne Yarbro-Bejarano's interrogation of the narrative's "serpentine movement," José David Saldívar's early classification of the book as a "Chicano border narrative" then as "border-defying," and Norma Alarcón's schematizing of Anzaldúa's tropes as representative of "actual subaltern native women in the US/Mexico dyad."[7] While the multifarious conceptualizations are not the focus of this project, it is critical to recognize the divergent theoretical directives of *Borderlands* in Chicana/o intellectual genealogies.

In the extensive circulation of Anzaldúa's conceptual frameworks across discursive contexts, her book has been prone to analytical cooptations that extract the specific geographical location of her "borderlands" applying this site to *all* ambiguous, interstitial, and fluid sites of postmodern subject inscription. Challenging these problematic appropriations most eloquently, Yarbro-Bejarano writes, "Two potentially problematic areas in the reception of *Borderlands* are the isolation of this text from its conceptual community and the pitfalls in universalizing the theory of mestiza or border consciousness, which the text painstakingly grounds in specific historical and cultural experiences."[8] While Anzaldúa articulates the specific geographic and historical locations that inform this mestiza

consciousness on the Mexican/U.S. border, I am interested in how she gestures toward another set of deities and spiritualities not rooted in Mexican histories or Mesoamerican Indigenous (predominately Mexica) cosmologies[9] The particular passages in which she employs African diasporic Orishas complicate her canonical positioning as a "border writer" and make a critical departure from established Chicana/o theory of the "borderlands," expanding what Yarbro-Bejarano implicates as Anzaldúa's "conceptual community."[10]

Anzaldúa's invocation of Yemayá operates as particularly powerful. It is framed by two passages that are frequently cited in anthologies of critical theory, transnational feminisms, and Chicana/o cultural studies.[11] The quote that precedes this invocation functions as an influential articulation of the geographic border as an open wound linking explicit female corporeality with early formulations of Chicana feminist and lesbian identity politics. She writes,

> dividing a *pueblo*, a culture,
> running down the length of my body,
> staking fence rods in my flesh,
> splits me splits me
> *me raja me raja*[12]

In this passage, Anzaldúa conceptualizes the Chicana mestiza body (violated, dismembered, fragmented) as the liminal site of critical "borderlands" consciousness, an intervention that is central to Chicana feminist writing and sociopolitical discourse. Positing this space as one in which bodies are "split," she formulates this psychological and corporeal fragmentation as generating a "third space": the site of mestiza consciousness.

Anzaldúa theorizes this discursive concept as *nepantla*, the Nahuatl concept for the ambiguous, fluid, and constantly changing space that challenges institutionally prescribed dyads: a landscape on which the subjects of the "borderlands" reimagine and inhabit multiple subjectivities. As Yvonne Yarbro-Bejarano articulates, "Anzaldúa enacts this consciousness in *Borderlands* as a constantly shifting process or activity of breaking down binary dualisms and creating the third space, the in-between, border, or interstice that allows contradictions to coexist in the production of the new element (*mestizaje*, or hybridity)."[13]

This space of *nepantla* operates as the psychological yet material location in which Chicana/o subjects negotiate manifold contradictory points of entry into identity formation or what Yarbro-Bejarano theorizes as "non-unitary" subjectivity.[14] For Emma Pérez, the conceptual frame-

work of *nepantla* facilitated her theoretical formulation of the "decolonial imaginary." Pérez writes, "Gloria's *nepantla* concept allowed me to think about the liberatory space that Chicanas/os exist in today. Neither colonial nor postcolonial, we reside in that in-between gap where we make sense of our agency."[15] In *Borderlands* Anzaldúa calls on Yemayá to destroy the barbwire fence so that this physical and psychological "borderlands" thrives as an interstitial—yet liberatory—site of radical subject inscription and knowledge production. Central to my project is the critical acknowledgment of African diasporic spiritual histories (or narratives) in the work of this canonical Chicana social theorist.

Immediately following Anzaldúa's summoning of Yemayá comes one of the most politically eminent and controversial passages from *Borderlands*: "This land was Mexican once,/was Indian always/and is./And will be again."[16] Anzaldúa references the Southwestern states that were Mexican territory before the U.S. victory through the 1848 Treaty of Guadalupe Hidalgo and refers to the sacred indigenous lands before the Mexican occupation of those territories. This quote functions as the paramount mandate and radical premonition that these colonized territories be returned to and reoccupied by the autochthonous inhabitants of this region before the Spanish, Mexican, and United States colonial projects.[17] Alicia Arrizón writes, "Anzaldúa's poetic passage is an attempt to revive the historic memory of a stolen land and its forgotten people. The poem recaptures the cultural displacement of an indigenous people while it recovers their past, forcing the reader to memorialize their lost history."[18] Prominent Chicana/o theorists cite Anzaldúa's passage as a foundationally generative concept for Chicanas/os to critically engage with the legacies of colonization in their collective histories and cultural practices.

Immediately following the mandate for this re-territorialization by indigenous communities, Anzaldúa deploys another widely discussed concept of the border: "The U.S.-Mexican border es *una herida abierta* where the Third World grates against the first and bleeds. And before a scab forms it hemorrhages again, the lifeblood of two worlds merging to form a third country—a border culture."[19] Throughout the text, Anzaldúa situates contemporary Chicana/o cultural identities as rooted in those hemispheric indigenous legacies while intricately theorizing the gendered and sexual political genealogies of that "border culture."

As Anzaldúa positions the powerful and resistant female energy of Yemayá in the midst of these critical passages, she proclaims linkages between collective Chicana and Indigenous cultural practices of resistance with African diasporic spirit practices that survived the colonial imposition of Christianity in the Americas. Anzaldúa positions discourses

of spirituality in broader geopolitically charged theoretical frameworks and challenges hegemonic disciplinary demarcations. Throughout *Borderlands*, she privileges spirituality as an epistemic methodology in which her invocations of hemispheric deities function as intellectual formulations of mestiza consciousness and vice versa. Despite the widespread circulation and extensive analysis of Anzaldúa's deployment of Mexica cosmologies, I have never encountered a discussion of the African diasporic cosmologies that she inscribes throughout this influential text nor the relationship between these complex Indigenous and African belief systems.[20]

In my exploration of Anzaldúa's invocations of Yoruba *orishas*, I am not invested in a discussion of her as a practitioner of African diasporic spiritualities; I am interested in why—in the midst of her foundational theorizing of mestiza/border consciousness—she departs from invoking Indigenous deities of the Mexica pantheon that is central to her theoretical formulations. Anzaldúa's rigorous investigation and reflection of non-Eurocentric systems of spirituality, as well as her close relationships with practitioners of Santería, led her to these invocations of these *orishas*.[21] Yarbro-Bejarano examines the personal underpinnings of Anzaldúa's theorizations, "Given the text's careful charting of *mestiza* consciousness in the political geography of one particular border[,] reading it as part of a collective Chicano negotiation around the meanings of historical and cultural hybridity would further illuminate the process of 'theorizing in the flesh,' of producing theory through one's own lived realities."[22] While there are extensive analyses of Anzaldúa's reinscriptions of Indigenous spiritualities, I am invested in how she critically re-imagines African diasporic sacred iconographies and energies.[23]

As Anzaldúa introduces Yemayá in the opening excerpt, she shifts from her prominent employment of Mexica deities throughout *Borderlands*—specifically the figure of the mother goddess figure, Coatlicue. In *Feminism on the Borderlands*, Sonia Saldívar-Hull affirms Anzaldúa's strategies for "unearthing a razed Indigenous history as a process of coming to consciousness as political agents of change."[24] The image and narrative of Coatlicue operate for Chicana cultural producers across disciplines in reclaiming the history and power of female Mexica spiritualities.

In the fourth section of *Borderlands* entitled "*La herencia de Coatlicue:* The *Coatlicue* State," Anzaldúa explicates the liberatory potential of Coatlicue in the face of patriarchal regimes of gender and sexuality, before and after colonialism. She writes: "I see *oposición e insurrección*. I see the crack growing on the rock. I see the fine frenzy building. I see the heat of anger or rebellion or hope split open that rock, releasing *la Coatlicue*. And someone in me takes matters into their own hands, and

eventually, takes dominion over serpents—over my own body, my sexuality, my soul, my mind, my weaknesses and strengths. Mine. Ours. Not the heterosexual white man's or the colored man's or the state's or the culture's or the religion's or the parents'—just ours, mind."[25] Anzaldúa deploys Coatlicue as an archival signifier in *Borderlands* conceptualizing a contemporary mandate for collective radical Chicana feminist ideologies and practices.

In the midst of these invocations Anzaldúa weaves her theoretical directive always returning to what Saldívar-Hull describes as "a political consciousness with a specific political agenda that identifies not with the patriarchal nation-state Aztlán but with the feminist state, Coatlicue."[26] Anzaldúa critically assembles autobiographical memories (primarily images of her mother's rituals alongside her lesbian desire) along with her readings of early archaeological accounts of Mexica cosmology to create what she theorizes as "the Coatlicue State," another vehemently contested concept of "*mestiza* consciousness."

Norma Alarcón articulates that Anzaldúa "resituates Coatlicue through the process of the dreamwork, conjures her from nonconscious memoir, through the serpentine folklore of her youth."[27] Alarcón goes on to illustrate this theoretical construction as "[t]he desire to center, to originate, to fuse with the feminine/maternal/lover in the safety of an imaginary 'third country,' the borderlands disidentitified from the actual site where the nation-state draws the juridical line, where formations of violence play themselves throughout miles on either side of the line.'"[28] In the "Coatlicue State," Anzaldúa decenters heteronormative and patriarchal constructions of the nation-state, creating a methodological approach through which to excavate the potentiality of contradiction in this "third" space of *nepantla*.[29] Propelled by what Emma Pérez identifies as a "psychic sensibility,"[30] Anzaldúa deconstructs her "home" or "this thin edge of barbwire."[31]

Despite this pervasive legacy of Coatlicue in *Borderlands* and other Chicana feminist texts, literary and visual, Anzaldúa chooses to request the power of Yemayá to destroy one of the preeminent signifiers in Chicana/o sociopolitical discourse: the United States/Mexican border. Yemayá, this Yoruba mother deity who presides over this "border culture" and allows for the "lifeblood of two worlds" to meet, strikes the barbwire fence down and facilitates the healing of the collective "*herida abierta.*"[32] While *Borderlands* is rooted in this specific geopolitical location, Anzaldúa's journey takes her beyond the Rio Grande Valley of South Texas.

Anzaldúa challenges her readers to expand a historical remembering of the Indigenous/European dyad prominent in Chicana/o

historical narratives. She writes, "Our mothers, our sisters and brothers, the guys who hang out on street corners, the children in the playgrounds, each of us must know our Indian lineage, our afro-*mestisaje*, our history of resistance."[33] She succinctly links this acknowledgment of the African legacies in a collective Chicana/o historical consciousness with a "history of resistance."[34] Yet there is a tension between identifying explicit African lineage in contemporary Chicana/o communities and Anzaldúa's mandate for an expansion of critical "mestiza consciousness." In the cited passages, Anzaldúa unearths a space in which to critically examine "whom" the "borderlands" includes and "what" it excludes, specifically with relation to race, gender, and sexuality. Positioning Yemayá on the Mexican/U.S. border, she challenges Indigenous/Spanish dichotomies prominent in Chicana/o scholarship and cultural production.

While Yemayá is associated with the expansiveness of the maritime waters, specifically the Atlantic and the Caribbean, Anzaldúa requests the power of this specific elemental deity to attend to the "1,950 mile-long open wound."[35] She extends the reach of the Rio Grande to meet other hemispheric bodies of water, thereby implicating the discursive and material histories of the Chicana/o Southwest in diasporic movements, or what Omise'eke Natasha Tinsley renders as "transoceanic crosscurrents." In Tinsley's article, "Black Atlantic, Queer Atlantic: Queer Imaginings of the Middle Passage," she writes, "These are theoretical and ethnographic borderlands at sea, where elements or currents of historical, conceptual, and embodied maritime experience come together to transform racialized, gendered, classed, and sexualized selves.[36] While I recognize the historical specificity with which Tinsley theorizes the intersections between "black queerness and the forced migration of the Middle Passage," her work invites an expansive interrogation of the ways in which discourses of the African Diaspora and Chicana/o "borderlands" traverse and intersect in multiple bodies of water.[37]

Anzaldúa does not utilize the word "diaspora," but she asserts herself in a personal excavation of forgotten legacies in collective Chicana/o histories and diasporic reformulations. As she theorizes this grievous process of this remembering, she affirms James Clifford's conceptualization of diasporic histories as "broken, the present constantly shadowed by a past that is also a desired, but obstructed, future: a renewed, painful yearning."[38] Throughout the text, Anzaldúa mourns the effacement of Indigenous histories in Chicana/o consciousness. In the cited passages, she also leads her audience one step further and demands a critical remembering of African ancestors in the "borderlands." Anzaldúa suggests that these exigently recuperative practices facilitate a healing of the

"*herida abierta*" and mobilization of diasporic histories. She engages with syncopated notions of diasporic temporality while formulating liberatory possibilities in the reclamation of effaced histories. As Clifford writes, "This overlap of border and diaspora experiences in late twentieth-century everyday life suggests the difficulty in maintaining exclusivist paradigms in our attempts to account for transnational identity formations."[39] José David Saldívar aligns himself with Clifford as he affirms, "U.S.-Mexico border writing does not dichotomize the local and the global."[40] Anzaldúa resists the policing of these paradigms and looks beyond the Mexico/U.S. border in conceptualizing her indeterminate journey to mestiza consciousness. She envisions this route framed by discerning affirmations, at times abruptly intersected by denunciatory currents that carry her (and her mestiza subject) to divergent yet crucial points of departure, a series of crossings.

"Otro Camino": Another Crossing in Red and Black

Anzaldúa identifies "The Coatlicue State" as the "Prelude to Crossing," and several chapters later, she moves to one of the most discussed sections of the book, "*La conciencia de la mestiza*/Towards a New Consciousness."[41] Early in this chapter, Anzaldúa begins "*La encrucijada/ The Crossroads*" with an invocation of Eshu or Eleggua (also known as Papa Legba/Elegba/Elegbara), the male Yoruba *orisha* honored at the beginning of a significant journey. She declares,

> A chicken is being sacrificed
> at a crossroads, a simple mound of earth
> a mud shrine for *Eshu*,
> *Yoruba* god of indeterminacy,
> who blesses her choice of path.
> She begins her journey.[42]

Eshu/Eleggua functions as "the messenger among the Orisha and between the Orisha and men, the owner of the crossroads who must open the way for communication between the visible and invisible worlds."[43]

Occupying this critical intersection, Eshu/Eleggua also symbolizes the multiplicity of directions and possibilities that present themselves. Invoking Eshu/Eleggua to bless this journey, Anzaldúa appeals to him to open up a path to mestiza consciousness that she explicates throughout the text. M. Jacqui Alexander illuminates the manifold potentialities

of Eshu's conjuring, "Guardian of Divine energy and communication, guardian of the crossroads, the force that makes things happen, the codification of potentiality and its indispensable tool, choice, which is multiplied at the crossroads—the place where judicious vigilance needs always to be exercised."[44] Although Alexander identifies this careful vigilance, she also recognizes the indeterminate nature of Eshu's authoritative capacity as "continually being transformed through a web of interpretative systems that ground meaning and imagination in principles that are ancient with an apparent placement in a different time. Yet, both the boundaries of those principles as well as what lies within are constantly being transformed in the process of work in the present; collapsing, ultimately, the rigid demarcation of the prescriptive past, present, and future of linear time."[45] Alexander's theorization of nonlinear temporality in the domain of Eshu/Eleggua allows for a generative interstitial space, a site that is opened up between the "rigid demarcation" of the past and the future. Unsettling these dichotomies resonates with Anzaldúa's framing of the space of *nepantla*, a crossroads.

In a poignant maneuver Anzaldúa pronounces, "*La mestiza* has gone from being the sacrificial goat to becoming officiating priestess at the crossroads."[46] She implicates herself as queer mestiza priestess, and, from this esteemed position of spiritual authority, she determines her own path to consciousness while simultaneously allowing for the potential of both fluidity and ambiguity. Yet, at times, the directive of her journey toward consciousness is impossible to ascertain and evades a resolution. Instead, it operates as a series of arduous meditations and strategic mandates.

The domain of Eshu/Eleggua requires cautious observation and is simultaneously informed by the generative mandate of ambiguity, which drives much of Anzaldúa's theorizing of mestiza consciousness. She does this quite literally in a section entitled, "A Tolerance for Ambiguity" where she writes: "She has discovered that she can't hold concepts or ideas in rigid boundaries. . . . Rigidity means death. Only by remaining flexible is she able to stretch the psyche horizontally and vertically. La mestiza constantly has to shift out of habitual formations; from convergent thinking, analytical reasoning that tends to use rationality to move toward a single goal (a Western mode), to divergent thinking, characterized by movement away from set patterns and goals and toward a more whole perspective, one that includes rather than excludes."[47] This indeterminacy is also linked to a fundamental concept in Yoruba cosmologies: There are no rigid boundaries or binaries, no radical opposites. Amalia Cabezas affirms, "Santería belief does not conceive of the universe and sexuality, for that matter, as existing within binary fields

of male/female, straight/gay, and good/bad. Instead, these cosmological systems allow for ambiguity and fluidity in gender and sexuality, with greater availability of gender options, deities that change gender identification, androgynies, and spirit possession."[48] In Lydia Cabrera's influential book *Yemayá y Ochún*, she relates this gender fluidity remarking on Yemaya's tendency to be a *machetera*, and "*marimacho*" in some of her *caminos*.[49]

Anzaldúa theorizes the potentiality of gender ambiguity and androgyny in relation to border consciousness throughout her text. In a section entitled "Half and Half," Anzaldúa tells the story of a girl who lived near her house who people talked about as being *una de las otras*/of the others: "They said that for six months she was a woman who had a vagina that bled once a month, and that for the other six months she was a man, had a penis and she peed standing up."[50] She goes on to align her own sexuality with the *muchacha* from her community, "There is something compelling about being both male and female, about having entry into both worlds. . . . But I, like other queer people, am two in one body, both male and female. I am the embodiment of *hieros gamos*: the coming together of opposite qualities within."[51] This embodied liminality between two genders invokes elements of the sacred, the convergence of the spirit world with the human world.

In his work on sexuality and gender in Santería communities in New York City, Salvador Vidal-Ortiz examines the ways in which queer devotees negotiate their identities in this complex system of spiritual commitment and practice. He pays particular attention to the ways in which Santería offers specific roles for *santera/os* to embody non-normative genders in ceremonies. He affirms that "the presence of spirits through bodily possession offers gendered and sexualized images, and it is most often understood as a freeing of gender structures."[52] Through their ceremonial practices devotees embody manifestations of gender fluidity and in turn serve as intermediaries between spiritual realms. In his book *Queering Creole Spiritual Traditions: Lesbian, Gay, Bisexual, and Transgender Participation in African-Inspired Traditions in the Americas*, Randy Conner (who was a close friend of Anzaldúa for over thirty years) identifies these spaces as providing "multidimensional reality, multiple manifestations of the divine."[53] Anzaldúa articulates a connection between these systems of gender ambiguity and the generative instability of queer mestiza consciousness.

Discursive fragmentations of identities are commonly attributed to postmodern conceptions of unstable subject production. For example, Yarbro-Bejarano addresses these appropriations in her previously cited

cautionary statement against the theoretical universalizing of *Borderlands*. However, throughout the text Anzaldúa grounds both liminality and identity construction in specific spiritual traditions, and it becomes apparent that Yoruba cosmology informs Anzaldúa's thinking even when not overtly named. Alexander accounts for how these spiritual systems simultaneously travel and synthesize multiple conceptual frameworks for "African-based cosmological systems are complex manifestations of the geographies of crossing and dislocation. They are at the same time manifestation of locatedness, rootedness, and belonging that map individual and collective relationships to the Divine."[54] Anzaldúa appeals to Yemayá and Eshu/Eleggua to incisively negotiate her "plurality of self"[55] throughout the journey to mestiza consciousness that she renders in *Borderlands*.

Diasporic Imaginings

For over twenty-five years, Bay Area-based artist Juana Alicia has meticulously crafted images that have become some of the most iconographic murals in the history of Chicana/o visual art. In Alicia's extensive body of work, she renders monumental depictions of hemispheric histories that are compelled by her commitment to global social justice. Among these are her depictions of the struggles of farm workers and mothers in the pesticide-ridden agricultural fields of California in "Las Lechugeras"; a representation of the multiplicity of local characters in San Francisco's Mission District in "Mission Street Manifesto"; and the illustrative testimonies against United States military aid to Central America in "Ceasefire." In this section, I focus on three pieces in which Alicia illuminates African and African diasporic legacies positing that she both aligns herself with and answers Anzaldúa's call for a radical acknowledgment of these histories in Chicana/o cultural production.

In examining how Alicia's images operate in a discussion of performance, I turn to Irma Mayorga's innovative conceptualizations of the "theatricality" in visual art. In Mayorga's analysis of San Antonio-based artist and photographer Kathy Vargas, she asserts that, through Vargas's positioning of images in multiple registers, she "mines theatricality, in other words, makes use of theatrical orchestrations—any number of strategic aesthetic logics that make use of ideas inherent to formal theatrical staging and positions that mimic the energies of dramatic spectacle."[56] While Mayorga is specifically referring to the medium of photography, this conceptual framework is generative in the interrogation of how Juana Alicia's public art critically re-imagines hemispheric histories.

In a 2006 visit to Stanford University, Alicia shared images from one of her latest projects in which she renders images of African diasporic iconography and spiritualities.⁵⁷ The mural entitled "SANARTE: Diversity's Pathway" is located at the Ambulatory Care Clinic of University of California, San Francisco (UCSF) Medical Center (see figure 6.1).⁵⁸ In this ceramic mural, Alicia creates images of the multiracial communities served by the UCSF Medical Center and honors the traditional healing practices of these multiple cultural inheritances. In her vision of holistic health practices, images of acupuncturists and *curanderas* (traditional healers who use the medicinal qualities of plants and other natural sources) are represented in the same privileged position as the physicians utilizing stethoscopes and other clinical Western instruments.

One of the images extensively discussed during her public discussion was the image of the cowrie shells, a powerful symbol in Yoruba cosmology. Robert Farris Thompson explains, "Metaphoric capture of the moral potentiality inherent in certain powers of the natural world—thunder, oceans, herbs, and stones—and a demonstration that creative persons have shaped certain images, pillars of lateritic clay, implements of iron, metal fans, brooms decorated with leather and cowrie-shell embroidery, so that they illumine that world with intuitions of the power to make right things come to pass."⁵⁹ Juana Alicia explicitly engages with these elements of the sacred in her extensive body of work. She comments, "Art is an intermediary between my spirit and the forces of the universe."⁶⁰ In *SANARTE: Diversity's Pathways* she situates cowrie

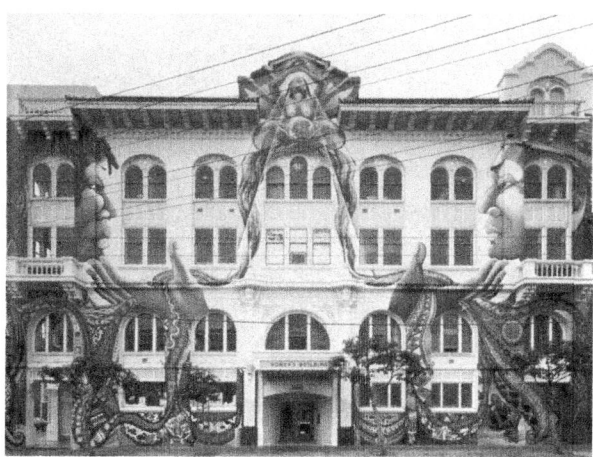

Figure 6.1. *Sanarte: Diversity's Pathway*, Juana Alicia ©2005. Suite of four murals and the double helix and cementatious tile walkway at UCSF Medical Center, 400 Parnassus Avenue, San Francisco.

shells as symbols of fertility, framing them with the Mexica symbol for movement, Ollin, in a literal synthesis of ancient West African and Indigenous iconography.[61] Elucidating the connections between these global healing practices with spiritual iconographies, she declares these compelling images as deeply personal.

In 2003, authorities notified Alicia that one of her most well-known murals, *Las Lechugeras*, painted in 1983 on the corner of York and Twenty-Fourth Streets in San Francisco's Mission District, would have to be destroyed due to water damage to the wall. In conceptualizing the images that would replace her widely circulated and influential image of female farmworkers, water emerged as the central element. Completed in June 2004, *La Llorona's Sacred Waters* depicts the contemporary struggles of communities organized against the privatization of water in a global context. Women emerge as the principal figures with Chalchiuhtlicue, Mexica goddess of lakes and streams who wears a skirt of jade towering over the multiple narratives of the communities woven together; the women of Cochabamba, Bolivia, who have fought to keep the Bechtel Corporation from buying their country's water rights; the Indian farmers in the Narmanda Valley protesting the government's

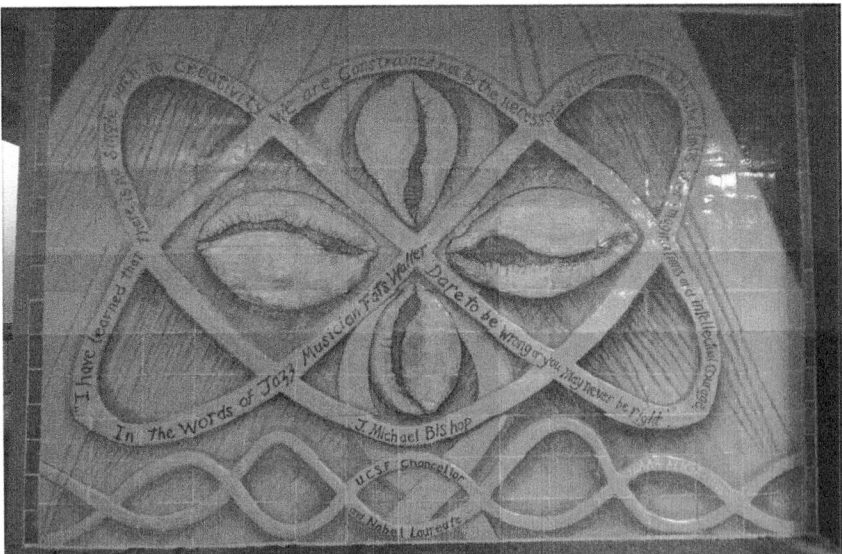

Figure 6.2. OLLIN Mural, detail of *Sanarte: Diversity's Pathway*, Juana Alicia ©2005. Suite of four murals and the double helix and cementatious tile walkway at UCSF Medical Center, 400 Parnassus Avenue, San Francisco.

dam projects that have flooded their homes and threatened their livelihood; and women dressed in black protesting the hundreds of unsolved murders of female *maquiladora* workers along the Rio Grande on the Juárez/El Paso border. As Leticia Hernandez-Linares writes, "This mural merges the battles against overwhelming subconscious mythologies, persistent political realities, and the struggle of everyday life."[62] In Alicia's aesthetic representations, she critically formulates connections between spiritual practices and mandates for social justice.

Besides the prominent portrayal of Chalchiuhtlicue, another figure emerges as a focal representation: that of La Llorona, the mythical "weeping woman" figure who laments the loss of her children after she has killed them. This figure has undergone multiple incarnations from pre-Columbian, colonial, and contemporary periods. Among them is La Siguanaba, which is the combination of Nahuatl words meaning "spirit of a woman" who lives in the river in wait of unfaithful husbands and misbehaving children. According to an interview with Alicia, La Siguanaba is "the spirit of a woman, tell legends from Central America, made ugly by the rain god, Tlaloc, because of her disobedience. Woman's power, like that of water, is feared and misunderstood even by gods."[63] Reinterpretations of the Llorona narratives vary, but one that I heard as a child referred to an Indigenous woman who had been raped by a Spaniard early in the colonial period, and, rather than have the child suffer under Spanish rule, she killed the child.

Sonia Salvívar-Hull cites another version, "The storytellers of my youth insisted on portraying La Llorona sympathetically. She was a young woman, either *mestiza* or Indian, who was *engañada* (fooled) into betraying her race and herself by 'marrying' a wealthy Spaniard who would eventually leave her for a woman of his own race and class. Llorona drowns her children when she learns that he intends to take them away. As I read more on the history of the conquest, I realized that the story I heard as a child was a version of the enslavement of the Indigenous Mexicans; the infanticide is what I now recognize as a political act of resistance by *mestiza* Indigenous women."[64] Contemporary Chicana writers and visual artists continue to revise the narrative of this prominent cultural figure (re)envisioning her not as a victim but as a woman who embodies political agency.[65]

In Alicia's *La Llorona's Sacred Waters*, the figure of La Llorona laments the corporate exploitation of this divine element as well as the violent and perverse exploitation of female bodies in the case of Juarez' *maquiladora* murders (see figure 6.2). She illustrates the relationship between the exploitation and violation of women's bodies and water. As she cradles a sole drop of water with her right hand, she holds the body

of a mulatto boy with her left arm. In the global and multiracial context of this mural, La Llorona protects her black child from the repressive conditions represented in the three specific communities. Expanding the notion of multiracial representations that portray people of color alongside each other as a representation of coalitional politics, Alicia renders these figures as blood relatives: that is, as mother and son. (Please see Color Gallery plate 1, *La Llorona's Sacred Waters* by Juana Alicia.)

During her public discussion at Stanford University, Alicia lamented the undercurrent of internalized racism in the critical feedback from community members as to why she portrayed La Llorona's child as a boy of African descent in the prominent representations of Mexican and Central American Indigenous mythologies.[66] She links her consistent portrayal of Mexican, Chicana/o, and Central American Indigenous narratives alongside those of the African and African American Diaspora to her formative years in predominantly African American downtown Detroit, embodying the negotiation of the personal within the public realm of her craft.

Maestrapeace, a three-story mural that adorns the Women's Building in San Francisco's Mission District, was painted over a period of thirteen months during 1993 and 1994 by a collective of seven women muralists, including Alicia.[67] According to the official Women's Building website, the mural presents several "messages" that include "women's wisdom over time, the contributions of women throughout history, and the making of history by women from all corners of the earth."[68] The mural was commissioned to celebrate the final mortgage payment for the building, which was originally purchased in 1979. In conceptualizing the mural, the artists (in conjunction with the Women's Building) distributed surveys to community members asking them what kinds of images they would like to see on the massive neighborhood building.[69] The images depict women from all over the world represented by prominent cultural, political, and spiritual iconography in the form of religious symbols, cosmological figures, women playing musical instruments and performing healing ceremonies, among other activities.

In the published guide to the *Maestrapeace* mural available at the Women's Building, the authors detail the genealogy of the momentous public art project:

> The mural process was a testament to community involvement and artistic collaboration. In 1992 The Women's Building administration formed a committee to plan a mural project. Funding strategies were implemented and 8,000 questionnaires on possible themes were distributed to building visitors,

neighbors, and community organizations. The results from this survey were compiled. About a year later enough funds were in place to begin. Fundraising was ongoing throughout the [two-and-a-half year] span of the project, including several special events. A call was put out to artists to apply. The committee decided that the selected artists should reflect cultural diversity and artistic excellence. Out of the numerous applicants, seven women were selected. . . . The muralists . . . collectively possess over a hundred years of mural experience. They play an active and integral part of the Bay Area mural movement. [They reflect] ethnic diversity (Lesbian, straight, and bi-sexual), ranging in age from 26 to 56, including two grandmothers.[70]

These multifarious and celebratory depictions of women in this international context are immensely rich and merit a dissertation in and of themselves (see figure 6.4).[71]

For the purpose of this chapter, I focus on one particular set of images from the façade facing Lapidge Street, perpendicular to Eighteenth Street. In this section of the mural, Rigoberta Menchú, the first Indigenous woman Nobel Peace Prize laureate, holds Mexica moon goddess Coyolxauhqui (painted by Chicana artist Irene Perez) in one hand and Yoruba *orisha* Yemayá (painted by Juana Alicia) in the other

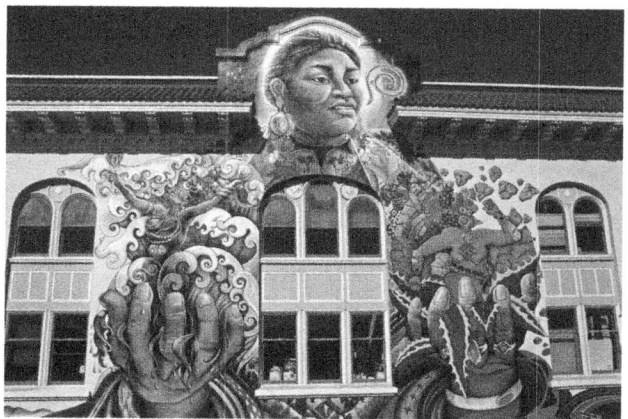

Figure 6.3. *MaestraPeace* (1994 and 2000) by Juana Alicia, Edythe Boone, Susan Kelk Cervantes, Meera Desai, Yvonne Littleton, and Irene Perez. Photo Credit: Marvin Collins, Ruben Guzman, et al. All Rights Reserved. Permissions granted.

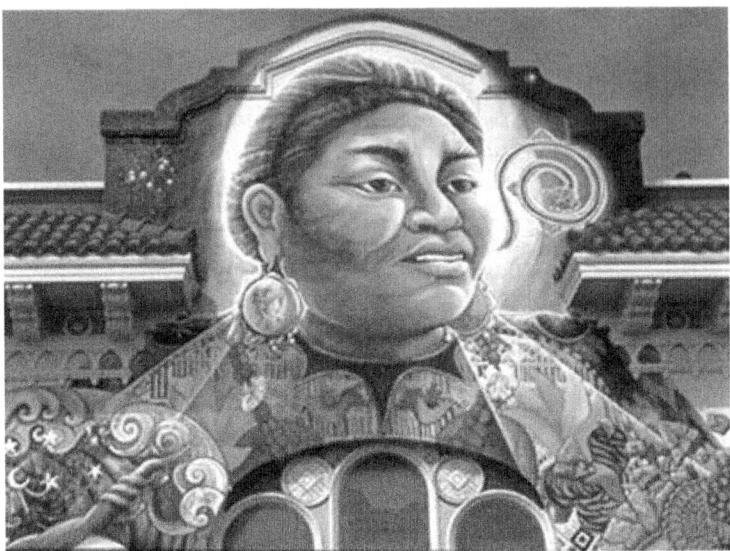

Figure 6.4. *MaestraPeace* (Detail) (1994 and 2000) by Juana Alicia, Edythe Boone, Susan Kelk Cervantes, Meera Desai, Yvonne Littleton, and Irene Perez. Photo Credit: Marvin Collins, Ruben Guzman, et al. All Rights Reserved. Permissions granted.

hand. Irene Perez reproduced the mural image from her smaller painting *Coyolxauhqui Last Seen in East Oakland* (1993) in which she literally puts Coyolxauhqui back together in what Laura Pérez identifies as a "groundbreaking and contestatory imagining of the goddess's body whole, rather than dismembered."[72] The figure of Coyolxauhqui is often invoked by contemporary Chicana writers and visual artists as a radical critique of patriarchy in Mexica narratives as well as Chicano nationalist politics. Cherríe Moraga chooses to venerate Coyolxauhqui as a reclamation and radical affirmation of queer and feminist mythological revisions proclaiming: "I pray to the daughter, La Hija Rebelde. She who has been banished, the mutilated sister who transforms herself into the moon. She is la fuerza femenina our attempt to pick up our fragments of our dismembered womanhood and reconstitute ourselves. She is the Chicana writer's words, the Chicana painter's canvas, the Chicana dancer's step. She is motherhood reclaimed and sisterhood honored."[73] Moraga positions Chicana lesbian sexuality as central in Mexica and Chicana/o nationalist mythologies and reconceptualizes Coyolxauhqui as her Luna character in *The Hungry Woman: A Mexican Medea*.

The *Maestrapeace* mural towers as testament to feminist, and even queer, renderings as "La Hija Rebelde" literally breaks out of the stone onto which is she fixed by the archaeological archive (see Figure 6.5). Laura Pérez writes, "One cannot help but to see Rodríguez scholars and artists as the *tlamatinime* . . . of our times, orally deciphering their own or others' scholarly writings and artwork, the myths about Rodríguez, and the iconography of the stone sculpture of Coatlicue's warrior daughter."[74]

In her other hand, Menchú holds Alicia's depiction of Yemayá (also known as Yemoja in West Africa), a powerful water deity—first of the sweetwaters, the rivers of Yoruba land. As previously mentioned, she came to be known as the *orisha* of the ocean waters after the Middle Passage, venerated as the female energy who received the corporeal offerings coerced by the trans-Atlantic slave trade.

Like pre-Columbian deities (and most ancient spiritual traditions around the world), *orishas* are embodied by multiple avatars, never completely amorous or tyrannical. To maintain a balance and reciprocal relationship between the divine and the humane, they require complex enactments of veneration. Associated with the fiercely powerful female majesty of the open waters and visualized as a woman wielding a sword, Yemayá is often feared for her "supreme witchcraft" (alongside other female water *orishas*, Oshun and Oyá). In her article, "Radical Yoruba Sexuality," Judith Hoch-Smith writes: "Without the concept of witchcraft, power would have flowed naturally through society, lodging only in socially structured positions, most of which were held by men in the traditional Yoruba patrilineage. However, the concept of witchcraft permitted great quantities of power to become lodged in women, who in turn were thought to use that power against the institutions of society. In this sense, witchcraft symbolized the eternal struggle of the sexes in Yoruba society over control of the life-force."[75] The compelling potentiality of actions by the female *orishas* (specifically Yemayá) threatens the ancient power struggles between both gendered elemental forces and gender roles in contemporary society.

There is a connection between women as carriers of this life force and the reign of female *orishas* over domains of water (Yemayá, Ochun, Oyá). Robert Farris Thompson affirms Hoch-Smith's feminist rendering of witchcraft as that which militates "against not only total male dominance but the threat of class formation and drastically unequal distribution of wealth."[76] Alicia's portrayal of Yemayá embodies these critical reconceptualizations of the *orisha's* transformative capacity. She positions Yemayá among global feminist figures—cosmological and quotidian—who challenge pervasive masculinist narratives and images.

In an incantation recorded by Pierre Verger in the town of Ketu, Senegal, in 1957, Yemayá is both revered and feared for her power,

> Yemoja, the wind that whirls with force into the land.
> Yemoja, angered water that smashes down the metal bridge.[77]

This oral veneration echoes Anzaldúa's previously cited honoring of Yemayá as the provoked elemental force that demolishes imposed borders and bridges:

> But the skin of the earth is seamless.
> The sea cannot be fenced,
> *el mar* does not stop at borders.
> To show the white man what she thought of his arrogance,
> *Yemayá* blew that wire fence down.[78]

In Verger's translation, Yemayá is said to have smashed down a bridge made of metal, which is the material of "the hard god," Ogun, a male deity of war and iron.[79] This specific conflict comes to represent a binary opposition between the female reign of the waters and the male institution of metal (represented by the soldier Orisha, Ogun). In the Anzaldúa passage, the female power that surges from beneath the water's surface cannot be contained by the wire fence, a boundary violently imposed by colonialist and patriarchal forces. Separated by thousands of miles across the Atlantic and divergent historical contexts, Anzaldúa's and Verger's passages operate as testimonies to Yemayá's unrelenting and transformative power to revise these narratives.

In *Maestrapeace*, Pérez's Coyolxauhqui breaks out of the hardened stone that immobilizes her in the archeological context, and Alicia's Yemayá bursts out of the waters under which her force pulsates. She wields a round fan in one hand, what Farris Thompson describes as "an emblem embodying the coolness and command of these spirits of the water," and a cowrie shell in the other hand, which is a representation of Yoruba coinage.[80] In her womb, Yemayá holds the ancient currency of these shells, which double as an image of fertility. She maintains a vigorous proximity to these esteemed objects that originate at the bottom of the sea. (Please see Color Gallery plate 2, Yemaya detail from '*MaestraPeace*' by Juana Alicia, et al.).

Yemayá is often referred to as the "Mother of the *orishas*," yet the *Maestrapeace* artists do not position her in parallel portraiture with the Mexica mother deity, Coatlicue. Instead, they situate Coatlicue's daughter Coyolxauhqui and Yemayá in Menchú's hands. Although they

are looking away from each other, their parallel alignment sets up a dialectic between trans-Atlantic relatives. Coyolxauhqui and Yemayá are framed by two rays of light that radiate from Menchú's circular earrings that in turn frame the image of three naked women of different skin colors dancing and holding each other.

As Coyolxauhqui and Yemayá radiate from the trajectories of Menchú's earrings, they emerge from Menchú's hands that are outstretched in gestures of offering. Quite literally, this ancient conversation between the two female energies takes place across the body of Menchú in a monumental testament to the acknowledgment of trans-Atlantic diasporic conversations and shared hemispheric histories. This visual rendering allows for what Diana Taylor refers to as an "alternative perspectives on historical processes of transnational contact and invites a remapping of the Americas."[81] The very depiction of these bodies operates as a critical praxis in addressing representations of the corporeal and prompts us to remember a pre-Columbian conversation between ancestors, one that Anzaldúa invokes throughout her text. As Yarbro-Bejarano pointed out in reference to the representation of the two deities, their bodies are painted with two distinct aesthetic approaches.[82] While Coyolxauhqui is portrayed in the traditional two-dimensional style of pre-Columbian codices with a focus on the profile of the body, Alicia represents Yemayá in more contemporary portraiture.

The prominent positioning of these deities in the context of this mural links the political, aesthetic, social, and sexual implications of representations of the body with material spiritual practices. While this particular façade of *Maestrapeace* portrays women enacting multiple practices from the seemingly mundane to the culturally specific, the images that function as the most prominent are those of Menchú, Coyolxauhqui, and Yemayá. This framing posits an inextricable relationship between the work that Menchú has dedicated her life to social and environmental justice with the spiritual legacies of these two ancient deities, reminding us that cultural and political work *is*, in fact, spiritual work.[83] Linking this legacy of political action with cultural production, Anzaldúa affirms, "Creative acts are forms of political activism employing definite aesthetic strategies for resisting dominant cultural forms and are not merely aesthetic exercises."[84]

Coalitional Politics/Diasporic Implications

The representations in *Maestrapeace* bridge radical women of color politics in the United States with global struggles for justice and peace. The acknowledgment of these relationships is rooted in contemporary

multiracial and radical women of color coalitional politics developed since the 1970s and 1980s articulated by writers such as Audre Lorde, Cherríe Moraga, Gloria Anzaldúa, Toni Cade Bambara, M. Jacqui Alexander, Angela Davis, and Chandra Mohanty, among many others. The political directives of these scholars and activists have been anthologized in such collections as *This Bridge Called My Back*; *Feminist Genealogies, Colonial Legacies, Democratic Futures*; *Sing, Whisper, Shout, Pray! Feminist Visions for a Just World*; and *Making Face, Making Soul/Haciendo Caras*.[85]

In Chela Sandoval's momentous theoretical mandate for U.S. Third-World feminism and "differential consciousness," she articulates how these practices function as a critical departure from "U.S. hememonic feminist theory."[86] Sandoval writes: "The 'truth' of differential social movement is composed of manifold positions for truth: these positions are ideological stands that are viewed as potential tactics drawn from a never-ending interventionary fund, the contents of which remobilizes power. Differential consciousness and social movement thus are linked to the necessity to stake out and hold solid identity and political positions in the social world."[87] Alicia manifests these ideologies in her visual representations, thus mobilizing the political imperatives of Sandoval's mandate.

In "Remembering *This Bridge Called My Back*, Remembering Ourselves," Alexander reflects on the unprecedented articulations of the influential book, "I want to insist on its generosity, for in the midst of uncovering the painful fault lines of homophobia, culture, and class within different communities of belonging, and advancing critiques of racism within the women's movement, it did not relinquish a vision of interdependence, of interbeing, if you will. It was not a transcendent vision, but one that was rooted in transforming the mundaneness of lived experience, the very ground on which violence finds fodder."[88] I extend the implications of this coalitional politics and present the radical legacies of these coalitions as a historically powerful positing that, through their intellectual and cultural work, Anzaldúa and Alicia position themselves as part of African and African American diasporic consciousness.

In her artist statement Juana Alicia writes, "I make murals with groups because of the learning that process provides me. It forces me to think and see from other minds and eyes, and to stretch my emotional capacities and communication skills. I also learn new techniques from other muralists and artisans. Naturally, a group allows one to take on a more monumental work, and lightens the burden that the individual artist would also have to bear, vis-à-vis community relations, adminis-

tration, documentation and the actual execution of the work."[89] This collective creation is rooted in a democratizing process that is central to Alicia's art-making philosophy. Alicia's statement resonates with both the process and content of the Maestrapeace mural. The creation of *Maestrapeace* with its representation of a myriad of identities in the mural and among the *artists* (with relation to race, sexuality, class, gender expression, differently-abled bodies, etc.) operates as parallel to the foundational directives for the transnational feminist texts mentioned above.

Performing on the Scaffold

It is critical to recognize the form in which many of Alicia's images operate and circulate: the public space of muralism. In the tradition of Chicana/o art during the Chicana/o movement, murals were rooted in representing the demographics of the space, location, and neighborhood in which they were constructed. In the context of *Maestrapeace*, the visual manifestations of African and Indigenous iconographies speak to the multiracial and multicultural communities of the Mission District. As Marcos Sánchez-Traquilino articulates, "Mural making represented the community's public efforts at self-definition in and through an artistic form which did not require validation by the academic, museum or gallery-oriented art world."[90] This personal commitment to contemporary community-based politics functions as fundamental to the work of Juana Alicia who continues to be a prominent activist and artist in the San Francisco Bay area.

Alicia focuses on global spirit practices in many of her images and makes critical connections between these representations of the sacred and her commitment to social justice as a Chicana feminist. As Alexander writes, "secular feminism has perhaps assisted, unwittingly, in the privatization of the spiritual—in the dichotomization of a 'private' spiritual self from the corpus of work called feminism and from organized political mobilizations."[91] Through her art practice Alicia transcends those dichotomizing processes. She declares:

> In much of my work, I use imagery of essential elements as found in the symbolic systems of earth-based religions. Among the practices that resonate with my own beliefs, with its rich and compelling symbolic system is the Yoruba religion or the Lucumí practice in Cuba. A sacred aspect for these elements is central to living lightly on the planet and

> acting politically to oppose the forces of massive consumption, greed, capitalism, and environmental destruction. My creative work is a medium for developing my spiritual life as well as a medium for communicating many ideas, conceptual, spiritual and political, with a wide public. The act of celebrating, symbolizing and reinterpreting the sacred elements occurs not only in monumental pieces of art but in one's daily life, relationships and practices.[92]

Alicia's mandate is rooted in an approach to art-making that Laura Pérez so voraciously examines, particularly the ways in which Chicana visual artists engage with what she describes as "the spiritual alongside more familiar areas of social struggle (gender, sexuality, class, 'race') as another terrain upon which to challenge the cultural blind spots in mainstream values, in our assumptions and dismissals, in our pretensions to the universality and superiority of our beliefs, and in our anti-religiosity or religious dogmatisms."[93]

In her representations of feminist figures, Juana Alicia reclaims public space in the tradition of other Chicana muralists who made critical interventions from the early murals of the Chicano movement painted predominately by male artists (or credited by mostly male artists even though murals are almost always collective efforts). According to Sperling Cockroft and Holly Barnet Sanchez, the Chicana/o *movimiento* murals of the 1970s "tended to reflect the nationalistic concerns of the times and dealt largely with questions of Chicano identity."[94] However, Alicia radically departs from the ethnonationalist murals of this period and performs (together with the figures in her murals) multiple subjectivities. She engages with Mayorga's interrogation of how visual artists (photographers in particular) engage in "theatrical tropologies" as they reveal how "an object, person, or idea can communicate or accomplish agency—as a *primary* tool of creating meaning through and within images."[95] Alicia inscribes diasporic histories in her work as she embodies multiple iterations of agency. She visually synthesizes a vehement commitment to social justice issues together with personal spiritual convictions to create these monumental invocations.

In closing, I return to Anzaldúa and the Coyolxauhqui/Yemayá image in *Maestrapeace*—this parallel pairing of Mexica and Yoruba. Alicia's depiction of Yemayá in the Maestrapeace mural operates as a vivid manifestation of Anzaldúa's calling of Yemayá. These representations function as a visual testament to Anzaldúa's textual invocation of Yemayá in her pivotal conceptualization of radical Chicana mestiza sociopolitical consciousness.

> You were Yemayá's child.
> In a photograph you flow blue and white
> like the waves foaming around your
> knees.
> Laughing hard in long shirtsleeves and jeans
> you walk into the holy cross of the Pacific
> gathering conch shells and sea horses
> for the secret lover that dwells inside.
>
> —From "Tu última cruzada/In Memoriam"
> (a Gloria E. Anzaldúa, 1942–2004) by Alicia Gaspar de Alba

Notes

1. Gloria Anzaldúa, *Borderlands/La Frontera: The New Mestiza* (San Francisco, CA: Aunt Lute, 1987), 86, hereinafter referenced as *Borderlands/La Frontera: The New Mestiza*.

2. Pierre Verger as cited in Robert Farris Thompson, *Flash of the Spirit: African and Afro-American Art and Philosophy* (New York: Vintage Books, 1983), 75.

3. Santería, in brief, is a belief system developed by Nigerian slaves brought to Cuba in the eighteenth century and eventually syncretized with elements of Spanish Catholicism. Today it is practiced throughout the African Diaspora in the Americas and by devotees globally in multiple forms and by different names. Santería is formally referred to as Lukumí, "La regla de Lukumí," "La regla de Ochá," or "La regla de Ifá."

4. M. Jacqui Alexander, *Pedagogies of Crossing: Meditations on Feminism, Sexual Politics, Memory, and the Sacred* (Durham: Duke University Press, 2005), 299.

5. In May 2009, the Society for the Study of Gloria Anzaldúa hosted the First Annual Conference on the Life and Work of Gloria Anzaldúa at the University of Texas, San Antonio (UTSA). In the opening address, Dr. Randy Conner, a friend and colleague of Anzaldúa' for over thirty years, vehemently called for scholars to interrogate these unexplored currents of Anzaldúa's work and specifically acknowledged the paper that I was presenting, " 'Yemayá Blew That Wire Fence Down': Invoking African Spiritualities in Gloria Anzaldúa's *Borderlands/La Frontera: The New Mestiza*," proclaiming that Anzaldúa would have been thrilled at the fact that someone was addressing this aspect of her spiritual and literary contributions. It was the only paper out of hundreds that addressed this aspect of her work.

6. It is beyond the scope of my project to address the most provocative critiques of Anzaldúa's texts, but I mention two in particular that address her representation of Indigenous female identities. María Josefina Saldaña-Portillo

writes: "What Anzaldúa does not recognize—indeed, cannot recognize from her privileged position as First World minority rather than Third World subaltern—is that her very focus on the Aztec female deities is an effect of the PRI's statist policies to resuscitate, through state-funded documentation, this particular, defunct Mexican Indian culture and history to the exclusion of dozens of living Indigenous cultures." María Josefina Saldaña-Portillo, *The Revolutionary Imagination in the Americas and the Age of Development* (Durham: Duke University Press, 2003), 282.

Sheila Marie Contreras echoes Saldaña-Portillo's incisive analysis of Anzaldúa's "de-historicized" mythologies, "[I]ndigeneity exists most forcefully in Anzaldúa's text as myth and signifies the denied or unconscious side of mestiza consciousness. And although Anzaldúa strives to give expression to the Indigenous elements of Chicana identity in the present, her persistent appeal to an Aztec panthon represented by Coatlicue/Serpent Skirt, Tlazolteotl, the snake, and smoking mirror effectively dehistoricizes the relations between Chicanas/os and Native." Contreras, Sheila Marie Contreras, *Blood Lines: Myth, Indigenism, and Chicana/o Literature* (Austin: University of Texas Press, 2008), 116.

7. Yarbro-Bejarano, "Gloria Anzaldúa's *Borderlands/La Frontera*: Cultural Studies, 'Difference,' and the Non-Unitary Subject," *Cultural Critique* 28 (Fall 1994): 17; Saldívar, José David. *The Dialectics of Our America: Genealogy, Cultural Critique, and Literary History* (Durham: Duke University Press, 1991), 84; José David Saldívar, *Border Matters: Remapping American Cultural Studies* (Berkeley: University of California Press, 1997), 8; Nortma Alarcón, "The Theoretical Subject(s) of This Bridge Called My Back and Anglo-American Feminism," in *Making Face, Making Soul: Haciendo Caras Creative and Critical Perspectives by Feminists of Color*, ed. Gloria Anzaldúa (San Francisco: Aunt Lute Books, 1990).

8. Yarbro-Bejarano, "Gloria Anzaldúa's *Borderlands/La Frontera*," 7.

9. See the introduction for my explanation as to why I use "Mexica" as opposed to "Aztec."

10. Yarbro-Bejarano, "Gloria Anzaldúa's *Borderlands/La Frontera*," 17.

11. See Sonia Saldívar-Hull, "Mestiza Consciousness and Politics: Gloria Anzaldúa's *Borderlands/La Frontera*," in *Feminism in the Borderlands: Chicana Gender Politics and Literature* (Berkeley: University of California Press, 2000).

12. *Borderlands*, 86.

13. Yarbro-Bejarano, 11.

14. Reflecting on these multiple points of entry into the subject formation specifically with regard to the authors of *This Bridge Called My Back*, Norma Alarcón writes, "The peculiarity of their displacement implies a multiplicity of positions from which they are driven to grasp or understand themselves and their relations with the real, in the Althusserian sense of the word." Norma Alarcón, "The Theoretical Subject(s) of *This Bridge Called My Back* and Anglo-American Feminism," in *Making Face, Making Soul/Haciendo Caras*, ed. Gloria Anzaldúa (San Francisco: Spinsters/Aunt Lute, 1986), 356.

15. Emma Pérez, "Gloria Anzaldúa: La Gran Nueva Mestiza Theorist, Writer, Activist-Scholar," *NWSA Journal* 17, no. 2 (Summer 2005): 4.

16. *Borderlands*, 86.

17. In 2005 the "anti-illegal immigrant" organization, Save Our State of Ventura County, demanded the removal of Anzaldúa's mandate on a twelve-year-old monument in Baldwin Park, California, entitled "Danzas Indigenas." This anti-immigrant "activist" group referred to Anzaldúa's quote as a battle cry for the "reconquista" (or reconquest) that they purported as actualized by the continued settlement of Mexican immigrants in the United States, particularly in California (though the organization has chapters in various states). Chicana public artist and activist Judy Baca was commissioned to create this work in 1993 by Metropolitan Transit Authority and the City of Baldwin Park in collaboration with the Kate Diamond Architectural Group. Right-wing activist groups perceived it as a dangerous threat of literal reoccupation of the Southwestern states by the continued influx or as they phrased it "invasion" of immigrants from south of the border. Anzaldúa's articulation of a mestiza "reconquista" composed of four short lines proved to function beyond a discursive exercise and the literal application of reclaiming land threatened nativist groups. In an article on the Los Angeles Writers Collective website, Judy Baca made a statement about the piece, "This quote 'this land was Mexican once, was Indian always, and is, and will be again' is by a critically acclaimed Chicana author, Gloria Anzaldúa. On the Save Our State website, she is referred to as a 'dead Chicana lesbian.' I chose this quote because the mission is one mile from the Mission San Gabriel, and descendants of the Gabrielinos still live in the region, making Anzaldúa's text particularly relevant to the increasingly indigenous population. A correct reading of the quote makes it clear that this is not about Mexican 'reconquista,' but about the land returning to its origins." Judy Baca, "Judy Baca's Monument in Baldwin Park is Under Attack," L.A. Writers Collective, http://lawriterscollective.blogspot.com/2005/06/judy-bacas-monument-in-baldwin-park.html (accessed June 7, 2005).

18. Alicia Arrizón, *Queering Mestizaje: Transculturation and Performance* (Ann Arbor: University of Michigan Press, 2006), 53.

19. "*Una herida abierta*" translates to "an open wound" (*Borderlands*, 3).

20. Yarbro-Bejarano writes, "The first six essays of the book inscribe a serpentine movement through different kinds of *mestizaje* that produce a third thing that is neither this not that but something else: the blending of Spanish, Indian, and African to produce Chicano language, of male and female to produce the queer, of mind and body to produce the animal soul, the writing that 'makes face'" (Yarbro-Bejarano, "Gloria Anzaldúa's *Borderlands/La Frontera*," 17).

21. In *Borderlands*, Anzaldúa cites Luisah Teish, a *santera* and close friend, with having named her as a daughter of Yemayá (*Borderlands*, 36, 95). Her biography in the list of original contributors to the 1981 version of *This Bridge Called My Back* reads, "Gloria Evangelina Anzaldúa. I'm a Tejana, Chicana poet, hija de Amalia, Hecate y Yemayá" *This Bridge Called My Back: Writings by Radical Women of Color*, ed. Cherríe Moraga and Gloria Anzaldúa (New York: Kitchen Table; Women of Color, 1981), 246.

22. Yarbro-Bejarano, "Gloria Anzaldúa's *Borderlands/La Frontera*," 8.

23. In her critique Saldaña-Portillo writes, "Anzaldúa's model of representation reproduces liberal models of choice that privilege her position as a U.S. Chicana: she goes through her backpack and decides what to keep and what to

throw out, and she chooses to keep signs of Indigenous identity as ornamentation and spiritual revival." María Josefina Saldaña-Portillo, "Who's the Indian in Aztlán? Re-Writing Mestizaje, Indianism, and Chicanismo from the Lacadón," in *The Latin American Subaltern Studies Reader*, ed. Ileana Rodríguez (Durham: Duke University Press, 2001), 420.

At the First Annual Conference on the Life and Work of Gloria Anzaldúa at the UTSA, Randy Conner cited Saldaña-Portillo's critique and defended Anzaldúa as a vigilant student of global spirit practices not engaged in a project of appropriation as critics have stated. Randy Conner, "Santa Nepantla, A Borderlands Sutra," unpublished lecture, First Annual Conference on the Life and Work of Gloria Anzaldúa, San Antonio, Texas, May 16, 2009.

24. Saldívar-Hull, 60.
25. *Borderlands*, 51.
26. Saldívar-Hull, 64.
27. Alarcón, "The Theoretical Subject(s)," 50. Contreras contends how Anzaldúa came to her knowledge of Coatlicue and other Mexica figures: "The pre-Columbian gods and goddesses that people her text, however have been made available not by the local folklore of Chicana/os of South Texas, but rather by modern archaeological discourse that has long concerned itself with documenting and interpreting the Aztec pantheon" (Contreras, *Blood Lines*, 119). She also writes, "If we accept, however, that the indigeneity of Chicanas/os can be represented metaphorically through Aztec mythology, we position ourselves as modern anthropologists, which raises questions about Chicana/os' relationship to the past and the present of contemporary Indigenous communities in the United States and in Mexico" (113).
28. Alarcón, "The Theoretical Subject(s)," 50.
29. The concept of *Nepantla* as a liminal space propels generative theorizations against the limiting binaries of both gender and sexuality.
30. Emma Pérez, "Gloria Anzaldúa, La Gran Nueva Mestiza Theorist, Writer, Activist Scholar." *National Women's Studies Association Journal*, 17:2 (Summer 2005): 5.
31. Borderlands, 13.
32. In the Afro-Brazilian spiritual narratives of *Candomblé* it is Yemaya who heals Baba Lu Aiye's wounds with her water.
33. *Borderlands*, 86.
34. While Mexican historians have often referred to this acknowledgement as "la tercera raíz" it is often employed to speak of a historical past and not contemporary identity politics.
35. *Borderlands*, 86.
36. Omise'eke Natasha Tinsley, "Black Atlantic, Queer Atlantic: Queer Imaginings of the Middle Passage," *Gay Lesbian Quarterly* 14, nos. 2–3 (2008): 192. Tinsley does not explicitly cite Anzaldúa, but her use of the word "borderlands" leads me to believe that she might have been referring to Anzaldúa's theoretical framework given its comprehensive circulation and exposure in countless fields.
37. Tinsley, 192.

38. Clifford, James. *Routes: Travel and Translation in the Late Twentieth Century* (Cambridge: Harvard University Press, 1997), 264.
39. Ibid., 247.
40. Saldívar, *Border Matters: Remapping American Cultural Studies* (Berkeley: University of California Press, 1997), 35.
41. In this section, I discuss Anzaldúa's conjuring of the male *orisha* Eleggua, whose sacred colors are red and black, the same as the Mexican male deity Tezcatlipoca (also know as Smoking Mirror) whom Anzaldúa invokes throughout her text transferring the power of Smoking Mirror to *la mestiza*.
42. *Borderlands*, 80.
43. Mary Ann Clark, *Where Men Are Wives and Mothers Rule: Santería Ritual Practices and Their Gender Implications* (Gainesville: University Press of Florida, 2005), 14.
44. Alexander, 292.
45. Ibid.
46. *Borderlands*, 80.
47. Ibid., 79.
48. Amalia Cabezas, *Economies of Desire: Sex and Tourism in Cuba and the Dominican Republic* (Philadelphia: Temple University Press, 2009), 116.
49. Lydia Cabrera, *Yemayá y Ochún: Kariocha, Iyalorichas y Olorichas* (Miami: Ediciones Universal, 1996), 44–46.
50. *Borderlands*, 19.
51. Ibid.
52. Salvador Vidal-Ortíz, " 'Sexuality' and 'Gender' in Santería: Towards a Queer of Color Critique in the Study of Religion" (PhD Dissertation, City University of New York, 2005), 22.
53. Randy Conner and David Sparks, *Queering Creole Spiritual Traditions: Lesbian, Gay, Bisexual and Transgender Participation in African-Inspired Traditions in the Americas* (Binghamton, NY: Harrington Park, 2004), 1.
54. Alexander, 290.
55. Alarcón, 366.
56. Irma Mayorga. "Constructing Stages of Hope: Performance and Theatricality in the Aesthetic Logics of Chicana Expressive Culture" (PhD diss., Stanford University, 2005), 184–85.
57. Juana Alicia, Public Lecture, Stanford University, February 16, 2006.
58. The title refers to the Spanish phrases for *sanar* (to cure) and *arte* (art)." For images of this mural see Juana Alicia's website: http://juanaalicia.com.
59. Robert Farris Thompson, *Flash of the Spirit*, 93.
60. Juana Alicia, personal communication with author, Berkeley, California, June 10, 2009.
61. The message inscribed along the intersecting rays of Ollin reads: "In the words of Jazz Musician Fats Waller, '*Dare to be wrong or you may never be right*.' Woven together with Waller's passage is a quote by University of California, San Francisco Chancellor and Nobel Laureate, J. Michael Bishop, 'I have learned that there is no single path to creativity. We are constrained not

by the necessary discipline of rigor but by the limits of our imaginations and intellectual courage."

62. Leticia Hernández-Linares, "Painting the River Clean," in *Street Art in San Francisco: Mission Muralismo*, ed. Annice Jacoby (New York: Abrams, 2009), 39.

63. http://www.juanaalicia.com/content/57/ (accessed March 20, 2006).

64. Saldívar-Hull, 120.

65. See the work of Cherríe Moraga, Ines Hernández-Avila, Lorna Dee Cervantes.

66. In a similar situation, María Ochoa discusses the famous 1974 Mission District mural, "Latinoamerica" by Mujeres Muralistas in which she states that representations in the mural "are notable for breaking away from the rendering of *mestizaje* as an India/o-Spanish mixing culture. In the work *mestizaje* is portrayed through the use of Latinas of African descent. The central figures of the only two contemporary urban scenes are clearly of African descent, with their dark skin, nappy hair, broad noses, and lush-lipped mouths. The artists wished to show the range of Latina/o culture, but their intention was not so large as the reconfiguration of the representational paradigm of *mestizaje*. However, given that the overall representational claim of the mural is its depiction of *Latinoamerica*, it seems appropriate to conclude that the artists' transgressive iconography effected some public thought and discussion within the Mission District's Latina/o community." María Ochoa, *Creative Collectives: Chicana Painters Working in Community* (Albuquerque: University of New Mexico Press, 2003), 51.

67. The "Maestrapeace" Collective includes Juana Alicia, Edythe Boone, Susan Kelk Cervantes, Meera Desai, Yvonne Littleton, and Irene Pérez.

68. http://www.womensbuilding.org/public/about/mural.html (accessed February 8, 2006).

69. The Women's Center, operated and led by women, defines their programming as addressing three critical needs of women in the community: economic security, building community, and promoting social change. http://www.womensbuilding.org/ public/programs/programs.html.

70. Aracely Soriano and Sandra Sánchez, *Maestrapeace: A Guide to the Mural on the San Francisco Women's Building* (San Francisco: Mission Cultural Center, 1996), 2–3.

71. In Julie Minich, "National Bodies/Embodied Nations: Reading Disability in Chicana/o, Mexican and Spanish Cultural Production" she discusses the representation of differently-abled bodies in the mural (PhD diss., Stanford University, 2008).

72. Pérez, *Chicana Art*, 250.

73. Moraga, *The Last Generation: Prose and Poetry* (Boston: South End, 1993), 74.

74. Pérez, *Chicana Art*, 247.

75. Judith Hoch-Smith, "Radical Yoruba Female Sexuality," in *Women in Ritual and Symbolic Roles*, ed. Judith Hoch-Smith and Anita Spring (New York: Plenum, 1978), 265.

76. Farris Thompson, *Flash of the Spirit*, 74.
77. Pierre Verger as cited in Farris Thompson, *Flash of the Spirit*, 75.
78. *Borderlands*, 86.
79. Farris Thompson, *Flash of the Spirit*, 72.
80. Ibid.
81. Other than Juana Alicia's rendering of Yemayá and Irene Pérez's Coyolxauqui, I do not know who specifically painted the other images. However I understand the mural to be collectively conceptualized.
82. Yvonne Yarbro-Bejarano, Class Discussion, Stanford University, Palo Alto, California, February 16, 2006.
83. Guisela Latorre writes, "It can even be argued that Rigoberta Menchú *herself* collaborated with the making of *Maestrapeace*. When she was unable to attend the mural's first dedication, a second one was organized to accommodate her busy schedule. As a way to justify the second dedication, Menchú simply asked, 'Why shouldn't a *maestrapiece* such as this have two inaugurations?" Guisela Latorre, "Gender, Muralism and the Politics of Identity: Chicana Muralism and Indigenist Aesthetics," in *Disciplines on the Line: Feminist Research on Spanish, Latin American, and U.S. Latina Women*, ed. Anne J. Cruz, Rosilie Hernaández-Pecoraro, and Joyce Tolliver (Newark: Juan de la Cuesta, 2003), 338.
84. Gloria Anzaldúa, ed., "Haciendo Caras, una entrada," in *Making Face, Making Soul: Haciendo Caras Creative and Critical Perspectives by Feminists of Color* (San Francisco: Aunt Lute Books, 1990), xxiv.
85. *This Bridge Called My Back; Feminist Genealogies, Colonial Legacies, Democratic Futures; Sing, Whisper, Shout, Pray! Feminist Visions for a Just World*, and *Making Face, Making Soul*.
86. Chela Sandoval, *Methodology of the Oppressed* (Minneapolis: University of Minnesota, 2000), 54.
87. Ibid., 60.
88. Alexander, 279.
89. Juana Alicia, http://www.juanaalicia.com/about/ (accessed June 30, 2007).
90. Marcos Sánchez-Tranquilino, "Murales del Movimiento: Chicano Murals and the Discourses of Art and Americanization," in *Signs from the Heart: California Chicano Murals*, ed. Eva Sperling Cockcroft and Holly Barnet-Sánchez (Albuquerque: University of New Mexico Press, 1990), 94.
91. Alexander, 326.
92. Alicia, personal communication with author, 2009.
93. Laura Pérez, *Chicana Art: The Politics of Spiritual and Aesthetic Altarities* (Durham: Duke University Press, 2007), 3.
94. Eva Sperling Cockroft and Holly Barnet-Sanchez, eds., *Signs from the Heart: California Chicano Murals* (Albuquerque: University of New Mexico Press, 2001), 12.
95. Mayorga, 186–87.
96. Alicia Gaspar de Alba, "Tu última cruzada/ In Memoriam," *La Voz de Esperanza* 17, no. 6 (July/August 2004): 25.

References

Alarcón, Norma. "The Theoretical Subject(s) of *This Bridge Called My Back* and Anglo-American Feminism." In *Making Face, Making Soul/Haciendo Caras*. Edited by Gloria Anzaldúa. San Francisco: Spinsters/Aunt Lute, 1986.

———. "Traddutora, Traditora: A Paradigmatic Figure of Chicana Feminism." *Cultural Critique* (1990): 57–87.

Alexander, M. Jacqui. *Pedagogies of Crossing: Meditations on Feminism, Sexual Politics, Memory, and the Sacred*. Durham: Duke University Press, 2005.2005.

Alicia, Juana. http://juanaalicia.com.

———. Public Lecture, Stanford University, February 16, 2006.

Anzaldúa, Gloria. *Borderlands/La Frontera: The New Mestiza*. San Francisco, CA: Aunt Lute Books, 1987.

———, ed. "Haciendo Caras, una entrada." In *Making Face, Making Soul: Haciendo Caras Creative and Critical Perspectives by Feminists of Color*. San Francisco: Aunt Lute Books, 1990.

Arrizón, Alicia. *Queering Mestizaje: Transculturation and Performance*. Ann Arbor: University of Michigan Press 2006.

Baca, Judy. "Judy Baca's Monument in Baldwin Park Is under Attack." L.A. Writers Collective, http://lawriterscollective.blogspot.com/2005/06/judy-bacas-monument-in-baldwin-park.html (accessed June 7, 2005).

Cabezas, Amalia. *Economies of Desire: Sex and Tourism in Cuba and the Dominican Republic*. Philadelphia: Temple University Press, 2009.

Cabrera, Lydia. *Yemayá y Ochún: Kariocha, Iyalorichas y Olorichas*. Miami: Ediciones Universal, 1996.

Clark, Mary Ann. *Where Men Are Wives and Mothers Rule: Santería Ritual Practices and Their Gender Implications*. Gainesville: University Press of Florida, 2005.

Cockcroft, Eva Sperling, and Holly Barnet-Sánchez, eds. *Signs from the Heart: California Chicano Murals*. Albuquerque: University of New Mexico Press, 1990.

Conner, Randy. *Queering Creole Spiritual Traditions: Lesbian, Gay, Bisexual and Transgender Participation in African-Inspired Traditions in the Americas*. Binghamton, NY: Harrington Park, 2004.

———. "Santa Nepantla, A Borderlands Sutra," Lecture, San Antoniounpublished lecture, First Annual Conference on the Life and Work of Gloria Anzaldúa, San Antonio, Texas, May 16, 2009.

Contreras, Sheila Marie. *Blood Lines: Myth, Indigenism, and Chicana/o Literature*. Austin: University of Texas Press, 2008.

Farris Thompson, Robert. *Flash of the Spirit: African and Afro-American Art and Philosophy*. New York: Vintage Books, 1983.

Gaspar de Alba, Alicia. "Tu última cruzada/ In Memoriam," *La Voz de Esperanza* 17, no. 6 (July/August 2004): 25.

Hernández-Linares, Leticia. "Painting the River Clean." In *Street Art in San Francisco: Mission Muralismo*. Edited by Annice Jacoby, 38–39. New York: Abrams, 2009.

Hoch-Smith, Judith, ed. "Radical Yoruba Female Sexuality." In *Women in Ritual and Symbolic Roles*. Edited by Judith Hoch-Smith and Anita Spring, 245–67. New York: Plenum, 1978.

Latorre, Guisela. "Gender, Muralism and the Politics of Identity: Chicana Muralism and Indigenist Aesthetics." In *Disciplines on the Line: Feminist Research on Spanish, Latin American, and U.S. Latina Women*. Edited by Anne J. Cruz, Rosilie Hernaández-Pecoraro, and Joyce Tolliver, 321–56. Newark: Juan de la Cuesta, 2003.

Mayorga, Irma. "Constructing Stages of Hope: Performance and Theatricality in the Aesthetic Logics of Chicana Expressive Culture" PhD Dissertation, Stanford University, 2005.

Minich, Julie. "National Bodies/Embodied Nations: Reading Diasbility in Chicana/o, Mexican and Spanish Cultural Production." PhD Dissertation, Stanford University, 2008.

Moraga, Cherríe, and Gloria Anzaldúa, eds. *This Bridge Called My Back: Writings by Radical Women of Color*. New York: Kitchen Table; Women of Color Press, 1981.

Ochoa, María. *Creative Collectives: Chicana Painters Working in Community*. Albuquerque: University of New Mexico Press, 2003.

Pérez, Emma. "Gloria Anzaldúa: La Gran Nueva Mestiza Theorist, Writer, Activist-Scholar." *NWSA Journal* 17, no. 2 (Summer 2005): 1–10.

Saldaña-Portillo, María Josefina. *The Revolutionary Imagination in the Americas and the Age of Development*. Durham: Duke University Press, 2003.

Saldívar, José David. *The Dialectics of Our America: Genealogy, Cultural Critique, and Literary History*. Durham: Duke University Press, 1991.

Saldívar-Hull, Sonia. "Mestiza Consciousness and Politics: Gloria Anzaldúa's *Borderlands/La Frontera*." In *Feminism in the Borderlands: Chicana Gender Politics and Literature*. Berkeley: University of California Press, 2000.

Sánchez-Tranquilino, Marcos. "Murales del Movimiento: Chicano Murals and the Discourses of Art and Americanization." In *Signs from the Heart: California Chicano Murals*. Edited by Eva Sperling Cockcroft and Holly Barnet-Sánchez. Albuquerque: University of New Mexico Press, 1990.

Sandoval, Chela. *Methodology of the Oppressed*. Minneapolis: University of Minnesota, 2000.

Soriano, Aracely, and Sandra Sánchez. *Maestrapeace: A Guide to the Mural on the San Francisco Women's Building*. San Francisco: Mission Cultural Center, 1996.

Tinsley, Omise'eke Natasha. "Black Atlantic, Queer Atlantic: Queer Imaginings of the Middle Passage." *Gay Lesbian Quarterly* 14, nos. 2–3 (2008): 191–215.

Vidal-Ortíz, Salvador. " 'Sexuality' and 'Gender' in Santería: Towards a Queer of Color Critique in the Study of Religion" (PhD Dissertation, City University of New York, 2005).

Women's Center, The. http://www.womensbuilding.org/ public/programs/ programs.html.

Yarbro-Bejarano, Yvonne. Class Discussion. Stanford University, Palo Alto, California, February 16, 2006.

———. "Gloria Anzaldúa's *Borderlands/La Frontera:* Cultural Studies, Difference, and the Non-Unitary Subject." *Cultural Critique* 28 (Fall 1994): 5–28.

Plate 1. *La Llorona's Sacred Waters*, Juana Alicia ©2004. Acrylic mural on stucco, 30' x 60'. 24th and York Streets, San Francisco Mission District.

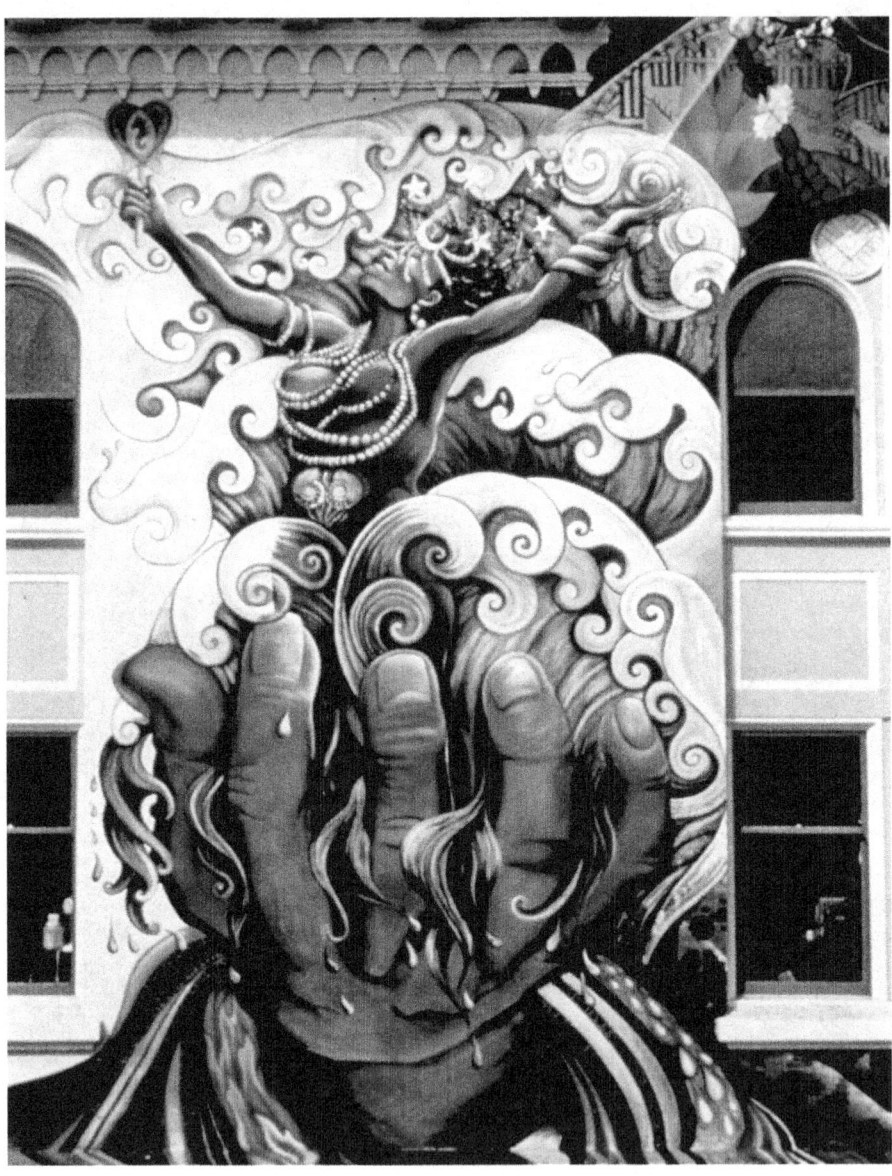

Plate 2. Yemaya Detail from *MaestraPeace* (1994 and 2000) by Juana Alicia, Edythe Boone, Susan Kelk Cervantes, Meera Desai, Yvonne Littleton, and Irene Perez. Photo Credit: Marvin Collins, Ruben Guzman, et al. All Rights Reserved.

Plate 3. *Bay of Portobelo at Sunset*, Arturo Lindsay, 2002. Digital photography, 11" x 14", in the collection of the artist.

Plate 4. *Requiem in Portobelo*, Bay of Portobelo, Panama, Arturo Lindsay, 2005. Bamboo, cayuco (hand-hewn wooden canoe), dried leaves, fire and water, 20' x 10' x 4'.

Plate 5. *The Voyage of the Delfina, a performance art ritual,* Arturo Lindsay with poet Opal Moore, 2002. The Atrium of the Camille Olivia Hanks Cosby Academic Center, Spelman College, Atlanta, Georgia, Multimedia performance/installation, dimensions variable.

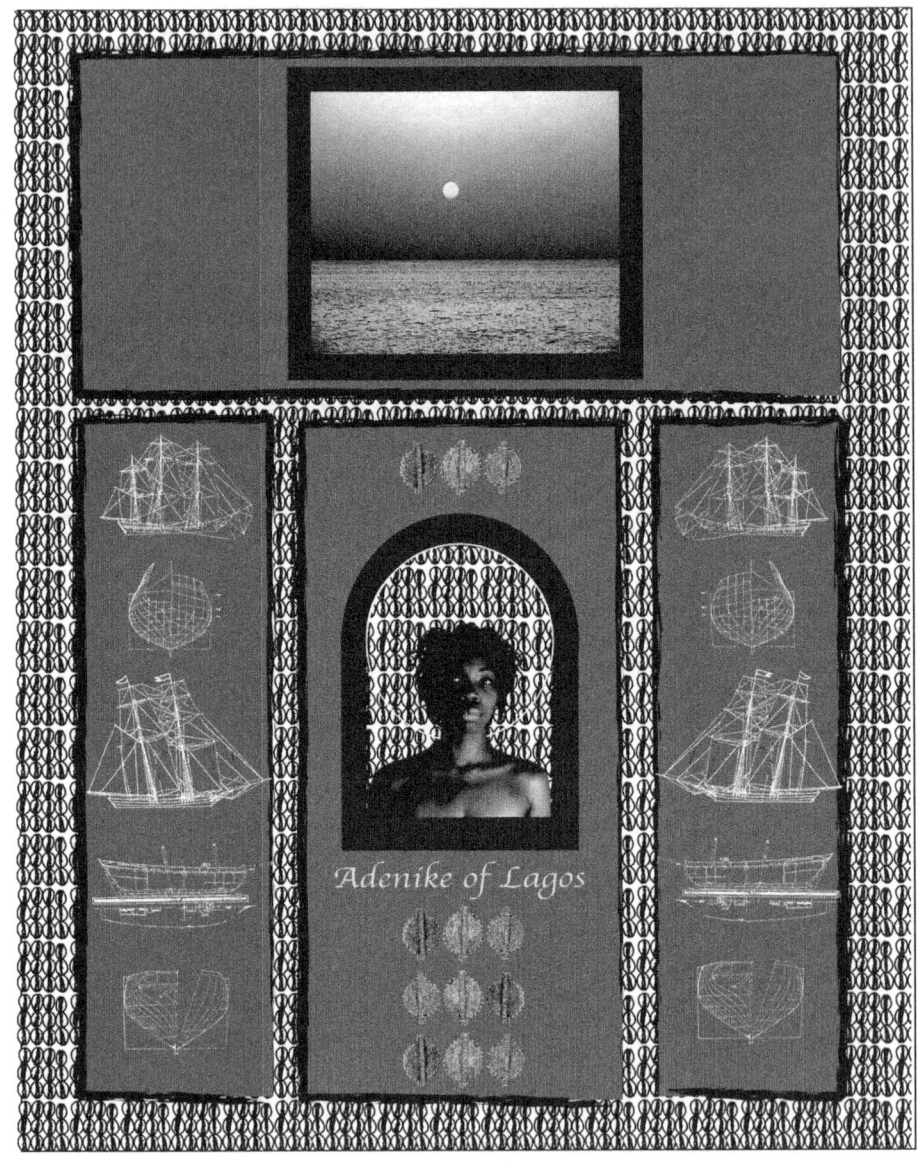

Plate 6. *Adenike of Lagos*, Arturo Lindsay, 2003. Digital print, 24" x 21", in the collection of the artist.

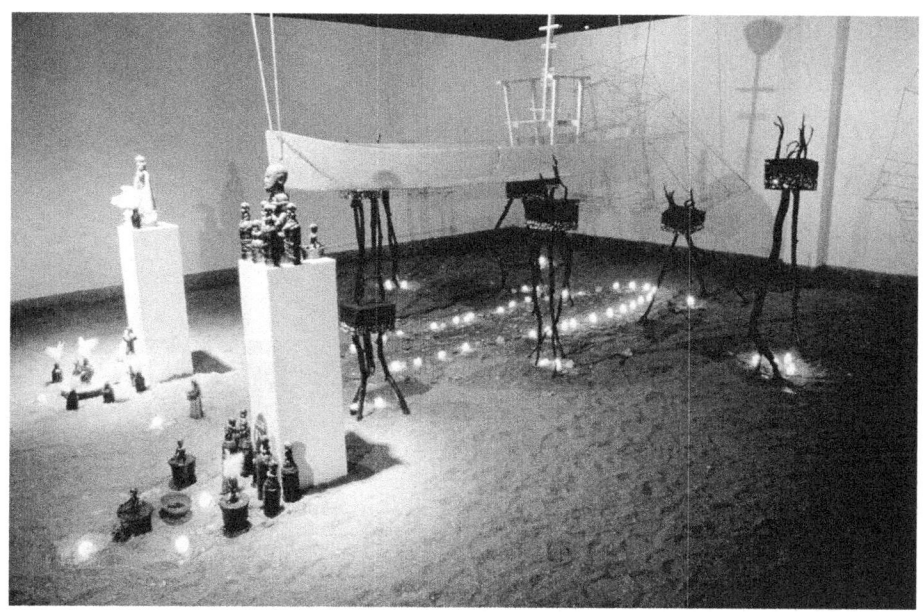

Plate 7. *Retorno de las ánimas Africanas / The Return of African Spirits*, Arturo Lindsay, installed by Amy Sherald, photo by Gustavo Araujo, 2000. Museo de Arte Contemporaneo, Panama. Mixed media installation, dimensions variable.

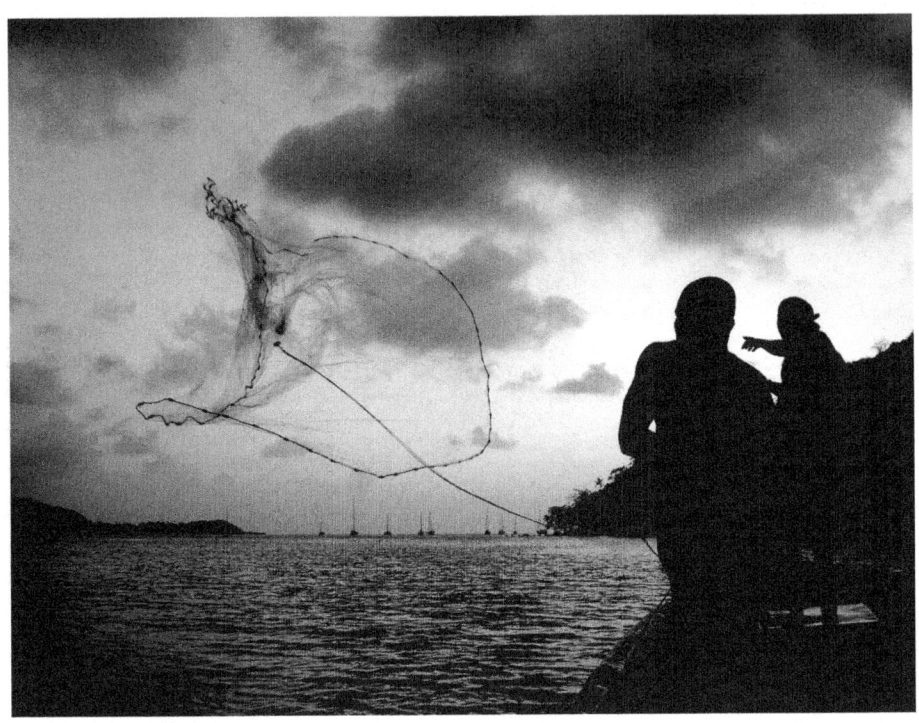

Plate 8. *Boli Catching the Skies #1* (The Sardine Fishing in Portobelo Series), Arturo Lindsay, 2012. Digital photography, 11" x 14", in the collection of the artist.

Chapter 7

Dancing *Aché* with Yemaya in My Life and in My Art
An Artist Statement

Arturo Lindsay

As a child growing up in the Republic of Panama, my mother encouraged me to pray to the Virgin Mary whenever I felt that I was in need of divine intervention. Her logic was that as the Mother of God Mary had special privileges and could intervene on my behalf with her divine son. My mother reasoned that this was akin to having a good friend in higher places. True or not, I believed her and consequently developed a lifelong affinity for this very powerful and influential female deity. As I became aware of the New World Yoruba religion of Santeria,[1] my affinity to the Virgin Mary was extended to Oshún and Yemaya: two of Mary's many manifestations in the African Diaspora in America.

At the height of the Pan-Africanist movement I was in graduate school and intent on infusing my work with all things African. In 1973 I was introduced to Oshún[2] by a Puerto Rican *santera*[3] who kept a small altar for her *orisha*[4] in her apartment. From the moment I met Oshún, I was enchanted. Oshún seduced me. I was enamored. I was so smitten by her that I opened my heart, my life, and my art to her. Before and after every work session in my studio I prayed to Oshún to invest my art and my life with a powerful *aché*[5] of love and beauty. My prayers often took the form of dancing in the studio to the *orisha* music of Celia Cruz.

My art-making process is centered on imbuing a life force (*aché*) into an object or event; dancing facilitates the movement of *aché*. It

is this imbuing of *aché* that transforms ordinary objects or events into works of art. The process of making art that invokes an *orisha* requires a rhythmic give and take of *aché* between the work, the *orisha*, and the artist that is best described as a dance. Dance enhances both the aesthetic and spiritual experience of the *orishas*.

A few days before Christmas 1989 the United States invaded Panama and my country and its people were devastated. Shortly after the invasion I returned home to help in the recovery and healing. I settled in the village of Portobelo and along with photographer Sandra Eleta and Congo artist Yaneca Esquina we founded a painting workshop at Taller Portobelo. Taller Portobelo is an artist cooperative dedicated to preserving the history and traditions of the Congos[6] while providing an income for the artists and their economically impoverished community. In 1997 I founded the Spelman College Summer Art Colony as a three-week artist residency program for U.S. American students and artists to live and work in the village of Portobelo along with the artists of Taller Portobelo.

Portobelo is located on a bay on the Caribbean coast of the Republic of Panama and was a seminal port for the disembarkation of enslaved Africans destined to work in the silver mines of Peru. Portobelo is a mystical village. At dusk, it becomes absolutely magical as the sun settles behind the hills on the other side of the bay. On a clear day, when the sea is calm, the rays of the setting sun refract and reflect between the sky and the calm waters of the bay, making the bay appear to be lit from a mysterious force emanating from below the surface. My studio is approximately three hundred yards from the ruins of the colonial dock where the enslaved came ashore. I have often imagined the silhouetted figures of Africans moving across that dock with hands bound and heads bent. (Please see Color Gallery plate 3.)

One sunset in early June 1998, I was lying in the hammock in my studio and looking out at the ruins of the docks as the mysterious light in the bay began to appear. That light made me think of those who did not disembark, the *desaparecidos*, the ones who "disappeared" during the journey. The thought of their absence, of their unknown fate, was disquieting. As I thought of those abducted Africans I wondered if the light I was seeing was in fact Yemaya/Olokun's[7] guiding the ascension of their souls from the depths of the sea.

That evening I began sketching portraits while imagining the faces of the *desaparecidos*. The following morning, I continued to draw and soon attracted a number of children from the village who gathered around me and began naming friends and family members that bore resemblances to the portraits I was drawing. Their naming game made

me realize that I was unconsciously using the facial characteristics of children and young people in the village for my drawings. It also dawned on me that since these children are descendants of the enslaved maybe I was drawing from a phenotypical profile of the *desaparecidos* as well. These drawings led to a series of lithographs entitled *Children of the Middle Passage*. While I was pleased with the prints, I was still unsettled. I did not know their stories. I had given each portrait a traditional African name and village to erase the anonymity imposed on the children, but they were still unknown to me.

This was also a time in Latin America in which civil and human rights advocates were "disappearing" and member states of the United Nations were crafting an international human rights instrument to denounce abductions and false imprisonments. The term *desaparecidos* became the rallying cry of family members who demanded to know the whereabouts of their loved ones. Sadly, the United Nations' resolution was more than a century late to protect the children of the Middle Passage.

The more I became involved in my research, the more the thought of the *desaparecidos* rested heavily on my mind. Migration of any sort—be it forced or willing—leaves a vacuum in the lives of the families left behind and a void in the psyche of the immigrant. This is my family's story; this is a Caribbean story. The postcolonial migration of Caribbeans in search of work has contributed to a vibrant *mestizaje Caribeña*.[8]

My ancestors—the Africans in chains and the Europeans fleeing their lot in life—were obliged to leave their homelands and their families. My four grandparents were born on four different Caribbean islands and migrated to Panama during the building of the canal. My brothers Jorge "Cito" and Luis, and I were born in Panama, while my younger brother Ricky was born in New York City after my parents migrated to the United States in hopes of providing us with better educational opportunities. My family history is filled with polylingual stories of sacrifice, of missing loved ones, and of longing for a certain smell, a favorite meal, a particular beach, or a special holiday to celebrate. These stories are mostly glossy, sentimental recollections of the best of past times that help to fill the void of missing loved ones and beloved environments. However, these longings pale in light of the plight of my enslaved ancestors.

My investigation led me to collect oral histories as well as to observe and participate in the cultural traditions of the Congos in Portobelo as they retold the history of their ancestors through the *juego de Congo*.[9] I also conducted research in libraries and archives in Colon and Panama City, Panama; Havana, Cuba; Seville, Spain; and Charleston,

South Carolina. Slowly, a clearer picture of the *desaparecidos* began to emerge as I unraveled the nuances of this very complex enterprise. For example, not every abducted African was blameless. In my research I came across accounts of former African kings and chiefs who were once slave traders that were later enslaved. Surely, they were not innocent victims. Wars, petty jealousies, revenge, greed, avarice, and a host of other human frailties fed the trade as neighbors, former friends, and lovers became willing participants in this nefarious commerce.

It is clear, however, that the truly innocent victims were the abducted children and young people who were the most powerless members of their societies. With that realization the plight of the innocent became the subject of my project. Ironically, as I began to make art to address the innocent victims of the trade I came to the realization that the souls of the children of the Middle Passage were at peace resting in the loving arms of our mother Yemaya. The knowledge that the children were with Yemaya resulted in an overall feeling of peace and tranquility in me and my work. This body of work was not angry.

But I still did not know their individual stories. To that end, I invited the poet Opal Moore to my studio, and I gave her a set of prints from the *Children of the Middle Passage* series. I asked Opal to live with them for a while and see if they would reveal their stories to her. Months later, Opal delivered a collection of poems to me that told their stories so well that I returned to the studio to begin a new series of drawings. This series included new faces that I began "collecting" wherever I went. I borrowed facial characteristics of the children in my Atlanta neighborhood and young people I saw on the subways of New York City, Washington, D.C., and Paris. I also found faces on the streets and buses in Brooklyn, Harlem, Havana, Senegal, Panama, Nigeria, Charleston, and New Orleans. I collected others from my students at Spelman, Morehouse, Clark Atlanta University, and Morris Brown College in Atlanta. Virtually everywhere I went in the African Diaspora, I sketched faces of black youth.

In the summer of 2002, Opal and I participated in a United Negro College Fund Mellon Faculty Seminar with Nobel Prize winner Wole Soyinka at the Goreé Institute in Senegal. Opal worked on new poems while I photographed and drew the faces of the young people of Goreé, a former slave port. On Goreé, Opal and I spent our time thinking and talking about a new project. During these discussions, we conceived *The Voyage of the Delfina, a Performance Art Ritual*. (Please see Color Gallery plate 5.)

Delfina was created, according to Opal, to "speak to and into the historical moment of Middle Passage—the history of the abduction of

millions of Africans from West Africa and their distribution, into bondage, throughout the Americas." The project takes its name from the slave ship *Delfina*, which set sail in April 1832 from the coast of West Africa with a "cargo" of 159 Africans; it docked in Rio de Janeiro, Brazil a few months later with one-third of the Africans missing. Our symbolic "voyage" of the *Delfina* invited our participants to "name" the unrecorded survivors and casualties of that passage. By naming these travelers, both those who survived to live enslaved and those who died during the passage, we intended to ritually undo the erasures of history by acknowledging their existence. We felt that we could make their absence present.

The performance was staged in the skeletal structure of a slave ship created by set designer R. Paul Thomason. The cast consisted of students and young people from the local artist and college communities in addition to faculty members. Two-thirds of the cast were dressed in black, representing those who survived the journey to Brazil. The remaining third wore white, symbolizing the souls of the *desaparecidos*. After Opal read each poem, five voyagers rose individually and called out a traditional African name and village. In so doing, they called home the soul of the enslaved person they represented. Those dressed in black resumed their places on the ship, while those dressed in white stepped out of the installation and laid spoon fashion on the floor outside of the boat, symbolizing the waves of the sea.

Saxophonist Joe Jennings, percussionist Omelika Kuumba Bynum, and opera soprano Laura English-Robinson accompanied the performance with original compositions. Filmmaker Ayoka Chenzira documented the performance, and other important members of the production who provided technical assistance and advice included choreographer Veta Goler, stage manager Joan McCarty, and Ras Michael Brown, who transcribed the song of the women of 'Ndeer.[10]

In 2003, Opal and I were awarded a Rockefeller Foundation Fellowship to travel to a villa in Bellagio, Italy to continue our collaboration. In Bellagio, Opal wrote new poems, and I experimented with a new series of computer-generated prints (please see Color Gallery plate 6). In 2006, at the request of the U.S. State Department, we reconceived the original performance of the *Delfina* and using the poems and videos from the original work presented it in Hamburg, Kiel, Frankfurt, Nuremburg, Munich, and Berlin, Germany.

In addition to the *Delfina*, I have also created a series of installations that reference Yemaya and the *desaparecidos*, including *Sanctuary for the Children of the Middle Passage*, 1998–2006. This mixed media installation was dedicated to the children of the trans-Atlantic slave trade

(see figure 7.1). The installation takes the form of a house that provides sanctuary at the bottom of the sea. Dolls in a small boat represent the souls of the children "rising" from the sea floor like the mysterious light in Portobelo. The blue and white colors as well as the small sculptures at the base of the installation are ideographic representations of Yemaya-Olokun.

Another project referencing Yemaya and the abducted Africans was *Retorno de las ánimas Africanas / The Return of African Spirits*, 1999–2000. This work was dedicated to those captured Africans who chose to commit suicide while at sea rather than enslavement in the

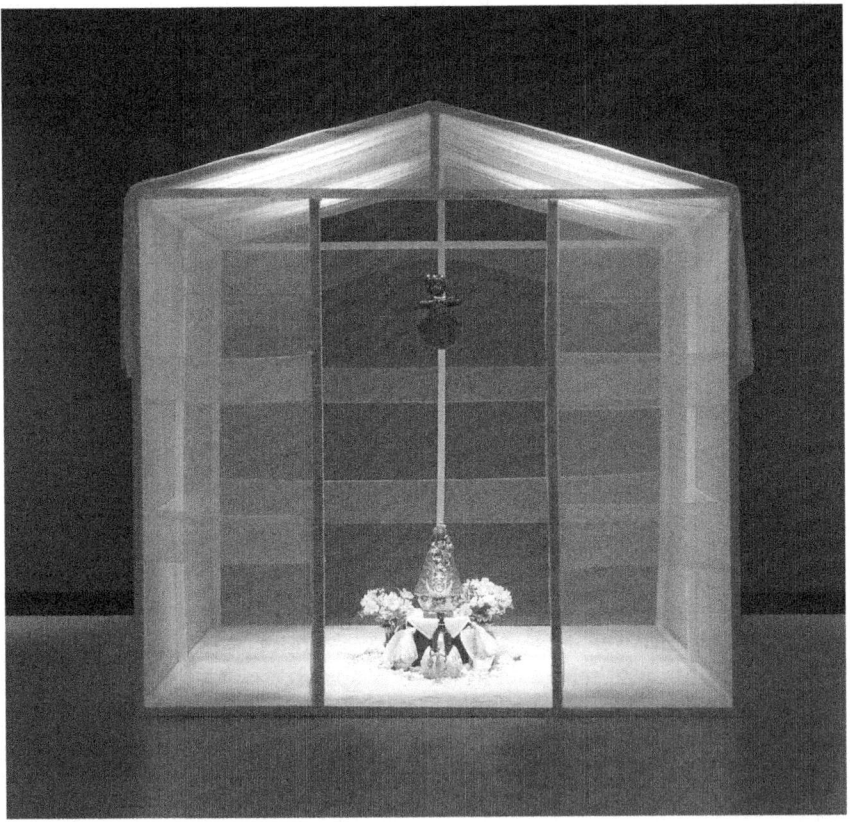

Figure 7.1. *Sanctuary for the Children of Middle Passage*, Arturo Lindsay, 2000. EXMA Centro Culturale D'Arte e Cultura, Sardinia, Italy.[11] Mixed media installation, dimensions variable.

New World. Invoking Yemaya, the installation speaks to the lost souls of captured Africans returning to their homelands. This work was created in 1999 for the Segunda Bienal Iberoamérica de Lima at the Galeria Pancho Fierro in Lima, Peru, and it was reinstalled the following year by my then assistant Amy Sherald at the Museo de Arte Contemporaneo in Panama City, Panama. (Please see Color Gallery plate 7.)[12]

Requiem in Portobelo (2005) was a mixed media, time-based work that was part of the 2005 Ferias de Portobelo exhibition that took place in the Bay of Portobelo (see Color Gallery plate 4). This work was created as a healing service for all of the enslaved Africans who died in transit to America. The "ritual sacrifice" of a burnt sculpture was offered to Yemaya as the ashes floated out to sea.

My *orisha* work can best be described as sacro-secular art. I do not pretend to be an artist/priest creating sacred objects or events. Essentially, I create works of art intended to live in the contemporary art world. Yet, these works are informed if not inspired by the spiritual and the sacred. Dancing *aché* with Yemaya or my beloved Oshún fulfills in me what Ana Mendieta (1948–1985) sought when she said, "I wanted my images to have power, to be magic."[13] The power and magic that Mendieta spoke of is realized while dancing *aché*.

Central to my body of work on the *desaparecidos* is the notion of remembrance and healing. I am troubled by the effects of the *tabula rasa* philosophy applied by enslavers in an attempt to erase the historic memory of Africans and their descendants. I believe in the power of art to heal. I believe that the *aché* in a work of art is like an *nkisi*[14] with healing powers. I believe that through the powers of *aché* in art I can erase erasure and assist in the healing process.

Cuban art critic/Contemporary Latin American art historian and critic Gerardo Mosquera said it best in his catalog essay for my solo exhibition at Nexus Contemporary Art Center in 1996. Mosquera wrote:

> Lindsay imagines the faces of the lost heroes of slave insurrections, deifying them through art. These works bring together a pop language associated with advertising and the media with traditional African inspired sculptures, religious Catholic and Afro-American votive objects, video, soil, and offerings. With all these elements Lindsay designs the iconography of an unofficial history that is lacking images. He harmonizes the aura of art with the religious power of the altars to legitimize the history of the marginalized of his country of origin. . . . At

the same time, he provides a romantic tone to history through an approach that, as in the case of his ancestors, is invested with and characterized by personal affection.[15]

For more than four decades I have been using photography to document events in port cities in Africa and the African Diaspora. However, for my own aesthetic pleasure and as a diversion while doing field research I began photographing the sea. In so doing I discovered that photographs of the sea as well as things related to or affected by the sea are indeed portraits of Yemaya. These photographs were organized into a 2013 solo exhibition for City Gallery at Chastain in Atlanta, Georgia, entitled *Arturo Lindsay: Portraits of Yemaya*. This work departs from the pain and anguish of the Middle Passage and focuses on the beauty of Yemaya and her children enjoying the benefits of her bounty. (Please see Color Gallery plate 8.)

Aché

Notes

1. Santeria is a New World Yoruba religion that is growing in Latin America and the United States. In Cuba it is also known as Lucumí and as Candomblé in Brazil, as well as Vodou in Haiti.
2. Oshún is the goddess of love and beauty.
3. A *santera* is a female practitioner of Santería. The male form is *santero*.
4. An *orisha* is a Yoruba deity.
5. *Aché*, also spelled as *ashé, àse, ase, axe* and *axé* is the Yoruba concept of a divine life force that exists in all things—animate or inanimate. It has the power to make things happen. *Aché* can also be used as an aesthetic criterion to describe the power imbedded in works of art.
6. The Congos are descendants of *cimarrones*—enslaved Africans that liberated themselves by running away then returning to fight their former enslavers.
7. Yemaya/Olokun is a conjoined manifestation of two *orishas*—Yemaya whose dominion is the surface of the sea and Olokun who resides at the bottom of the sea.
8. *Mestizaje Caribeña* refers to the cultural mixing of Caribbean people.
9. The *juego de Congo* is essentially a morality play centered on the struggle between good and evil. During carnival, the Congos represent or better said re-present their ancestors, the *cimarrones*. The Congos, the *ánimas* (tortured souls of the enslaved) along with *el sacerdote* (the priest) and *el Arcángel* (the archangel) are cast in the role of the forces of virtue. The Diablo Mayor (the major devil), along with the other *diablos*, do not represent Satan; rather

they represent the sins and malevolent deeds of the colonial Spaniards. They are cast in the role of the forces of evil. Pajarito (the Little Bird) is a complex character. He is a trickster and the son of the king and queen.

10. A video clip of the production is available at http://www.youtube.com/watch?v=4gX04l6OMI8.

11. This installation has also been presented at the Clifford Gallery, Colgate University, Hamilton, New York, and the Sumter County Gallery of Art, Sumter, South Carolina.

12. This work was also displayed at the Segunda Bienal Iberoamérica de Lima, Galeria Pancho Fierro, Lima, Peru.

13. Petra Barreras del Rio, "Ana Mendieta: A Historical Overview," in *Ana Mendieta: A Retrospective,* Exhibition Catalog (New York: The New Museum of Contemporary Art, 1987), 29.

14. An *nkisi* is an object believed to have divine healing powers and is made by the Kongo people of Central Africa as well as their descendants in the African Diaspora.

15. Gerardo Mosquera, "Faces for the History without History," in *Animas, arcángeles y antepasados: Recent Work by Arturo Lindsay,* a catalog essay for the 1998 solo exhibition, Nexus Contemporary Art Center, Atlanta, Georgia.

References

Barreras del Rio, Petra. "Ana Mendieta: A Historical Overview." In *Ana Mendieta: A Retrospective,* Exhibition Catalog. New York: New Museum of Contemporary Art, 1987.

Mosquera, Gerardo. "Faces for the History without History." In *Animas, arcángeles y antepasados: Recent Work by Arturo Lindsay.* Atlanta: Nexus Contemporary Art Center, 1996.

Chapter 8

What the Water Brings and Takes Away
The Work of María Magdalena Campos Pons

Alan West-Durán

> The ancestor speaks, it is the ocean.
>
> —E. Glissant[1]

Cubans have an intimate, loving, and troubled relationship with the sea. As an island, we have little choice except to know it, embrace it, and reckon with it. The ocean has been a constant inspiration for romantic poets and a grim historical warning as an aquatic graveyard during the Middle Passage and, more recently, for rafters traversing the Florida straits. Whether one agrees with Virgilio Piñera in his landmark poem, "Esa maldita circunstancia del agua por todas partes" ("That accursed circumstance of water all around us") or with José Lezama Lima's more celebratory and poetic definition of island ontology, "La mar violeta añora el nacimiento de los dioses/ ya que nacer aquí es una fiesta innombrable" ("The violet sea longs for the birth of the gods/ since to be born here is an ineffable celebration"), the sea speaks eloquently to the island's diasporic history.[2] María Magdalena Campos-Pons (1959–) was born in Matanzas, and she is now living in Boston. Campos-Pons is an artist who embraces Virgilio and Lezama by way of Yemayá and Ochún. She literally embodies multiple diasporas, using technology, memory, and spirituality to ask difficult questions about art, identity, history, and race through her work in different media (photography, painting, installation, and video).[3]

Yemayá: The Water Speaks

In a telling phrase, Gaston Bachelard writes, "Thus water will appear to us as complete being with body, soul, and voice."[4] In Campos-Pons's early work, water and liquids feature prominently: two pieces from 1989, one called "Isla," which features a body-island from an aerial view, and a second photograph of the artist holding two little statues.[5] The statue in Campos-Pons's left hand is Ochún or the Virgin of Charity, and in her right hand is Yemayá or the Virgin of Regla, both of which are associated with water. Each statue covers her naked breasts.

They are two of the most venerated *orishas* in Cuba, and both evoke many aspects of female power. Ochún (Virgin of Charity) is linked to sensuality, childbirth, fertility, enjoyment, celebration, fine things (such as jewelry, beads, and the like), and fresh water. Yemayá (in Cuba the Virgin of Regla, a port city near Havana). is the *orisha* of all waters, and particularly the ocean. Lydia Cabrera writes, "Yemayá is the Universal Queen because she is Water, fresh and salty, the Sea, the Mother of all that is created. She nourishes all, since the World is earth and sea, earth and all that lives on earth, and thanks to Her the earth is nourished. Without water, animals, humans, plants would all die"[6] Yemayá is one of the most knowledgeable *orishas*, possessing the wisdom not only of motherhood but, when called upon, of the Ifá divination system as well.

In many of her works, Campos-Pons draws upon the imagery and spiritual energy of these two powerful female *orishas* who are central to the Cuban cultural imaginary. Campos-Pons' aesthetic concerns are deeply imbued with the aquatic and cosmological qualities of Yemayá and Ochún: more directly in works such as "I am a Fountain" (1990), "The Seven Powers" (1992), "The Seven Powers Come by the Sea" (1992), "When I'm Not Here/Estoy Allá" (1994), "When I'm Not Here/Estoy Allá" (1997), "Susurro" (1997), "Spoken Softly with Mama" (1998), "Replenishing" (2001), and "Elevata" (2002), and indirectly in others.[7]

In both versions of "The Seven Powers," she draws on the memory of the Middle Passage and builds upon "Tra . . ." (1991), a work from the previous year, with its triple word association (*travesía, trata, tragedia*; traversing, trade [as in slave trade], and tragedy).[8] This phase of her work delves into diasporic memory, and Campos-Pons historicizes Yemayá: she becomes a welcoming and grieving mother who embraces her dead children in the watery depths of the Atlantic as well as being a witness to those who traverse the seas under conditions of unspeakable suffering. This work seems to echo Walcott's famous poem "Sea Is History," with its haunting evocations of the Middle Passage.[9] On wooden boards that evoke drawings of slave ships with their human

cargo, the artist places at the bottom the names of the major *orishas*: Oyá, Obbatalá, Ochosi, Oshún, Oggún, Yemayá, and Changó, or las Sietes Potencias (the Seven Powers) as they are known in Cuba. It is a poignant counterpoint: images of captive humans as commodities juxtaposed with the spiritual power of the *orishas*. Despite the depiction of dehumanization and commodification, the *orishas*' presence reminds one that the kidnapped Africans were human beings, with a culture, beliefs, and profound relationship to their ancestors. The latter is highlighted in a 1994 version of the piece that includes some forty-odd framed photographs of Cuban family and friends of African descent from Matanzas.

Campos–Pons has brought together the human, historical, and spiritual dimension of the Middle Passage powerfully and with economy of means. This diasporic space (and time) of rupture and renewal is underlined by James Clifford: "In diaspora experience the co-presence of "here" and "there" is articulated with anti-teleological . . . temporality. Linear history is broken, the present constantly shadowed by a past that is also a desired, but obstructed future: a renewed painful yearning. For Black Atlantic diaspora consciousness, the recurring break where time stops and restarts is the Middle Passage."[10] This rupture and renewal is similar to Glissant's notion of a "prophetic vision of the past" where one does not merely remember a past but co-creates it in order to fashion a more hopeful future.[11]

While these temporal frameworks are applicable to Campos-Pons's work, it is equally germane to look at African philosophical and religious thought, where there is a strong bond between the world of the living, the dead, and other spirits as well as the *orishas* that do not adhere to linear concepts of time.[12] This temporal fluidity is matched by an interpenetration of the worldly and spiritual; in fact, this distinction is not as stark as in Western thought, best exemplified in the Ifá *odu* that states, "Nothing is more natural than the supernatural."[13]

With these non-Western frameworks in mind, it is not surprising that Campos-Pons's work often seems to incorporate ritual elements, often blurring the boundaries among quotidian, sacred, and profane spaces. Other critics have pointed out that "Las Siete Potencias" seems like an altar, not only because of the content but also in the ways that the artist transforms spaces and uses her own body to articulate and redefine the aesthetic space she configures, ever mindful of the sacred.[14]

This continuum is analogous to the practices of Regla de Ocha (also known as Santería), a religion with a high degree of corporal performativity and upon which the artist has drawn consistently in her work. Be it divination (where one is on a mat without shoes on, handling different objects as well as the cowry shells); a *bembé* or *tambor* (where

one dances and sometimes kisses and places one's forehead on the batá drum); an initiation (shaving the head for ritual meals and baths); or clapping, chanting, prayer, making of offerings, healing techniques, and spiritual cleansings, everything in Ocha involves the human body.

In a 1998 interview, when asked about the performative traditions of Yoruba culture, Campos-Pons responded: "Absolutely! Performative and oral traditions are very important in Cuba. In santería rituals the presence of the body is overwhelming, totally overwhelming."[15] Consistent with this highly spiritual, corporeal performativity, Campos-Pons uses her own body in much of her art. Not only does she suggest that her art and her body are twin, interdependent energies but also that the material (that is, the body and physical components of art) and spiritual dimensions of life are equally entwined in a kind of mystical materialism.

The head is perhaps the most important part of the body for *santeros* (initiates of Ocha), known in Yoruba as *ori*. But *ori* is more than one's physical head; it is also consciousness, knowledge, wisdom, thought, and emotion.[16] According to Awo Falokun Fatunmbi, "[O]ri has four distinct arenas of perception; we think about our internal experience (identify emotions [air, east]), we acknowledge our relationships with our people and things (evaluate levels of trust and empathy [earth, west]), we examine the past (access memory [water, south]), and we envision the future (activate imagination [fire, north])."[17]

Much of Campos-Pons's work could be viewed within this concept of *ori*: the internal experience revealing (and questioning) the self and identity, relationships (family, community), examination of the past (history, public and private), and envisioning the future (the creation of art). What is significant in the Yoruba concept of *ori* is the association between memory and water, especially when viewed within the context of Yemayá and water spirits.

Two of the most overt references in Campos-Pons's work to Yemayá are from the series "When I'm Not Here/Estoy Allá" (1994), which are all 20" x 24" Polaroid format works.[18] The first depicts the artist from the waist up to the bottom of the chin; her face is not visible. Her body is painted blue with white squiggles to represent the waves of the ocean. Hanging from her neck are two half-empty milk bottles joined by a tube that connects them; the bottle tips rest on her breasts and drip into a wooden boat that she holds in her hands. The photo, despite the presence of the milk bottles, conveys a sense of ritual, of a maternal archetype (reinforced by the absence of the face). The boat is the receptacle for the drops of milk that leak from the bottles.

Campos-Pons has taken several maternal symbols appropriate to Yemayá, such as milk, nurturing hands and breasts, and birth, to histo-

ricize Yemayá. Although the wooden boat does suggest the size of an infant or even a tiny cradle, more than anything else, because of the way her body is painted, it evokes the Middle Passage. Most traditional images of Yemayá (or the Virgin of Regla) in Cuba depict her holding an infant; Campos-Pons has turned the "infant" into a collective image of death, birth, and regeneration. The comforting image of the nurturing mother has transformed pain into a collective strength (the boat contains milk, not blood). Yet the water of birth (the womb) is indelibly linked to the water of death (captivity). Similarly, in his description of the Middle Passage, Glissant speaks of an abyss and a womb, since from that abyss (of those "lucky" enough to survive the journey) arose the new hybrid cultures of the Caribbean.[19]

In a diptych from the same year and with the same title, Campos-Pons combines the iconography of Yemayá with Ochún. Although her torso is painted blue, evoking Yemayá, there are also yellowish streaks on the body and a yellow or golden-hued background. In the left panel she again holds the wooden boat, this time filled with honey. Underneath the hands holding the boat is a wooden crate with six partitions. The top three partitions have an orange in the right and left slots and a duck's head made of wood in the middle one. The bottom three contain oranges in the middle and right slots; the bottom left slot is empty.[20]

The combination of Yemayá and Ochún is not uncommon, they are known as sister *orishas* and are associated with salt water and fresh water, respectively. The oranges are ritual food given to both *orishas*, as well as Inle, *orisha* of the fertility of water to produce crops and to heal illnesses. However, the duck, although a ritual food for both, is more often associated with Yemayá. Depicting ritual foods or offerings reminds us that despite their power and ownership of *aché*, the *orishas* must be fed. Sacrifice is replenishment, a balancing of spiritual energies.

The honey is more associated with Ochún since she is the *orisha* who sweetens life. There is a *pattakí* (story) of Ochún who is put in charge of "rescuing" Oggún from the forest. Oggún, the *orisha* of metals and war, fed up with human folly and its capacity for self-destruction, retires deep into the forest, wanting to be left alone. But tools, implements, and all types of machinery would suffer without Oggún's presence as they are all the implements that make society prosper. Ochún was sent in to fetch him. By dancing, singing, and finally through the use of *oñí* (honey), which she spread on Oggún's lips, she was able to bring him out of the forest and return him to his role of blacksmith and forger of tools.[21] Honey is also used in many ritual offerings or sacrifices.

Campos-Pons draws on the iconography, legends, and attributes of these two female *orishas* quite deftly, but a warning might be called for

before continuing. First, how people view *orishas* has generated numerous misunderstandings. Elsewhere, I have explained the multidimensional aspects of an *orisha*:

> Many well-intentioned researchers have called them divinities or gods, which is not exactly accurate. Orishas are the varied and multifaceted manifestations of all the divine energies in the universe that together would constitute God, which is too vast for our human capacities to comprehend, so we give names and attributes to these manifestations. It is the proliferation of names and orishas that erroneously gives the impression that Ocha is polytheistic. Others have characterized the orishas as guardian angels or saints (here both show Catholic influences), as well as representing natural forces (water, wind, lightning, fire, earth, herbs, etc.), the latter not surprising for a religion born in rural surroundings and intricately entwined with nature.
>
> Still others see the orishas as a metaphysical principle or as an archetype. As archetypes they are viewed as people, like ancestral spirits, but more powerful. They are described as personifications of certain personalities. An orisha materializes in the life, actions, and the personality of a person. They are role models: parent, sibling, public defender, psychologist, botanist, healer, spiritual advisor. This view is common because believers develop a definite personal relationship with their tutelary orisha, and the orisha becomes a member of the family.[22]

Orishas embody energies, relationships, forces in nature, and principles that are a daily part of our lives. This complexity is further augmented by the fact that an individual *orisha* has different *avatares o caminos* (avatars or paths). For example, in "The Seven Powers Come by the Sea," Campos-Pons has drawn on the best-known of Ochún's traits (or paths): honey, sensuality, beauty, flirtatiousness, and lover of parties; but she can be someone who is a homebody (Ochún Olodí), who lives in the forest (Ochún Niwé), who teaches and is imbued with wisdom (Ochún Funké), who is a sorceress and associated with vultures and death (Ochún Kolé-Kolé or Ochún Awé), or who epitomizes seriousness (Ochún Sekesé).[23] Something similar is true for Yemayá, who can be a mother protector (Yemayá Awoyó), a warrior who fights like a soldier and accompanies Oggún into battle (Yemayá Okuti), a severe sage (Yemayá Achabá), a forest dweller (Yemayá Mayalewo), or a mes-

senger of Olokun, the *orisha* of the depths of the ocean who is powerfully linked to the Middle Passage (Yemayá Asesú).[24]

One has to be careful, then, in attributing only a single, central attribute to an *orisha* and must be cognizant that, as an artist, Campos-Pons might be using certain archetypes but, within them, a plurality of meanings that are implied by the *caminos* or avatars. In addition, within a central or plural manifestation of attributes and meanings is the artist's own interpretation, which can be respectful, ironic, or juxtaposed with objects, images, and words that recontextualize sacred meanings to bring into play historical, feminist, diasporic, and postcolonial counterpoints.

Yemayá and Ochún form part of a global network of water spirits that many scholars, especially Henry John Drewal, have brought under the umbrella of Mami Wata (see Drewal's *Mami Wata*, and *Sacred Waters*). Be it Sierra Leone, the Congo, Togo, the Igbo in Nigeria, Lasiren in Haiti, Santa Marta la Dominadora in the Dominican Republic, Iemanja and Oxum in Brazil, these spirits (divinities, energies, cosmic forces) share some remarkable similarities. Drewal defines Mami Wata as follows:

> Mami Wata is a complex multivocal, multifocal symbol with so many resonances that she feeds the imagination, generating, rather than limiting, meanings and significances: nurturing mother; sexy mama; provider of riches; healer of physical and spiritual ills; embodiment of dangers and desires, risks and challenges, dreams and aspirations, fears and forebodings. People are attracted to the seemingly limitless possibilities she represents, and at the same time, they are frightened by her destructive potential. She inspires a vast array of emotions, attitudes, and actions among those who worship her, those who fear her, those who study her, and those who create works of art about her. What the Yoruba peoples say about their culture is also applicable to the histories and significances of Mami Wata: "she is like a river that never rests."[25]

Campos-Pons mines this richness and complexity in her work. In "Susurro (Whispers)" (1997),[26] the artist creates a diptych with Yemayá in the left panel and Ochún in the right panel; they face each other, even though their eyes are closed. Each holds a carved wooden bird on her shoulder: Yemayá holds a blue-colored one, Ochún a yellow one. Despite the identifying characteristics of each *orisha* (face paint, nail polish, and bird colors), Campos-Pons highlights their complementarities, the interconnectedness of Yemayá and Ochún. Hence, the Yemayá

panel has a golden background and the Ochún panel a dark blue one. Each uses a different arm to hold the bird, and each has yellow mini-sunflowers in the hair. The title *Whispers* evokes a conversation between the two that is both meaningful and intimate, as one might expect between two sisters. The closed eyes and measured gestures suggest a ritual calm, drawing on the spiritual energy evoked by the two powerful female *orishas*.

The spiritual and worldly power that emanates from the artist's re-creation recalls the power of *ajé*, a Yoruba word that has been mistranslated for centuries as "witch." Teresa N. Washington has carefully examined that history but also offers a corrective that puts the importance of female spirituality and empowerment in Yoruba culture in greater context:

> Ajé is depicted in Yoruba mythistories and Odú Ifá (divination verses for the Ifá spiritual system—The Yoruba way of knowing) as a biological, physical, spiritual force of creativity and social and political enforcement. A vastly influential power that is inclined toward paradox and multiplicity. Ajé is holistic and neutral and can be used in myriad ways depending upon the entity wielding the power and the circumstances and motivations dictating the actions. In addition to being a cosmic force that originates with Great Mother Deities, Ajé is a naturally occurring property of select human beings. Women of Ajé have many significant attributes and roles in society. They are bestowed with spiritual vision, divine authority, power of the word, and *asé* [*aché* in Cuba], the power to bring desires and ideas into being. As "children" of Imolé, the Mother of the Earth, they control agricultural fertility and plant life. Holistic healing is an important aspect of Ajé, and its wielders use their incomparable knowledge and ownership of flora and fauna to create nourishment, healing elixirs, and poisons. Ajé also enact spiritual communication through divination and *Oró*, power of the word. Most important, Awon Yá Wa [Our Mothers] are teachers whose gifts, lessons, trials, and punishments compel their communities to seek higher levels of spiritual evolution and redirect misguided destiny, direction, or power.[27]

Perhaps one of Campos-Pons's works that best exemplifies the "paradox and multiplicity" of *ajé* is a 2001 work titled "Replenishing."[28] Also in Polaroid format, it depicts the artist's mother on the

left in three vertically placed shots and on the right is the artist, also in three vertical shots. Between the two is a connector photo. The overall design looks like a capital letter "H." The mother is dressed in a blue dress with white flower prints and is holding a long, beaded blue and white necklace. The color schemes associated with her mother (dress and necklace) are clear references to Yemayá. In addition, the seven panels of the piece echo Yemayá's number. The artist is dressed in a white and yellow dress, which, in the Ocha tradition, are important colors. For example, white is most often associated with ritual attire, particularly in different types of initiations (partial or full). White is also associated with the *orisha* Obbatalá.

The two necklaces that the artist holds are associated with Ochún and Elegguá. Again, she has drawn on the two female *orishas*, who speak (or whisper) to each other as well as replenish each other. Yemayá is often referred to as Ochún's older sister and sometimes as her mother, so the parallel of her own family life with that of the *orishas* is consistent. The placement of the mother's hands a little higher than that of her daughter's only reinforces this relationship. The link between mother and daughter visually depicted by the necklaces recalls the nineteenth-century bronze sculpture depicting the *osogbo* society of elders, who are of Yoruba origin.[29] While there might be a mutual replenishment, the artist clearly indicates that her mother's seniority, wisdom, and *ajé* replenish her physically and spiritually.

What is interesting about the right-hand side of the piece is that a bit of the Elegguá necklace dangles down from the artist's right hand as if to suggest that even with all the replenishment, her life and art are still in the hands of Elegguá, the *orisha* of the crossroads. Perhaps she is referencing her ten-panel work from 1997, "El abridor de caminos" ("The One Who Opens the Path"),[30] in which the eighth, ninth, and tenth panels visually index the past, present, and future.

In her discussion of *ajé*, Washington speaks about the spirit birds of the mothers: "Ajé assume many astral and material forms to enact 'cosmic causation,' but they are most commonly linked to birds: doves, vultures, pigeons, and owls. Indeed, Ajé are known as Eléye, the owners of Birds."[31] Birds crop up in the artist's "Nesting" series, a set of two triptychs and two four-panel pieces executed in 2000.

In "Nesting III,"[32] Campos-Pons uses the far right and left panels to depict birds; the one on the right has a white breast and grey back, and the other, a yellow breast and brown back. On the left-central panel is a shot of the artist from the collarbone up with her eyes closed, and the yellow-breasted bird is atop her head. Her hair is braided in a way that suggests African headdresses (Yoruba), Calabar masks, and

Cameroon hairdos. Her face has little yellow "check marks" that also suggest ritual painting of the visage and the body that occur in both African and New World African-derived religious traditions. The bird on her head certainly evokes Yoruba-beaded crowns that not only have birds on the top (symbolizing *aché*) but beaded strings that come down and cover the face as well.[33] Intertwined with the artist's braided hair, which swirls about her head and face, is a necklace with the colors of the *orisha* Oggún. Campos-Pons again references the importance of the head in Yoruba culture, including sayings such as, "It is the head that created us; nobody created the Head" or "May my inner head not spoil my outer one."[34] Not surprisingly, the Yoruba word for civilization is *olaju*, which, etymologically-speaking, means "to give the earth a human face."[35]

Hair is equally important in this series, and not only does it have aesthetic value but also multiple purposes: a link between different worlds or realities, a bridge to her past, an emotional bond to her mother and family, a strand of memory, a diasporic concatenation of exile, wandering, and historical turmoil. "Nesting IV" (2000) is almost entirely involved with hair.[36] Also featuring four panels, the two inner ones provide a divided portrait of the artist from the chest up, with the face roughly divided at the nose. The hair is worn as a headdress and, in the left panel, a beaded object with a feather is in her hair behind the right ear.

Feathers are symbols of *aché*, and the fact that the feather is coming out of her hair makes it doubly significant. The piece echoes an earlier piece titled "Everything Is Separated by Water, including My Brain, My Heart, My Sex, My House" (1990) in which the entire body is separated by a column of water, and each half of the body is encircled by seven pieces of barbed wire.[37]

Across the four panels is a huge strand of braided hair that crosses just above the artist's eyebrows, ending on the extreme right and left panels in a tangle of hair. The braided, tangled hair is the only thing visible in these two panels. The long braid that traverses the four panels is not physically connected to the subject's head, although it is the artist's hair. In the two central panels, there are braids around her neck that look like collars. "Nesting IV" is an ambiguous work since the title seems to suggest a place one can call home, yet the imagery of the piece (the split body and head, the tangled braids, and the turquoise panels that cover the subject) indicate that home is provisional and precarious.

"Nesting IV" prefigures pieces like "Elevata" (2002), "Constellation" (2004), "Rhapsody" (2004–2005), and "Dreaming of an Island" (2008), all which use hair and braids on a more massive scale (the

works are mostly sixteen to twenty panels); "Dreaming" consists of nine panels.[38] In "Elevata," "Constellation," and "Rhapsody," hair assumes a cosmic and astral dimension, as if to echo Lydia Cabrera's phrase about Yemayá: "Stars are the jewels in Yemaya's cape."[39]

Diaspora, Race, and Identity

Campos-Pons's "Yemayá aesthetics" has allowed her to examine her own complex identity, since she is now part of a Cuban diaspora that has arisen after the Cuban Revolution. Although Cuba never had a racial history like the United States' with the systematic violence of lynching, miscegenation laws, and Jim Crow segregation, the artist was still aware that, as a dark-skinned Cuban, social realities were indeed different and that her beloved island was not the racial democracy it was often touted to be. However, living in the United States, she also confronted different racial realities. Even though there are important Cuban artists who influenced her, namely, Wifredo Lam, Marta Pérez Bravo, Flavio Garciandía, Ana Mendieta, Manuel Mendive, and José Bedia, she has also found an aesthetic kinship with African American artists such as David Hammons, Lorna Simpson, and Carrie Mae Weems. As she wrestles with the racial conundrums of these two worlds, Campos-Pons has denounced racism and undertaken a rigorous examination of racial representation across cultures in ways that engage and intertwine historical, personal, gendered, and spiritual realms.

Cuban visual artists like Belkis Ayón, Alexis Esquivel, Juan Roberto Diago, and René Peña are not only adamant in their denunciations of racism, but they also carefully examine the intricacies of what it means to be of African descent in contemporary Cuba. Campos-Pons is no exception to this generation of artists, and her work was part of a group show that included the above-mentioned artists on race and racism in contemporary Cuban art that first opened at the Wifredo Lam Contemporary Art Center in Havana and later traveled to the Mattress Factory in Pittsburgh. The show was titled "Queloides" ("Keloid"), which, according to co-curator Alejandro de la Fuente, means a "pathological scar in the site of a skin injury produced by surgical incisions or traumatic wounds."[40]

These artists by no means totally agree on racial assumptions of personal and collective identity, best exemplified in a work by Campos-Pons titled "When I'm Not Here/Estoy Allá" (Tríptico I, 1996).[41] The triptych consists of three large Polaroids of the artist: the left panel shows her in white face (with "Patria una Trampa" ["Fatherland a Trap"]) on

her chest; her hair is braided in six upward strands, and, at the end of each braid, a single string hangs down, giving the overall effect of a kind of headdress/willow tree.

The white face has a ghostly feel but at the same time evokes ritual painting of the body. In fact, the whitening effect has been done with *cascarilla* (eggshell), which is used in Ocha rituals. However, in conjunction with the words on her chest, the warning seems ever more poignant. Campos-Pons is critically engaging the Cuban view of race and nationality. For Cubans, nationality (or culture) trumps race in a way that is quite distinct from that in the United States. A Cuban highlighting race can be considered "divisive" or "unpatriotic."[42] To this degree, there is a common ground with the history of African Americans and the ways their patriotism has often been questioned in a white supremacist society.[43]

Campos-Pons is not questioning a healthy sense of nationalism but the kind of knee-jerk patriotism that exalts national unity to the detriment of complexity and pluralism. Her critique of Cuban ultranationalism involves both race and gender: The "whiteface" suggests that nationalism involves a kind of whitening (the Cuban norm), but the use of the word "patria," with its inevitable association with patriarchy (and the notion of "founding fathers") is a reminder that the foundations of nationality are profoundly gendered.

The middle panel shows her skin tones accurately, though her face is partially obscured by an array of seven sticks that look incredibly like upside-down *garabatos*. Little strips of red cloth dangle from the ends of the thin braids. Her open right eye is obscured by the red cloth and the tip of one of the *garabatos*. The left eye is also open and is partially obscured by one of the *garabatos*.

The color of the artist's hair along with the red cloths, not to mention the *garabatos* themselves, seem to suggest Eleggúa, *orisha* of the crossroads, destiny, and messenger to all the other *orishas*. It anticipates the "Abridor de caminos" (The One Who Opens the Roads) (1997).[44] Campos-Pons has strategically placed this photo in the middle, as if to suggest that it is steering a path between two calamities: the trap of nationalism (Cuba) and the tragedy of identity politics in the United States. Following this layout, Cuba is on the left, and the United States is on the right; in the middle is the artist herself in all her bilingual, bicultural, and binational complexity. Not only is her skin tone natural, but nothing is written across her chest, again suggesting the openness of the future—maybe Eleggúa will provide those words, perhaps of portent? This middle photo is perhaps expected to avoid the excesses of the right and left panels, but it offers no consolation: the illusions and

elisions of race remain stubbornly elusive, yet the traumas of racialized history remain forever inscribed on the body.

The right panel, in which the artist's eyes are closed, shows her as "mixed race," and on her chest is written, this time in English, "Identity Could be a Tragedy." The image is clearly a warning about a narrow interpretation of identity politics limited to race, gender, or geography. It evokes an earlier sextet of photos from that same year,[45] in which the same phrase is written on her chest. In this series of photos, the light and the artist become lighter until the sixth photo, where only the contours of her head, hair, and shoulders are barely visible. The spectral sixth image is haunting, if not chilling. Not only is it a reminder of the reductive nature of certain kinds of identity politics, but it also captures the fear that immigrants or exiles face that they may be swallowed up by their host culture. Both pieces are reminders that even with Obama as president, the United States and Cuba are far from being postracial societies.

The title and the visual rhetoric of both pieces capture Campos Pons's bicultural reality; she has lived roughly half her life in Cuba and half in Boston. They also capture the intense dialogue about race and identity being negotiated between Cuba and the United States, which her body mediates. In the latter piece (the triptych), the left panel (Cuba), where culture and nation trump racial difference, she appears in white face, an exact visual reminder of Fanon's book *Black Skin, White Masks*—a trap. The right panel, with its "mixed-race" image, aside from what was previously discussed, could also be a reference to Cuba as a "mestizo nation," which some could interpret as a whitening process. The middle panel's dark skin tones suggest Yemayá, and the right panel's "mixed-race" tones suggest the mulatta Ochún. Following in the spirit of Fanon, Campos-Pons sees the body as speaking the truth but speaking it as a question.[46] As she documents her questioning body, Campos-Pons challenges Cuba's and the United States' most cherished notions of self, society, race, and culture. She challenges us like the "river/ocean that never rests,"[47] with Yemayá's serenity, compassion, warrior-like determination, and creativity.

Notes

1. Édouard Glissant, *The Collected Poems*, trans. J. Humphries and Manolas Melissa (Minneapolis: University of Minnesota Press, 2005), 50.

2. Virgilio Piñera, *La isla en peso* (Barcelona: Tusquets, 2000), 37; and José Lezama Lima, "Noche insular: jardines invisibles," in *Poesía completa I* (Madrid: Ediciones Aguilar, 1988), 87. The Piñera poem is from 1943.

3. For more biographical information on Campos-Pons, see Lisa D. Freiman, Lisa D., ed., *Maria Magdalena Campos-Pons: Everything Is Separated by Water* (New Haven: Yale University Press, 2007), 15–26.

4. Gaston Bachelard, *Water and Dreams: An Essay on the Imagination of Matter*, trans. Edith R. Farrell (Dallas: Dallas Institute of Humanities and Culture, 1994 [1942]), 15.

5. Freiman, Maria Magdalena Campos-Pons, 28.

6. Lydia Cabrera, *Yemayá y Ochún* (Miami: Ediciones Universal, 1996 [1974]), 20–21.

7. Freiman, 95, 107, 113, 123, 128–29, 131, 147, 149.

8. Ibid., 39.

9. Derek Walcott, *Collected Poems 1948–1984* (New York: Farrar, Straus and Giroux, 1986), 364–67.

10. As quoted in Freiman, *Maria Magdalena Campos-Pons*, 71.

11. Édouard Glissant, *Caribbean Discourse* (Charlottesville, VA: University Press of Virginia, 1989), 64.

12. Juan Mesa Díaz, "The Religious System Ocha-Ifá," in Music in Latin America and the Caribbean: An Encyclopedic History, ed. Malena Kuss, vol 2, of The Joe R. and Teresa Lozano Long Series in Latin American and Latino Art & Culture, ed. Malena Kuss (Austin: University of Texas Press, 2007), 57, 60; and Kola Abimbola, *Yoruba Culture, A Philosophical Account* (London: Iroko Academic, 2006) 47–76.

13. Mesa Díaz "The Religious System Ocha-Ifá," 58.

14. For more on altars and aesthetics, see Arturo Lindsay, ed., *Santería Aesthetics in Contemporary Latin American Art* (Washington, DC: Smithsonian Institution Press, 1996); and Robert Farris Thompson, *Faces of the Gods: Art and Altars of Africa and the African Americas* (New York: Museum of African Art, 1993).

15. Lynne Bell, "History of a People Who Were Not Heroes: A Conversation with Maria Magdalena Campos-Pons," *Third Text* 43 (1998): 40.

16. Awo Falokun Fatunmbi, *Inner Peace: The Ifá Concept of Ori* (New York: Athelia Henrietta Press, 2005), 12.

17. Awo Falokun Fatunmbi, *Inner Peace*, 28.

18. Freiman, 113.

19. Édouard Glissant, *Poetics of Relation* (Ann Arbor: University of Michigan Press, 1997), 5–9.

20. Freiman, 114–15.

21. Cabrera, 74–76.

22. Alan West-Durán, "Regla de Ocha and Ifá," in *Cuba*, ed. Alan West-Durán (Farmington Hills, MI: Charles Scribner's Sons-Gale, 2011), 296.

23. Cabrera, 70–72.

24. Ibid., 28–30.

25. Henry John Drewal, ed., *Mami Wata: Arts for Water Spirits in Africa and Its Diasporas* (Los Angeles: University of California Los Angeles, Fowler Museum of Cultural History, 2008), 25.

26. Freiman, 128–29.

27. Teresa N. Washington, *Our Mothers, Our Powers, Our Texts: Manifestations of Ajé in Africana Literature* (Bloomington: Indiana University Press, 2005), 13–14.
28. Freiman, 147.
29. Henry John Drewal, John Pemberton III, and Rowland Abiodun, eds., *Yoruba: Nine Centuries of African Art and Thought* (New York: Harry Abrams, 1989), 40.
30. Freiman, 126–27.
31. Washington, 22.
32. Freiman, 140–41.
33. Drewal, and Abiodun, 36.
34. Lawal as cited in Roy Siber, Frank Herreman, and Niangi Batulukisi, eds., *Hair in African Art and Culture* (New York: The Museum for African Art, 2000), 93, 95.
35. Lawal as cited in Siber, Herreman, and Batulukisi, *Hair in African Art and Culture*, 95.
36. Freiman, 142–43.
37. Ibid., 93.
38. Ibid., 149, 157, 159; West-Durán, 183.
39. As quoted in Armando Vallado, *Iemanjá: A Grande Mae Africana do Brasil* (Rio de Janeiro: Pallas Editora, 2002), 152.
40. Alejandro de la Fuente, ed., *Queloides, Race and Racism in Cuban Contemporary Art* (Pittsburgh: Mattress Factory, 2010), 10.
41. Freiman, 118–19.
42. De la Fuente, 11–12.
43. See Randall Kennedy, *The Persistence of the Color Line: Racial Politics and the Obama Presidency* (New York: Pantheon Books, 2011), 161–95.
44. Freiman, 126–27.
45. Ibid., 116–17.
46. Frantz Fanon, *Black Skin, White Masks*, trans. R. Philcox (New York: Grove, 2008 [1952]), 206.
47. Drewal, *Mami Wata*, 25.

References

Abimbola, Kola. *Yoruba Culture: A Philosophical Account*. London: Iroko Academic, 2006.
Bachelard, Gaston. *Water and Dreams: An Essay on the Imagination of Matter*. Translated by Edith R. Farrell. Dallas: The Pegasus Foundation, 1942; reprint, Dallas: The Dallas Institute of Humanities and Culture, 1994.
Bell, Lynne. "History of a People Who Were Not Heroes: A Conversation with Maria Magdalena Campos-Pons." *Third Text* 43 (Summer, 1998): 33–43.
Cabrera, Lydia. *Yemayá y Ochún*. Miami: Ediciones Universal, (1974) 1996.
Campos-Pons, María M *Interiority*, Milan: Libri Schwiller, 2004.

de la Fuente, Alejandro, ed. *Queloides, Race and Racism in Cuban Contemporary Art*. Pittsburgh: Mattress Factory, 2010.

Drewal, Henry John, ed. *Mami Wata: Arts for Water Spirits in Africa and Its Diasporas*. Los Angeles: University of California Los Angeles, Fowler Museum of Cultural History, 2008.

———, ed. *Sacred Waters Arts for Mami Wata and Other Divinities in Africa and the Diaspora*. Bloomington: Indiana University Press, 2008.

———, John Pemberton III, and Rowland Abiodun, eds. *Yoruba: Nine Centuries of African Art and Thought*. New York: Harry Abrams, 1989.

Fanon, Frantz. *Black Skin, White Masks*. Trans. R. Philcox. New York: Grove, (1952) 2008.

Fatunmbi, Awo Falokun. *Inner Peace: The Ifá Concept of Ori*. Brooklyn, NY: Athelia Henrietta, 2005.

Freiman, Lisa D., ed. *Maria Magdalena Campos-Pons: Everything Is Separated by Water*. New Haven: Yale University Press, 2007.

Glissant, Édouard. *Caribbean Discourse*. Charlottesville, VA: University Press of Virginia, 1989.

———. *Poetics of Relation*. Ann Arbor: University of Michigan Press, 1997.

———. *The Collected Poems*. Translated J. Humphries and Manolas Melissa. Minneapolis: University of Minnesota Press, 2005.

González-Mandri, Flora. *Guarding Cultural Memory: Afro-Cuban Women in Literature and the Arts*. Charlottesville: University of Virginia, 2006.

Hassan, S. M., and C. Finley, eds. *Diaspora, Memory, Place: David Hammons, Maria Magdalena Campos-Pons and Pamela Z*. Munich: Prestel, 2008.

Kennedy, Randall. *The Persistence of the Color Line: Racial Politics and the Obama Presidency*. New York: Pantheon Books, 2011.

Lezama Lima, José. *Poesía completa I*. Madrid: Ediciones Aguilar, 1988.

Lindsay, Arturo, ed. *Santería Aesthetics in Contemporary Latin American Art*. Washington, DC: Smithsonian Institution Press, 1996

Mason, John. *Olokun: Owner of the River and Seas*. Brooklyn, NY: Yoruba Theological Archministry, 1996.

Mesa Díaz, Juan. "The Religious System Ocha-Ifá." In *Music in Latin America and the Caribbean: An Encyclopedic History*, edited by Malena Kuss. Vol. 2 of the Joe R. and Teresa Lozano Long Series in Latin American and Latino Art and Culture, edited by Malena Kuss, 55–65. Austin: University of Texas Press, 2007.

Piñera, Virgilio. *La isla en peso*. Barcelona: Tusquets, 2000.

Sieber, Roy, Frank Herreman, and Niangi Batulukisi, eds. *Hair in African Art and Culture*. New York: The Museum for African Art, 2000.

Thompson, Robert Farris. *Faces of the Gods: Art and Altars of Africa and the African Americas*. New York: Museum of African Art, 1993.

Vallado, Armando. *Iemanjá: A Grande Mae Africana do Brasil*. Rio de Janeiro: Pallas Editora, 2002.

Walcott, Derek. *Collected Poems 1948–1984*. New York: Farrar, Straus and Giroux, 1986.

Washington, Teresa N. *Our Mothers, Our Powers, Our Texts: Manifestations of Ajé in Africana Literature*. Bloomington: Indiana University Press, 2005.
Weaver, Lloyd, and Olokunmi Egbedale. *Yemonja: Tranquil Sea and Turbulent Tides*. Brooklyn, NY: Athelia Henrietta, 1999.
West-Durán, Alan, "Regla de Ocha and Ifá." In *Cuba*, edited by Alan West-Durán, 294–304. Farmington Hills, MI: Charles Scribner's Sons-Gale, 2011.

Chapter 9

"The Sea Never Dies": Yemọja:
The Infinitely Flowing Mother Force of Africana Literature and Cinema

Teresa N. Washington

The most versatile element, the elemental force, the essential source of all life is water, and the Mother of all of the waters of this world is Yemọja. So important a God is she, Yemọja boasts the *oríkì* Yewájọbí, which means Mother of All of the Gods and of All Living Things.[1] There are no Gods without the Mother. There is no life without the Mother. Every human being frolics first in her rich waters, in the safest, most serene home, the most perfect domicile—the womb. Mother molded us to perfection in liquids that we carry in us and spontaneously replenish for life. Seventy percent of our being is Yemọja. She is the saliva that makes speech possible. She is the blood surging through our veins. She is the vehicle through which sperm travels. She is the albumin of fertile eggs, blood, and milk. She is the vaginal fluid of the Earth[2] that glistens between lips, flows through rock gardens, chuckles in creeks, and shimmies down streams. The dance of the river, the ocean's roar, the gold-laced milk of my breasts, the salt of your tears: Yemọja.

Like many Òrìsà, Yemọja originated in the spiritual realm and traveled to Earth to experience life and effect change. While all of the Gods are essential to the construction and maintenance of the spiritual and material worlds, C. L. Adeoye describes Yemọja as being "superior in both òrun (the spiritual realm) and earth."[3] Fittingly, Yemọja was highly sought after and enjoyed marriages to both Gods and mortals. In each of her many unions, reciprocal knowledge sharing resulted in impediments being transformed into blessings. In her marriage to Ògún, the

God of Iron and Technology, Yemọja gained knowledge of and access to a vast cache of weaponry that she uses to protect her children. Her marriage to the human Oluweri of Ketu resulted in the sacrifice and dance that became the legendary Gèlèdé. During her marriage to the God Sàngó, Yemọja created a dance so entrancing that her cowives, Ọsun and Yemojì, ran away enraged and did not stop running, as they became rivers. The same fate struck Yemọja, who, also caught in the throes of transformative *asẹ* and Àjẹ̀, became the Ògún River in Nigeria.[4] Another origin text reveals that when Yemọja transformed, "Two streams of water gushed from her breasts and formed a lake which is said to be the source of all the rivers of the world."[5]

The concept of a God transforming into a self-proliferating river that, in turn, births all of the waters of the world reflects the holism that is central to Yoruba cosmology, ontology, and geology. In his article, "In Praise of Metonymy: The Concepts of 'Tradition' and 'Creativity' in the Transmission of Yoruba Artistry over Time and Space," Olabiyi Babalola Yai discloses an important truth: "The Yoruba have always conceived of their history as diaspora."[6] Yai reveals that the Yoruba diaspora, or Ìtànkálẹ̀, includes Ìkọ Àwúsí (the Americas), Ìdòròmù Àwúsẹ̀ (Africa), Meréètélú (Eurasia), Mẹsìn Àkááruba (Arabia, the Middle East), and Ìwọ́nran Níbì Ojúmọtí í Móọ́ Wá (Australia).[7] Just as the Earth's continents are "all lands of Ifá,"[8] so too are the oceans, streams, lakes, and seas that fertilize these lands and nourish their inhabitants all the waters of Yemọja.

Within the geopolitical confines of Yorubaland, Yemọja boasts a plethora of origin texts, names, praisenames, characteristics, and identities. But the God respects no geopolitical boundaries; she is global. A Yoruba proverb extends to human beings an empowering entitlement: "*Orúkọ tó wu ni làá jẹ́ lẹ́hìn odi* (Outside the walls of your birthplace, you have a right to choose the name that is attractive to you)."[9] Just as water has perhaps as many names as there are languages, so too does Yemọja seamlessly adorn herself in the names and characteristics specific to her various locales and roles therein. As the literal lifeblood of the globe and the global Yoruba Ìtànkálẹ̀, Yemọja flows from Mali to Mississippi, from Benin to Brazil, from the Congo to Cairo to Cuba and Canada. Whether she is invoked as Yemọnja, Yemaya, Mother of Waters, or Mary, she is the owner of a womb of infinite depths that is eternally contracting and expanding with the exultant labor of creation. Yemọja is the Mother of multitudinous divine descendants including the Water Gods Olókun, Omi, Ọya, Afrekete, Mami Wota, Ọsun, Faro, and Simbi. But her offspring are innumerable, for every God and every living thing finds his or her source in Yewájọbí Yemọja.

In the light of her ubiquity and essentiality it is ironic that Yemọja attained global recognition in the modern era because of the greatest

atrocity in human history: the exile and trafficking of millions of Africans through Yemọja's own womb, the Ethiopic Ocean. The continent that was once known as Ethiopia and boasted an ocean called Ethiopic saw a colossal reversal of fortune: Morally bankrupt oppressors renamed the continent's ocean "Atlantic," but they grew rich by marking the ocean with the bodies of millions of Ethiopians. In their struggle to commoditize African identity and divinity, Europeans turned the Ethiopic Ocean into what playwright August Wilson calls "the largest unmarked graveyard in the world."[10]

A multitude, "*Sixty Million / and more*,"[11] did not survive the Middle Passage. Millions of people dove into Yemọja's arms when they were forced to exercise on deck. Millions were not allowed to die before they were pitched overboard screaming. Millions tried to use their chains to squeeze the breath from their oppressors' ruddy necks before they were deemed unfit for slavery and pushed into the ocean. An unimaginable many sank into the Source where the Force fingered their infected wounds, massaged their rent limbs, and rocked their exhausted souls to sleep. Yon, they rock there still. Cradled by Yemọja under the waves of the Ethiopic, they rock there still. Mother used her preserving powers to store up the energies of those unceremoniously slaughtered; and when summoned, those riddling emissaries of Yemọja rise, respond, and walk from the waves and into souls to steer the misaligned back on course.

The Africans who survived the crossing did so because Yemọja used her soothing waters to heal lacerated bodies that had been rubbed raw and anointed with feces, menstrual blood, urine, tears, and destitution. Mother used the salty waters of her womb to preserve her children so they could persevere no matter what type of wickedness was concocted to hurt them. No, exiled Africans could not forget her: She was the first God they thanked for having survived the horror that was the Middle Passage.[12] Those warrior-ancestors knew that fresh hell awaited them in America, Haiti, Jamaica, Cuba, France, England, Brazil, Ecuador, Surinam—all of Babylon's far-flung lands—but they also knew that the fact of their existence was the covenant that ensured rich, free, whole lives. John Mason describes Yemọja as "the universal principle of the survival of the species, and . . . the procreative urge which causes living beings to continue to propagate."[13] Every time water breaks, Mother welcomes her libation. The newborn's wail is her praisesong. A force of profundity and paradox, Yemọja's artistic, political, and biological influence ranges from tsunamic to smooth. Her current is sinuous and swift. Her power is the undeniable undulation of understatement.

The Gẹ̀lẹ̀dẹ́ festival, which is held in honor of Yewájọbí and all of her divine progeny, is an elaborate amalgamation of celebration, revelation, homage, and critique. Entire communities mount these expansive

tributes to Yemọja and the Mothers to ensure the fertility and continuity of their communities. This disquisition is a Gẹ̀lẹ̀dẹ́-in-ink that seeks to honor Yemọja and elucidate and analyze her profound impact on rich and diverse survey of Africana literary and cinematic works. A study of the flow of the Mother and the art, ritual, and revelation she inspires reveals a dynamic and intricate discourse. Writers and filmmakers use art to document, revivify, and recycle Africana triumphs, tragedies, cultural symbols, and political strategies, and in the process, they extend the influence of and further the cleansing, re-membering, rebirthing, and renaming that is essential to Africana continuity.

The depth and breadth of Yemọja's healing, artistic, analytical, and communicative repertoire is stunning within her Yoruba environs, but by focusing on works born of the Ìtànkálẹ̀, the lands to which the Yoruba traveled either of their own volition or by force, this discussion highlights the God's inherent dynamism, malleability, and immortality. Through comparative analysis, this study reveals how Yemọja initiates intra-, inter-, and extra-textual dialogue to and through the Pan-African geographic and creative continua. As the literature and films under study make clear, Yemọja may boast any of many names in the Ìtànkálẹ̀. She may bear a name that is an attractive cultural encomium or one that serves as a protective shield to pacify an oppressor; she may boast no name at all. But as sure as everything on the Earth has a mother,[14] Yemọja is the groundwater that vivifies Africana life, creativity, and artistry.

"A Lil Mo Juba for My Shrine"[15]

At one time, the Mother of All could not conceive. She consulted wisdom keepers and performed the sacrifice and dance that filled her womb with life and served as the prototype for the Gẹ̀lẹ̀dẹ́ festival.[16] African Americans would consider Gẹ̀lẹ̀dẹ́ a juba. Spelled in various ways and having many uses, juba may be the most Pan-African and utilitarian word in existence. In addition to Juba being the capital of the Republic of South Sudan, Jubba is a river in Somalia, a country that also boasts a Jubaland. Juba is also a proper name for Africana males and females. In African America, Pat Juba is a dance; and, logically, there is also a song called "Juba." In Yoruba language, *júbà* is a verb that means "to regard; acknowledge as superior," and invocations to the Òrìṣà often include the phrase *mo júbà*, which means, "I pay homage." Juba owes its transmission and transmutability to two of Yemọja's eternal waterways: the mother tongue and the mothers' wombs. As Africans migrated throughout the Continent and the world by land and sea they carried with them the flexible and potent signifier that is juba.

In acknowledgment of the healing force of water, Yoruba wisdom asserts that "there is no problem so big that it cannot be transformed by the power of the sea,"[17] but in the case of Africans drug through and lost to the Middle Passage, the sea exacerbated the problem. However, Yemọja is considered the ultimate Àjẹ́, and Àjẹ́ are known for the paradoxical nature of their lessons. Àjẹ́, the Mother Gods who control existence; they can do and undo; they can devastate and deliver the devastated.[18] After a three-and-a-half-month, nine-thousand-mile journey through watery atrocities, Africans emerged from the hulls of ships to face a quandary: Although thankful that Yemọja chose them to undertake the arduous task of spreading the sacred earth of Ifẹ̀ by fomenting life in the midst of death, they wondered how they could survive the promised brutalities; they wondered if survival was worth the guaranteed pain.

The institution of slavery strove to wring the joy out of motherhood and childhood in particular and out of life in general. It was difficult to find a reason to smile, hug a loved one, or startle the birds with one's laughter. The rich artistic traditions for which Africa is lauded became twisted forms of mockery in America. The only intricate carvings African Americans could boast were those oppressors cut into their flesh with singing whips or sizzling brands. The only masks enslaved Africans could dance in were those that hid their rage from the sadistic gaze of enslavers. The only jewelry that jingled when dislocated Africans jumped was manacles that cut to the bone and hideous curved bell-wand necklaces that no human being could or would have invented. Rather than ritually protect their infant's lives with cooling waters from the Onídá stream,[19] enslaved mothers stood at the crossroads where the longing to nurture life competed with the desire to hold life under a bubbling creek and introduce it to the peace of the afterlife.

Enslaved and religiously oppressed African Americans could not mount a Gẹ̀lẹ̀dẹ́ with its sumptuous pageantry and full-throated honorings of the mothers and the Mother. But they could juba: silently by the crackling fire in the cabins; furtively while protected by the low-slung branches of oaken sentinels; vigilantly with a determination to give birth to and raise free children or kill trying, they could juba. In African America, juba often refers to a ritual ceremony of fluid and flexible form. Juba may take the form of ring shouts in which congregants move rhythmically in a counterclockwise circle as they align themselves to the rotation and power of the Earth. Juba can involve instruments, including the only ones never outlawed: the hands, thighs, hips, abdomens, and chests. Perhaps the most important feature of African American juba is its conflation of exultation, celebration, lamentation, and invocation. Juba is everything: All emotions, triumphs,

births, deaths, losses, and gains are re-membered to the individual and collective body so that healing can occur and wholeness can be reestablished. Juba occurs repeatedly in Africana America literature and cinema, and when it does, Yemọja is near or coming. Juba to Yemọja—spontaneous and planned, individual and communal—is central to Toni Morrison's *Beloved*, and the prevalence of this ritual praise and its form and flexibility are indicative of the power of the God, her covert and overt impact on the lives the character Beloved touches, and the power of pure unfettered love.

That Yemọja represents the principle of the survival of the species takes on new meaning when the species is denied its membership in the human family. To ensure the existence of one's people despite oppression, copulation is not enough: One must be driven by love. For many individuals, as is illustrated in the quiet fury that defines the lives of the characters in *Beloved*, it was safer to construct a loveless world than open one's self to the righteous murderous rage that love can inspire. How, in the institution of slavery, could a loving father protect his wife from rape? How could a devoted mother ensure her milk was reserved for its rightful owner as opposed to an infant oppressor? How could a child look at, embrace, and learn songs from a mother who has a bit in her mouth? How could vigilant parents teach their children the blessings of self-defense under an institution that denied they had blessed selves? The challenge facing Africans tragically separated from their foundation was to do the impossible: love and protect the Africana self foremost and fully.

Loving one's enemy has been all too easy a feat for Africana peoples, especially those indoctrinated with Christianity. It is loving one's self, beauty, progeny, and power that continues to prove difficult. In *Beloved*, Ella and Paul D take the austere path of stripping love from their lives so that they can endure the unendurable. Sixo, however, has loving down to a science; he is the embodiment of holistic existential love. Sixo loves his mind and the wisdom he gains from the Earth too much to allow an oppressor's ideology room to grow inside of him.[20] He jubas with the trees at night to recharge his divinity, which is reflected in the power of Earth and in its flora and fauna.[21] The Earth rewards his love and pulsing blood by leading him to ecstasy and immortality through Patsy, who is honored with the *oríkì* Thirty-Mile Woman because Sixo treks thirty miles to touch, gaze upon, inhale, and smile with her, even if for mere minutes.

Patsy is essential to Sixo's existence because she is his complement and liberator. As Sixo reveals, "She is a friend of my mind. She gather me, man. The pieces I am, she gather them and give them back to me in all the right order. It's good, you know, when you got a woman

who is a friend of your mind."²² Patsy's effort to collect every precious element that slavery scattered, scarred, jumbled, and discarded, and then to polish, massage, restructure, and restore them to African order and perfection is impossibly arduous and dangerous work. To successfully undertake these labors one must be motivated and directed by a force deeper than mere love. In the perfect marriage of reciprocity, continuity, and immortality, the principle of the survival of the species guides Sixo's dynamic sperm through the silt-rich loam of Patsy's womb to unite with her eager ovum and create Seven-O.²³ The answer to Yemọja's prayer, and bearing the number that signifies her divinity, Seven-O is the embodiment of juba and a cause for jubilation.

Sixo proves it can be done. A man can manifest his masculinity and divinity through love despite slavery. A man can be so liberated by love that when his oppressors try to roast him alive, he is filled with laughter, caught up in his own rapture, and overflowing with juba.²⁴ What about a mother? In the wilds of Ohio, surrounded by unimaginable savages and unconscionable savagery, Baby Suggs, holy, calls her community to juba their love of the ancestral, present, and unborn Self. She painstakingly teaches the men, children, and women of her community to isolate, examine, and embrace every individual element of their biological, sexual, and spiritual selves.²⁵ Baby Suggs is Yemọja for her community, and the neo-Gèlèdé she oversees in the Clearing is a personal *cum* communal gender-balance gender-blending juba of love and empowerment. In a similar manner, when Sethe arrives at 124, she performs the intimate exultation of kissing, feeding, hugging, and loving her children. Sethe's private juba is answered with a spontaneous community Gèlèdé that is overseen by Baby Suggs. However, rather than join Sethe, summon forth their buried numinosity, and exult in their personal and collective miraculousness, the community directs a silent rage at Sethe and Suggs, who have the audacity to revel in a "thick love."²⁶ The community's vindictiveness facilitates the rebirth of Yemọja.

Beloved walks right "out of the water,"²⁷ and similar to other Water Gods who sojourn on land,²⁸ Beloved craves water, her signifying force. Her physical thirst is nearly unquenchable, but her desire to enter the womb of bottomless Motherlove that she knows awaits her is literally all-consuming. The passion Beloved feels is reciprocal, for as soon as Sethe sees Beloved, Sethe experiences a symbolic breaking of water, as if in celebration of her daughter's return. In addition to breaking her mother's water, Beloved breaks down the defenses and breaks into the hearts of everyone lucky enough to feel the weight of her gaze. She forces members of her community to undertake an inner juba and plumb the depths of their souls' chambers, run their fingers through the furrows of the scars and breathe new life and pump fresh

blood into their destinies and awaken the divinity of their identities.

Beloved also undertakes a personal juba of self-love, remembering, and critique, and through her recollections it becomes clear that Yemoja did not just help enslaved Africans survive the Middle Passage; she was there. With a speech pattern punctuated by unspeakable memories of terrorism and oblivion, Beloved describes her journey in the hold of a ship that doubles as a grave for the living:

> All of it is now it is always now there will never be a time when I am not crouching and watching others who are crouching too I am always crouching the man on my face is dead his face is not mine his mouth smells sweet but his eyes are locked some who eat nasty themselves I do not eat[29]

Beloved does not eat for fear of soiling herself; she forgoes food because she, and everyone in that ship, is seeking death. In this living, rolling, pitching tomb lives a host of paradoxical impossibilities: There is not enough water to drink to produce tears; there is not enough room to tremble; the captives are too hungry to eat; and they are too exhausted to summon enough energy to leave their bodies. The Middle Passage leaves Beloved and her fellow captives so destitute that rather than continue the curvilinear journey of life, death, and rebirth, they wish to "die forever."[30] The tragedy is that they cannot die. The Principle of Survival cannot perish, but that is also the ultimate blessing. Yemoja lived many deaths to become Beloved, and despite the hell that water holds, she is drawn to it. Beloved stares at herself in flowing water with a longing that is incomprehensible. After disappearing from 124, Beloved is last seen near a creek with fish for hair[31]—an unmistakable sign that she is re/turning in/to Yemoja.

That the goal of Beloved is to heal a devastated community is implied in the *oríkì* she takes as her name and in the name of the address where the unifications commence: 124 Bluestone Road. The numerological value of 1-2-4 is seven, which is the number of both Yemoja and Ògún. Bluestone signifies the Beloved-Yemoja confluence in both color and characteristics. Bluestone is a paradoxical curative with a toxicity that burns "like hell" when applied to a wound but heals instantly.[32] Beloved-Yemoja and her charged elixirs take many forms. For some, healing comes through the inhalation of the fire of her breath. Others are revivified by the throbbing of her "inside part."[33] Some can decode the blood of the ink and find gorgeously painful pools reflecting the promise of their spirits.

Mother Who Births Worlds of Bone

With the European institutionalization of slavery, profit-driven oppressors turned Yemoja's waters into repositories of broken histories, blasted bodies, and suspended animation. The enslavers' goal was profit, so while death by slave ship was inevitable, it was not desirable economically—at least not until marauders began insuring their "cargo" against loss so that they would profit no matter what. When the motive is not profit but extermination, genocidal maniacs have used Yemoja's waters to attempt to wash away their crimes. When the American Civil War ended, Confederate soldiers took out the shame of defeat on African Americans. As an African American elder recalls: "They used to stand slaves backwards to the river and shoot them off in the river."[34] Oppressors used terrorism by land and by sea to disenfranchise, debilitate, and destroy free Africana peoples. The same elder reveals, "Out at Hillsman's iron works they have shot niggers and chopped their heads off, and stick their heads on poles and throw their bodies in the river. They did everything they could think of."[35]

Perhaps America's racist slaughterers were inspired by the biblical scripture of Judges 12:4–6, which describes the Gileadites killing forty-two thousand Ephraimites at the River Jordan. Edwidge Danticat uses this scripture as the frontispiece of *The Farming of Bones*, her historical novel which details the Dominican massacre of tens of thousands of Haitians in 1937 under the direction of Rafael Trujillo, the Dominican dictator whose *antihaitianismo*, or anti-Haitian, policy constituted his hatred of his African identity magnified, nationalized, and militarized with devastating efficiency. By using the biblical account to contextualize the recent historical slaughter, the reader can better understand the cyclic ethnocentrism that oils the wheels of wickedness. In a twinning that reflects the dynamic syncretism of Haiti and that is evidenced throughout Danticat's novel, the biblical scripture is juxtaposed to the protagonist's dedication to her ultimate confessor: "In confidence to you, Metrès Dlo, Mother of the Rivers." By offering her audience two interpretive lenses, that of the Bible and that of Yemoja, Danticat helps her reader recognize the overt and covert roles that religion often plays in genocide, and she invokes Yemoja so that the God can help her write painful truths and provide the sacred water that can help Haitians heal from atrocities decreed by lesser Gods and orchestrated by their scheming minion.

In the Caribbean Ocean, there is an island named Ayiti; when Columbus stumbled upon it, he called it Hispaniola, and thus the conflicts began. The river that separated Ayiti's Spanish invaders from its

French usurpers is called Dajabón, but it is widely known as Massacre River because of the massacres that occurred there in 1728 and 1937. On the western side of the Massacre, African warriors, from Makandal and the Maroons to Boukman and Jean-Jacques Dessalines, had been fighting for their freedom since 1517. Allied with a Pan-African conglomeration of Warrior-Gods, the Africans defeated the French, British, and Spanish in 1804, and they named their liberated land Haiti.[36]

To turn the first liberated Africana nation in the Western Hemisphere into the poorest nation in the Western Hemisphere; to prevent it from enjoying respect, prosperity, and glory; and to keep it from helping other Africana peoples and nations gain freedom; the European nations mentioned above along with the United States embarked on cyclical campaigns of destabilization against Haiti. With their nation constantly occupied, attacked, and ransacked, many Haitians flocked to the Dominican Republic. The work most readily available—and needed to satisfy the high teas, sweet teeth, and alcoholic lusts of the West—was planting, harvesting, and processing sugar cane. The labor is so brutal that Danticat named her book after it.

The farming of bones is not only dangerous enough to take one's life, but those who die and are no longer subjected to its rigors are considered lucky.[37] Those who survive the farming of bones find themselves forever altered. The book opens with Amabelle's observation that the cane has decorated the contours of her lover's face with "crisscrossed trails of furrowed scars" and that, like other cane workers, his "palms have lost their life-lines to the machetes that cut the cane."[38] But just as the tree whipped onto Sethe's back becomes emblematic of her strength, the cane's attempt to obliterate Sebastien Onius' destiny only adds greater dimension to his intense and anointed character.

Sebastien is Amabelle's savior. Every night he rescues her from the nightmare of her parents drowning in the Dajabón River. Amabelle recalls that before her father enters the river with his wife on his back, he "sprinkles his face with the water, as if to salute the spirit of the river and request her permission to enter"; Amabelle's mother "crosses herself three times."[39] Whether her parents' rituals invoke Yemoja as Metrès Dlo; the BaKongo Water God, Simbi, who is analogous to Yemoja in power, form, function, and fluidity;[40] or the Virgin Mary, neither supplication is enough to save them as they enter the swollen water's fierce current. Sebastien in spirit, in dreams, and in reality claims Amabelle at the moment of her loss, and he gives her the tools and space to re-member her parents' legacy to her destiny.

Sebastien also tries to save Amabelle from voluntary slavery. While the cane has decorated his body with permanent scars, Sebastien realizes Amabelle's soul is being marred. He bids her remove her clothes

because "[y]our clothes cover more than your skin.... You become this uniform they make for you."[41] Her relationship with her Dominican "employers" is a complex one. Amabelle met Valencia at the Massacre River immediately after her parents made the miscalculation that led to their untimely reunification with Yemoja. Apparently oblivious to the loss Amabelle has suffered, Valencia sees the child and asks her to whom she belongs. When Amabelle points to herself, Valencia takes the orphan home with her and acquires a companion to ease her own parental loss and a source of free labor as well.

The fact that Amabelle is free but entwines her life with Valencia's in the same way that a slave is entwined with an oppressor also serves as a metaphor for certain Haitian-Dominican relationships. Despite the facts that both peoples are free and equal and that opportunities for healthful development exist in Haiti, as is apparent in Yves' and Amabelle's success upon their return, many Haitians literally go out of their way to willingly bind themselves to their oppressive neighbors. It is also important to note that although nearly all of the inhabitants of the island of Ayiti boast African blood and identity to varying degrees and that the linguistic influences of French or Spanish offer the clearest indicators of nationality, it is hatred of the African self that fuels island-wide inferiority and superiority complexes.

Historically, many Haitians herald their African ancestry, identity, spiritual systems, and liberators, whereas many Dominicans were indoctrinated to despise their African heritage and phenotypic traits. Leading the cult of self-hatred was Trujillo, whose policies to "lighten up" his nation went from the personal (he would religiously apply make-up to his face in hopes of hiding his Africanity) to the international (using the United States as his model, Trujillo used European immigrants to change the face of his nation through miscegenation).[42] However, the dominance of African genes flows like a river and surfaces in the most surprising places, like Trujillo's face and Valencia's womb. Valencia gives birth to twins, and Rafi (short for Rafael, in honor of the dictator) looks Caucasian, while his sister, Rosalinda, looks African. While marveling at her daughter, Valencia muses to Amabelle: "[W]hat if she's mistaken for one of your people?"[43] The intricacies of Africanity, power, birth, and death are further emphasized by the fact that Rafi appears to have wrapped the umbilical cord around his sister's neck, as if he were beginning the work of his namesake in the womb.

Just as an enslaved person must glean extensive knowledge of her oppressor to survive, Amabelle has vast knowledge of Valencia, from her ancestors to her uterus. By contrast, although Valencia considers herself a friend to Amabelle, and even saves many Haitians during the massacre because she cannot save Amabelle, she does not love or know Amabelle,

and she has neither the need nor the desire to. Sebastien, however, is, to paraphrase Sixo, a friend of Amabelle's mind. He is her confidant and confessor; he loves the topography of her body and the geography of her soul. Amabelle's feelings for him are reciprocal. While the Dominicans punctuate sentences with various Catholic oaths, Amabelle is silent. When Juana asks her if she believes in anything, Amabelle's response is telling: "[A]ll I could think to say was Sebastien."[44]

The waters of the Dajabón represent a storehouse of grief for Amabelle, as they eternally reflect the loss of her parents, but Sebastien offers her a liquid treasure house where timelessness and passion meld to create bliss. Similar to the emerald boxwood sanctuary where Sethe's daughter Denver jubas, whirls, and dreams up worlds,[45] Sebastien presents Amabelle with a prismatic "luminous green fresco," where the curve of time bends endlessly into itself: "[T]he waterfall, Sebastien says, holds on to some memory of the sun that it will not surrender. On the inside of the cave, there is always light, day and night. You who know the cave's secret, for a time, you are also held captive in this prism, this curiosity of nature that makes you want to celebrate yourself in ways that you hope the cave will show you, that the emptiness in your bones will show you, or that the breath in your blood will show you, in ways that you hope your body knows better than yourself."[46] This haven where light and dark, water and land, birth and death coexist is emblematic of both Yemoja's storied underwater empires and the womb. By introducing her to the cave of eternity, Sebastien reveals the depths of Yemoja's comprehensiveness to Amabelle, who can now envision water as a womb where love and life are cyclically reborn as well as the home of her parents. Water itself becomes juba for Amabelle, as it is rich with unfathomable loss and unimaginable passion.

As if to test Amabelle's, Haiti's, and Yemoja's ability to heal and re-member, in 1937 the Dominican Republic decided to rid its side of Ayiti of Haitians, and the primary tools in ethnic cleansing were Yemoja, as manifest in the Massacre River, and parsley. Well-trained, prepared, and organized Dominicans determined who among them was Haitian by forcing people to say "*perejil*," which is Spanish for parsley. When the tongue revealed a French linguistic influence rather than a Spanish one, the Dominicans knew where and how to strike the most efficient death blow. The Dominicans tossed the mangled bodies into the water to wash away the evidence of their crimes. Whether they took lessons from the Bible, Confederate soldiers, or European sailors, the Dominicans were methodical in their attempt to create a Middle Passage of their own, one seasoned with parsley.

Tibon, one of Amabelle's traveling companions, describes how Haitians are forced to jump off a cliff into the sea so that they will be expeditiously disposed of. Those whom the lengthy descent and bone-shattering impact do not kill, Dominican peasants armed with machetes execute: "[S]ome even wading in to look for the spots on the necks where it's best to strike with machetes to cut off heads."[47] With such ruthlessness, the concept of "the farming of bones" takes on new meaning. Perhaps hearing the whispers of Yemoja, who has prepared covert sanctuaries wherever her children reside, Tibon finds a sea cave and waits in a suspended state, similar to Amabelle and Sebastian, until the lynchers have finished gorging themselves on the screams, bodies, and blood of the innocent.

Before the massacre begins, Amabelle ponders parsley's usefulness and finds it to be nearly as important as water. The herb is essential for "our food, our teas, our baths, to cleanse our insides as well as our outsides of old aches and griefs, to shed a passing year's dust as a new one dawned, to wash a new infant's hair for the first time and—along with boiled orange leaves—a corpse's remains one final time."[48] After surviving the five days of hell that became known as the Parsley Massacre, Amabelle returns to her initial musings and arrives at a devastating conclusion: "We used parsley . . . to cleanse our insides as well as our outsides. Perhaps the Generalissimo in some larger order was trying to do the same for his country."[49] The herb that is so abundant as to be commonplace and so useful that it is taken for granted yields its final secret to Amabelle. In the hands of the wicked, anything—a healthful plant, a river, even breast milk—can be used for destruction.

The Gileadites killed forty-two thousand Ephraimites at the Jordan River. The Dominicans killed thirty thousand Haitians. The Dominicans were perhaps attempting to duplicate the actions of their biblical progenitors. Given that estimates of Africana atrocities and accomplishments are routinely minimized, the Dominicans may have matched or surpassed the Gileadites. The massacres share many similarities: both destroyers attacked a defeated or defenseless people; the attackers cut down their victims as they were attempting to return home; the slaughterers used waterways to facilitate the disposal of their victims' bodies; and both Gileadites and Dominicans created shibboleths using flora to determine whom to kill because they were otherwise indistinguishable from their victims. The fact that the original Hebrew translation of shibboleth is "torrent of water" only heightens the ironies and curvilinear nature of the tragedies.[50]

When Amabelle arrives on the Haitian side of the Massacre River, she is irreparably maimed and near death. At this, her lowest point,

her mother, Irelle Pradelle, comes to her in a form that is identical to Yem<u>o</u>ja's:

> In my sleep, I see my mother rising, like the mother spirit of the rivers, above the current that drowned her.
>
> She is wearing a dress of glass, fashioned out of the hardened clarity of the river, and this dress flows like raised dust behind her as she runs towards me and enfolds me in her smoke-light arms. Her face is like mine is now, in fact it is the exact same long, three-different-shades-of-night face, and she is smiling a both-rows-of-teeth revealing smile.[51]

Amabelle's description of her mother is also a powerful recasting of Sethe's rememories of her mother and Beloved's rememories of Sethe. The intertextuality between *Beloved* and *The Farming of Bones* is undergirded by Yem<u>o</u>ja, who leads these mothers and daughters through eternal cycles of living, dying, and rebirth repeatedly with/in one another in their quests for wholeness. Sethe's mother names her after a man she loved, one "she put her arms around."[52] Even though she has no idea the fate her child will meet, she protects and ensures her child's life. She aborts the other pregnancies, refusing to bring the products of rape, humiliation, and devastation into the world for the benefit of a racist enslaver. Expanding her mother's example, Sethe loves Halle and nurtures and protects the products of that love with a fierceness reserved for the Gods. Sethe's protection of Beloved results in a literary rebirth of Yem<u>o</u>ja. In the same way, the sweeping loss of Amabelle's mother and father coupled with a genocide only self-hatred could conceive and enact ushers the pathway for another literary rebirth of Yem<u>o</u>ja, through Irelle, who is the sugar woman, who, like water, is always present and symbolizes eternity.

Yem<u>o</u>ja did not merely supply the skills to survive atrocities or provide the creative urge to ensure longevity; she crossed the Massacre River with a mangled body and demolished mind. She is Odette, who floated in the Dajabón with *pési* on her perfect lips, defying the mandate of a coward.[53] She is Tibon, who shape-shifted from bird to fish in his bid to survive and who spent his last breath fighting against *perejil*. Before drifting in the Massacre River, Yem<u>o</u>ja lived through the fetid hell of the Middle Passage. She survived a voyage horrific enough to make her reconsider her own principle of survival. What gave her the determination to live is the promise that peers into these pages. When Beloved reenacts crouching in the hold of the ship in perfect misery, the only thing that can inspire her to live is "Over there. Her face."[54]

When Sethe is not near, Beloved can be found staring into water, seeing through the horrors of the Passage through to her mother's face. In seeing Sethe's face, Beloved is seeing not only her own visage; she is also seeing Sethe's mother's face as well as that of the masked Gèlèdé-dancing sugar woman, Irelle Pradelle, and Amabelle. Indeed, speaking in third person and sounding very much like Yemoja or Sethe, Irelle Pradelle assures her daughter, "Your mother was never as far from you as you supposed. . . . And how can you have ever doubted my love? You my eternity."[55]

Amabelle reveals that "[b]irths and deaths were my parents' work";[56] as such, her parents are emissaries of Yemoja who dedicate their lives to ensure that the wheel of continuity continues spinning. Irelle Pradelle and Antoine Désir appear to focus their efforts on ushering the unborn into existence, whereas, other than welcoming Valencia's twins into the world, Amabelle's work concerns ensuring that the "dead" do not die. She needs neither paper and pen nor *oríkì* and *ìtàn* to ensure her ancestors' immortality: Yemoja is her repository of eternity. Yemoja Akúààrà is the Mother "Whose Abode the Dead Frequent," and she resides where the river and the sea meet.[57] The watery crossroads where the Massacre meets the Ethiopic becomes Amabelle's home, her next of kin, her afterlife: "Heaven—my heaven—is the veil of water that stands between my parents and me. To step across it and then come out is what makes me alive."[58] Amabelle does not step across the veil; she becomes that misty shroud. Amabelle enters the water and joins Yemoja Akúààrà. Together the two of them continue the eternal work of uniting those who have been forgotten with those who wish to forget.

What would the world be like if so many Africans had not been unceremoniously slaughtered and casually tossed away? How much more beautiful would our countenances be? How much richer our melanin? Would the ratio of men to women be equalized enough for us to perfectly balance our children's equilibria? Would we be a more joyous and less self-conscious people if we had repaid the lynchers, rapists, lobotomists, usurpers, torturers, enslavers, and destroyers blow for blow, stroke for stroke, life for life? And after bathing in the waters of righteous vengeance, would we be capable of showering our children with the soul-deep love that they deserve instead of decorating their tender bodies with welts, gashes, and lacerations from the switches, extension cords, canes, steel toe boots, anything handy, as mentally enslaved parents mete out plantation-style violence on those who are the most vulnerable? Would we respect ourselves more? How would our music sound? How would our nations function? Would our shriveled souls

soak up the rain of redemption and expand to fit our selves? Perhaps the answers to these questions and the ancestors who prompted them wait in dimensions more welcoming than this one. Perhaps those who were forgotten, disrespected, and discarded are rebuilding their lives and constructing covert worlds within the womb that jealous racists guided by infernal and eternal inadequacy cannot destroy.

Yemoja is said to have erected hidden worlds within the Earth's waters, and the African continuum is rich with testimonies and tales of and rituals and remembrances for individuals who have visited or are inhabitants of Yemoja's submerged worlds. In *Of Water and the Spirit*, his aptly titled autobiography, Malidoma Somé reveals that he was required to enter the womb of Mother as part of his Dagara initiation rites. The Dagara wisdom keepers tell the initiates that the sacred pool they will enter has existed "since time immemorial. It protects the doorway to the ancestors. . . . This water is the roof of the world you are going to visit for a while."[59] After entering the sacred lake and maneuvering through water, space, and time, Somé emerges in a shrouded world where Water's soul speaks to his own: "This presence had been pouring information into my heart since I arrived. I had no power to resist or to act on what was going on."[60] When he emerges from his journey, Somé is rocked by "a tremendous longing for what I had seen and experienced under the water. I knew this wholeness and peace was what I deserved, what everyone deserved at every moment of his or her life. Coming back to the cave was like being exiled from my home. My face was wet with tears as my body was with water."[61] Somé experiences the bliss that every fetus enjoys. And everything—from the focused urge of copulation; to the release of sobs; to playing in oceans, ponds, and pools; to Amabelle and Sebastien reveling in their prismatic water cave; to Beloved's eagerly awaited "join"—is our attempt to reconcile ourselves to this world until we can return to the Source.

Somé's experiences are as rich as they are rare: He is able to explore the uterine walls of Yemoja's womb from which life springs and return to share his encounter. His experiences are comparable to those of Simbi's visitors. Simbi is the collective name for BaKongo Water Gods who are siblings of Yemoja. In Haiti, Simbi is said to abduct children while they fetch water and take them to his underwater world: "After a few years he sends them back to the earth, and as a reward for their trouble bestows upon them the gift of clairvoyance."[62] African American rituals also represent an acknowledgment of the hidden worlds of Yemoja and her multitudinous divine emissaries. On the Sea Islands of the southeastern United States, there exists the custom of "paying the water." After the interment of a relative, the survivors toss "a few

coins into the sea, pennies or perhaps a silver half dollar. But 'paying the water' is not exclusively a mortuary ritual. A coin dropped into the sea before a hazardous voyage will ensure a safe return; and sometimes when a fisherman is drowned, his death is attributed to failure to pay the water."[63] Relatives also send gifts to loved ones who are residing with/in Yemoja. In Ntozake Shange's *Sassafrass, Cypress, & Indigo*, after Alfred drowns off the coast of Zanzibar, his wife and daughters "wd toss nickels & food & wine in the sea down the coast / so daddy wd have all he needed to live a good life in the other world."[64]

That Yemoja's waves promise a marriage of perfect immortality and unimaginable ecstasy is described with spiraling intensity in Opal Palmer Adisa's short story "Widow's Walk." The story commences with June-Plum jumping in the ocean to challenge Yemoja and demand the return of her husband, Neville. Yemoja answers June-Plum's challenge with caresses so seductive she confuses Yemoja's embraces with Neville's. Similar to Beloved shining with ecstasy for her mother and leaving Paul D at a loss as to how to interpret an unfettered mother-daughter passion that Western love and sexuality cannot define, June-Plum can only laugh and admit that Yemoja is "mistress indeed, and more powerful than she, June-Plum, could every hope to be."[65] Neville also provides the reader with evidence of the power of the paradox Yemoja promulgates. After he struggles in vain to save both his catch and the boat he decorated in Yemoja's honor, Neville prepares to begin a new life with Yemoja. While he first scolds the God, "Now look ere, ooman, me ave wife a yard. She nah guh understand," when he finally surrenders to her waves he does so with a smile on his face.[66]

June-Plum nearly loses her mind at the thought of losing Neville, and she could have lost everything with her salty consultation. The world weary walk a fine line invoking Yemoja. In *Jambalaya: The Natural Woman's Book of Personal Charms and Practical Rituals*, Luisah Teish encourages worshippers to go to Yemoja's nearest representative and "cry if you need to; let the water pass through you. Sit on the shore and gaze on Her or take a quick dip in the water naked."[67] But Teish warns, "[D]on't linger too long; don't complain too much. Be careful! Yemaya does not wish to see to you in misery and may pull you into Her arms with the undertow and restore you to Her Belly. All over the world there are stories of women who went to see Yemaya, walked into Her Waters, and were never seen again!"[68]

While many joined the Mother voluntarily, and others were specially selected for spiritual instruction, all too many made Yemoja's waters richer by force. She welcomed them, the sixty million and more. And more. And more. There are enough ancestors in the sea to recreate

worlds from Madagascar to Mississippi. The elders in Toni Cade Bambara's short story "Broken Field Running" describe the ancestors as waiting with the Mother in the depths of the ocean. When Miz Surrentine calls, "I know why the Ethiopic is so salty, Lawd," her listeners respond, "Hmmm, we know why the ocean be so salty."[69] The elders continue re-membering the ancestors:

> "They sleep in the deep, sated with salt."
> "How many you suspect? How many?" the call.
> "Many thousands gone," the reply. "Many thousands gone."[70]

In his poem, "Skulls along the River," Quincy Troupe asserts that "home is wherever ancestor bones are."[71] For many, "home" is a river. The freedom song "In the Mississippi River" acknowledges the fact that from Emancipation to after the Civil Rights Movement, when lynching was America's favorite national pastime, innumerable Africana people, "with their hands tied," with their "feet tied," and "with their heads cut off," were tossed into America's bogs, swaps, and rivers, especially the Mississippi River.[72] Henry Dumas' short story "Ark of Bones" reveals the reconstructive efforts being undertaken on behalf of those Africans who were made ancestors before their time and who reside in the Mississippi's muddy bosom.

The prophet of "Ark of Bones" is Headeye, whose name reflects the fact that his eyes are so big and bursting with numinosity that they appear to be larger than his head.[73] His appearance is indicative of divine *orí* (destiny) and *ojú inú* (spiritual vision), making Headeye the perfect guardian of the knowledge and power of the ark. The narrator of the story is Fish-hound, who appears to be an untutored neophyte but who also has spiritual insight. Beyond knowing the best fishing spots, hence his Yemọja-inspired name, Fish-hound is aware that the Mississippi talks and is a spiritual site rich with inexplicable occurrences. While Headeye's spiritual intensity sets him apart from his community, he embraces Fish-hound as a brother and complement—similar to the way that Ògún bonds with Yemọja—and makes it clear that any divine inheritance bequeathed to him is also Fish-hound's because they are both "the people of God."[74]

Headeye, who possesses the "keybone to the culud man," guides his friend to the threshold of eternity where they board the Ark of Bones.[75] Framed by Ezekiel's dry bones prophecy, an excursion to Deadman's Landin, and the remembered moans of a multitude, Headeye prepares Fish-hound to bear witness to a "soulboat" that they have been "called" to board. When Fish-hound goes below deck he witnesses the

work his calling involves: "Bones. I saw bones. They were stacked all the way to the top of the ship. I look around. The underside of the whole ark was nothing but a great bonehouse. I looked and saw crews of black men handlin in them bones. There was a crew of two or three under every cabin around that ark. Why, there must have been a million cabins. They were doin it very carefully, like they were holdin onto babies or something precious."[76] Reclaiming, gathering, and nurturing these bones is such devastating and important work that a member of the crew pauses to holler and release his personal juba of grief, recognition, pain, and promise. As the crew labors, the wizened Africana captain reads from sacred scrolls and calls out numbers that appear to be dates that document when victims were lynched and tossed into the river. As a complement to the captain's tally, "[a]ll along the side of the ark them great black men were haulin up bones from that river."[77] Gently, like Gods making men, the crewmen meticulously arrange and unite bone bits and fragments to form skeletons who once were and will become you and me.

Initially, Fish-hound thinks the ship is a glory boat that will sail him to heaven; later he assumes the ark is Noah's. But the reality of a soulboat manned by muscular African men whose hands are as gentle as a mother's and who labor unceasingly to collect the many millions of ancestors—including those being killed and tossed into bayous, rivers, and streams as I write—is more profound than anything described in the Bible. The most important work in the world occurs on the ark: the painstaking gathering and restoration of Yemoja's progeny, and Fish-hound and Headeye are specially selected to continue this work. The captain tells Headeye, "Son, you are in the house of generations. Every African who lives in America has a part of his soul in this ark. God has called you, and I shall anoint you."[78] Headeye is the keeper of Yemoja's covenant, and his ritual anointing appears to be directly inspired by Ògún, Yemoja's husband who is also the God Weaponry and War. Draped in a dark green shield, Headeye swears to have his bones consecrated, to have his soul planted, and to set his brother free.

Headeye leaves his Mississippi home, and although he does not disclose his itinerary, perhaps he travels to Pittsburg to use his keybone to enter the City of Bones. Solly Two Kings of August Wilson's *Gem of the Ocean* describes the metropolis as "[a] whole city a half mile by a half mile made of bones. All kind of bones. Leg bones. Arm bones. Head bones. It's a beautiful city."[79] The Western concept of death instills no fear in Two Kings: He looks forward to making his transition because when his terrestrial life ends, he will begin a new life and career as a Keeper of the Gate at the City of Bones. But one need not die in any

sense to enter the City of Bones: It exists in cosmic time, a sphere that surfaces in nearly every work that is directed by Yemọja.

Aunt Ester ferries needy individuals to the City of Bones so that they can have their souls washed, and she knows the city intimately: "I seen it. I been there.... My mother live there. I got an aunt and three uncles live down there in that city made of bones."[80] The City of Bones is a soul sanctuary that lies at the heart of the world. Aunt Ester explains that the city's architects "made a kingdom out of nothing. They were the people that didn't make it across the water. They sat down right there. They say, 'Let's make a kingdom. Let's make a city of bones.'"[81] In this city, Yemọja and the sixty million continue the work of healing, elevation, and evolution. Aunt Ester serves as Yemọja's intermediary. A grand elder, who is at least 285 years old, Aunt Ester was enslaved in Africa and chained in the hold of a ship of horrors. Similar to her sixty million kin, Aunt Ester had nothing but her soul power, so she learned how to magnify it exponentially, and she teaches her submerged and terrestrial kin to do the same.

Aunt Ester transforms a bill of sale that an enslaver held to assert he owned her into a boat that transports the lost back to themselves. During Citizen Barlow's journey, which is a literary recasting of Mona/Shola's journey in Haile Gerima's film *Sankofa*, the bill of sale boat becomes a slave ship where Citizen is chained to and surrounded by enslaved Africans who all look like him. Citizen is branded and whipped along with his selves and left to die on the ship. After begging for water, Citizen learns that he must quench his thirst with "the law of the sea": Yemọja's principle of survival that "Life is above all."[82] Aunt Ester reveals to Citizen his destiny: "You got a duty to life. So live, Mr. Citizen! Live!"[83] It is important to note that Citizen is not merely obliged to live; the phrase "duty to life" underscores the fact that his existence is inextricably bound to weighty responsibilities. To manifest his destiny, Citizen cannot simply exist; he must know, show, and shine. Just as we are all Yemọja, so too are we all Citizens. Embracing the principal of survival and finding the waters of life flowing within his being, when Citizen Barlow arrives at the City of Bones, so do we all. When Citizen leaves, he (and we) emerges as a fully privileged and entitled member of a world family that boasts genealogical as well as spiritual completion.

A chronological decade later in August Wilson's century cycle, another gentleman with a weighty name finds himself in the middle of a riddle in Yemọja's world of renewal. Herald Loomis of Wilson's *Joe Turner's Come and Gone* is a man traumatized by having been enslaved after slavery had been officially abolished. In order to survive being held

in bondage to Joe Turner for seven years, Loomis submerged his *asé* deep within his soul. While Turner was not able to steal Loomis' *asé*, Loomis forgot how to access it once he was free. Loomis is a man stalled at the crossroads of negation and actualization. To regain wholeness, Loomis must re-member to himself the divine birthright bequeathed to him by the "Bones People" who reside in his soul.

Loomis reveals his experience with the Bones People after having a violent reaction to the term "Holy Ghost" during a juba ceremony. Loomis' acknowledgment that his penis and testes and the vital fluids therein give him a status that is equal to if not superior to the Christian Holy Ghost acts as a trigger that catapults Loomis into that timeless region that Beloved knows so well. In the spiritual realm, Herald witnesses the curvilinearity of the Divine: "I come to this place . . . to this water that was bigger than the whole world. And I looked out . . . and I seen these bones rise up out the water. Rise up and begin to walk on top of it. [. . .] Walking without sinking down. Walking on top of the water. [. . .] A whole heap of them. They come up out the water and started marching."[84] In his powerful vision, Yemọja's sea is a womb that rebirths, replenishes, and recharges the Earth with her divine offspring. After a wave covers the water-walking Bones People, they are adorned with flesh, and Loomis notices that they are "black. Just like you and me. Ain't no difference."[85] Bynum, the community's two-headed doctor and wisdom keeper, puts a finer point on the identity of the Bones People by stating, "They walking around here now. Mens. Just like you and me. Come right up out the water."[86] Similar to Beloved, who also came out of the water, Bynum speaks in eternal tense, and, by doing so, he reveals that not only are all the characters of the play Bones People—the ancestors returned, the sixty million and more—but so too are all Africana people. Loomis realizes that he is one of these miraculous Bones People, but enslavement, oppression, and ostracism have left him with spiritual osteoporosis, as his legs "won't stand up."[87] In other words, he has lost his spiritual foundation, his *asé*.

Just as the concept of a ghost being more holy than him enrages Loomis, the idea that someone's, anyone else's blood can clean him is ludicrous. The catalyst for Herald's liberation and illumination is his estranged wife, Martha Pentecost, reciting scripture to him and encouraging him to return to Jesus. Herald sees no difference between Jesus Christ and a plantation overseer. When Martha tells him that he needs to be cleansed with Jesus' blood, Herald realizes that the *asé*-charged fluids endowed in him from birth, the fluids that course to and from the womb of Yemọja, provide him with the only salvation, baptism, and cleansing necessary. Herald slashes himself and recovers his *àsẹ*. He

anoints himself in the dynamic power of his own blood and places the most precious sacrifice on the altar of a God too long neglected.

Revolutionary Mother Whose Waves Resurrect the Righteous

In the lush lands of southern Nigeria where rivers and lagoons abound, evidence of Yemoja is ubiquitous, overabundant. But in the Sahelian lands of Mali, Yemoja is manifest as Faro, and she is concentrated in the Niger River, which is carefully harnessed as a means of survival, transportation, communication, and cosmic elevation. Resonant revelations of water's numinosity occur in Souleymane Cissé's film *Yeelen*.[88] In Bambara, *yeelen* means brightness, and light is a prominent force in the film. Using the symbols of the Bambara Komo secret society, the film's introduction reveals, "Heat makes fire and the two worlds (earth and sky) exist through light." The unmentioned but indispensible force that is essential to the existence of the Earth and the sky is water, and in *Yeelen* water is associated with Woman.

The Bambara are renowned for their mastery of spiritual technology, and their savvy is on grand display in *Yeelen*. The protagonist, Nianankoro, wishes to share the sacred wisdom of the Bambara with all humanity so that everyone can benefit. His father, Soma, and his uncle, Bafing, are charged with keeping dominion over sacred knowledge by killing Nianankoro. The film opens with a sunrise on Soma immolating a red cock and galvanizing the *kolonkalanni*, a terribly phallic pylon that is used to find lost things and people and also to punish people. Soma invokes Mari, the God of the Earth, telling her, "To succeed we must betray." He demands his son be revealed, "If he is hiding in the distant bush, burn it. Dry the lakes, bare the trees so I can search them. Break it all and give me Nianankoro." As he speaks, Mari, manifest in the charred remains of a tree, ignites, fueled by the empowered *yeelen* of immolation and Soma's utterances.

In complete contrast to the blazing fury of Soma, Nianankoro is introduced through water and one of Africa's most well-known technologies: a spiritually charged pot of water that gives its gazer the ability to see what is happening in distant regions and eras.[89] The audience stares with Nianankoro into the water as an image of Bafing following a *kolonkalanni* materializes. Using his saliva as a catalyst, Nianankoro charges the water until the image of Bafing gives way to one of Soma looking through the water at his son. In addition to being allied with water, Nianankoro's primary wisdom sharer and protector is his mother. The powers of water and Yemoja are evident in every aspect of Ma

Diarra's being: She wears a royal blue dress and headtie and is seated next to pots which symbolize the womb, the perfect containment of power and the fomenter of existence.

Ma Diarra's source and force are highlighted in a stunning scene. Juxtaposed to Nianankoro fighting for his life while dehydrated and held captive is Ma Diarra stationed in a reed-filled marsh with four calabashes of milk. Ma Diarra anoints herself with milk that cascades over her head and her exposed breasts—breasts that once nursed Nianankoro to ensure his life. Consecrated in the libation of motherhood, Ma Diarra prays: "Goddess of the waters! Hear me, mother of mothers! Hear this helpless mother. Save my son! Keep him from harm!" Ma Diarra's prayers take on additional resonance in the light of the fact that she is emblematic of both mother and Mother with her powers, her ancient frame, and the symbols she harnesses: milk, which is synonymous with motherhood; calabashes, which represent the breasts, the womb, the Earth and the cosmos; and the water of Yemọja.

That Nianankoro is part of Yemọja's ancient cycle of continuity is apparent in his effective and humane use of African technology and the fact that his sperm, like that of Sixo, is guided by the Mother through Atou's silken vagina to the waiting egg embedded in her womb. The milk that Ma Diarra offers to the Mother, and that Nianankoro's Fulani captors initially deny him, will nourish and empower Nianankoro's son, who is Nianankoro returned. Whereas Soma is fueled by fire and is accompanied by flames in nearly every scene, Nianankoro represents balance and discernment, and water flows freely around and through him, directing and leading him.

In Dogon country, he and Atou purify themselves at the sacred Bongo spring, which is remarkably similar to the prismatic waterfall where Sebastien and Amabelle seal their union. The spring could also be the source of the pond of eternity into which Somé dove to meet Yemọja's emissary. The Dogon wisdom keepers reveal, "This spring existed even before the Biandagara mountain. It is bottomless . . . inexhaustible. We have other ways to get water. [. . .] We light the sacred pipe, pray to the fire spirit. Its smoke rises to heaven. When we need water, we call on the sky god . . . and earth god. Their force swirls up to the sky. It turns into clouds that gather. A hot wind rises before falling on us as rain." Nianankoro asks, "Will those who come after you know [how] to make rain?" The elder responds, "Science is inexhaustible, miracles eternal."

As evidence of the curvilinear existence of science, miracles, and divinity, *Yeelen* is a recasting of a Bambara origin text that details the creation of the world. The Creator Mangala placed twin embryos into the womb of life. Pemba stole his sister Faro's placenta in an attempt

to obtain and control all of Mangala's power. Pemba's theft resulted in the chaos, confusion, and imbalance of the world, and Faro became a multiplied force of order, unity, and balance whose emissaries are stationed along the Niger River—from Onitsha to Niamey, from Timbuktu to Tembakounda—to help humans establish harmonious existences.[90] Twins Djigui and Soma continue the curvilinear cycle that reveals such binary oppositions as good/evil and life/death to be inherently united. Nianankoro and Soma, like Djigui and his father, continue the cycle of destruction/creation so that the world can renew itself. Indeed, the battle between Soma and Nianankoro ends with them being returned to their embryonic states and awaiting rebirth.

Yeelen gives ample evidence of the power of curvilinear time and its role in recycling ancient properties. Just as Yemọja is a truly Pan-African God whose water and fish serve as powerful symbolic elements that are inseparable from Mande and Dogon cosmology and ontology, and just as her powers flow throughout the Continent and the world, the technological prowess of the Bambara and Dogon that Nianankoro harnesses effectively and seeks to share with the world actually did suffuse the globe. Ironically, the Middle Passage was the primary vehicle of transmission of such powers as invisibility, human flight, shape shifting, water gazing, walking on water, and suspending animation.[91] That dislocated warriors and technologists used these skills and tools to free themselves and others underscores the veracity of Djigui's prophecy that "[a]ll upheavals are full of hope" and the Dogon elder's revelation, "Science is inexhaustible, miracles eternal."

The fluidity and potency of African science, technology, and Gods are exhibited in Zeinabu irene Davis' short film, *Mother of the River*.[92] The audience is introduced to Mother of the River through the figure of the wetland-loving crane through which she shifts shapes. Mother of the River's human image is first seen on a wanted bulletin that floats in a river. The bulletin offers a ten-thousand-dollar reward for a "[r]unaway slave known to entice other slaves to run"—even her vocation is analogous to Yemọja and the flow of water. When Mother of the River introduces herself to Dofimae, the child retorts, "Water ain't got no Mama." The elder informs her that "[e]verything on this here earth has a Mama," an elemental truth easily forgotten in a patriarchal society.

Similar to Nianankoro, Mother of the River has an arsenal of spiritual technologies. She can fly, disappear, and reappear as she wishes, and she has charged eggs that can be used to blind attackers; in the latter a recasting of the eggs and "brightness" of *Yeelen* is apparent. Mother of the River can also project Dofimae into a world of peace and end-

less Motherlove by simply brushing Dofimae's temple. While Dofimae risks her life to bring her elder food and medicine, Mother of the River does not need help from Dofimae. She is there to educate the child. Despite the daily doses of self-hatred she receives, Dofimae has what the Yoruba call *ilutí*: She is fit to walk with, listen to, and learn from her elders. Mother of the River, true to her title, washes from the child the stain and stigma of racism projected inward and introduces Dofimae to boundless power, familial unity, and the inexhaustible science to which she is an heir.

Mother of the River also teaches Dofimae knowledge of self. Through religious terrorism and the intentional misinterpretation of biblical fables, Africana people are taught to view themselves as cursed reprobates and their powers as "evil" or "black magic." Africana liberators are also described as violent, evil, and savage. A true product of miseducation, Dofimae asks if the "very special people" Mother of the River is going to meet are "like the evil spirits massa says lives in the woods." Mother of the River responds by replacing terroristic fairy tales with profiles in liberation featuring "Sister Nanny, Dessalines, and Ganga Zumba." These African heroes who led wars for liberation in Jamaica, Haiti, and Brazil, respectively, may be as unknown to Davis' audience as they are to Dofimae. Mother of the River mentions these revolutionaries so that viewers can run, like the river, to the library and learn about Africana abolitionists.

As evidence of Dofimae's acceptance into the circle of liberated liberators and her future obligations therein, Mother of the River gives her a cache of eggs emblazoned with Komo-like symbols and filled with *yeelen*. The film's climax is a study in reciprocity as Mother of the River flies to save Dofimae from being whipped and Dofimae uses her slingshot to shoot the eggs of blinding *yeelen* at the oppressors to save her mentor. Mother of the River liberates Dofimae's mind from racist propaganda and teaches her the value of African technology and wisdom. But the tools Mother of the River gives are also given to Davis' audience. The filmmaker's goal is to ensure that true freedom, along with wisdom, knowledge, and understanding, runs like the river throughout a parched Africana community. Davis, like the other artists under study, is not creating art for its own sake or for financial gain; she is creating art for life's sake, and life begins with the Mother of the River.

That Mother of the River is a cinematic manifestation of Yemọja, who carries eggs emblazoned with Bambara symbols, and who is preparing to meet Queen Nanny, Ganga Zumba, and Jean-Jacques Dessalines reveals the pangeographic multidimensionality that Yemọja inspires and

that is central to the Africana ethos. Carlos Diegues continues the Pan-African discourse on divine diversity with the cinematic epic *Quilombo*.[93] The film offers a lush portrait of the autonomous militarized communities, known as *quilombos*, of Palmares that were founded by liberated Africans in Brazil around 1600 CE. In *Quilombo*, Yoruba Gods S̱àngó and Ògún are revivified in Ganga Zumba and Zumbi, respectively, and the force of Mother Yem̱oja abounds in Acotirene.

Every nation that supported slavery was also home to sanctuaries of liberation. These Maroon communities, which are also known as *quilombos, cumbes,* and *palenques,* are fortified oases of freedom. Established logically and strategically in dense forests, "dismal" swamps, and foreboding hills, these enclaves are the perfect homes for a manifestation of Yem̱oja known as Ògùntẹ̀, who lives deep in the forest and "carries the knife and other tools of Ògún on a chain around her waist."[94] Like Queen Nanny, Acotirene was an historical leader who governed the autonomous liberated nation of Palmares. In *Quilombo*, Acotirene is depicted as a reticent hoary-headed Ìyánlá who is adorned in blue and white clothing and bathed in blue light. A cinematic sister of *Yeelen's* Ma Diarra, Acotirene exudes power, and, like Yem̱oja Māyẹ́'lé'wo,[95] she is associated with pots, which are symbolic of the womb and existence as well as the Earth and terrestrial re-creation. The sheer volume of the pots that surround her indicate that Acotirene is Yewájo̱bí: the keeper of the lives of all members of Palmares.

Acotirene's role in the life of Ganga Zumba is similar to that of Ma Diarra vis-à-vis Nianankoro: She prepares him to embrace his destiny and divinity as the next leader of Palmares. The coronation of Ganga Zumba is marked by the pouring of libation in the original way—not with gin or rum but—with Yem̱oja: An earthen floor is drenched with calabashes of water, and boys, who bear the seeds of life, splash in the water and create ẹrẹ̀, mud. All members of the community, who are all clothed in blue, join the boys, and everyone ritually ties himself and herself to the land, water, and ancestors. The communal libation ensures the society's continuity and proliferation, as Onílẹ̀ (the Mother of the Earth) plus Yem̱oja equals life, fertility, and abundance. Having consecrated a new generation of warriors, Acotirene disappears from the throne of pots. She is next seen in the forest suffused in mist; she has become Yem̱oja Māyẹ́'lé'wo, the elder who "lives in forest springs," "promotes the fertility of the forest," and "is associated with the ọ̀tùn, pot of cool water, that sits on the shrines of initiates."[96]

Acotirene is not central to the action of *Quilombo*, but that she is the force that empowers the autonomous nation is undeniable. From the singing of her *oríkì*

> Come, Acotirene, lady of the secret
> Priestess that calls Ganga Zumba,
> Offering you the throne of plenty
> .
> Springs and more springs
> Pots and more pots

to the revelation of the truth of her prophecy regarding Ganga Zumba's heart growing soft, Acotirene is Palmares' soul. Even the scope of Ganga Zumba's miscalculation is measured by the symbols of Acotirene and Yemoja: "All pots break / All hopes scatter / All graces shatter." The film's final depiction of Acotirene occurs when she meets with Zumbi in the dream state of cosmic time. Acotirene lounges on a beach, surrounded by pots, and looking as if she has just surfaced after a lengthy consultation under the sea with Yemoja. She tells her son all he needs to know: "Palmares is eternal. Palmares will never end . . . Never!" In the next shot the pots that surrounded Acotirene are being lapped by a gentle wave. The mother has rejoined the Mother. The veracity of Acotirene's prophecy is evident in the fact that Palmares *is* eternal and so too are the quilombos of Jamaica, Surinam, Mexico and many other lands. As long as the womb gives life, as long as water flows, as long as Ògùntè is in the forest building homes, there will be safe havens in which to raise free Africana children and foment soul-deep Africana love.

Ever-Present Mother Who Re/Turns You In/To Yourself

Haile Gerima's film *Sankofa* masterfully harnesses the transformative power of Africana love, and Yemoja is his conduit. The Mother of Waters is assisted by more than sixty million Bones People who are summoned from Yemoja's womb during the film's opening invocation:

> Spirit of the dead, rise up!
> Lingering spirit of the dead,
> Rise up and possess your bird of passage!
> Those stolen Africans, step out of the ocean
> from the wombs of the ships, and claim your story.[97]

Gerima understands that Yemoja has used the preservative power of salt to store up and shore up divine ancestral power so that it can be summoned from the sea when necessary. And just as African ancestors suffuse the globe, *Sankofa's* ritual invocation summons brothers and

sisters from Surinam, Alabama, Cuba, Mississippi, and Brazil who were tortured, chained, lynched, castrated, tarred and feathered, lobotomized, roasted, and chopped up to rise up and re-member their far-flung bones and fractured spirits and use their holistic wisdom to educate and make whole Africans who have been fooled by the myths of paper freedom and financial gain.

Sankofa seeks to move members of the audience to *sankofa* along with the protagonist, Mona/Shola, and return to the source and reclaim what has been lost. This will mean different things for each person depending upon what has been dismembered from his or her soul and psyche. Mona, like many Africana women, has forgotten the sacredness of her Self, from her vagina to her identity to her sensuality. She writhes on the sands of Cape Coast, Ghana, where her ancestors were slaughtered and enslaved, and is only concerned with fulfilling her photographer's demands, which include: "Do it to the camera!" and "More sex!" Mona is as complicit a force in her subjugation as her enslaved alter ego, Shola, who initially prays for Lafayette to stop raping her instead of slitting his throat.

Africana women are not the only entities who need to *sankofa*. During the film's opening at the Cape Coast factory where Europeans labored to turn human beings into commodities, the Divine Drummer vents his rage on the European tourists who leisurely mill through one of the most devastating edifices in the world:

> What do you want here? Where do you come from? Here is sacred ground, covered with the blood of people who suffered. It is from here that our people were snatched and taken by the white man. Get away from here. Leave this ground. . . . This ground is holy ground. Blood has spilled here before. It was from here that we were bought and sold to America, to Trinidad, to Jamaica. The white man forcefully snatched away our people. It was genocide. They treated us with contempt. They disgraced us, put us to shame. Go back. It is special ground.

The sacred ground confirms, at once, two disparate but, now, eternally connected truths: the irreducibility of Africana divinity and the exacting efficiency of evil.

The castle at Cape Coast is equipped with a convenient ladder that leads from the women's dungeon to the hatch door of the governor's raping room, a wooden sliding board by which female captives were shuttled into a dungeon, and a "Door of No Return" that opens onto

Yemoja's eternally flowing tears and the rage of her waves. The smell of ancient semen, blood, feces, and tears is as pungent and powerful as the salty breezes that wage a constant battle to destroy the castle. A pilgrimage to the Cape Coast castle and the fort of Elmina is enough to make one lose one's mind. Having to endure such grief and pain while coming to terms with one's own inherent numinosity in the midst of oblivious tourists who are killing time and who may well have spent a lifetime profiting off of their ancestors' "industry," which is synonymous with the world's most monumental betrayal of humanity, is sufficient to move the hand to murder. Gerima makes it clear that *everyone*, every ethnic group shown in the film, needs to *sankofa*.

When Mother of the River strokes Dofimae's temple, she projects her into a sphere in which there is no time—only ample space to remember, love, and learn. The Lafayette plantation, the primary setting of *Sankofa*, is also situated in the cosmic time sphere. Just as Beloved recognizes, "All of it is now it is always now" and Sethe knows that, due to the force of rememory, the Sweet Home plantation will always be waiting to enslave her children—even if the whole plantation were razed to the ground—*Sankofa's* Lafayette plantation, replete with its lessons, is ever-existent in a space that could be any of many locales, and it is always waiting.

In *Slavery and Social Death*, Orlando Patterson offers a stunning definition of slavery as "the permanent, violent domination of natally alienated and generally dishonored persons."[98] Patterson would agree with Sethe that the institution and the physical and psychological scars it leaves are indelible. But slavery can indeed be abolished if and when the enslaved overthrow their oppressors and relocate to or create an egalitarian society of people of shared beliefs, traits, and mores. For such a revolution to occur one must first understand the nature of her or his enslavement and be desirous of being free. As is depicted in *Mother of the River*, one of most pernicious agents in ensuring the permanence of mental and physical slavery is religion. In *Sankofa*, Haile Gerima uses Nunu's relationship with her son Joe as the primary vehicle through which to critique Christianity and explore its impact on the Africana psyche.

While Joe is a genetic and phenotypic melding of two ethnically disparate peoples, as his mother is a pure African powerhouse, and his father is a Caucasian rapist, Joe's psychological conflict is the result of Father Raphael indoctrinating him with Christian propaganda in general and myths about the Virgin Mary in particular. Raphael is turning Joe into the perfect slave by turning him against his mother, whom he defines as "the devil," and attempting to replace Nunu with the

Virgin Mary. In addition to destroying his identity, Raphael's myths about the Virgin Mary have the added bonus of denuding Joe of his masculinity. The success of Raphael's experiments is apparent in many scenes, including when Joe attacks and trains his gun on Nunu as she struggles to save Kuta and her unborn child and when, in the midst of having sex with Lucy, Joe pauses to look at a picture of the Virgin Mary and loses his erection. When he sees Lucy touching his Virgin Mary charm, he is so revolted that he attacks her. The fact that Lucy bears a phenotypic resemblance to Nunu is important, as Joe is being trained to hate what is African in himself, his mother, and his people. Similar to Mona learning the power of Patterson's definition of slavery when begging her enslavers, "I'm not an African! Don't you recognize me? . . . I'm an American!" Joe spurns the warm breasts, unwavering devotion, and tender embraces of Nunu and Lucy and seeks comfort in the vacant gaze of a portrait instead.

Nunu is a powerful force of resistance for the enslaved Africans. As the embodiment of Yemoja, she is always active in fighting oppression and urging everyone around her to self-actualize. Nunu is also a manifestation of Queen Nanny. An Akan of royal lineage who boarded a slave ship—probably one docked at the Cape Coast castle—of her own volition, Queen Nanny sailed to Jamaica and used her science and technology to liberate her peoples.[99] As a testament to her valor, Queen Nanny is honored with Yemoja's *oríkì* and called "Mother of Us All." Queen Nanny is so important that she has a town named after her in Jamaica, and she adorns the Jamaican five-hundred-dollar bill. Nunu continues the struggle of Queen Nanny, as she is one of the leaders of *Sankofa's* Maroon secret society, and she is an eternal force ever ready to assist in the liberation of victims of mental slavery.

Yoruba cosmology describes Yemoja Ògùntè as wearing the tools of Ògún on a chain around her waist, and those tools are put to use by Nunu, who brandishes a machete while chanting in Akan to invoke the Gods and community to shield her as she performs a cesarean section on Kuta. Although Kuta has been whipped to death, Nunu directs her efforts to saving the child. Here is the ultimate example of the principle of survival at work. The community could easily allow Kuta to take her child with her, but Kwame must survive these horrors. He is "The Witness": He is the proof and the truth. The birth of Kwame is also symbolic of Mona becoming Shola, as the newborn's screams meld with Mona's as she is stripped, branded, and enslaved.

Kwame is also a powerful symbol of the bond that Joe should enjoy with his mother. Nunu cradles Kwame and sings to him a lullaby

that promises protection, identity, and harmony. These tender moments are intercut with images of Raphael leading Joe through a church and recounting tales about the Virgin Mary. On one hand we have a living, vibrant, full woman who embodies the Source of All Existence—the African Mother. On the other hand we have an image that most human beings are familiar with and taught to revere but whose existence is the result of a desecration of the images of African Gods.

Aset and her divinely conceived son, Heru (also known by the Greek names Isis and Horus, respectively), are African Gods who have been worshipped in Africa, the Mediterranean, and Eurasia for many thousands of years. With the convening of the Nicean Councils in 325 CE, Constantine and his minion began constructing the version of Christianity that they made the official religion of the Roman Empire.[100] To infuse their construction with the luster of supremacy and historicity, they changed the images of African Gods to appear Caucasoid. The image of the African mother Aset nursing her African child Heru was ethnically altered and renamed Mary and Jesus. Friezes of Aset nursing Heru in Egypt have been literally defaced in an attempt to remove evidence of their African features, but the melanin-rich skin tones, indicative of their African identity, remain visible.[101] Despite crude facelifts, political mandates, and attempts at ethnic alteration, many European worshippers remain devoted to Aset and Heru and refuse to alter the ethnicity of these Deities. As a result, Black Madonnas or Black Virgins can be found in Italy, Spain, France, Russia, Sweden, and Czestochowa, Poland, where Pope John Paul II would pray at her shrine.[102] As evidence of the ability re-member identity and reclaim divinity, when enslaved Africans were forced to adopt Catholicism, they hid the Òrìsà behind or inside of the empty figurines of saints, and Yemoja found a perfect hiding place within the Virgin Mary with whom she is still associated in such syncretic religions as Santería, Lucumí, Candomblé, and Umbanda.

Haile Gerima hails from Ethiopia, a nation that boasts the one of the oldest, if not the oldest, Christian legacies in the world. Furthermore, long before the creation of Christianity, the Sicilian historian Diodorus acknowledged Ethiopia as the source of the religion, philosophy, and civilization of Kemet (Ancient Egypt): "The Ethiopians say that the Egyptians are one of their colonies which was brought into Egypt by Osiris. They even allege that this country was originally under water, but that the Nile, dragging much mud as if flowed from Ethiopia, had finally filled it in and made it a part of the continent. . . . They add that from them, as from their authors and ancestors, the Egyptians get

most of their laws. It is from them that the Egyptians have learned to honor kings as gods and bury them with such pomp; sculpture and writing were invented by the Ethiopians."[103] In this resonant explication we find Ethiopians, as guided by the Mother of Waters, providing the building blocks of Kemetic civilization—the spiritual system, philosophy, culture, science, letters, and DNA of the polity. Given his genetic and intellectual provenance, Gerima is the perfect ambassador of truth and image restoration, and *Sankofa* is the perfect didactic tool.

Gerima repeatedly juxtaposes the integrity, beauty, courage, and vitality of Nunu to the static Virgin Mary and a religion that demands vows of celibacy from priests and nuns but allows those same entities to rape individuals, literally and symbolically, and gain forgiveness so easily that they rape again and again. Nunu was only fourteen when she was raped and conceived Joe; her rapist could very well have been "Father" Raphael. Shola, who is raped repeatedly by Lafayette, is also subjected to a symbolic Christian gang rape when Raphael, Lafayette, and Joe string up her naked body, whip her, grind a crucifix into her breast, and force her to swear that she will never worship an African God. The two mothers' differences are also apparent in their resurrections. A scene in which Raphael describes the Virgin Mary as being "raised from the dead, exalted to glory. . . . enshrined and proclaimed, the queen of heaven" is juxtaposed to Nunu's triumphant return to the plantation. Because no one would buy her, she is free to delve even deeper into the work of liberation and revolution. This is Nunu's first resurrection, and it is symbolic of her being as vital a force as water in her community. She cannot float up to a heaven of eternal idleness and obliviousness with so much work to do and to undo.

Nunu's liberating work takes many paths, as she also critiques the false concepts of masculinity that lead so many Africana men to adopt thug lives and oppressor-approved stations in niggerdom when their true inheritance is much deeper, richer, and more complex. Noble Ali, whose whipping ushers Kuta to the doorway of death, tells Nunu he can no longer stand the thought of killing his own people to please an oppressor. Noble is unsure how to liberate himself, so Nunu simplifies the issue for him: "You can pull yourself up and say, 'No.' The choice is either to be a true man or a beast." Noble customizes Nunu's advice, reaches into his soul, and emerges with the tools of Èṣù, a revolutionary trickster.

Nunu also teaches Noble Ali that tenderness is perhaps a man's most admirable virtue. She ties Kwame to his back, as African mothers carry their children. This is a powerful scene that underscores the importance of the "harmonious dualism" between genders that Cheikh Anta

Diop finds is the cornerstone of traditional African matriarchy.[104] Nunu, and through her, Gerima, is also calling into question the logicality and source of the gender roles that many take for granted. The image of a man "backing" a child may seem ludicrous from the perspective of the socialized African male, but it is important to acknowledge that the God Sàngó is often depicted with ample breasts; that male priests of Ọsun braid their hair in the God's "feminine" styles; that male Gèlèdé dancers don elaborate dresses, breasts plates, and masks to pay homage to Yemọja; and that male priests of Òkè, the Hill God of Ibadan, dress "like women, with plaited hair, fake breasts."[105] For a man to back a child is a logical and natural extension of these ritual manifestations. Equally logical and natural are female Gods who crush assumed gender boundaries: Ọya is "[t]he wife who is fiercer than the husband";[106] Yemọja is "the goddess with the longest beard."[107] When Nunu picks up her machete, Gods of both genders and boasting a wide array of characteristics direct her aim.

The significance of the Yoruba confirmation that one has the right to adopt a new name to fit a new environment is apparent in *Sankofa*, as many characters bear two names. The names appear to signify both the characters' ideal African identities and the identities of dislocation. "Nunu" signifies an Akan stool of royalty,[108] and Nunu's sacred birth name is "Afriyie," which means "Special: One Who Is Born to See." Through her names, Nunu-Afriyie's ascension to divinity is presaged. However, Nunu's biggest challenge is transforming her son and helping him to embrace to his African identity. Although he has sunken into the anonymity of "Joe," his Akan name, "Tumey," means power and authority.[109] By naming him Tumey, Nunu employs the power of pun and inquires, "Why has this child been given *to me*?" while simultaneously crowning her son with the power to usher her into divinity.

That Joe is the personification of paradox is evident in the fact that his act of matricide leads to his full self-actualization. When Nunu rips the Virgin Mary medallion off of Joe's neck, Joe avenges his idol by smothering and drowning his mother. But rather than end Nunu's life, Joe's act unites Nunu with Yemọja, literally, and solidifies, for eternity, Nunu's divinity. Yoruba mythistory reveals that Ọya's response to seeing Sàngó's body dangling from the Ìrókò tree was to use Òrò, Power of the Word, to supplant death with deification. Joe follows Ọya's path. He manifests the power and authority of his African identity by placing Nunu on the church's altar, praying to her, and enshrining her. With Joe's effective use of Òrò, Afriyie, the true Queen of the Heaven and Earth and "Mother of us All" joins Yemọja and countless other Mothers in the realm of the Eternal Immortals.

Mother Whose Breast Is a Bridge

Nunu is a powerful depiction of an always already Mother Yemọja, and she has a cinematic and spiritual sister in Nana Peazant, the matriarch of Julie Dash's film *Daughters of the Dust*.[110] *Daughters of the Dust* is set on Ibo Landing in the American Sea Islands and features the Gullah peoples who, isolated on the islands, retained their African linguistic, cultural, and spiritual systems in manners more obvious than their mainland kin. Because of the island locale, it is logical that Yemọja would exert profound force on the lives of the Gullah, and the film begins with a mélange of scenes that alert the viewer to the Mother's influence.

The first image of Nana Peazant finds her at one with Yemọja. Fully clothed in an indigo dress, Nana kneels in the water at dawn and enacts a timeless ritual of spiritual cleansing and renewal that reminds her body and spirit of seventy percent of its force and source. Images of Nana Peazant shift to those of Bilal Muhammad who kneels before the expansive body of Yemọja, faces Mecca, and prays. In addition to being a recipient and transmitter of prayers, Yemọja is also a central mode of transportation: One can only reach Ibo Landing via water taxi, and Eula uses water as a vehicle to transmit her request for advice to her deceased mother. Eula's mother appears to her in a dream and, like Acotirene did Zumbi, provides her with needed counsel. Water also provides the truest of mirrors for the island women. Myown goes to a placid lake to admire her visage and is delighted to find Yemọja smiling back at her. Yellow Mary reveals that she never looks upon her reflection in muddy water, an act that may well muddy her destiny. She views the Yemọja in her with as much clarity as possible.

Daughters of the Dust also provides resonant evidence that the water-based rituals of continental Africa enjoy continuity and ubiquity in the Ìtànkálẹ̀. Melville Herskovits finds, "In ceremony after ceremony witnessed among the Yoruba, the Ashanti, and in Dahomey, one invariable element was a visit to the river or some other body of 'living' water, such as the ocean, for the purpose of obtaining the liquid indispensable for the rites. Often it was necessary to go some distance to reach the particular stream from which water having the necessary sacred quality must be drawn."[111] The significance of living water in the African continuum is evident in Eula's missive to her mother, in which the water is further vivified with wildflowers. But living water is no mere passive conduit; as the descriptive implies, and as science reveals, water is alive. Water is also Divine, and she acts and interacts with her human vessels. Herskovits and Alfred Métraux find that when Yemọja or one of her divine progeny slips from sea to shore, her human host cries for water

continuously until reunited with the Source.[112] In other cases, as Toyin Falola reveals in *A Mouth Sweeter than Salt*, the verbal recognition that Water has arrived is libation enough.[113] The visitation of Yemọja and her godly progeny in *Daughters of the Dust* occurs during a ring game. As seven young women play beside the living body of the ocean, their clapping and sashaying morph into a juba that becomes an intricately choreographed arrival of the Òrìsà. Yemọja and her daughters, Òsun, Faro, Simbi, Omi, Oya, and Olókun, simply rise from the water, inhabit the young ladies, greet one another, and juba.

African American Baptists would recognize these visitations as "getting the spirit," which causes the host to shout in ecstasy, spin, and dance, among other things. But the African American Baptist ritual that is most emblematic of Yemọja is the most obvious: baptism. While many African American Baptists do all they can to disassociate themselves from Africa, their insistence on full-immersion baptism, especially that which occurs in a living body of water while the participants are fully dressed, betrays a passionate reverence of Yemọja and reveals baptism to be the offspring of the ancient water-based rituals of Nana Peazant and Ma Diarra.

Daughters of the Dust also features the lauded bottle tree, which gave birth to the popular southern American custom of placing a plastic bag of water over an entrance or porch or carport. While the bag of water is supposed to keep flies away, the water is often dressed with ingredients and objects that insects cannot appreciate, such as a squirt of dish detergent or salt for purification, honey or sugar to sweeten dispositions, and pennies for prosperity. Perhaps this custom began as a way to gain the overt protection of Yemọja but disguise it with the myth of insecticide. Both bottle trees and water bags are technological devices that the Yoruba call *ààlè*: They are used to protect and to deter theft. Bluing is another obvious symbol of Yemọja, and a pot of bluing adorns her shrines.[114] The Peazant family porches, window sills, and graves are dusted with bluing to obtain Yemọja's protection and to keep the Peazants connected to the sea and its Source. Dusting with bluing may well be the progenitor of the African American custom of painting parts of one's home "haint blue" to harness the protection of Yemọja, impart calm, and keep harmful spirits at bay.

Displaced ancestors' spiritual unification with Yemọja is also expressed in the sea shells that adorn many southern African American graves. As Bessie Jones reveals, "The shells stand for the sea. The sea brought us, the sea shall take us back. So the shells upon our graves stand for water, the means of glory and the land of demise."[115] Objects symbolic of water and water itself was so important to displaced African American ancestors that they customarily erected cemeteries near bodies

of water: "The belief is that the soul of the departed will follow the water to the sea, and eventually to Africa."[116] Being buried near water is largely a neo-African custom born of Africans re-membering being trafficked overseas and losing millions of kin during the passage. More than any other element, water provides a tangible link to Africa and the multitudinousness thereof.[117]

Julie Dash, cognizant of the destruction of African culture and cultural signifiers on the Sea Islands, uses *Daughters of the Dust* to document the customs even as they are being bulldozed, forgotten, and stolen. Even the setting of the film, on the eve of the Peazant family's migration to the mainland, reflects the fact that one of the primary reasons Africana culture has been maligned and discredited is because of people like Viola and Haagar who nurture a rigorous hatred of their African heritage, science, technology, and culture.

An important but ignored fact is that Africans were exported throughout the world because of their mastery of technological, industrial, agricultural, and architectural skills. One example of such skills being harnessed by oppressors is the primary occupation of the enslaved Peazants: indigo cultivation and processing. The Peazant's African ancestors may have been Yoruba indigo manufacturers whose work and lives were overseen by Yemọja whose home is Ibú Aró: "Deep place of Indigo dye."[118] Nana Peazant is always adorned in Yemọja's signature indigo blue. The Unborn Child wears the white of the ancestors and a blue ribbon signifying a tie to Yemọja. The force of Yemọja even springs through the ultraconservative and hyperchristianized Viola, whose navy blue-accented clothes signify an unconscious yet unbreakable bond with Yemọja. In honor of her birth and its relationship to emancipation in 1863, Viola's parents carved her a white bassinette with deep blue trim that is a celebration of Yemọja's gift and guidance. Indeed, the only person to say the God's name in the film is Viola.

Yemọja is central to *Daughters of the Dust*. Nana Peazant needs Yemọja to help her bond her family before they migrate to the mainland; she also needs Yemọja to help her convince her great grandson Eli that the child his wife is carrying is indeed his. Although Nana Peazant tells him that any child sent to him by the Old Souls is his, Eli cannot bear the thought that his wife has been violated and might be carrying the product of rape. Eli is determined to discover and destroy the man who raped his wife. His desire is the normal justifiable response to such a violation. The problem is that in 1902, the United States of America denied human and civil rights to its Africana citizens. If Eli had found and punished the rapist, he—and most likely the entire Peazant family—would have been lynched.

Nana Peazant encourages Eli to apply the discernment of the ancestors, and she counsels him to re-member the cycle of life that connects him and his unborn child to their ancestors. But Eli stalls at the crossroads. He is a God trapped in a land that will only allow him the status of a "nigger." The son of Ògún seeks solace in his smithy and forge, but the God of Iron is not allowed to use his weaponry. Eli's rage leads him to the bottle tree outside of his forge. Bottle trees protect families, crops, and property, but for Eli the bottle tree stands as a reminder of the inability of his ancestors, Gods, and technology to protect his family. He destroys the bottle tree and inadvertently releases his unborn daughter's spirit. As is the case with *Beloved* and *Sankofa*, in *Daughters of the Dust*, destruction is actually a gateway for healing and rebirth. Eli's Ògún-directed anger, once soothed by Yemoja, literally gives birth to the soul of understanding.

From the iron anklets men wear when dancing the Gèlèdé to Sethe's handsaw, from Zumbi's bond with Acotirene to Nunu dancing with a machete, Ògún and Yemoja share a dynamic relationship that encompasses the elemental, spiritual, political, marital, and martial. One would think that the Òrìsà of Iron would keep a safe distance from the Mother of Waters lest he rust and disintegrate, but African spiritual systems are rooted in biological and cosmological facts as well as harmonization of extremes. Yemoja and Ògún's harmonic balance is evident in human blood, as water and iron are melded perfectly therein. The power in the blood is a microcosmic reflection of that which structured and sustains the Earth. As Awo Fa'lokun Fatunmbi reveals in *Ìwa-pèlé: Ifá Quest*:

> We see the passion for pro-creation symbolized on the altars of *Ogun*. *Onile* is the female aspect of *Ogun*. She is the womb of the Earth and *Yemoja* is her vaginal fluid. *Onile* is represented on *Ogun's* altar by an iron pot. The pot is trimmed by a metal chain and a red strip of cloth. It is a symbol of the primal womb bleeding at birth as it passes the grain of genetic memory. The pot is sprinkled with *irosun*. The *irosun* is a red powder that comes from the camwood tree. In Yoruba *irosun* means . . . "menstrual blood". Inside the pot is the *Ifá* symbol for androgynous procreation. *Ogun's* instinct for survival pushed ocean creatures toward the surface of the water, led them on to land and eventually sent them flying through the air.[119]

With a directive that is identical to Yemoja's, Ògún's pot is "an image of life giving birth to itself in spite of incalculable odds against success,"

and, together, these Gods represent "the instinct for survival and the urge for reproduction."[120] In addition to their being essential elemental, biological, and scientific forces in the creation of the Earth and its life forms, Yemọja and Ògún came to Earth to ensure the quality of life through balance, justice, and harmony.

When they were married, Ògún and Yemọja shared wisdom and weaponry. One of Yemọja's roads—Ògùntẹ̀, who laid down the Ògún River—makes clear her inextricable bond with Ògún. The couple's connections are also evident in the Ifá spiritual system. The aptly named figure Ògúndá in sixteen cowries divination represents Yemọja, and in one Ògúndá's divination verses we find Ògúndá and Ìròsùn, "the child of the king" and "the first born of the king," respectively, together at the shrine of Ògún, killing corrupt officials who were assassinating innocent people. Through Ògúndá and Ìròsùn, Ògún and Yemọja ensure life, righteousness, and integrity, as they establish a system of justice that includes trials to ensure the protection of human rights and human life.[121]

In the "land of the free" Africans were not allowed to enjoy the justice promised in the American Constitution or that established by Ògúndá and Ìròsùn. In the "home of the brave," Africans were not permitted to love and protect one another. In *Beloved*, Halle lost his mind as he watched his wife be raped of her breast milk; by contrast, Paul D, Stamp Paid, and Ella smother their ability to love, hoping that, without love, watching their relatives be repeatedly defiled and violated will not destroy them. In her autobiography, *From the Mississippi Delta*, Endesha Ida Mae Holland describes how Mr. Matthews fought to keep his wife from being raped and was beaten, drenched in sulfuric acid, and left to die a horrific death for his efforts.[122] Love can be a fatal force for the oppressed. In this era, internally fragmented Africana parents beat their children to the doorway of death and decorate their children's psyches with nicknames like "ho," "ugly," and "nigger" in a pathetic attempt to prepare them for a world of racist hatred that they do not have the courage or intellect to make safe. Many more individuals simply turn tail and walk away, as the institution of slavery and its equally destructive twin mental slavery have taught them to completely disregard and dismiss the divine lives they help usher into being.

Eli, Eula, Nana Peazant, and the Unborn Child are all allied in the effort to ensure the disaster that has befallen so many Africana families does not destroy them. Similar to the character Beloved and to Kwame in *Sankofa*, the Unborn Child represents survival despite all odds, and she is the progeny of Ògún and Yemọja. She knows well her history and destiny, and as she interacts with her ancestors on the land upon

which she will stroll one day, she reveals, "We were the children of those who *chose* to survive." The child's emphasis on choice is important. The sentiment expressed in Haiti, "*Ibos pend' cor' a yo*—the Ibos hang themselves,"[123] makes it clear that enslaved Africans knew that there was another world, which Sethe refers to as the "other side," where one could seek refuge and acquire the skills, weapons, and strategies necessary to enable a more successful return. While some Africans chose to sojourn in the spiritual realm, others fought in the eras in which they were born. The Peazant family is a melding of the Ibo who walked back to Africa and those who stayed on Ibo Landing. They are Yoruba, Bambara, BaKongo, and many other ethnic groups. Some Peazants have undiluted melanin; some are the products of rape. The existence of Peazants, with their diversity, dynamism, and vicissitudes, is a testament to the fact that with the Principal of Survival as one's foundation, one can endure the insurmountable and do the impossible with ease.

Yemoja may be most beautifully manifest as the force that supported the Ibo when they walked on water back to Africa in the 1800s. As evidence of her eternal support, Yemoja buoys Eli as she did his Ibo kin. While Eula recounts the landing of *The Wanderer* and the disembarkation of the Ibo on the island, Eli walks on water to the middle of the inlet where he kneels to embrace the wooden African figurehead that resides eternally at the watery crossroads. By the end of Eula's soliloquy Eli is on his knees before her, embracing her and their unborn child.

The figurehead that Eli commiserates with is a stunning symbol that represents the paradox of dislocated Africans' identities and histories. Dash recalls encountering the figurehead at an art gallery, although it had originally been stationed on the bow of a slave ship:

> It struck me as an awful joke, the idea that the people who built the slave ship decided to make the figurehead into an African warrior. And the vibes coming off of this thing were incredible, full of death. I just could not believe it. . . . [W]hen you see the thing carved out and you know that the slaves boarding the ship saw their own representation of themselves, tied up on the thing, it was just awful. So I was going to have a figurehead, broken off of a slave ship, floating throughout the swamps, rotting symbolic of the African warrior in the New World. This thing is forever floating and just rotting.[124]

Forever at the crossroads, the figurehead joins Amabelle as an emissary of Yemoja Akúààrà, who is found where the river and the sea meet and

"is stationed there to assist travelers as they journey from one world to the next."[125] The drifting Amabelle symbolizes inertia as a result of immeasurable loss. The floating figurehead represents either an eternity of emasculation or the eternal restoration of masculine dynamism. In his quest to determine which existence to embrace, Eli journeys through the crossroads—through time, space, gravitational laws, and impossibilities—and with African technology as his ally, he asks the embodiment of paradox to help him determine his destiny. This scene is also a testament to the conflict resolution that Yemọja inspires: She teaches Eli how to win a war without taking up a weapon.

The resolution of the conflicts created by exile, slavery, racism, rape, and other forms of terrorism is central to *Daughters of the Dust*. Nana Peazant is the salve and glue who employs the methodology of Yemọja to cool the fires of self-hatred, jealousy, and inadequacy and unify her family. Her role as resolver of conflicts is beautifully articulated in her relationship with Eli—which also underscores how effective a complement Yemọja is to Ògún. It is also important to note Yemọja's powers of discernment and flexibility, for the tools she uses to soothe the torn souls of Joe in *Sankofa* and Yellow Mary of *Daughters of the Dust*, both of whom struggle with intracommunal color conflict as they are the products of unanswered outrage, befit the specific temperaments of Joe and Yellow Mary and the spiritual-political objectives of the films.

Both Yellow Mary and Joe of *Sankofa* wear on their necks charms of Catholic saints. When Nana asks Yellow Mary about her St. Christopher medallion, and Yellow Mary says the charm protects her, Nana is disappointed, but, unlike Nunu, she does not rip off the charm and throw it away. She joins her third eye to Yellow Mary's—touching forehead to forehead, *ojú inú* to *ojú inú*—to reinvigorate in Yellow Mary the ancestral wisdom and protection that is their shared inheritance. The conflict over Joe's Virgin Mary charm, which results in Joe killing Nunu, is essential for Nunu to become an eternal immortal and to force Gerima's audience to acknowledge important truths about religion. As befits her objective in *Daughters of the Dust*, Julie Dash resolves conflicts with religious syncretism, experiential truths, and silence.

One of the most resonant examples of Yemọja-cool conflict resolution occurs when Bilal describes for Mr. Sneed what he witnessed on Ibo Landing: "I come here on a ship called *The Wanderer*. I come with the Ibo. Some say the Ibo fly back home to Africa. Some say they all join hand and walk on top the water. But, mister, I was there. Those Ibo men, women, and children, a hundred or more, shackled in iron. When they go down in that water they ain't never come up. Ain't nobody can walk on water." Eli, a descendant of the Ibo and son of Yemọja who walks

on water prior to Bilal's testimony, says nothing. His response and facial expression are markedly similar to those of Nana Peazant when she confers with Yellow Mary about her Catholic charm. Dash's audience is faced with a conundrum: acknowledge the facts presented by Eli, or believe Bilal's firsthand account. Similarly, when, at the end of *Sankofa*, Mona sees Nunu in the present era at the ritual ceremony at Cape Coast, the audience is issued a challenge: reconcile the Western concepts of "death" and the "past" to the fact of Nunu's eternal curvilinear existence.

The conflict most difficult to reconcile in *Daughters of the Dust* is the one that is the least logical but the most pervasive. Many of the Peazants are preoccupied with the Western dichotomy that classifies women as being either righteous or "ruint." Given what Africana women were forced to survive under the institutions of slavery and neoslavery, such divisions are ludicrous. To illustrate the atrocities endured, in a voiceover, Nana Peazant discusses how during slavery an oppressor might sell a son away from his mother and years later buy the son back and force him to mate with his own mother or his sister. Yellow Mary remarks that "raping a colored woman is as common as the fish in the sea." Given what Africana people in general and Africana women in particular have suffered, and considering the unknown horrors and humiliations one's own mother may have suffered for the sake of her progeny, calling Africana women "bitches" and "hos" should be unheard of; and yet, the opposite is true.

In this era, it is commonplace to hear justifications and arbitrary distinctions made whereby certain women are dismissed as "whores" while others are embraced as "queens." Many Peazants would categorize Yellow Mary as the former and Eula as the latter. Eula challenges this dichotomy and queries her relatives: "If you're so shamed of Yellow Mary cause she got ruint, what you say about me? I'm ruint too?" While the community members are engineered to sympathize with Eula and shun Yellow Mary, they cannot distinguish between the women any more than they can favor their right over their left thighs because Eula and Yellow Mary are the same. And this Everywoman, this Yemoja, is all of them—men included. Eula tells her family: "If you love yourselves, then love Yellow Mary. She a part of you just like we a part of our mothers."

While Ibo Landing appears to be an idyllic isle of love, quaint familial conflicts, and soul food, its citizens are violently oppressed. The need for an antilynching law is brought up repeatedly in the film, and Yellow Mary supports Eula's decision not to reveal the rapist's identity because "[t]here's enough uncertainty in life without wondering what tree your husband is hanging from." It is important to note that the orchestrators of violence and destruction are nowhere to be found. Simi-

lar to Joe Turner of August Wilson's play, a Caucasian destroyer came to Ibo Landing and left tragedy in his wake. In addition to acknowledging the powers of these Africana individuals and communities to survive the unimaginable, through the power of absence Dash draws her viewers' attention to the fact that the sole contributing factor in the supposed ruination of the Africana woman is the Caucasian defiler.

The conditions surrounding Yellow Mary's ruination are similar to Sethe's violation. After the abolition of slavery, the nexus of racial, sexual, and economic exploitation expanded and placed the Africana woman in the position of being both the most readily employable and the most vulnerable. After their child is stillborn, Yellow Mary and her partner agree that she should work as a domestic servant for a Caucasian family. Without the protection of her partner, Yellow Mary goes to Cuba with the family, who rapes her of her breast milk. Because they refuse to release a source of cheap labor who also provides free sustenance to their child, Yellow Mary "fixe[s]" her breasts so that they stop producing milk. What the fixing entails is unknown, but one can be sure Yemọja Māyẹ'lé'wo, with her knowledge of medicine, guides her hand.[126] What is known is that racism and the lust for the Africana woman's body—for forced sex and forced sustenance—ruin Yellow Mary. While we are not privy to his story, when Yellow Mary is ruined, so is her partner, who like Eli and Halle is not allowed to provide for and protect his family.

Yellow Mary and Sethe are victims, along with countless Africana women, of a horrific crime that is routinely overlooked: the raping of Africana women of their breast milk. Often, the image of the Africana woman forced to nurse infant oppressors is glossed over as quaint and harmless. But this image and the term it conjures, "Mammy," demand investigation. As Alice Walker reveals in "Giving the Party: Aunt Jemima, Mammy, and the Goddess," the slur "mammy" appears to be both a contraction of the word "mammary" and a mispronunciation of the word "mammae."[127] Both "mammary" and "mammae" signify breasts; consequently, "mammy" is the metonymic reduction of an entire woman to her mammary glands for the luxury, pleasure, and literal and figurative nourishment of racists and racism at the expense of the mother's own child. To be forced to ensure the existence of someone who will most likely grow up to rape you or your child and/or sell you or your child is, as Sethe, Yellow Mary, Nunu, and Yemọja can attest, unconscionable.

All over Africa one can find bronze, brass, stone, wood, and divine human examples of mothers providing their children with what knowledgeable pediatricians call "liquid gold." When one compares Western nations that penalize women for having vaginas that produce children, for being pregnant, and for nursing their children with the very best

sustenance available—in some cases kicking out of establishments women who are breastfeeding—to African nations where motherhood is *literally* celebrated and mothers feel free "backing" their children anywhere—including to work—and breastfeeding their children anywhere, openly, and with a glorious lack of self-consciousness, it is clear that the African depiction of Ast nursing Heru is a reflection of a societal norm: There are *living* shrines of Black Madonnas all over Africa and in liberated Pan-Africa. As Sethe can testify, Mother does indeed have milk for all, and, unless she is making a voluntary donation, Mother's sacred milk is for her cherished children. Period.

Yellow Mary does not share her plight with her community in hopes of earning respect or understanding. She wears the myth of ruination as a badge of honor. More than giving Viola and Haagar an easy target to revile, Yellow Mary seems to be showing them the holistic truth of Woman. As Viola and Haagar try to determine if there is a rung low enough on their hierarchical ladder of womanhood to accommodate Yellow Mary, Haagar's daughters have determined that Yellow Mary is "a new kinda oman" who renders Western categorizations obsolete. Yellow Mary is also that most ancient of women. Although her imagery and persona seem to indicate the influence of Òsun, Julie Dash reveals in her commentary to the film that Yellow Mary's Òrìsà is, in fact, Yemoja.

Yellow Mary, who can make herself a home wherever she lands, will not be denied Ibo Landing. This is not the case for Trula. Critics have described Trula and Yellow Mary as being friends-in-ruin and/or lovers. However, in the film's opening scenes, Yellow Mary is sailing to the island via river taxi by herself. When the taxi picks up Mr. Sneed and Viola, Trula is seated next to Yellow Mary, but they neither speak to nor look at one another.[128] Although Yellow Mary does not introduce Trula to Mr. Sneed and Viola or even acknowledge her, without saying a word, Trula introduces herself to Mr. Sneed with a smile that is lit with the delight only a "ruint" woman can promise. The smirk Trula offers Viola, who remarks that Mary is not as "light skinned" as some other people, is a reaction only a person tempered by a lifetime of insults about their lack of melanin could serve. These scenes and behaviors complicate the Trula character and wrap her in multiple layers of meaning, secrets, and possibilities.

When they reach the Peazant family home, Yellow Mary, Trula, and Eula form a trio of ruination, rumination, and inner jubilation. However, Trula says very little in the film, and while she interacts with the family, her communication is limited. Although Nana Peazant tells Yellow Mary that nothing she does can surprise her, Yellow Mary never mentions Trula to her elder, and Trula is never in immediate proxim-

ity to Nana. Trula seems to be, like the figurehead, an intentionally ambiguous character who, drifting on the periphery, represents everything—friend, lover, symbol of ruin—and nothing at all.

In her present-absence Trula is also suggestive of Beloved, who was last seen naked with fish in her hair and heading toward water. It is as if Beloved dove into the Ohio, headed south through the Kanawha and New Rivers, trekked through western North Carolina until she reached the Catawba, and continued swimming through South Carolina's Wateree and Cooper Rivers until she reached the Sea Islands and Ibo Landing. While she lost her "thunderblack" melanin during her journey, she is still thirsting for her Source. Before the mass exodus, Nana Peazant enacts a ritual bonding. In the BaKongo way, Nana ties her family with the Old Souls, Christianity, and African Gods and powers, and nearly everyone steps up voluntarily to be bound, but Trula runs away. Nothing prevents Trula from participating in the ritual. Nothing stops her from staying on Ibo Landing with Yellow Mary. Perhaps Trula does not desire a sprawling family rich with heritage, conflict, and intra- and inter-connections; perhaps she wants either all of Yellow Mary, in the way of Beloved yearning to "join" with Sethe, or nothing.

While Trula leaves with the migrating Peazants, her presence and absence remain charged with mystery. Is she Yemoja's daughter Òsun come to pay her terrestrial daughters a visit? Does she represent the shame, eternal dislocation, and sadness that hide in the corner of every Africana person's soul? Trula is truly a strolling paradox. She is the embodiment of the film's opening poem, and she is the container that holds the love, hate, jealousy, ugliness, beauty, rage, and shame of Yemoja's dislocated daughters searching for a home. Yellow Mary has her home where she can scream, dream, plant roots, sink into the moss, and see her beauty reflected in clear waters. Trula, like the river, continues moving both day and night.

La Agua Continua

A pool of still water perfectly reflects the brilliance of the sun and moon and its terrestrial surroundings. While it recasts the images of all, the pool shields its own mysteries and gives no indication of its depth or hidden whirls and worlds. Africans of the Ìtànkálẹ̀ are not unlike those still pools: While they may take on the names and attributes of their contemporary environments, the power of Yemoja is a constant force surging within them. Yemoja's terrestrial source is in West Africa, but it may be the case that those who understand her whorls, dimensions,

and depths best are the millions of Africans who were dragged through her watery womb to build new worlds—on the Earth and in the sea. Those dismembered, disremembered, discredited, lost/found Africans do not curse the womb or the waves; they are focused on the arduous work of re-membering.

Yemọja and her progeny use film, shells, ink, bottles, and bones to heal, reunite, and reconnect a lost and seeking people to the divinity and immortality bequeathed them. But Mother's water is perhaps the most effective documentarian, historian, secret sharer, and covenant keeper. As Toni Morrison reveals in "The Site of Memory," the consciousness and re-membering power of water is tremendous: "You know, they straightened out the Mississippi River in places, to make room for houses and livable acreage. Occasionally the river floods these places. 'Floods' is the word they use, but in fact it is not flooding; it is remembering. Remembering where it used to be. All water has a perfect memory and is forever trying to get back to where it was."[129] Morrison's assessment is also true of the water that comprises our beings. Our turbulent struggles, glorious triumphs, submerged pride, and salty outrage are all manifestations of Yemọja's majesty. Just as water morphs from liquid to solid to gas, so too do the flexible among us grow into and expand our concepts of Self. No matter how far we journey, no matter the transformations we experience, no matter the names we adopt, we are ever re/turning in/to the Source of eternity that surges within. Yemọja is the Sea of Immortality, and "the sea never dies."[130] Every sip, splash, and bath is a juba that re-members all of us once again to the Mother of All. Comprising seventy percent of our bodies, Yemọja is the divinosphere within. She makes Ntozake Shange's edict of finding God in yourself and loving her fiercely both effortless and inevitable.[131]

Notes

I dedicate this work to my Mother and my Daughter.

1. Babatunde Lawal, *The Gẹlẹdẹ́ Spectacle: Art, Gender, and Social Harmony in an African Culture* (Seattle: University of Washington Press, 1996), 39.
2. Awo Fa'lokun Fatunmbi, *Ìwà-Pẹ̀lẹ́: Ifá Quest: The Search for the Source of Santería and Lucumí* (Bronx: Original, 1991), 124.
3. C. L. Adeoye, *Ìgbàgbọ́ àti Ẹ̀sìn Yorùbá* (Lagos: Evans Brothers, 1985), 220.
4. Ibid., 220–22.
5. John Mason, *Orin Òrìṣà: Songs for Selected Heads* (New York: Yoruba Theological Archministry, 1992), 308.

6. Olabiyi Babalola Yai, "In Praise of Metonymy: The Concepts of 'Tradition' and 'Creativity' in the Transmission of Yoruba Artistry over Time and Space," *Research in African Literatures* 24, no. 4 (Winter, 1993): 30.

7. Ibid.

8. Ibid.

9. Ibid., 36.

10. August Wilson, "Preface," *King Hedley II* (New York: Theatre Communications Group, 2000), x.

11. Toni Morrison dedicates *Beloved* to the "*Sixty Million / and more*" Africans who did not survive the Middle Passage. El Hajj Malik El Shabazz estimates the number of those tossed in the ocean to be closer to one hundred million. Malcolm X and Alex Haley, *The Autobiography of Malcolm X*, 1964 (New York: Ballantine, 1992), 44.

12. Mason, *Orin Òrìṣà*, 308.

13. Ibid.

14. *Mother of the River*, directed by Zeinabu irene Davis (1995; New York: Women Make Movies, 1995), DVD.

15. Aseret Sin, "Mo Juba," *Estrella Mountain Community College Literary Review Magazine* (1998–1999): 1–2.

16. Babatunde Lawal, *The Gẹ̀lẹ̀dẹ́ Spectacle*, 39–40.

17. Fatunmbi, *Ìwa-Pẹ̀lẹ́: Ifá Quest*, 159.

18. Teresa N. Washington, *Our Mothers, Our Powers, Our Texts: Manifestations of Àjẹ́ in Africana Literature* (Bloomington: Indiana University Press, 2005), 34.

19. Lawal, *The Gẹ̀lẹ̀dẹ́ Spectacle*, 45 plate 3.2.

20. Morrison, *Beloved*, 208.

21. Ibid., 25.

22. Ibid., 272–73.

23. Ibid., 226.

24. Ibid., 227.

25. Ibid., 87–89.

26. Ibid., 157, 164.

27. Ibid., 50.

28. Alfred Métraux describes a woman ridden by the Water God Simbi repeatedly crying "water, water" until she finds and dives head first into her element. Alfred Métraux, *Voodoo in Haiti*, trans. Hugo Charteris, 1959 (New York: Schocken, 1972), 105.

29. Morrison, *Beloved*, 210.

30. Ibid.

31. Ibid., 267.

32. Washington, *Our Mothers, Our Powers, Our Texts*, 227.

33. Morrison, *Beloved*, 116–17.

34. "Massa's Slave Son," in *The American Slave: The Unwritten History of Slavery*, ed. George P. Rawick, vol. 18 (Westport: Greenwood, 1972), 81.

35. Ibid, 84.

36. Laurent Dubois, *Avengers of the New World: The Story of the Haitian Revolution* (Cambridge: Harvard University Press, 2004), 300–01.

37. Edwidge Danticat, *The Farming of Bones* (New York: Penguin, 1998), 55.

38. Ibid., 1, 143.

39. Ibid., 51.

40. Métraux, 105–06.

41. Danticat, 2.

42. "Haiti and the Dominican Republic: A Nation Divided," *Black in Latin America*, directed by Henry Louis Gates, Jr. (2011; New York: PBS, 2011), DVD, and Allen Wells, *Tropical Zion: General Trujillo, FDR, and the Jews of Sosúa* (Durham, NC: Duke University Press, 2009), 24.

43. Danticat, 12.

44. Ibid., 65.

45. Morrison, *Beloved*, 28–29.

46. Danticat, 100.

47. Ibid., 175.

48. Ibid., 62.

49. Ibid., 203.

50. "Shibboleth," *The American Heritage Dictionary of the English Language*, third edition (New York: Houghton Mifflin, 1992), 1664.

51. Danticat, 207–208.

52. Morrison, *Beloved*, 62.

53. Danticat, 202–03.

54. Morrison, *Beloved*, 124.

55. Danticat, 208.

56. Ibid., 5.

57. Mason, 311.

58. Ibid., 264–65.

59. Malidoma Somé, *Of Water and the Spirit* (New York: Penguin Compass, 1994), 254.

60. Ibid., 256.

61. Ibid.

62. Métraux, 105–06.

63. Quoted in Roberta Hughes Wright and Wilbur B. Hughes, III, *Lay Down Body: Living History in African American Cemeteries* (Detroit: Visible Ink, 1996), 104–05.

64. Ntozake Shange, *Sassafrass, Cypress & Indigo* (New York: Picador, 1982), 108. For a detailed analysis of the influence of Yemoja in Shange's novel, see Washington, *Our Mothers, Our Powers, Our Texts*, 141–64.

65. Opal Palmer Adisa, "Widow's Walk," in *Bake-Face and Other Guava Stories* (Berkeley: Kelsey Street, 1986), 95.

66. Ibid., 115.

67. Luisah Teish, *Jambalaya: The Natural Woman's Book of Personal Charms and Practical Rituals* (San Francisco: Harper and Row, 1985), 133.

68. Teish, 133.

69. Toni Cade Bambara, "Broken Field Running," in *The Sea Birds Are Still Alive* (New York: Vintage, 1977), 56.

70. Ibid.

71. Quincy Troupe, "Skulls along the River," in *Transcircularities: New and Selected Poems* (Minneapolis: Coffee House, 2002), 108.

72. Freedom Singers, "In the Mississippi River," in *Voices of the Civil Rights Movement Black American Freedom Songs 1960–1966* (Smithsonian Folkways Recordings, 1997).

73. Henry Dumas, "Ark of Bones," in *Echo Tree: The Collected Short Fiction of Henry Dumas*, ed. Eugene B. Redmond (Minneapolis: Coffee House, 2003), 9.

74. Ibid., 11.

75. Ibid.

76. Ibid., 18.

77. Ibid.

78. Ibid., 20.

79. August Wilson, *Gem of the Ocean* (New York: Theatre Communications Group, 2006), 56.

80. Ibid., 52.

81. Ibid., 52–53.

82. Ibid., 68.

83. Ibid.

84. August Wilson, *Joe Turner's Come and Gone* (New York: Plume 1988), 53.

85. Ibid., 54.

86. Ibid., 56.

87. Ibid.

88. *Yeelen*, directed by Souleymane Cissé (1987; New York: Kino, 2002), DVD.

89. Teresa N. Washington, "Nickels in the Nation Sack: Continuity in Africana Spiritual Technologies," *Journal of Pan-African Studies*. Special Issue: *Black Spirituality* 3, no. 5 (March, 2010): 21–22, <http://www.jpanafrican.com/docs/vol3no5/3.5-2newNickelsintheNation.pdf> accessed March 9, 2012.

90. See Aguibou Y. Yansane, "Cultural, Political, and Economic Universals in West Africa," in *African Culture: The Rhythms of Unity*, eds. M. K. Asante and K. W. Asante (Trenton: Africa World Press, 1985), 58. For the Dogon creation texts see Marcel Griaule and Germaine Dieterlen, *The Pale Fox*, trans. Stephen C. Infantino, 1965 (Chino Valley, AZ: Continuum, 1986).

91. See Georgia Writers' Project's, *Drums and Shadows: Survival Studies among the Georgia Costal Negroes* (Athens: University of Georgia Press, 1940).

92. *Mother of the River*, directed by Zeinabu irene Davis (1995; New York: Women Make Movies, 1995), DVD.

93. *Quilombo*, directed by Carlos Diegues (1984; New York: New Yorker Films, 2005), DVD.

94. Mason, *Orin Òrìṣà*, 309–10.

95. Ibid., 310.
96. Ibid.
97. *Sankofa*, directed and written by Haile Gerima (1993; Washington, D.C.: Mypheduh Films, 2000), VHS.
98. Orlando Patterson, *Slavery and Social Death: A Comparative Study* (Cambridge: Harvard University Press, 1982), 13.
99. Karla Gottlieb, *The Mother of Us All: A History of Queen Nanny Leader of the Windward Jamaican Maroons* (Trenton: African World, 2000), 69–70.
100. Anthony T. Browder, *Nile Valley Contributions to Civilization: Exploding the Myths*, vol. 1 (Washington, D.C. Institute of Karmic Guidance, 1992), 68.
101. Field Research in Egypt, 2003.
102. Browder, *Nile Valley Contributions to Civilization*, 97, 190 and "Black Madonnas, "Christian Mystery Schools, Cults, Heresies," *Encyclopedia of the Unusual and Unexplained* <http://www.unexplainedstuff.com/Religious-Phenomena/Christian-Mystery-Schools-Cults-Heresies-Black-madonna.html> accessed 03 April 2012.
103. Quoted in Browder, *Nile Valley Contributions to Civilization*, 139.
104. Cheikh Anta Diop, *The Cultural Unity of Black Africa*, 1959 (Chicago: Third World, 1963), 120.
105. Toyin Falola, *A Mouth Sweeter than Salt: An African Memoir* (Ann Arbor: University of Michigan Press, 2005), 226.
106. William Bascom, *Sixteen Cowries: Yoruba Divination from Africa to the New World* (Bloomington: Indiana University Press, 1980), 45, 459.
107. Falola, 233.
108. "Ga Naming Pattern," Ghanaweb.com <http://www.ghanaweb.com/GhanaHomePage/tribes/ga_names.php> accessed 31 May 2012.
109. "Kasahorow—Dictionary of Modern Akan," <http://abibitumikasa.com/all.html> 31 May 2012.
110. *Daughters of the Dust*, directed by Julie Dash (1991; New York: Kino, 2000), DVD.
111. Melvin J. Herskovits, *The Myth of the Negro Past* (Boston: Beacon, 1958), 232–33.
112. Herskovits, 234; Métraux, 105.
113. Falola, 231.
114. Mason, 311.
115. Quoted in Robert Farris Thompson, *Flash of the Spirit: African and Afro-American Art and Philosophy* (New York: Vintage, 1983), 135.
116. "Midland Cemetery: Aspects of African American Burial Traditions at Midland," AfrolumensProject.com, http://www.afrolumens.org/rising_free/midland2.html, accessed July 15, 2011.
117. Being interred in immediate proximity to Yemoja posed no problem until the middle and late 1900s when developers began to covet "waterfront property," on the Sea Islands in particular, for real estate purposes. The lust for "location, location, location" has resulted in an attack on Africana communities

and cemeteries that continues today. See Hughes Wright and Hughes, *Lay Down Body*, 41, 64–66.

118. Mason, 311.

119. Fatunmbi, *Ìwa-Pèlé: Ifá Quest*, 124 (emphasis and diacritics are retained from the original).

120. Ibid., 124.

121. Bascom, *Sixteen Cowries*, 483–89.

122. Endesha Ida Mae Holland, *From the Mississippi Delta* (Chicago: Lawrence Hill, 1997), 37.

123. Herskovits, 36.

124. Julie Dash and Houston A. Baker, Jr., "Not Without My Daughters," *Transition*, no. 57 (1992): 165.

125. Mason, 311.

126. Ibid., 310.

127. Alice Walker, "Giving the Party: Aunt Jemima, Mammy and the Goddess," in *Anything We Love Can Be Saved: A Writer's Activism* (New York: Ballantine, 1997), 138.

128. In the director's commentary of the deluxe edition of *Daughters of the Dust*, Dash clarifies many issues that the film raises, including the intended nature of the relationship between Yellow Mary and Trula; however, the way the film is edited—especially with Yellow Mary initially shown arriving alone—a very resonant and powerful ambiguity continues to surround these and other issues.

129. Toni Morrison, "The Site of Memory," in *Inventing the Truth: The Art and Craft of Memoir*, ed. William Zinsser (Boston: Houghton Mifflin, 1987), 119.

130. Ben Okri, *Songs of Enchantment* (New York: Nana A. Talese, 1993), 191.

131. Ntozake Shange, *for colored girls who have considered suicide/when the rainbow is enuf: a choreopoem*, in *Totem Voices: Plays from the Black World Repertory*, ed. Paul Carter Harrison (New York: Grove Press, 1989), 274.

References

Adeoye, C. L. *Ìgbàgbó àti Èsìn Yorùbá*. Lagos: Evans Brothers, 1985.

Adisa, Opal Palmer. *Bake-Face and Other Guava Stories*. Berkeley: Kelsey Street, 1986.

Bambara, Toni Cade. "Broken Field Running." In *The Sea Birds Are Still Alive*. New York: Vintage, 1977. 43–70.

Bascom, William. *Sixteen Cowries: Yoruba Divination from Africa to the New World*. Bloomington: Indiana University Press, 1980.

Browder, Anthony T. *Nile Valley Contributions to Civilization: Exploding the Myths*. Volume 1. Washington, D.C. Institute of Karmic Guidance, 1992.

Danticat, Edwidge. *The Farming of Bones*. New York: Penguin 1998.

Dash, Julie, and Houston A. Baker, Jr. "Not Without My Daughters." *Transition* 57 (1992): 150–166.

Daughters of the Dust. Directed by Julie Dash. 1991. New York: Kino, 2000. DVD.

Diop, Cheikh Anta. *The Cultural Unity of Black Africa.* 1959. Chicago: Third World, 1963.

Dubois, Laurent. *Avengers of the New World: The Story of the Haitian Revolution.* Cambridge: Harvard University Press, 2004.

Dumas, Henry. "The Ark of Bones." In *Echo Tree: The Collected Short Fiction of Henry Dumas,* edited by Eugene B. Redmond. Minneapolis: Coffee House, 2003. 9–22.

Fa'lokun Fatunmbi, Awo. *Ìwa-Pèlé: Ifá Quest: The Search for the Source of Santería and Lucumí.* Bronx: Original, 1991.

Falola, Toyin. *A Mouth Sweeter Than Salt: An African Memoir.* Ann Arbor: University of Michigan Press, 2005.

Freedom Singers. "In The Mississippi River." In *Voices of the Civil Rights Movement Black American Freedom Songs 1960–1966.* Smithsonian Folkways Recordings, 1997.

Georgia Writers' Project. *Drums and Shadows: Survival Studies among the Georgia Costal Negroes.* Athens: University of Georgia Press, 1940.

Gottlieb, Karla. *The Mother of Us All: A History of Queen Nanny Leader of the Windward Jamaican Maroons.* Trenton: African World, 2000.

Griaule, Marcel and Germaine Dieterlen, *The Pale Fox.* 1965. Translated by Stephen C. Infantino. Chino Valley, AZ: Continuum, 1986.

"Haiti and the Dominican Republic: A Nation Divided." *Black in Latin America.* Directed by. Henry Louis Gates, Jr. 2011. New York: PBS, 2011. DVD.

Herskovits, Melvin J. *The Myth of the Negro Past.* Boston: Beacon, 1958.

Holland, Endesha Ida Mae. *From the Mississippi Delta.* Chicago: Lawrence Hill, 1997.

Lawal, Babatunde. *The Gèlèdé Spectacle: Art, Gender, and Social Harmony in an African Culture.* Seattle: University of Washington Press, 1996.

Mason, John. *Orin Òrìṣà: Songs for Selected Heads.* New York: Yoruba Theological Archministry, 1992.

"Massa's Slave Son." In *The American Slave: The Unwritten History of Slavery,* edited by George P. Rawick. Volume 18. Westport: Greenwood, 1972.

Métraux, Alfred. *Voodoo in Haiti.* 1959. Translated by Hugo Charteris. New York: Schocken, 1972.

"Midland Cemetery: Aspects of African American Burial Traditions at Midland." AfrolumensProject.com, http://www.afrolumens.org/rising_free/midland2.html.

Morrison, Toni "The Site of Memory." In *Inventing the Truth: The Art and Craft of Memoir,* edited by William Zinsser. Boston: Houghton Mifflin, 1987. 183–200.

———. *Beloved.* New York: Plume, 1988.

Mother of the River. Directed by Zeinabu irene Davis. 1995. New York: Women Make Movies, 1995. VHS.

Okri, Ben. *Songs of Enchantment.* New York: Nana A. Talese, 1993.

Patterson, Orlando. *Slavery and Social Death: A Comparative Study.* Cambridge: Harvard University Press, 1982.
Quilombo. Directed by Carlos Diegues. 1984. New York: New Yorker Films, 2004. DVD.
Reed, Ishmael. "Henry Dumas: The Poet of Resurrection." *Black American Literature Forum: Henry Dumas Issue* 22, no. 2 (Summer, 1988): 337.
Sankofa. Directed by Haile Gerima, 1993. Washington, D.C.: Mypheduh Films, 2000. VHS.
Shange, Ntozake. *for colored girls who have considered suicide/when the rainbow is enuf: a choreopoem.* In *Totem Voices: Plays from the Black World Repertory*, edited by Paul Carter Harrison. New York: Grove, 1989. 225–274.
———. *Sassafrass, Cypress & Indigo.* New York: Picador, 1982.
Sin, Aseret. "Mo Juba." *Estrella Mountain Community College Literary Review Magazine* (1998-1999): 1–2.
Somé, Malidoma. *Of Water and the Spirit.* New York: Penguin Compass, 1994.
Teish, Luisah. *Jambalaya: The Natural Woman's Book of Personal Charms and Practical Rituals.* San Francisco: Harper and Row, 1985.
Thompson, Robert Farris. *Flash of the Spirit: African and Afro-American Art and Philosophy.* New York: Vintage, 1983.
Troupe, Quincy. *Transcircularities: New and Selected Poems.* Minneapolis: Coffee House, 2002.
Walker, Alice. "Giving the Party: Aunt Jemima, Mammy and the Goddess." In *Anything We Love Can Be Saved: A Writer's Activism.* New York: Ballantine, 1997. 137–143.
Washington, Teresa N. *Our Mothers, Our Powers, Our Texts: Manifestations of Àjẹ́ in Africana Literature.* Bloomington: Indiana University Press, 2005.
———. "Nickels in the Nation Sack: Continuity in Africana Spiritual Technologies," *Journal of Pan-African Studies.* Special Issue: *Black Spirituality.* 3, no. 5 (March, 2010): 5–28. http://www.jpanafrican.com/docs/vol3no5/3.5-2newNickelsintheNation.pdf.
Wells, Allen. *Tropical Zion: General Trujillo, FDR, and the Jews of Sosúa.* Durham, NC: Duke University Press, 2009.
Wilson, August. *Joe Turner's Come and Gone.* New York: Plume 1988.
———. "Preface," *King Hedley II.* New York: Theatre Communications Group, 2000.
———. *Gem of the Ocean.* New York: Theatre Communications Group, 2006.
X, Malcolm and Alex Haley. *The Autobiography of Malcolm X.* 1964. New York: Ballantine, 1992.
Yai, Olabiyi Babalola. "In Praise of Metonymy: The Concepts of 'Tradition' and Creativity' in the Transmission of Yoruba Artistry over Time and Space." *Research in African Literatures* 24, no. 4 (Winter, 1993): 29–37.
Yansane, Aguibou Y. "Cultural, Political, and Economic Universals in West Africa." In *African Culture: The Rhythms of Unity*, edited by M. K. Asante and K. W. Asante. Trenton: Africa World Press, 1985. 39–70.
Yeelen. Directed by Souleymane Cissé, 1987. New York: Kino, 2002. DVD.

Chapter 10

A Sonic Portrait with Photos of Salvador's Iemanjá Festival

Jamie N. Davidson and Nelson Eubanks

This is a multimedia work. To engage it, please log on to http://www.bluethroatproductions.com/iemanja/.

Here in Bahia, they say that the shimmering trail of moonlight reflecting off the Bay of All Saints is the hair of Iemanjá. We find her represented in the form of a mermaid and also as something more akin to the Catholic saints: a *morena* with sensuous locks, a light blue robe that miraculously accentuates all the right curves as she hovers above the water, arms relaxed with palms open, adorned with pearls and a starfish crown. In ceremony, we find her veiled by a beaded crown, and bearing a silver *abano* decorated with fishes. She is called Mãe das Águas, Rainha do Mar, Dona Janaína, and Iara among other names. Her sacred choreography resembles the undulating movement of slow roller waves, with a lofty grace at the surface and a deep, knees-bent power to suck you fast below. She is associated with Nossa Senhora da Conceição da Praia, the patron saint of Bahia celebrated on the eighth of December in the Cidade Baixa (Lower City) of Salvador. She is also celebrated with Nossa Senhora dos Navegantes on the second of February in what has become a massive festival falling just between the Lavagem do Bomfim and Carnaval. Throughout Brazil, Iemanjá is honored on New Year's Eve as well—most famously in Rio, but in Bahia too—when the faithful, dressed in white, light candles for her on the beach or toss offerings of flowers into the water and jump over seven waves at the stroke of midnight to ensure good fortune in the new year.

In this city of sound, an important port of entry for understanding contemporary manifestations of and for Iemanjá are the waves of

sound that reverberate as she rolls out along the streets. This piece is a sonic portrait of the Festa de Iemanjá held each year on the second of February in the Rio Vermelho neighborhood of Salvador, Bahia.

During the 2010 festival, we accompanied the Filhos de Gandhy, Bahia's largest Afoxé bloco. The Afoxés have been referred to as the Candomblé of the street for their adaptations of the Candomblé rhythm in the secular context. Their signature sound is an inversion of the Ijexá[1] rhythm, one of the rhythms played in the Candomblé for Iemanjá, among other *orixás*. In the secular context, the rhythm remains the same, while the high and low notes are swapped. It is played on the *agogô*—or the *gã* in the sacred context.

We followed the Filhos' ritual and subsequent departure from their headquarters in the Pelourinho and then captured the culminating moment as they reached the beach in procession at sunset when the great float of gifts honoring Iemanjá is towed out to the open sea. Men dressed all in white with their terrycloth turbans belt out songs to the driving big drum beats. One hears the rhythm of the Afoxé, almost trance-inducing, and those who listen carefully will hear the beat of Iemanjá herself—the ocean lapping in the foreground.

In 2011, rather than focus on one group, we opted to record the sound of festival as a whole, sensory event. The resulting audio and images highlight the unproblematic union of sacred and profane that characterizes the ritual celebration. The recordings capture intersections of brass bands with *trio elétricos* and *afoxés* in a semispontaneous aural montage, all with the roar of the streets of Salvador in high festival mode: the energy of the crowd, the sizzle of grilling meats, the calls of drink sellers, the sudden popping of fireworks—everything but the smells of urine and sweetened popcorn on the salt air. We experience the process of the festival from preparations the evening prior when people begin to leave their gifts—flowers, mirrors, soaps, and even dolls—in the great baskets arranged outside the Casa de Yemanjá. We see the sellers of perfume and trinkets intended as gifts for the goddess of the sea and as souvenirs too. Then come daytime and the sun and the sweat, women all made up pretty squeezed into baby blue tank tops and skin tight shorts knock back Skols and laugh and dance. And the polyrhythm of unrehearsed encounters . . . bodies, acarajé, exuberant sound makers, and the fishermen with their wooden boats for whom every day is a day of Iemanjá.

Images and audio from the 2012 festival highlight the *space* of the festival, an homage to the sea that becomes a throng of bodies moving between street and sand, and of all behaviors sacred, profane, and mundane. In the street, persons of all ages, genders, classes, and religious affiliations wait in a queue blocks long to place their offerings in the baskets

near the Casa de Yemanjá. Others came the previous night, or just before dawn. Some forego the cue and toss their flowers directly into the sea from the beach. Streets lined with vendors fill with passing bands, drinking revelers, and litter over the course of the day. On the sandy beach below, we see the growing float bearing the great baskets of gifts and flowers. Various Candomblé houses raise a shade tent or temporary altar where passersby may receive a blessing for a small donation. This year, rougher waters thrill frolicking children and send little boats teetering into a beach break. I spot Ogun in an orange life jacket! Today, the beginning of a police strike in Bahia has folks cutting out of work early fearing violence, looting, assaults on busses, and the traffic that comes with it all. But the party continues in Rio Vermelho. At the water's edge a woman enters an ecstatic trance, while up on a cobblestone hill a toasting reggae DJ scratches then sings along with a passing marching band.

Note

www.bluethroatproductions.com/iemanja. Visuals by Jamie Davidson, recordings by Nelson Eubanks, and web design by Evan Clayburg, Blue Throat Productions, 2010, 2011, 2012.

1. Ijexá is also one of the nations of Candomblé in Bahia.

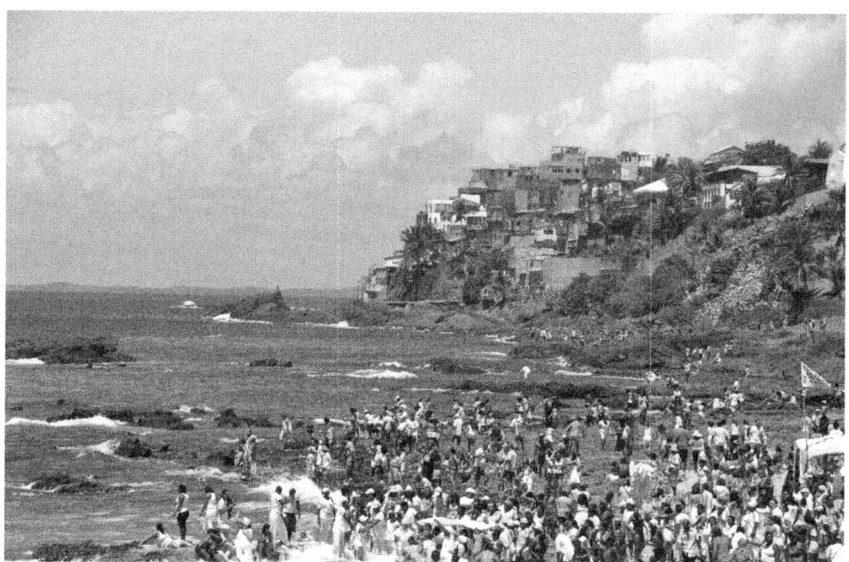

Figure 10.1. Iemanjá Festival, Praia da Paciência, Rio Vermelho, Salvador, Brazil, 2 February 2012, photo by Jamie Davidson.

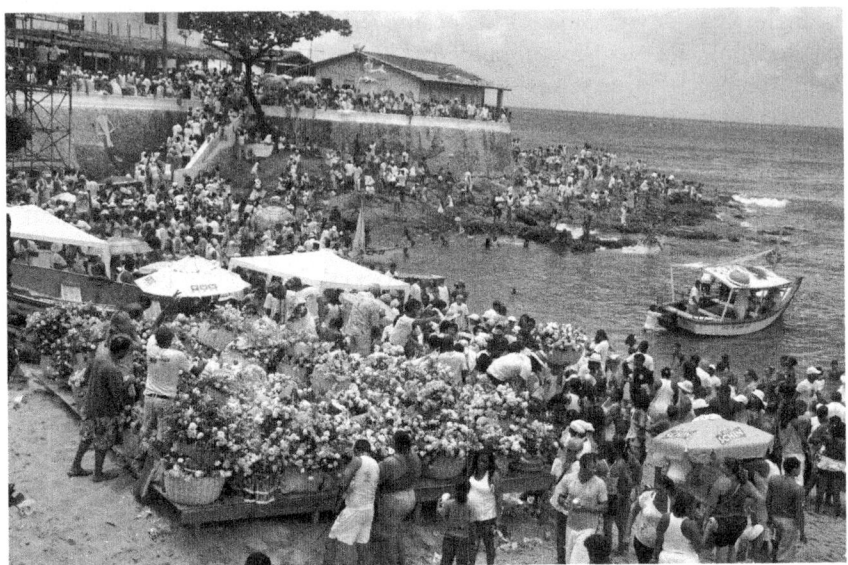

Figure 10.2. Iemanjá Festival. On the Praia da Paciência, the great float of offerings grows. In the background, the Casa de Yemanjá. 2 February 2012, photo by Jamie Davidson.

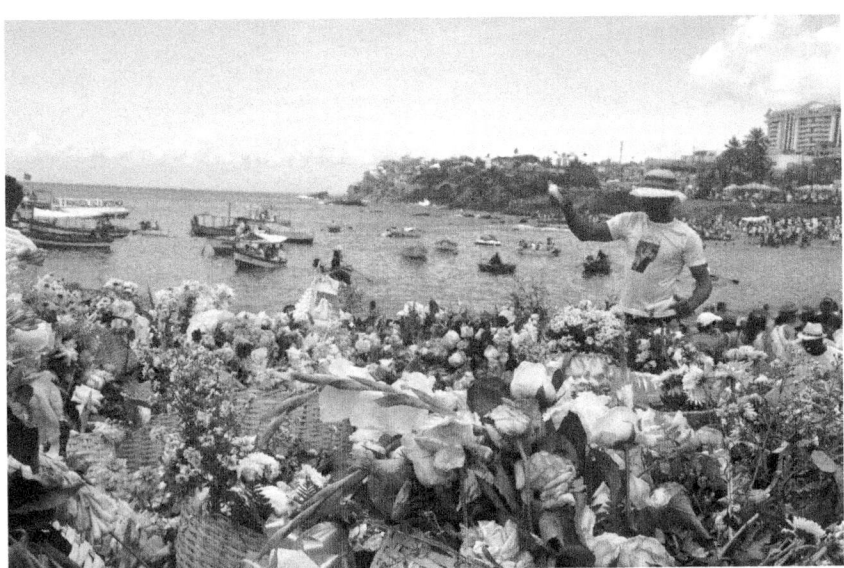

Figure 10.3. Iemanjá Festival. Flowers and gifts await departure. Praia da Paciência, Rio Vermelho, Salvador, Brazil, 2 February 2012, photo by Jamie Davidson.

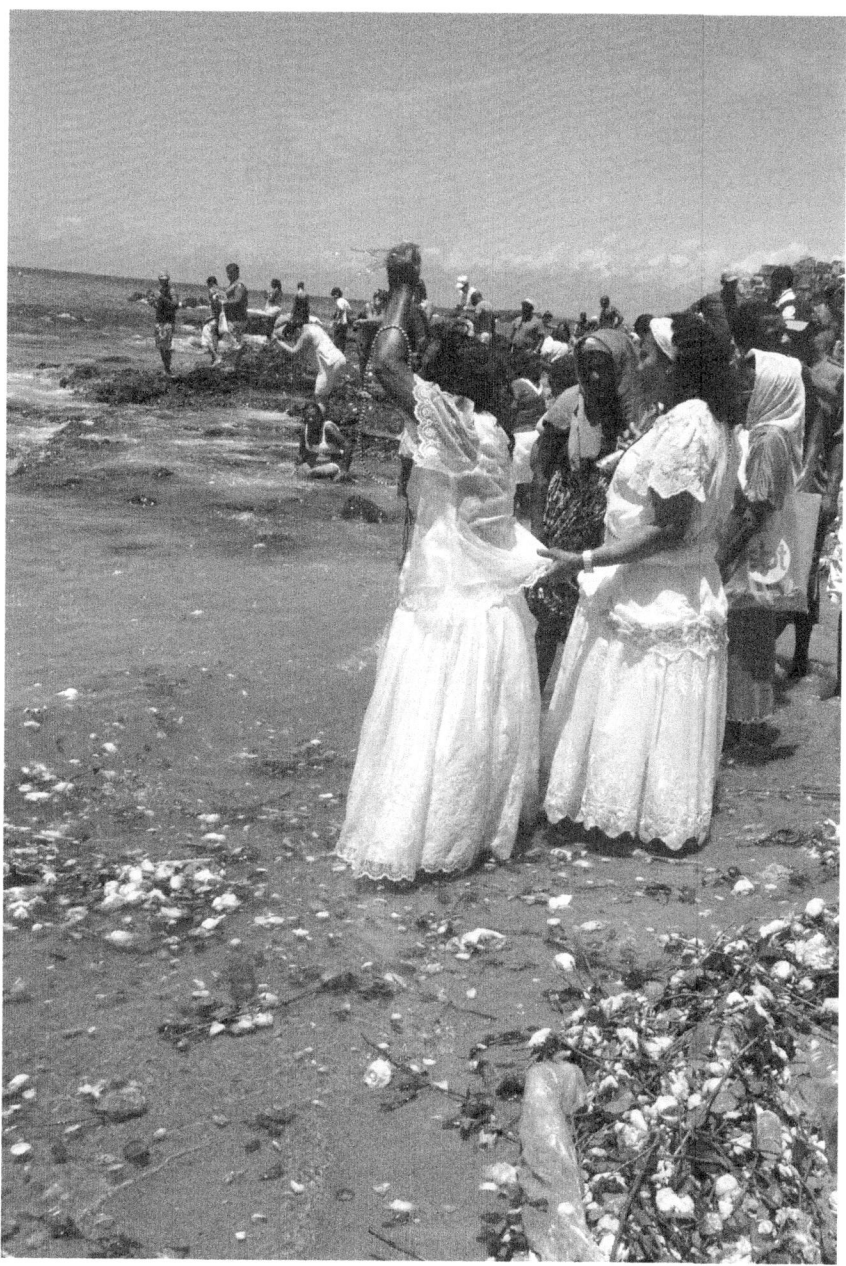

Figure 10.4. Iemanjá Festival. On a beach strewn with flowers, an ecstatic devotee receives support. Praia da Paciência, Rio Vermelho, Salvador, Brazil, 2 February 2012, photo by Jamie Davidson.

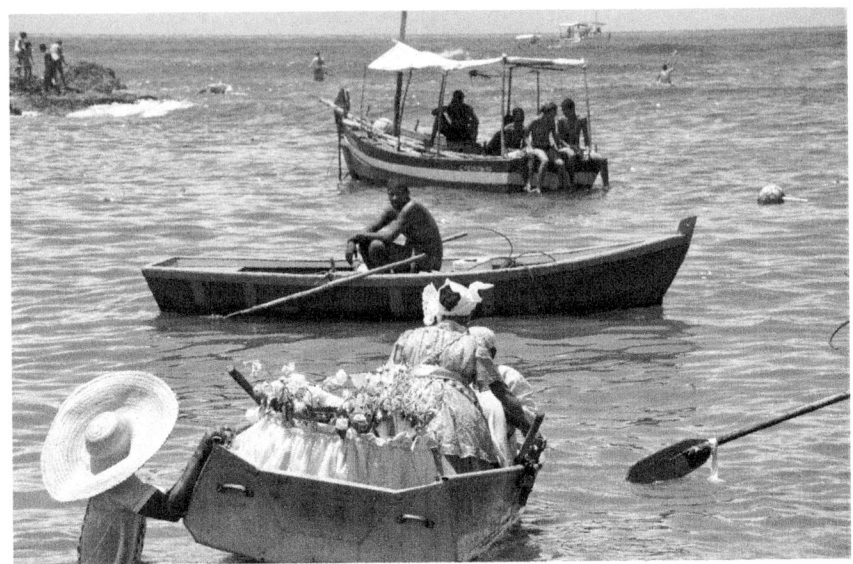

Figure 10.5. Iemanjá Festival. Boats carry offerings to the sea. Praia da Paciência, Rio Vermelho, Salvador, Brazil, 2 February 2012, photo by Jamie Davidson.

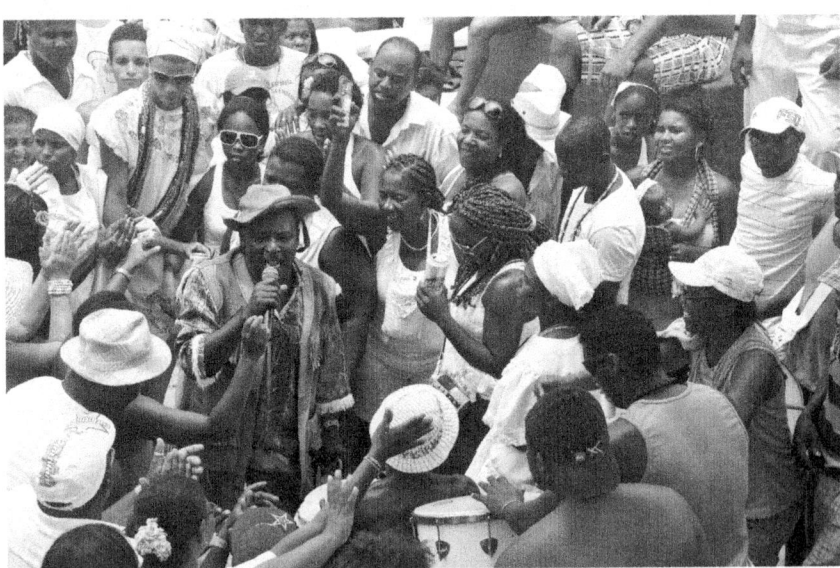

Figure 10.6. Iemanjá Festival. *"A muvuca."* Revelers make music on the Praia da Paciência, Rio Vermelho, Salvador, Brazil. 2 February 2012, photo by Jamie Davidson.

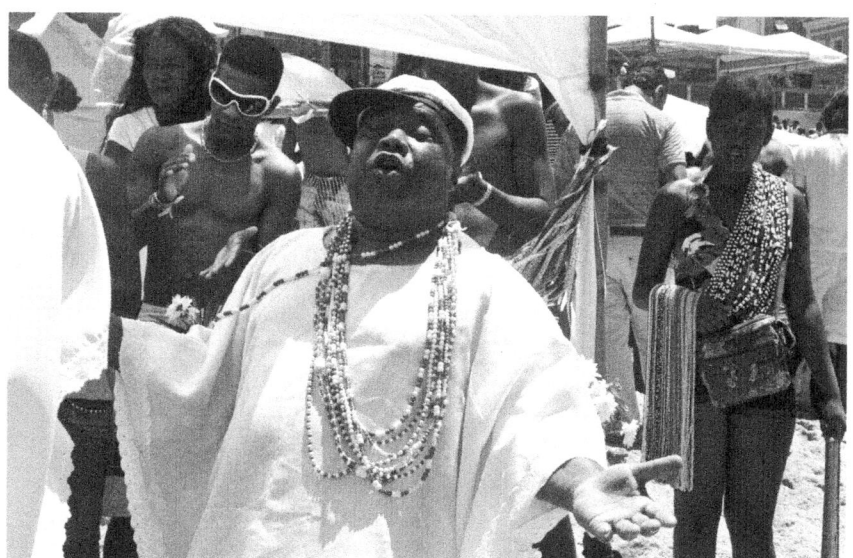

Figure 10.7. Iemanjá Festival. Song of praise with bead seller. Praia da Paciência, Rio Vermelho, Salvador, Brazil, 2 February 2012, photo by Jamie Davidson.

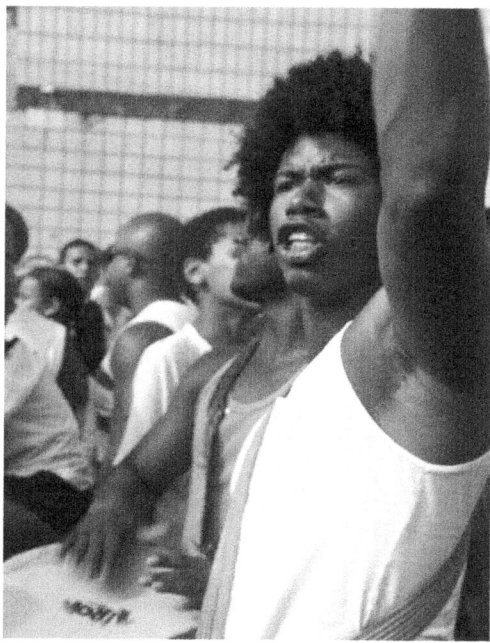

Figure 10.8. Iemanjá Festival. Drummers take the streets. Rua João Gomes, Rio Vermelho, Salvador, Brazil, 2 February 2011, photo by Jamie Davidson.

Chapter 11

Yemayá Offering a Pearl of Wisdom
An Artist Statement

Erin Dean Colcord

I am an eclectic pagan who has loved mermaids since I was a small child and have informally studied mermaid folk art since that time. When I was in the initiation process to become a Bloodroot Honey high priestess for CAYA Coven in Berkeley, California, I had to devote three months to a mother goddess to get in touch with the divine mother within. Since I was pregnant at the time and was also friends with several ladies who were kind enough to pass on oral traditions of various *orishas* passed down from Luisah Teish and the American Magic Umbanda House, Yemayá was very close to my heart, so I worked with her. This work involved a lot of meditation, art, altar making, and preparation for childbirth. Right before giving birth, I formally dedicated to Yemayá as part of my Wildflower priestess path for CAYA, vowing to not only deepen my relationship with her over the rest of my life but also to represent her when needed, to let her shine through me for the benefit of the rest of the coven and the world. I continue to make art for Yemaya and always do special acts of reverence for her on Saturdays, like wearing blue and silver, cleaning her altar in the bathroom, taking a salt water bath with my toddler son, singing her songs that other priestesses taught me, and looking for opportunities to learn and act on the wisdom of gentle motherhood. Motherhood has been quite a journey so far, and I know Yemayá has guided me all along and always will. *Ashe*, Yemayá.

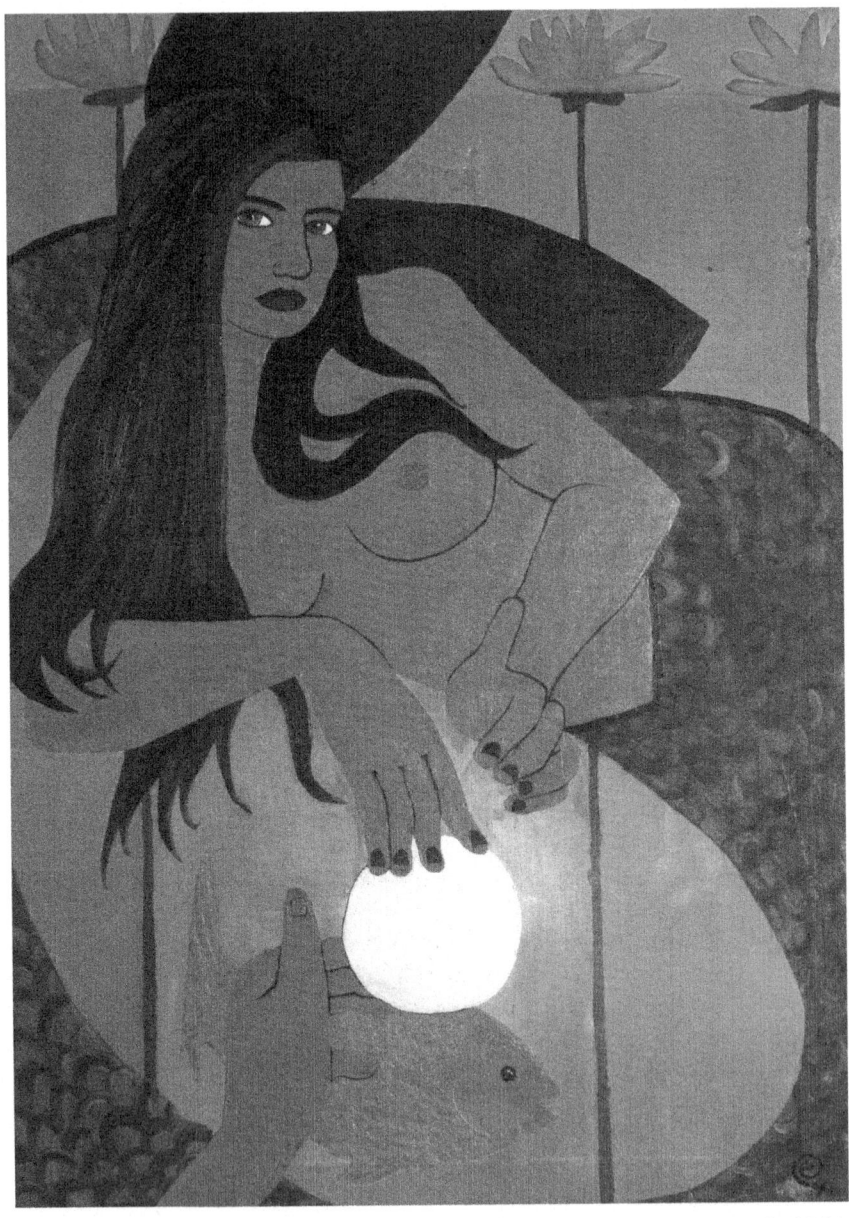

Figure 11.1. *Yemaya Offering a Pearl of Wisdom*, Erin Dean Colcord, 2004. Acrylic on canvas, 20" x 28", courtesy of the artist.

Yemayá Offering a Pearl of Wisdom

This painting hearkens back to a guided meditation I once undertook in an Elements of Witchcraft class. In our visions, the teacher guided us to the seaside to meet a guide, who would then give us a message. Rising up from the waves, this mermaid goddess met me with a warm, maternal smile and put a bright, shining pearl into my belly while giving me this advice: "Keep this pearl with you always, inside of you. It will help you to know what you really want." I painted her, not knowing yet that she was Yemayá, wishing to share the experience with others, so that they, too, could feel her love and wisdom for themselves.

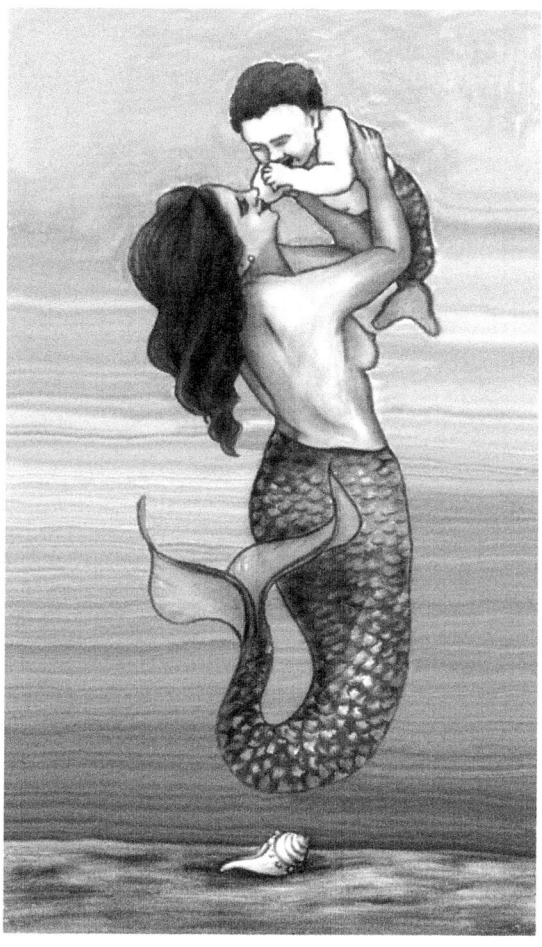

Figure 11.2. *Mermaid Playing with Merbaby*, Erin Dean Colcord, 2009. Jar Candle Sticker, color, 3" x 5", courtesy of the artist.

Mermaid Playing with Merbaby

I created this image as a gift for my friend Maia. At the time, she was about to have her head washed, devoting herself to a lifetime of service to Yemayá, through the American Magic Umbanda House. She made tall jar candles with this artwork as party favors for her guests. It was my honor to attend her head wash, a privilege she gave knowing that I was also dedicated to Yemayá. The illustration shows Yemayá as a mermaid, playing joyfully with a merbaby. We know that Yemayá is the goddess of all things maternal and that she looks after infants, but beyond that simple acknowledgment, I used that imagery as a supplication to help Maia achieve motherhood for herself, as was her earnest dream.

Notes on Contributors

Aisha M. Beliso-De Jesús is assistant professor of African and African Diaspora religions at the Harvard Divinity School. Dr. Beliso-De Jesús is a cultural and social anthropologist who has conducted multi-site ethnographic field research with Santeria practitioners in Havana and Matanzas, Cuba, and Miami, New York City, and the San Francisco Bay Area. She studies religious travel, tourism, media, and issues of race, gender, sexuality, and power. Dr. Beliso-De Jesús was a 2011 Ford Foundation Postdoctoral Fellow at Yale University's Department of Anthropology where she worked on her upcoming book manuscript on transnational Santeria between the United States and Cuba. In fall 2012 she returned to her regular position at Harvard Divinity School.

Erin Dean Colcord, a lighting consultant, writer and artist, lives in Los Angeles with her husband and two kids. She grew up in Ohio and has a Bachelor of Fine Arts in photography from the Ohio State University. Erin lived for many years in the San Francisco Bay Area, working as an art teacher, photographer and in the lighting industry, before moving to LA. Her art covers various media, including painting, drawing and photography, and is usually made as an act of reverence, as adoration for a goddess or for a beloved friend. She is a high priestess of Come As You Are (CAYA) Coven, where she is known as "Ladybug." Erin's artwork expresses her worldview that all people and creatures are divine beings. Now she is working on a fiction novel featuring a witch and a tribe of mermaids living at Venice Beach.

Jamie N. Davidson is an ethnographer, dancer, and mother. A PhD candidate in the Department of World Arts and Cultures at University of California, Los Angeles, Davidson is currently a Fulbright-Hays Fellow living in Brazil. Her primary area of research regards ritual dances in Afro-Brazilian religions.

Micaela Díaz-Sánchez is an assistant professor in the Department of Spanish, Latina/o Studies, and Latin American studies at Mount Holyoke College where she teaches Latina/o Cultural Studies. She received her PhD from Stanford University's Department of Drama in 2009; her dissertation is entitled *(In)Between Nation and Diaspora: Performing Indigenous and African Legacies in Contemporary Chicana/o and Mexican Cultural Production*. While at Stanford, she focused on directing and performing in original work by queer writers of color while working in community-based performance projects throughout the San Francisco Bay Area. After Stanford, Díaz-Sánchez was a Mellon Postdoctoral Fellow in Latina/o studies with an affiliation in African American studies at Northwestern University. At Northwestern, she was selected as Faculty Member of the Year by the Multicultural Student Affairs Office for bridging student affairs with her work in the classroom as well as for serving as a mentor to students of color on campus. While in Chicago, she immersed herself in local performance communities as a practitioner of two diasporic musical traditions, Afro-Mexican Son Jarocho and Afro-Puerto Rican Bomba, which she performed professionally as part of a Humboldt Park-based ensemble. Her article "Impossible Patriots: The Exiled Queer Citizen in Cherríe Moraga's 'The Hungry Woman: A Mexican Medea" was published in *Signatures of the Past: Cultural Memory in Contemporary North American Drama*. Her article on performance artists Jesusa Rodriguez and Celia Herrera-Rodriguez, entitled "Body as Codex-ized Word/Cuerpo Como Palabra (en-)Códice-ado: Chicana and Mexican Transnational Performative Indigeneities," will be published in the forthcoming book *Performing the Latina/o Borderlands*. Her article about Chicago-based playwright Tanya Saracho, "Race-ing Class and Gender on the Border," is part of a forthcoming anthology about Latina/o theater in Chicago. She is currently working on an article focusing on gender and sexuality in the contemporary practices of Bomba as well as an article about Chicana/o cultural practitioners' part of the African Diaspora through what she conceptualizes as "Afro-Chicana/o Diasporic Aesthetics."

Nelson Eubanks, a graduate of Columbia University's Masters of Fine Arts program in writing, is a fiction writer, sound engineer, and creator of bluethroatproductions. After publishing his first book, *The First Thing Smoking*, a collection of connected short stories (Ballantine 2003), Nelson took to chasing sound. Nelson has recorded parades, processions, and sounds from the oceans, rivers, jungles, juke joints, clubs, and streets of the black Diaspora, including New Orleans, Cuba, Venezuela, Peru, and Brazil. He has done sound for documentaries and has been the

soundman for New Orleans brass bands such as the Hot 8 Brass Band and TBC brass band. He is currently living, writing, and recording in Salvador, Bahia.

Toyin Falola is the Jacob and Frances Sanger Mossiker Chair in the Humanities and a Distinguished Teaching Professor at the University of Texas at Austin. He received the 2011 Africanist Distinguished Award by the African Studies Association. Falola has published numerous authored and edited books, including *Sango in Africa and the African Diaspora*, *The Altantic World*, *The Yoruba Diapsora in the Atlantic World*, and *Esu: Yoruba God, Power and the Imaginative Frontiers*. He is the Vice President of the International Scientific Committee of the UNESCO's Slave Route Project.

Arturo Lindsay is professor of art and art history at Spelman College. He is one of fifteen American artists selected by the U.S. Department of State's Bureau of Educational and Cultural Affairs to engage in people-to-people diplomacy through the visual arts. The initiative titled "smARTpower" builds on Secretary of State Hillary Rodham Clinton's vision of "smart power diplomacy," which brings people together to foster greater understanding. He has won numerous awards, including a Lila Wallace-*Reader's Digest* International Artist Award to establish a studio in Portobelo, a sixteenth-century Spanish colonial village in Panama in 1994. Lindsay has participated in a number of traveling exhibitions including Ceremony of Spirit: Nature and Memory in Contemporary Latino Art, organized by the Mexican Museum in San Francisco, and Art in Atlanta, organized by Artists-in-Residence International. As a scholar, Lindsay has lectured and published several essays on New World African religious, spiritual, and aesthetic retentions. In 1996, he edited *Santería Aesthetics in Contemporary Latin American Art*, which was published by the Smithsonian Institution Press. In 1997 he won the Spelman College Presidential Award for Scholarship. In 1998, he won a Fulbright Scholar award to conduct research on the manifestations of black Christ figures in the Americas and to work with emerging self-taught artists of the village of Portobelo.

Solimar Otero is associate professor of English and a folklorist at Louisiana State University. Her research centers on Afro-Caribbean spirituality and Yoruba traditional religion in folklore, literature, and ethnography. She is the author of *Afro-Cuban Diasporas in the Atlantic World* (University of Rochester Press, 2010). Her current projects deal with gender

and embodiment in Afro-Cuban religious practices and performances. Based on this work, she won a visiting research position at the Harvard Divinity School's Women's Studies in Religion Program from 2009 to 2010; and a Ruth Landes Memorial Research Fund grant in 2013. Dr. Otero is completing her second monograph, *Coming Home: Nation, Gender, and Diaspora in Afro-Cuban Religion*, which investigates how the representation and expression of gender in Afro-Cuban religions affects Cuban transnationalism. Her work has also appeared in *Atlantic Studies, Western Folklore, Phoebe, Africa Today, The American Journal of Psychoanalysis,* and *The Black Scholar.*

Elizabeth Pérez is assistant professor of religion at Dartmouth College. A historian and ethnographer of Afro-diasporic religions, she earned her PhD at the University of Chicago Divinity School. She is currently preparing a book manuscript based on doctoral research conducted in a predominantly black community of Afro-Cuban Lucumí, Espiritismo, and Palo Monte practitioners on the South Side of Chicago. Her most recent research project examines the challenges of transgendered and transsexual people as religious actors in the contemporary United States.

Pedro Pérez-Sarduy is a poet, writer, journalist, and broadcaster living in London. He is the author of *Surrealidad* (Havana, 1967), *Cumbite and Other Poems* (Havana, 1987 and New York, 1990), and a novel, *Las Criadas de La Habana/The Maids of Havana* (2003, 2010). He is also coeditor with Jean Stubbs of *Afro-Cuba: An Anthology of Cuban Writing on Race, Politics, and Culture* (1993) and coauthor of the introduction for the anthology *No Longer Invisible/Afro-Latin Americans Today* (1995). He is the recipient of numerous awards, including several Rockefeller Foundation Fellowship Awards (1993, 2000) and a UNESCO Medilia Victor Hugo (2009).

Allison P. Sellers is a master's in history candidate at the University of Central Florida. She has written a commentary with Joel E. Tishken from Washington State University on a *Yoruba Praise Poem to Sango* (1970).

Martin Tsang completed his master's in social anthropology at the School of Oriental and African Studies, University of London. He has undertaken extensive fieldwork and written on *orisha* worship in North America, Cuba, and Europe. He is a doctoral candidate in anthropology at Florida International University researching Chinese influence in Afro-Cuban religions.

Teresa N. Washington is the Ann Petry Endowed Professor in English at Grambling State University. She is the author of *Our Mothers, Our Powers, Our Texts: Manifestations of Àjẹ́ in Africana Literature*; *The Architects of Existence: Àjé in Yoruba Cosmology, Ontology, and Orature*; and *Manifestations of Masculine Magnificence: Africana Divinity in Life, Lyrics, and Literature*. Her work appears in *Toni Morrison's* Beloved: *Bloom's Modern Critical Interpretations*, *Èṣù: Yoruba God, Power, and the Imaginative Frontiers*; *Step into a World: A Global Anthology of the New Black Literature*. Her work has also been published in *African American Review*; *Journal of Pan-African Studies*; and *FEMSPEC*.

Alan West-Durán is professor of modern languages in the Department of Languages, Literatures, and Cultures at Northeastern University, where he is the director of the LLACS (Latino/a, Latin American and Caribbean Studies) Program. He was born in Cuba and grew up in Puerto Rico. He is the author of two books of poems, *Dar nombres a la lluvia/Finding Voices in the Rain*, which won the Latino Literature Prize for Poetry (1996), and *El tejido de Asterión o las máscaras del logos* (2000). He has also written *Tropics of History: Cuba Imagined* (1997). Dr. West-Durán edited *African Caribbeans: A Reference Guide* (2003) and *Latino and Latina Writers* (2004). He is also the editor-in-chief of the 2011 Gale Publishers' two-volume reference work on Cuba. West-Durán's essays on Cuban music have appeared in the *Journal of Popular Music Studies*, *Latin American Music Review*, *The Michigan Quarterly Review*, *Encuentro de Cultura Cubana*, *La Gaceta*, *Temas*, and *Hopscotch*. He has translated Alejo Carpentier's *La música en Cuba* (2001), Rosario Ferré's *Language Duel/Duelo de lenguaje* (2002), Nelly Richard's *Cultural Residues* (2004), and Luisa Capetillo's *Mi Opinión Sobre Los Derechos de la Mujer* (2005). Currently he is working on a book on Caribbean literature, essays on Cuban hip hop, and Regla de Ocha (Santeria).

Index

Note: Page numbers in *italics* indicate figures;
the plates in the Color Gallery (following page 186) are indicated by *pl.*

áálè, 249
Abakua societies, 12, 54, 55, 59, 75n72
Abatán, 116
Abraham, R. C., 86–87
Abreo González, Claudina, 87–90, 92, 94, 96, 100, 102
aché, xxiv, 22, 26, 118–21, 125, 206; feminine guild of, 115; Arturo Lindsay on, 187–94; Teresa Washington on, 216; August Wilson on, 235–36
Acotirene, 240–41, 248
Adeoye, C. L., 215
Adepegba, Cornelius, 122
Adisa, Opal Palmer, 231
Afoxé bloco, 268
African Americans, 168
Afrocentrism, 20, 48, 70n31. *See also* Pan-Africanism
Aganyu, 57, 134
AIDS/HIV, xxiv, 40n113, 60
Aina, 127n6
aje, xix, 204–6, 240
Aje Shaluga, 118, 134
Àjé traditions, 113, 216, 219
alaleyo, 119, 128n8
Alarcón, Norma, 155, 159, 178n14

Albear Ajayí Lewú Latuán, Timotea, 119–20
Alexander, Jacqui, xix, 155, 161–62, 164, 174, 175
Alicia, Juana, xxiii, 154–55, 164–77; works of: "Ceasefire," 164; *La Llorona's Sacred Waters*, *pl. 1*, 154, 166–68; *Las Lechugeras*, 164, 166; *Maestrapeace*, *pl. 2*, 154, 168–76, *169*, *170*, 183n83; "Mission Street Manifesto," 164; "SANARTTE: Diversity's Pathway," 154, *165*, 165–66, *166*
"all-knowing eye," 55
Allen, Jafari Sinclaire, 50
Althusser, Louis, 19
American Magic Umbanda House, xxv, 275, 278
Anne, Saint, 146
Anzaldúa, Gloria, xx–xxi, 98, 153–64; Juana Alicia and, xxiii, 154–55, 164–77; Arrizón on, 157
Aponte y Ulabarra, José Antonio, 20, 21, 23, 30
Arrizón, Alicia, 14, 89–90, 97, 98, 157
Artemis, 39n98
Arugbá Olókun, 114

285

Ascencio, Michaelle, 31n4
Aset, 245
ashé. See *aché*
Augustine of Hippo, 11
avatars, 33n26, 39n98, 114, 171, 202; *caminos* and, 148n41; dualistic, 93
awo. See *babalaos*
Awo Ifá, 123
axé. See *aché*
Ayarakotó, 118
Ayede, Nigeria, 144
Ayón, Belkis, 207

Baba Lu Aiye, 180n32
babalaos, 51–56, 61, 123, 140; homosexual, 53, 57, 75n70
Baca, Judy, 179n17
Bahia, Brazil, 267–69, *269–73*
BaKongo Water Gods, 224, 230, 258
Baluandé. See Madre Agua
Bambara, Toni Cade, 174, 232
Bambara Komo society, 236–38, 240
Bantu, 13
baptism, 249
Barber, Karin, xx, 104n13, 127n3
Bascom, William, 131
batá drum ritual, 27
Batuque, 137
Bechtel Corporation, 166
Bedia, José, 207
Beier, Ulli, 131, 135
Beliso-De Jesús, Aisha M., xxii, 43–65, 279
Benito of Palermo, Saint, 20
Bishop, J. Michael, *166,* 181n61
Bolivia, 166
"border culture," 157–63
Boromu, 116
Bosch y Martínez, Antonio, 23
botanicas, 48, 70n28
Brazil, 217
Brown, David H., 12, 24
Brown, Ras Michael, 191
Bryant, Jacqueline K., 24

Buddhism, 75n72
Bynum, Omelika Kuumba, 191

Cabezas, Amalia, 162–63
cabildos de nación, 11, 12, 20–23, 30
Cabrera, Lydia, xx–xxi, 22, 24, 198, 207; El Pato and, 43, 46, 51, 58, 63–64; on *marimacho*, 98, 163; Ortiz on, 70n24; Otero on, 85–94, 96, 100–103; Sellers on, 131
Cajón al muerto ritual, 12, 13, 33n19
calabash, 237; of Olókun, 114, 118, 119, 126; of Yemoja, 144–45, 240
Calvo Cano, Alfredo, 60
caminos, 13, 148n41; of Yemayá, 13, 93, 98, 116–18, 127n5, 137–38, 202
Campbell, Nilaja (pseudonym), 25–30
Campos Pons, María Magdalena, xxiv, 197–209
Candomblé, 137; Afoxé bloco, 268; Catholicism and, 145–46; homosexuality and, 59, 125; Matory on, xx; Santería and, 194n1. See also Umbanda
Cantero, Susana, 21
Carby, Hazel, 35n39
Cárdenas, "Panchita," 22
Castro, Fidel, 47–48, 50
Castro, Mariela, 73n55
Catholicism, 52, 259; creolization of, 75n72, 99, 145–46. See also Virgin Mary
Chalchiuhtlicue, 166, 167
Changó, xxii, 9, 61, 70n31, 77n86, 132–39; accompanying deities of, 127n6; children of, 57; Ganga Zumba and, 240; Las Sietes Potencias and, 199; wives of, 216
Chenzira, Ayoka, 191
Chicanas/os, 153–77
cimarrones, 194n6, 194n9, 224, 240, 244

Cissé, Souleymane, 236–38
Clarke, Kamari, 70n31
Clifford, James, 43, 160–61, 199
Coatlicue, 158–59, 161, 171–73
Cockroft, Sperling, 176
Colcord, Erin Dean, xxv, 275–78, 279; works of: *Mermaid Playing with Merbaby*, xxv, *277*, *278*; *Yemaya Offering a Pearl of Wisdom*, *276*, *277*
Congos (spirits), 26, 54–55, 188, 194n6, 194n9
Conner, Randy, 71n31, 163, 177n5, 180n23
Constantine, Roman emperor, 245
Contreras, Sheila Marie, 178n6, 180n27
cowry shell divination, 44, 57–60, 114, 118–24, 128n16, 200; Erinle and, 121; signs in, 59–60, 76n80
Coyolxauhqui, 169–70, 172–73, 176
Creoles, 12, 34n31, 100–103, 160–63
criolleras (nursemaids), 15
critical race theory, 10
crossroads, 161–62, 205
crowns, 119, 125, 142
Cruz, Celia, 187
Cuban Americans, 72n36
curanderas, 165

Dada (vegetable deity), 134
Dagara wisdom keepers, 230
Dahomey, 137
dance, xx, 200, 216, 267; *aché* and, 187–94; Gèlèdé, 216, 247, 251; juba, 218–19, 249
Danticat, Edwidge, 223–28
Dash, Julie, 253, 257; works of: *Daughters of the Dust*, xxiv, 248–51, 253–58
Daughters of the Dust (film), xxiv, 248–51, 253–58
Davidson, Jamie N., xxiv–xxv, 267–69, *269–73*, 279
Davis, Angela, 174

Davis, Zeinabu irene, 238–40, 243
De Jesus, Piri, 60, 77n84
de la Fuente, Alejandro, 207
desaparecidos, xxiv, 188–93
Dessalines, Jean-Jacques, 224, 239–40
Diablo Mayo, 194n9
Diago, Juan Roberto, 207
Diamond, Kate, 179n17
Díaz-Sánchez, Micaela, xxiii, 153–77, 280
Diegues, Carlos, 240
dillogún. *See* cowry shell divination
disidentifications, 46, 62
divination: Ifá, xxvii n9, 118, 123–25, 140, 204. *See also* cowry shell divination
dogs, 144
Dominican Republic, 203, 223–28
Las Dos Aguas, 125
Drewal, Henry John, 203
Drewal, Margaret, xx
Du Bois, W. E. B., 37n72
Duck (El Pato), xxii, 43–65
Duke, Dawn, 18
Dumas, Henry, 232–34
Duodorus, 245
Duque, Francisco M., 23

ebbos (offerings), 57
Ebron, Paulla A., 15, 45
Ecovios. *See* Abakua societies
Ecuador, 217
Efe traditions, 113
Efunshe Warikondo, Ña Rosalía Abreú, 119–20
egún, 28
Elegba, 118, 119
Eleggua (deity of communications), 25, 51, 58; Alexander on, 161–62, 164; Anzaldúa on, 161, 164; Campos-Pons on, 205, 208; Tezcatlipoca and, 181n41
Eleta, Sandra, 188
Ellis, A. B., 131
Emanje, 131

English-Robinson, Laura, 191
Erinle, 98, 114, 116, 118, 121–22, 128n11
Eshu. *See* Eleggua
Espiritismo, 97; creolization of, 75n72, 87–88; Madama in, 19–20; *misa blancas* in, 25–26; Yemayá and, 10, 12
Esquina, Yaneca, 188
Esquivel, Alexis, 207
Ethiopia, 217, 232, 245–46
ethnography, 43–44
Eubanks, Nelson, xxiv–xxv, 267–69, *269–73*, 280–81
Eyila Chebora, 57
Eyila sign in cowry shell divination, 76n80

Fagbamila, Oluwo, 71n31
Falola, Toyin, xvii–xxvi, 249, 280–81
Fanon, Frantz, 37n72, 209
Farajajé-Jones, Elias Ibrahim, 40n113
Faro, 236–38
Farris Thompson, Robert, 165, 171, 172
Fatunmbi, Awo Falokun, 200, 251
Fernandez, Alexander, 128n7
Fernandez Robaina, Tomas, 69n17, 75n70
Filhos de Gandhy, xxv, 268

Ganga Zumba, 239–41
Garcia, Ña Ines, 120
Garciandía, Flavio, 207
Gaspar de Alba, Alicia, 177
Gates, Henry Louis, Jr., 261n42
gay men. *See* homosexuality
Gèlèdé traditions, 113, 115, 117, 216, 221, 229, 247; festivals in, xix, 217–19, 251
Gerima, Haile, 234, 241–47, 252–55
Ghana, 242, 244, 255
Glissant, Edouard, xxiv, 197, 199, 201
Goler, Veta, 191
Gómez, Fermina, 117, 120
Gómez Luaces, Eduardo, 23

González Obá Teró, Ma Monserrate, 119–20
Grajales, Mariana, 25
Grewal, Inderpal, 69n14
Guelperin, Charley, 33n27
Gullah, 248, 253–58

Haiti, 217, 223–27; Columbus on, 223; Vodou in, 116, 125, 137, 143, 194n1
Hammons, David, 207
"hand" ritual, 54
Hathor, 39n98
Haug, Kate, 17
herbal remedies, 19, 142, 165
Hernández, Juan Antonio, 38n74
Hernandez-Linares, Leticia, 167
Herrera, María Josefa "Pepa," 21–23
Herrera, Ño Remigio, 21
Herskovits, Melville, 66n4, 248–49
Heru, 245
Hoch-Smith, Judith, 171
Holland, Endesha Ida Mae, 252
homophobia, xix–xxii, 174; in Cuba, 45–49, 53, 60–61, 73n55
homosexuality, xxi–xxii, 26, 29, 45–51, 115; "butch," 50, 98, 163; Candomblé and, 59, 125; Chicana, 170; creolization and, 160–63; in Cuban soap operas, 74n58; Ifá and, 71n31, 75n70; Lukumí and, 71n31, 121; queer theory and, xx–xxi, 97, 98; *Santería* and, 44–45, 52–65, 75n70, 77n91, 163; terminology for, 66–67nn6–10, 72n37; "visibility" of, 58–59, 77n91; Vodou and, 125. *See also* sexuality
honey, 14, 126, 129n18, 140, 201–2, 249
Horus, 245

Iara, 267
Ibeyi, 9
Ibo Landing, South Carolina, 248, 253–58

Ibú Mojelewu, 116, 117
ibú, 33n26
Ìdòròmù Àwúsè, 216
Iemanjá festival, xxiv–xxv, 267–69, 269–73. *See also* Yemoja
Ifá, 136–37, 140; divination of, xxvii n9, 118, 123–25, 140, 204; homosexuality and, 71n31, 75n70; names of, 128n16; priestesses of, 52; procreation and, 124; Santería and, 54
Ifà Irosun, 120
Ife (town), 135
Ifè (deity), 219
Igba Odu, 118
ikin, 118
Ìko Àwúsí, 216
Ikú divination sign, 60
ilde, 61
Ilé Laroye, 25–30
ilutí, 239
incest, 138–39
indigo, 117, 125, 250
initiation rituals, 53–54, 119–20, 133, 230
Inle. *See* Erinle
Ìràsùn, 252
Ìràwo, 122
ire, 128n15
Isis, 245
Islam, 136
Ìtànkálè, 216, 218
Ìwónran Níbì Ojúmotí í Móó Wá, 216
iworo, 52
Iya, 135
Ìyáàmi sorority, 115
iyalochas, 29, 43, 52, 58, 104n11
iyanifa, 140
Iyánlá, 240
iyawo, 60
Iyewa, 116

Jamaica, 217, 242, 244
Janaína, xix, 267. *See also* Yemoja/Yemajá
Jehovah's Witnesses, 49
"Jemima women," 19–20
Jennings, Joe, 191
Jews, Santería among, 75n72
Jim Crow laws, 207
John Paul II, pope, 245
Jones, Bessie, 249
Juárez, Mexico, 167–68
juba, 218–22, 235, 249
juego de Congo, 189, 194n9

King, Joyce E., 19–20
King, Serge, 70n31
Kuekueye, 43, 46, 62, 63
Kutzinski, Vera, 89

Lachatañeré, Rómulo, 23
Lam, Wifredo, 207
Landes, Ruth, 77n83
Lasiren, 203
Latorre, Guisela, 183n83
Lawal, Babtunde, 117, 131
Lele, Ocha'Ni, 60
lesbians. *See* homosexuality
Lezama Lima, José, 197
Lindsay, Arturo, xxiv, 187–94, 281; works of: *Adenike of Lagos*, pl. 6; *Bay of Portobelo at Sunset*, pl. 3; *Boli Catching the Skies #1*, pl. 8; *Children of the Middle Passage*, 189, 190; *Portraits of Yemaya*, pl. 8, 194; *Requiem in Portobelo*, pl. 4, 193; *The Return of African Spirits*, pl. 7, 192–93; *Sanctuary for the Children of Middle Passage*, 191–92, 192; *The Voyage of the Delfina*, pl. 5, 190–91
La Llorona, 167–68
Lorde, Audre, xvii, xx–xxi, 174
Lukumí (Afro-Cuban creole), 46, 52
Lukumí (religion), 10, 114, 118; in Chicago, 25–26; Erinle in, 121; homosexuality and, 71n31, 121; Ochún in, 14; priesthood of, 119; Virgen de Regla and, 11–13. *See also* Santería

Maceo brothers, 25
Macumba. *See* Candomblé
Madama (spirit), 19–20
Madre Agua, 10, 13, 33n27, 116, 267; Congo parties for, 26
Malcolm X, 260n11
Mama Azul, 101–2
Mami Wata, xix, 89, 90, 203
"mammy" stereotype, xxi, 10, 17–20, 22, 23, 30
mano de Orula ("hand" ritual), 54
maquiladoras, 167
Marcus, George, 43
Mariel Boatlife, 47–48, 72n36
Maroons. See *cimarrones*
Mason, John, 217
Matory, J. Lorand, xx, xxviii n26, 29
Màyé'lé'wo, 240, 256
Mayorga, Irma, 164, 176
McCarty, Joan, 191
McClintock, Anne, 17
McKenzie, P. R., 128n14
melão, 126, 145
Menchú, Rigoberta, 169–73, 183n83
Mendieta, Ana, 193, 207
Mendive, Manuel, 207
Meréètélú, 216
Merlín, Countess of, 16–17
mermaids, 88–90, 104n15, 133, 267, 276, 277; with merbaby, xxv, 277, 278
Mesìn Àkáárúbà, 216
"*mestiza* consciousness," 155–56, 158, 159, 161, 164
Métraux, Alfred, 248–49, 260n28
Metrès Dlo, 223, 224
Mexican-U.S. War, 157
Middle Passage, 27, 114, 154, 171; Campos-Pons on, 198–99, 203; casualties of, 188–93, 217, 219, 223, 229, 232–34, 260n11; Cissé on, 238; Glissant on, 201; Lindsay on, 190–91; Morrison on, 222; Tinsley on, 160; Walcott on, 198; West-Durán on, 197

Miguelón, 44
minstrel shows, 18
Mohanty, Chandra, 174
molasses, 126, 145
Moore, Madison, 28–29
Moore, Opal, *pl. 5*, 190–91
Moore, Robin, 18
Moraga, Cherríe, 170, 174
Morell de Santa Cruz, Pedro Augustín, 11
Morrison, Toni, 259; works of: *Beloved*, xxiv, 220–22, 226–31, 235, 252, 258
mortuary rituals, 117–18, 230–31
Mosquera, Gerardo, 193–94
Mother of the River (film), 238–40, 243
mpungus, 13, 26
mulattas/os, 10; Chicana, 153–77; creolization and, 15–16; *morenos* and, 32n13; Ochún as, 13–14, 88; *pardas* and, 36; *santeros* and, 52; stereotypes of, 14; Tinsley on, 24. See also race
Muñoz, Jose Esteban, xxi, 62, 97
Murphy, Joseph M., 39n98
Muslims, 136

Nana Buruku, 116
negritos (one-act plays), 18
Neimark, Philip, 71n31
nepantla, 156–57, 159, 162
New Age religions, xxv, 48, 74n65, 275–78
Niger River, 236, 238
nkisi, 193, 195n14

Oba, 76n81, 116, 134
obá (king of the crown), 52
obá oriaté, 44, 54. See also *oriaté*
Obalofun, 135
Obatalá, 11, 114, 141, 205; accompanying deities of, 127n6; Changó and, 138, 139; children of, 57; Ògún and, 140; El Pato

and, 51; Las Sietes Potencias and, 199
Ocha. *See* Regla de Ocha
Ochoa, María, 182n66
Ochosi, 199
Ochún, 48, 56, 171; honey and, 201; Mami Wata and, 203; Virgen de Caridad as, 11, 13, 198; Yemayá and, xxii, 29, 76n81, 85–103
Ochusi, 51
odu, 14, 57, 58, 121, 123–24, 128n15
Odu Ifǎ, 123–25
Odua (Earth Mother), 132
Odudua, 134, 135
Oge, 127n6
Ògún, 51, 54–55, 172, 199, 201; mythology of, 134–35, 139–41; offerings to, 116; Teresa Washington on, 215–16, 233, 251–52; Zumbi and, 240
Ogun Alagbede, 116
Ògún River, 12, 26, 132, 136, 216, 252
Ògúndá, 252
Ògùntè, 240, 252
ojú inú, 232, 254
Òkè, 134, 247
Okere, 136
òkòtó shells, 117
Oliana, Chris, 70n31
Ollin, 166
Olocun. *See* Olókùn
Olodumare, 114
Olofi, 51, 56, 58
Olofin, 118
Olókùn, xix, 114, 116, 118, 137–38; festival of, 120; mask of, 117; El Pato and, 43, 59; as sea deity, 120, 128n9, 134
olorisha, 119, 123
Olosa, 116, 134
Oludumare (deity), xxvii
oluwo, 123

Omari, Mikelle Smith, 146
Omi Aríbúsolá, 142
omírèke, 126
Omodu, 123
Opa Orisha Oko, 122
opele, 118
Ordi Melli divination sign, 59–60
oriaté, 44, 52–54, 60
oríkì, xx, 114, 142–43, 215, 241, 244
Orisha Oko, 118, 122–23, 126, 134, 139, 141
orishas, xviii, 171; accompanying deities of, 127n6; altars of, 21; Anzaldúa and, 158; devotees birthdays of, 133; gendering of, xx, 69n17; hot/cool, 132; language of, 46; manifestations of, 33n26; Murphy on, 39n98; pantheon of, 24, 52, 131, 134; praise poems of, 114, 142–43; regional, 131–32; Tsang on, 114; West-Durán on, 202; "white," 132. *See also specific orishas*
Oró (power of the word), 204, 247
Ortiz, Fernando, 23, 66n4, 70n24
Orula, 52, 76n81, 134; wives of, 57, 140, 141
Orungun, 134
Òrúnmìlá, 119, 123–24
Oshori, 135
Oshumaré, 116, 117
Oshún, xix, 116, 125–26; Arturo Lindsay on, 187; Las Sietes Potencias and, 199; Teresa Washington on, 216
osogbo, 128n15
Osogbo Ano (divination sign), 60
Òsun, 134, 139–40
Otero, Solimar, xvii–xxvi, 85–103, 128n9, 281–82
Otin, 118, 121–22
Oxum, 203
Oyá, 11, 116, 134, 171, 247; Oge and, 127n6; personalities of, 32n7;

Oyá *(continued)*
 Las Sietes Potencias and, 199;
 sobriquet of, 247
Oyewumi, Oyeronke, xx

Pajarito, 195n9
paleras, 97
Palmares, Brazil, 240–41
Palo-Congo spirits, 54–55
Palo Mayombe, 54, 75n72
Palo Monte: creolization of, 87–88;
 Madre Agua in, 10, 13; Yemayá
 in, 116
Pan-Africanism, 187, 218, 224, 238,
 240, 257. *See also* Afrocentrism
pantheonization, 24, 52, 134
Papa Legba. *See* Eleggua
Partido Independiente de Color
 (PIC), 22
patakís (stories), 89, 128n12, 201
El Pato, xxii, 43–65
Patterson, Orlando, 243, 244
"paying the water," 230–31
Peña, René, 207
pepeyé. *See* El Pato
Pérez, Elizabeth, xxi, 9–30, 282
Pérez, Emma, 156–57, 159
Perez, Irene, 169–70
Pérez, Laura, 170–72, 176
Pérez Bravo, Marta, 207
Pérez-Sarduy, Pedro R., 282; works
 of: "En busca de un amante
 desempleado," xxi, xxiii, 2–7
Philippine Islands, 32n9
Piñera, Virgilio, 197
Portobelo, Panama, *pl. 3, pl. 4, pl. 8*,
 188–93

Queen Nanny, 240, 244
queer theory, xx–xxi, 97, 98. *See also*
 homosexuality
Quilombo (film), 240–41
Quiroga, José, 91, 93; works of:
 Topics of Desire, 85, 100

race, xviii, 10–17; categories of,
 35n46; in Cuba, 50, 207–8; in
 Dominican Republic, 225; Jim
 Crow laws and, 207; "*mestiza*
 consciousness" of, 155–56, 158,
 159, 161, 164. *See also* mulattas
Ramos, Miguel "Willie," 12
rape, 15, 18
Regla. *See* Virgen de Regla
Regla de Ocha, 29, 113, 127n2,
 177n3, 199–200
reglas de Congo, 13
Rey, Terry, 40n113
Rodriguez, Nelson "Poppy," 57,
 76nn80–81, 77n84
Rodríguez-Mangual, Edna, 70n24,
 93

Saldaña-Portillo, María Josefina,
 178n6, 179n23
Saldívar, José David, 155, 161
Saldívar-Hull, Sonia, 158, 159, 167
Salvador, Brazil, 267–69, *269–73*
Sanchez, Holly Barnet, 176
Sánchez-Traquilino, Marcos, 175
Sandoval, Chela, 174
sandunga, 24–25
Sàngó. *See* Changó
Sankofa (film), 234, 241–47, 252–55
Santa Marta la Dominadora, 203
Santería, 97, 145–46, 200; Anzaldúa
 and, 158; *babalaos* and, 52–56,
 75n70; economics of, 48;
 homosexuality and, 44–45, 52–65,
 77n91, 163; Ifá and, 54, 140;
 mythology of, 137–41; Regla
 de Ocha as, 199–200; stigma
 of, 49–50, 52; in United States,
 45–49, 53–58, 64, 187. *See also*
 Lukumí
Saunders, Tanya, 49
Sellers, Allison P., xxii–xxiii, 131–46,
 282
Senegal, 172, 190
The Seven Powers, 199, 202–3
sexual tourism, 50
sexuality, xviii–xxi, 96–100;
 "deviant," 53, 55, 57, 60. *See also*
 homosexuality

Shange, Ntozake, 231, 259
Shangó. *See* Changó
Sherald, Amy, *pl. 7*, 193
Shopono, 135
Siete Sayas. *See* Madre Agua
Las Sietes Potencias, 199, 202–3
La Siguanaba, 167
Simbi, 230–31
Simpson, Lorna, 207
slave rebellions, 20. See also *cimarrones*
smallpox, 135
Somalia, 218
Somé, Malidoma, 230
soul food, 26, 255
Soyinka, Wole, 190
Sparks, David, 71n31
Spelman College, *pl. 5*, 188, 190
Spivey, Diane M., 24
St. John, Maria, 18
Stubbs, Jean, 25
Sudan, 218
sugar cane, 126, 145, 224–25
Surinam, 217
swans, 117

Taller Portobelo, 188
Taylor, Diana, 173
teatro bufo, 18
Tedún, Changó, 20–21
Teish, Luisah, 179n21, 231, 275
Teresa of Ávila, Saint, 32n7
Tezcatlipoca, 181n41
Thomas, Hugh, 15–16
Thomason, R. Paul, 191
Thompson, Stith, 90
thrones, 21, 133
Tinsley, Omise'eke Natasha, 24, 160, 180n36
Tlaloc, 167
transsexuals, 56–57
trickster figures, 195n9
Trinidad, 131, 137, 242; Yemoja in, 145, 146
Troupe, Quincy, 232
Trujillo, Rafael, 223, 225–27
Tsang, Martin, xxii–xxiii, 113–27, 282

tuberculosis, 133
Two Cubas (film), 76n77

Umbanda, xxv, 245, 275, 278. *See also* Candomblé

Valencia, Carlos/Carolina, 76n77
Vargas, Kathy, 164
Verger, Pierre, 172
Viarnes, Carrie, 38n84
Vidal Ortiz, Salvador, 64, 77n91, 163
Villaverde, Cirilo, 37n68, 39n100
Virgen de Candelaria, 11, 32n7
Virgen de Caridad, 11, 13, 198
Virgen de Caridad del Cobre, 87, 89–90, 99; feast day of, 104n9; Ochún and, 104n9, 105n23
Virgen de Regla, 87, 99, 115, 116; feast day of, 104n9; in fiction, 37n68, 101–2; "mammy" stereotype and, 18–19, 22; Ochún and, 104n9; Olókun and, 120–21; as warrior queen, 20–23; Yemayá as, 10–13, 15–16, 30, 146, 201
Virgin Mary, 19, 32n15; correspondences of, 11, 30; Arturo Lindsay on, 187; sobriquets of, 19; Teresa Washington on, 216, 224; Yemoja as, 146, 187
Vishnu, 33n26
Vodou, 116, 137; homosexuality and, 125; Santería and, 194n1; Yemayá in, 143
Voodoo Woman (film), 56–57, 76n78

Walcott, Derek, 198
Walker, Alice, 24, 256
Waller, Thomas Wright "Fats," *166*, 181n61
Warden, Nolan, 12, 13
Washington, Teresa N., xxiv, 204, 205, 215–59, 283
Weems, Carrie Mae, 207
West-Durán, Alan, xxiv, 25, 197–209, 283
Wilcox, Melissa, 71n31

Wilson, August, 217, 233–36, 256

X, Malcolm, 260n11

Yai, Olabiyi Babalola, 216
yams, 139, 144, 145
Yarbro-Bejarano, Yvonne, 155–56, 158, 163–64, 173, 179n20
Yeelen (film), 236–38
"Yemayá's Song," 143
Yemoja/Yemajá, 9–30, 131–46; Alicia's mural of, *169*, 171–73; Bahia festival of, xxiv–xxv, 267–69, *269–73*; *caminos* of, 13, 93, 98, 116–18, 127n5, 137–38, 202; characteristics of, xix, 86, 113–18, 126–27, 132–33; children of, 9, 56–58, 116, 118, 141; as divinatory authority, 118–20; favorite foods of, 26, 27, 144; illnesses associated with, 133; as Muslim, 136; El Pato and, xxii, 43–65; poems for, xvii, 2–7, 142–43, 172; sobriquets of, xix, 19, 114–18, 131, 142, 215, 247, 267; songs for, vi, xxi, 12, 113, 132, 133, 154; taboos of, 144; as Virgen de Regla, 10–13, 15–16, 30, 146, 201; as warrior, 20–23, 29, 68n11, 113, 116, 202; worshiping of, 12, 43, 116, 143–46, 193
Yemojì, 216
Yewájobí, 215, 217–18
Yeyéolókun, 144

Zamora Albuquerque, Mercedes, 87, 94–95, 100, 102
zarzuelas, 18
Zumbi, 240, 241, 248, 251

Made in the USA
Coppell, TX
30 September 2020